PANIC ATTACK!

ART IN THE PUNK YEARS

Edited by Mark Sladen and Ariella Yedgar

Jean-Michel Basquiat

Victor Burgin

COUM Transmissions

Tony Cragg

Cerith Wyn Evans

Gilbert & George

Nan Goldin

Keith Haring

Jenny Holzer

Peter Hujar

Derek Jarman

Mike Kelley

Barbara Kruger

David Lamelas

Linder

Andrew Logan

Robert Longo

Paul McCarthy

Robert Mapplethorpe

Gordon Matta-Clark

Mark Morrisroe

Tony Oursler

Raymond Pettibon

Adrian Piper

Richard Prince

Jamie Reid

Martha Rosler

Cindy Sherman

John Stezaker

Hannah Wilke

Stephen Willats

David Wojnarowicz

Bill Woodrow

CONTENTS

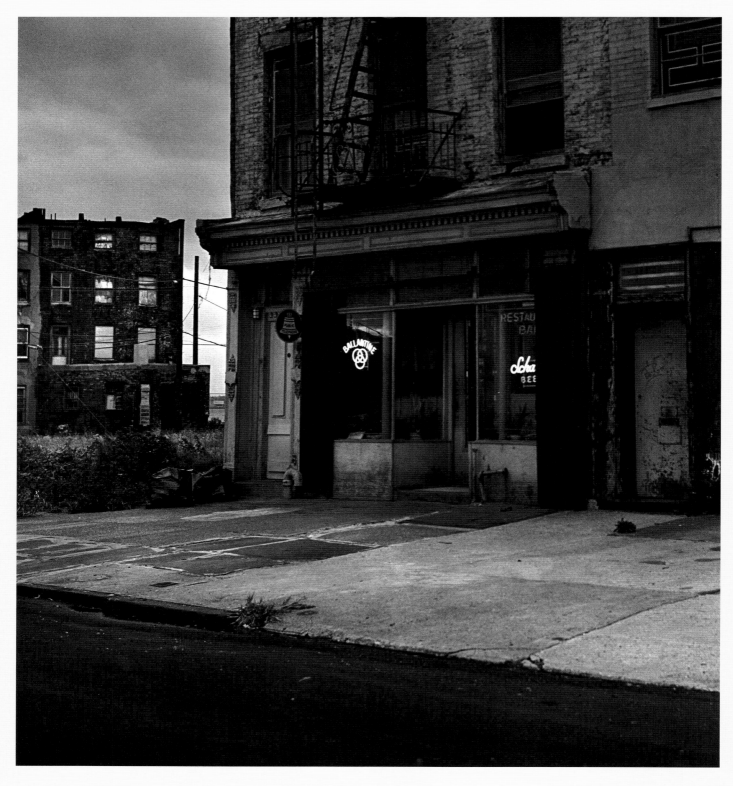

PETER HUJAR
Bar, Brooklyn, 1975

PREFACE

On 7 June 1977 a televised Service of Thanksgiving was held at St Paul's Cathedral in London to celebrate the twenty-five-year reign of Queen Elizabeth II. On the same day, punk band the Sex Pistols sailed down the Thames playing their controversial single 'God Save the Queen'. *Panic Attack! Art in the Punk Years* opens exactly thirty years later. This major exhibition examines art produced between the mid-1970s and mid-1980s in Britain and the United States. The focus of the exhibition is on the visual arts, rather than on the disciplines more readily associated with punk, such as music, fashion and graphics. It reveals the vibrant art scene that exploded in cities as diverse as London, New York and Los Angeles, where visual artists shared the radical attitudes, and the radical aesthetics, of punk and post-punk musicians and designers.

The period explored in *Panic Attack!* is one of political, economic, social and cultural turbulence. Britain and America were hit by recession following the oil crisis of 1973. Thatcherism and Reaganism emerged, and social divisions became more pronounced. Public spending suffered massive cuts. Riots erupted in Brixton, south London, in 1981. AIDS devastated many lives and many communities. The Sex Pistols' iconoclastic 'God Save the Queen' surpassed the 250,000 sales mark, going silver within a month of the Silver Jubilee celebrations, despite being banned by radio stations. The art of the time, on both sides of the Atlantic, echoed this sense of a society under stress. *Panic Attack!* is structured around four recurring themes: art with overt political intent that uses the inner city as a symbol of social breakdown; the body as a site to explore transgressive ideas of sexuality, violence and abjection; do-it-yourself aesthetics, collage and appropriation as alternative means of visual communication; and the underground scene as a radical social space and ground for artistic cross-fertilization.

We would like to thank all the artists and their representatives who have lent work to the exhibition, including Alison Jacques Gallery, London; The Approach, London; James Birch, London; Cabinet, London; Electronic Arts Intermix, New York; Galerie Kienzle & Gmeiner GmbH, Berlin; Helen Kornblum, St Louis; Max Lang, New York; Lisson Gallery, London; James Mackay, London; Matthew Marks Gallery, New York; Paliotto Collection, Naples; PPOW, New York; Regen Projects, Los Angeles; Robert Mapplethorpe Foundation, New York; Ronald Feldman Fine Arts, New York; Sammlung F.C. Gundlach, Hamburg; Richard and Ellen Sandor Family Collection, Chicago; Aurel Scheibler, Berlin; Stuart Shave/Modern Art, London; Thomas Erben Gallery, New York; Galerie Thomas Zander, Cologne; Carol Vena-Mondt, Occidental, California; and the estates of Keith Haring, Gordon Matta-Clark and David Wojnarowicz. Our thanks also go to our other lenders: Arts Council Collection, Southbank Centre, London; Arts Council England, London; Daros Collection, Switzerland; The Fales Library & Special Collections, New York; Haus der Photographie, Deichtorhallen, Hamburg; Museum Boijmans Van Beuningen, Rotterdam; The Museum of Contemporary Art, Los Angeles; The Museum of Modern Art, New York; Smart Museum of Art, Chicago; and Tate, London.

We are also indebted to Mark Sladen and the curatorial vision that he has brought to the project. His introduction deftly brings into focus the exhibition's main ambitions. Andrew Wilson's contribution to the exhibition and accompanying book has been immense: he has given his time, expertise and treasured personal belongings, as well as writing an important contextualizing essay. We are grateful to Rosetta Brooks, David Bussel, Carlo McCormick and Tracey Warr for their illuminating and highly enjoyable texts, and to Stephen Willats for granting permission to reprint extracts from his engaging publication of 1986. Paul Bayley and Elizabeth Manchester have scrupulously researched and compiled the chronology. We would like to thank all at Merrell Publishers for their patience and encouragement throughout, especially Hugh Merrell, Nicola Bailey, Claire Chandler and Michelle Draycott. Designers Damon Murray and Stephen Sorrell of FUEL have created *Panic Attack!*'s vivid graphic identity. Finally, we would like to thank our colleagues at the Barbican, in particular Clementine Hampshire and Cassandra Needham, who organized this project so expertly and diligently.

Graham Sheffield
Artistic Director, Barbican Centre

Kate Bush
Head of Barbican Art Gallery

Ariella Yedgar
Curator, Barbican Art Gallery

—— 'These people are the wreckers of civilisation'——

TORY MP Nicholas Fairbairn fought his way through Hell's Angels and young men with multi-coloured hair, lipstick and nail varnish last night —
AND SAW

sex-show

A STRIPPER, accompanied by a rock group called "Throbbing Gristle," far, far worse than anything I have ever seen. I was appalled.

"They must be very sick people indeed."

A WEIRD porn-and-pop show,

Its filth is exceeded only by its banality.

their pornography can only destroy the values of our society.

Nicholas Fairbairn ... outraged.

And the MP's critical appraisal was: 'It's a sickening outrage. Sadistic. Obscene. Evil.' money is being wasted here to destroy the morality of our society. These people are the wreckers of civilisation. They want to advance decadence.

'I came here to look, and I am horrified,' said the MP.

THROBBING GRISTLE

ARE attempting "to destroy the difference between good and bad, and right and wrong

"I'm sickened . . . This show is an excuse for exhibitionism by every crank, queer, squint and ass in the business."

Mr. Fairbairn said he saw

SADISM with sticks and flails.

WEIRD music from what exhibition organisers called the Death Factory, by a rock group called "Throbbing Gristle." allowing people to promote every swill-bin attitude they can to degrade language, meaning and thought"

Stripper

The show includes a stripper accompanied by masochistic performances by a rock group called Throbbing Gristle; They are devoid of any sense of proportion and respect for the decencies of life.

MASOCHISTIC performances by a rock group may be a scabrous symbol of one facet of Britain today; but not yet, thank heavens, of the whole. And the underlying impulse is not one of survival but of destruction and the death-wish—

controversial pop-and-porn show

T. G.

A rock group called Death Rock will be taking part at the opening. They will be singing songs about mass murder and about the child murderer Ian Brady. "They offer reflections on the way TV programmes and the other media work."

"spooks with soft-belt intellectual arrogance . . . anxious to promote every swill-bin attitude they can to degrade language, meaning and thought."

"The organisers must be very sick people. I wish I'd never got involved." it was an excuse for exhibitionism by every crank, queer, squint and ass in the business."

'We're only just getting a look at the maggots in the nest. By the time the current controversy dies down their scrapbook will be fat enough to ensure gigs a plenty here and abroad for them, their rock band Throbbing Gristle and any professional striptease artiste they care to take along with them.

— PARANOIA CLUB —

GENETIC FEAR

BLURRED SELF IMAGE

Visitors ... what today's connoisseur is wearing.

'We are presenting information. Without people, information is dead. People give it life.

But for me, it was like a scene out of a real-life horror show last night.

As I walked in, a drunken young woman was being carried out. She had green hair.

At the bar, a girl in trousers and bright orange hair was embracing a blonde in a gold lamé dress.

Next to them was a 6ft. 5in. tall West Indian transvestite in a red off-the-shoulder gown.

There was also a very noisy rock group called Throbbing Gristle, dressed in more black lurex.

My main concern is that it has become the phenomenon of the age in music for non-creative people to make up for their inability and lack of imagination by being obscene, vulgar and depraved." Such filthy rubbish has always been available in holes and corners for those willing to pay for it; and there have always been people ready to make a living by purveying it.

A red-and-white crewcut nearby wiggled its black lurex trousers and shouted: 'God there are so many straights around"

Scotland Yard said today: "A report is being sent to the Director of Public Prosecutions."

"This all sounds rather menacing, but these are always the things which attract publicity."

CEASE TO EXIST

SECONDARY ORGASMIC DISFUNCTION

INTRODUCTION

MARK SLADEN

On 18 October 1976 *Prostitution* previewed at the Institute of Contemporary Arts (ICA) in London. This exhibition, up for just eight days, proved to be one of the most incendiary in the ICA's history. It was organized by the artists' group COUM Transmissions, which had been founded by Genesis P-Orridge in 1969 and featured P-Orridge, Cosey Fanni Tutti and Peter 'Sleazy' Christopherson. The exhibition included photographs of performances by COUM in the preceding years, as well as museum cases with props, such as chains, syringes and Vaseline, that had featured in these actions, and sculptural assemblages featuring used tampons. The exhibits that proved most controversial, however, were a series of signed and framed images of Tutti, which were in fact the appropriated pages of pornographic magazines for which she had routinely posed. The exhibition gained instant notoriety, and Conservative MP Nicholas Fairbairn, who had visited the opening to see the event for himself, railed in the newspapers that the show was 'a sickening outrage. Sadistic. Obscene. Evil. … Public money is being wasted here to destroy the morality of our society. These people are the wreckers of civilisation.'[1] The group responded by making the press cuttings that the scandal generated part of the exhibition itself, pinning up photocopies on the gallery walls.

In retrospect, *Prostitution* can be described as a highly 'punk' event. COUM's performances were a form of body art, a loose category of work associated with the late 1960s and early 1970s that involves the ritualized staging of the body, often deploying forms of self-exposure or self-harm. The performances presented in photographic form in *Prostitution* included shamanic rituals involving enemas and self-mutilation, and obvious ways in which the event was punk were its theatrical deployment of bodily transgression and its confrontational exploration of sexuality, deviance, violence and abjection. Genesis P-Orridge had also been heavily influenced by the cut-up techniques of the writer William Burroughs and artist-writer Brion Gysin, and P-Orridge and Tutti had experimented extensively with collage in the form of mail art. The notion of appropriation was central to COUM, as was demonstrated by the photographs of Tutti that were at the heart of *Prostitution*, as well as by the press cuttings that came to adorn the exhibition. Other punk characteristics of the event included its collage of media-derived 'trash' and its use of 'do-it-yourself' techniques.

Furthermore, by revealing that Tutti had worked as a pornographic model and then re-representing these images of her as authored works, the exhibition created a mocking commentary on the prostitution inherent in all labour and on the hypocrisy of a culture in which such prostitution could be reframed as art. The whole exhibition was presented in a formal, 'museum' style, and the combination of radical social critique with the ironic co-option of accepted modes of cultural production is also highly punk. Social critique was pushed further in the activities of Throbbing Gristle. Featuring P-Orridge, Tutti and Christopherson, along with new collaborator Chris Carter, the band had been formed earlier in the year and performed at the opening of *Prostitution*. 'Tonight we're going to do a one-hour set called *Music from the Death Factory*', P-Orridge announced to the audience. 'It's basically about the post-breakdown of civilisation. You know, you walk down the street and there's a lot of ruined factories and bits of old newspaper with stories about pornography and page three pin-ups, blowing down the street, and you turn a corner past the dead dog and you see old dustbins. And then over the ruined factory there's a funny noise.'[2] This notion of social crisis, and in particular the embodiment of social crisis in the image of the traumatized city (as well as the imagery of totalitarianism), is also extremely punk.

The opening night of *Prostitution* represented a significant meeting point of the worlds of art and punk, not only because of the shared imagery and strategies that have been outlined above, but also in a more literal way. The performance of Throbbing Gristle was followed by another, by the punk band Chelsea, and the opening was full of Chelsea's fans; Fairbairn commented that he had to fight his way through crowds of young men with multicoloured hair, lipstick and nail varnish. Moreover, Throbbing Gristle were responsible for the creation of Industrial music, a harsh and multilayered sound that was to be a significant part of the post-punk array of musical styles. The final way in which P-Orridge, Tutti and their various collaborators can be described as punk is through their use of all the resources of the 'scene' at their disposal, their exploration of music as well as art, and their exploration of the power of subculture – and in particular the ability of subculture to inspire 'moral panic', the point at which a person, group or phenomenon becomes a focus of social hysteria.

Throbbing Gristle press flyer, 1976

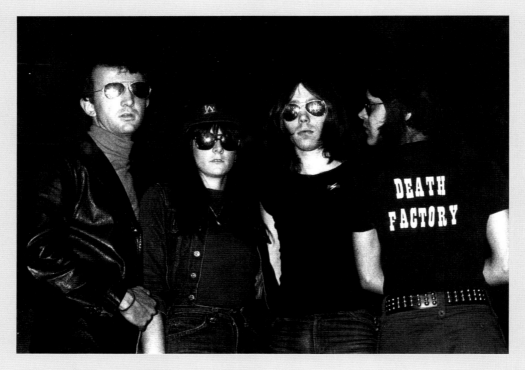

Throbbing Gristle in 1977: (from left) Peter Christopherson,
Cosey Fanni Tutti, Chris Carter and Genesis P-Orridge

The punk years

This book looks at British and American culture in the late 1970s
and early 1980s, a period of great social and economic turmoil in both
countries. It begins in the mid-1970s, in the shadow of the oil crisis,
and a time when the United States was preoccupied by Watergate
and the end of the Vietnam War; in Britain there were IRA bombings
on the mainland and massive public-spending cuts (the background
to a series of arguments about public spending on the arts in which
the *Prostitution* scandal was just one episode, following scandals
earlier in the year surrounding the Tate's purchase of Carl Andre's
Equivalent VIII and the exhibition of Mary Kelly's *Post-Partum
Document* at the ICA). It ends in the early 1980s, with the two
countries ruled by right-wing governments, with a British war in the
Falklands and an American one in Grenada, and with the emergence
of AIDS. This was a period in which crisis was in the air in both
countries, and in which the United States and Britain were the
breeding ground of punk and post-punk culture, a culture that seemed
to be both a symbol of and an adequate response to the ravaged times.

However, if it is now very easy to conceive of *Prostitution* as a punk
event, it must be remembered that in October 1976 'punk' was not
yet a common buzzword. The roots and development of punk as a
musical movement are much disputed, but it is certainly true that the
phenomenon had important progenitors in the United States, and that
a recognizably punk scene formed in New York in 1974–75 around
such bands as Television and the Ramones. The transference of
elements from this scene to London is often associated with Malcolm
McLaren, who visited New York in 1974 before returning to London

and starting to shape the band that would become the Sex Pistols.
In 1975–76 the Sex Pistols were a largely underground phenomenon,
but all this was to change just a few weeks after the closure of
Prostitution, when, on 1 December 1976, the band were interviewed
live on British television by the journalist Bill Grundy, the resulting
performance – drunken on the part of Grundy and foul-mouthed
on the part of the Pistols – provoking a media scandal.

The Grundy interview marked the start of the Sex Pistols' national
notoriety, a phenomenon that would peak with the scandal surrounding
their single 'God Save the Queen'. This single was released to coincide
with the Queen's Silver Jubilee celebrations in June 1977 and featured
Jamie Reid's cover artwork, with its image of the monarch with
ransom-style lettering across her face. The Sex Pistols' story quickly
took on an American dimension as well, a story that climaxed with
the twin deaths of Nancy Spungen and her partner Sid Vicious, the
band's bassist, in New York in 1978 and 1979. The national and
international celebrity of the Sex Pistols propelled the punk movement
into public consciousness and also spurred the creation of waves
of punk and post-punk bands in a number of cities in Britain and
the United States – including a very significant scene on the West
Coast – as well as other cities around the world. (Here it must be
noted that the terminology gets rather varied, with such labels as
punk, New Wave, No Wave and post-punk competing for attention.)

The punk movement is most commonly associated with music and
its attendant graphics and fashions, but the primary focus here is not
music but art, and the argument is that much of the best British and

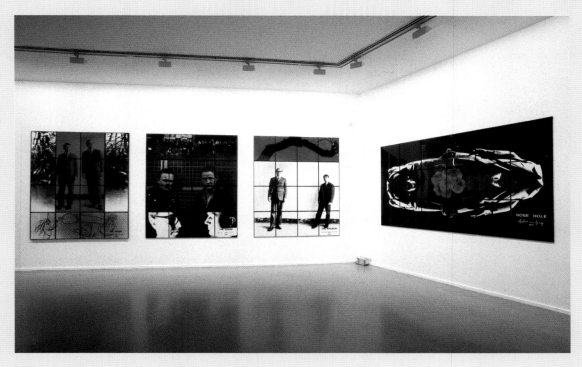

Installation view of the exhibition *Gilbert & George*, Musée d'Art Moderne de la Ville de Paris, 1997–98

American art of this time was also punk in spirit. While some of the American artists featured in this book (especially those based in New York) became canonized relatively quickly, the British art of this period has often been neglected. However, there were significant links between the art worlds in the two countries, and in particular between London and New York, and this book proposes a new lens through which to look at the art of this time.

The artists featured in this book embody the punk zeitgeist in a number of different ways, and one strand looks at artists who made work with direct political intent, who used their work to criticize society, often deploying the imagery of the city as a symbol of social crisis. Another strand looks at artists who deployed transgressive bodily imagery, as well as drag and performance, to explore such issues as sexuality, violence, abjection and empowerment. Yet another strand looks at appropriation, collage, trash, 'do-it-yourself' and the generation of alternative means of production and dissemination. The final strand looks at the notion of the scene and of subculture, at the overlapping worlds of art and music at this time, and at the exploration of the scene as radical social space. Sometimes confrontational or angry, but always fiercely independent and intelligent, this is art that reflects the spirit of the punk years.

The traumatized city

The oil crisis had exacerbated economic inequalities in Britain and the United States, and many artists became increasingly politicized, addressing issues of economic injustice as well as sexual and racial discrimination.[3] Victor Burgin had been one of the pioneers of Conceptual art, which had often been characterized by its combination of photography and text, and in the early 1970s he became one of the leading figures in a second wave of photo-conceptual work.[4] Burgin reinvented his practice through the use of advertising-style imagery and copy, making guerrilla interventions in the media landscape, undermining the constructs of the dominant culture at the same time that he aped them. His most notable pieces in this mode include *UK76* (1976; pp. 24–26) and *US77* (1977; pp. 27–29), two cycles of images that depict the fractured social landscapes of Britain and America respectively; over one image from *UK76*, of a female factory worker in Coventry, Burgin superimposes a piece of fashion 'advertorial'.

Other artists associated with 'photo-text' include Martha Rosler and Stephen Willats. Both of these artists chose to work with subjects and imagery that were more resolutely urban in nature, commenting on the social deprivation and dispossession that was a highly visible feature of American and British cities at this time. Rosler's *The Bowery in two inadequate descriptive systems* (1974–75; pp. 154–55) consists of a set of photographs depicting the bottle-strewn doorways of Lower Manhattan, with each photograph accompanied by a text listing euphemisms for drunkenness. It was her attempt to represent the crisis of alcoholism and homelessness without exploiting the images of its victims. Willats, meanwhile, made a series of collaborative works with people living on housing estates in Hayes, an impoverished suburb west of London. These works addressed the problems of what the artist called the 'New Reality' of these post-war tower-block estates, and documented the attempts of their inhabitants to find their own realities within them.[5]

Other artists departed further from the didacticism of Conceptual practice in their depiction of the city, among them Gordon Matta-Clark. Matta-Clark's most celebrated work, *Day's End* (1975; pp. 114–15), was made by removing elliptical sections of the walls and floor of a vast abandoned warehouse on New York's waterfront, creating a dazzling interplay of water and light. While defending this work, which had been made without permission, Matta-Clark declared his right to intervene in the urban fabric of the city: 'By urban fabric I mean social economic and moral conditions as much as the physical state or structures throughout the city.' In an attempt to combat 'neglect and abandonment' in all its forms, he asserted his right to 'improve the property, to transform the structure in the midst of its ugly criminal state into a place of interest, fascination and value'.[6] Matta-Clark was one of the pioneers of a new and often agitational attitude to cultural production that emerged in downtown New York in the mid-1970s, flourishing outside of the gallery circuit and favouring alternative channels of production that included performance, installation and the use of alternative spaces.[7]

The use of the seeming violence of the cut to retrieve the utopian possibilities of social space is also manifested in the work of John Stezaker, another graduate of Conceptualism, who in the mid-1970s began to create collages using found images, following the example of Surrealist and Situationist practice. One series, entitled *Eros* (1977–78; pp. 162–63), is made from cut-up postcards of London's Piccadilly Circus, the title of the series referring to the famous statue of the Greek god of love but also evoking the Surrealist promotion of the city as a place of hallucinatory desire. An equally hallucinatory but more brutal image of London was offered by Gilbert & George in their series *Dirty Words Pictures* (1977). In these works the artists spliced together photographs of subjects that include the dismal remnants of Victorian London and the modern London of tower blocks, the trading floors of the City and the milling multiracial crowds of the impoverished East End, and drunks as well as policemen and soldiers. Such images are joined by graffiti that scream out such words as CUNT and QUEER, completing a cursed landscape of London in the year of the Queen's Silver Jubilee.

Performance and transgression

The 1970s saw a flowering of work involving performance and the body, and a confrontational exploration of such issues as sexuality and violence, as reflected in the practices of Adrian Piper and David Lamelas. In an extended body of work in the early 1970s entitled *The Mythic Being*, Piper developed a fictional character for herself – complete with Afro haircut, moustache and dark glasses – whom she presented through performance, photographs and drawings. In such

ADRIAN PIPER
The Mythic Being: I Am the Locus #2, 1975

works as *I/You (Her)* (1974; pp. 138–39), Piper delves into the uneasy territory of sexuality and race, while in other pieces, such as *I Am the Locus* (1975; opposite), she draws out issues of race in relation to urban conflict as her character stalks through the city streets. Lamelas, an Argentinian artist who was based in England in the late 1960s and early 1970s, created a comparable work in which he used the streets of London as his stage. *The Violent Tapes of 1975* (1975; pp. 84–87) consists of ten photographs depicting a chase through a city, supposedly in a post-nuclear society, charting the violent struggle for a canister of videotape. Lamelas has often drawn on the conventions of the mass media, and these images are styled to look like film stills.

Another artist who, like COUM, emerged from the background of body art was Paul McCarthy. In his video *Rocky* (1976; pp. 104–105) the artist plays a character loosely based on the one depicted by Sylvester Stallone in the Hollywood film of the same name and year. The artist is dressed as a boxer, but a completely dysfunctional one, muttering, smearing his genitals with tomato ketchup and repeatedly punching himself in an escalating orgy of violence. McCarthy's work offers a parody of machismo and popular culture, one that was in tune with contemporaneous work by such feminist artists as Hannah Wilke. In her *S.O.S. Starification Object Series* (1974–82; p. 169), Wilke photographs herself posed like an advertising model in a number of different personas. The work is an ironic presentation of female stereotypes, as well as some male ones, as the artist – naked from the waist up – is accessorized with hair-rollers, aprons and cowboy hats. But in each picture the artist's body is also marked by pieces of chewing gum shaped into forms suggestive of body parts, denying the commodification of her body in a highly punk manner.

Two younger American artists who explored performance are Cindy Sherman and David Wojnarowicz. In Sherman's famous series *Untitled Film Stills* (1977–80; pp. 156–61), the artist appears as different female characters, using costumes, wigs and make-up to achieve her transformations. The loaded scenarios evoke B-movie thrillers and European art-house films, and the exterior locations include the Hudson River piers and other downtown sites in New York. Some similar locations were employed by Wojnarowicz in his series *Arthur Rimbaud in New York* (1978–79; pp. 184–89), which consists of photographs of a man wearing a mask of the nineteenth-century French Symbolist poet, gay rebel and punk icon. The locations include abandoned piers, as well as peep shows, diners and underpasses, and one image shows the character shooting up, while another shows him masturbating. Both artists use performance photography and 'do-it-yourself' techniques to push beyond proscribed notions of identity and to attempt to locate themselves in their adopted city – a city that, in the 1970s, was a playground for such experimentation.

Sherman was one of the artists associated with the scene around Artists Space in New York, a scene from which the critic Douglas Crimp would draw for his famous *Pictures* exhibition, staged at the venue in 1977. These artists were exploring the Postmodern notion that any representation is the product of previous representations, and they often used found or appropriated images to do so. Another figure in this scene was Richard Prince, whose works included *The Entertainers* (1982–83, pp. 140–43), a series based on re-photographing images of aspiring actors and models – images that spoke of the tawdry realm of Times Square strip joints. One English artist who is distantly associated with the 'Pictures' group is John Stezaker, who spent time in New York in the late 1970s. In 1977 Stezaker started to make collages using film stills, including a series entitled *Dark Star* (1978–79), in which figures have been excised to leave uncanny silhouettes.

Another artist associated with the Pictures group is Robert Longo, whose breakthrough work was a series of drawings entitled *Men in the Cities* (1978–82). These drawings of over-life-size figures were made from photographs modelled by artists and performers from the downtown scene: *Untitled (Eric)* (1981; p. 102), for instance, was modelled by the actor Eric Bogosian. The artist told his subjects to dress in black suits or skirts, and then photographed them in traumatized poses that were inspired by the cinematic staging of death, including the slow-motion violence that became a feature of films in the early 1970s. But the poses were also inspired by the spasmodic dancing of punk performers: 'It seems like the gestures of *Men in the Cities* are very much about the time we live in,' Longo commented, 'that "jerking" into now.'[8] And the artist also compared the monumental melancholia of his drawings – with their flirtation with the 'last taboo' of fascism – to the work of the band Joy Division.[9] With their particular form of New Wave alienation, these drawings have undoubtedly become a symbol of their times.

Appropriation and collage
If appropriation is a feature of much of the most interesting work of the punk years, then the particular form of appropriation represented by collage is an especially important device. A number of figures used collage to address the representation of the body and gender, including Linder and Barbara Kruger. The artist and performer Linder was a part of the historically significant cell of punk and post-punk in Manchester, which produced such bands as the Buzzcocks and the Fall. One of the projects in which Linder was involved was the one-off fanzine *The Secret Public*, which she produced in 1978 with the writer Jon Savage. This publication, produced by the independent record label New Hormones, featured photomontages by Linder using images culled from pornography and glossy magazines, works in which men's and women's bodies are merged with domestic appliances. Like Reid's artwork for the Sex Pistols, Linder's collages were also used to promote bands, with one reproduced on the cover of the Buzzcocks' single 'Orgasm Addict' in 1977 (p. 200).

Kruger's work in the early 1980s was also based on found images, in her case combined with commonplace and stereotypical phrases. Kruger's use of juxtaposition is less confrontational and more ambiguous than Linder's, although at its centre is a similar concern to interrogate the relationship between bodies and power – and women's bodies in particular. If the imagery and language of advertising was one area from which artists in this period drew, then another significant development was the appropriation of particularly urban forms of promotion and display. Kruger was to experiment with billboards as a format for her work, and Jenny Holzer was especially active in this area, making works in the form of stickers, T-shirts, plaques and LED signs as well as billboards. Holzer's works employ a variety of voices expressing commonplace dictums, their messages destabilized by context. They include the *Inflammatory Essays* (1979–82, pp. 60–63), a series of posters beginning with such phrases as 'A CRUEL BUT ANCIENT LAW DEMANDS AN EYE FOR AN EYE' and 'RUIN YOUR FUCKING SELF BEFORE THEY DO'.

A particular form of urban bricolage was developed by Tony Cragg and Bill Woodrow, leading figures in the 'New British Sculpture' of the early 1980s. Cragg was making work using plastic detritus, commenting subsequently that it was 'almost a kind of punk gesture at the time, a little bit aimed against the pieties of Land art, Minimalism, or whatever'.[10] In 1981 he had a solo exhibition at the Whitechapel Art Gallery, London, for which he made a series of wall-based assemblages reflecting such subjects as inner-city unrest, economic uncertainty, militarism and hysterical patriotism (see pp. 37–39); the year 1981 witnessed both the Brixton riots and the wedding of Prince Charles and Lady Diana Spencer. In the same year Woodrow created a series of works using discarded twin-tub washing machines, their metal façades cut and folded into facsimiles of images from popular culture, including chainsaws, guitars and Native American headdresses. Subsequently he made a group of works in which discarded appliances and furniture provided the raw materials for 'primitive' masks, creating allegories of tribalism and consumerism (see pp. 190–91).

Local scenes
While the main argument proposed here is that artists in Britain and the United States shared common concerns and approaches, this should not obscure the fact that local scenes had particular characteristics. One of the distinctive local groupings was the East Village scene in New York,[11] a product of the 'do-it-yourself' attitude to cultural production that emerged in the city in the mid-1970s and that was characterized by an interest in alternative ways of making and showing work and by practices in which the distinctions between art forms were often blurred. The East Village scene had a symbiotic relationship with a number of clubs in downtown New York, such as the Mudd Club, Club 57 and the Pyramid Club, all of which staged events – including exhibitions, screenings and performances – in which the worlds of art and music met. The East Village scene was also notable for its embrace of graffiti art, a phenomenon that originated in South Bronx

hip-hop culture, and some of the most celebrated East Village artists, including David Wojnarowicz as well as Jean-Michel Basquiat and Keith Haring, were associated with graffiti.

In 1980 Haring started to make chalk drawings on empty subway poster sites and quickly developed a very recognizable cartooning style as well as a distinctive allegorical vocabulary that included dancing figures, flying saucers and blaring televisions. Haring would stay close to graffiti culture, but diversified his media in the following years, creating works on supports as varied as terracotta vases, tarpaulins, clothing and bodies. In 1981 Haring both exhibited in and curated shows at the Mudd Club, and although he quickly found gallery support, he continued to explore alternative channels for his work. Basquiat also found initial exposure in public space, in his case through the graffiti – featuring elliptical and poetic texts – that he sprayed on to slum buildings in Lower Manhattan under the signature SAMO. When he made the transition to gallery artist in 1981, Basquiat incorporated elements of graffiti within a broader neo-Expressionist style, and in many respects his work remained resolutely urban, appropriating features of black street culture and drawing on the imagery of the urban landscape – and was sometimes even made on discarded street materials.

Both Haring and Basquiat, and the scene of which they were part, reached a broader public through such exhibitions as *New York/New Wave* at P.S.1 in Queens in 1981. The two artists also featured in the programme of the FUN Gallery, a commercial gallery that was founded in the East Village the same year and did much to promote the explosion of new galleries in the area. The commercial reawakening of New York's art scene in the 1980s was one vehicle for the promotion of a punk aesthetic, but it also marked the death knell of the very scene that had given rise to this art in the first place. However, some of the conditions that had made the New York scene so fertile were also applicable to Los Angeles and were to remain so for longer. The lack of commercial support for young artists in Los Angeles had encouraged a more flexible attitude to artistic production, with artists exploring less commercial formats, such as performance, and looking to other art forms, including literature. At the same time, the West Coast experienced its own punk subculture in the late 1970s and early 1980s, one in which many young artists were engaged, resulting in a scene that – though not recognized internationally at the time, and not in dialogue with London in the manner of New York – would have a significant long-term influence on the art world.[12]

In the late 1960s Mike Kelley had been a teenager in Detroit, at the time when that city was home to an important group of proto-punk bands. Kelley was subsequently a member of two notable artists' bands, Destroy All Monsters and the Poetics, the latter formed after he moved to California in 1976 to study at the California Institute of the Arts in Valencia. The CalArts faculty was dominated by Conceptualists, and Kelley's work in the late 1970s was to display the imprint of

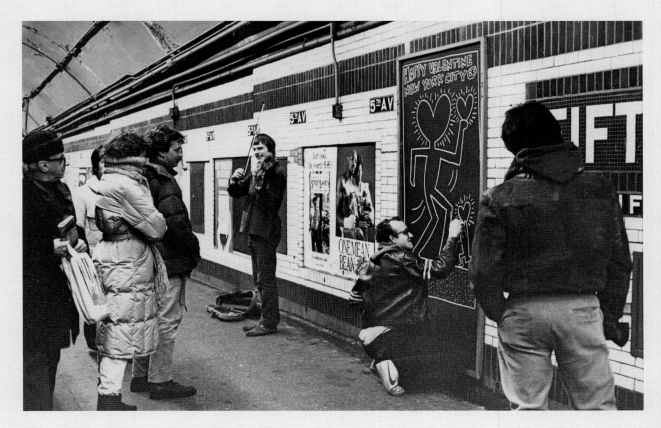

Keith Haring in the New York subway (*Happy Valentine's Day, New York City*), photograph by Tseng Kwong Chi, *c.* 1984

Conceptual practice and performance art. However, his experience of the music scene had stimulated an interest in the operation of subculture, as well as in a particular kind of excessive and ritualized performance. While Kelley's work is characterized by its apparent engagement with multiple intellectual systems of enquiry or analysis, the subjects on which these systems are imposed reveal an interest in the American vernacular, with kitsch topics and lowly preoccupations. Moreover, his work is a kind of hysterical application of such systems, creating a discourse of excess, degradation and failure. One example is offered by *The Poltergeist* (1979; pp. 77–79), a collaborative project with David Askevold. Kelley's portion combines text, drawing and performance photography, all brought to bear on the work's arcane subject: the photographs show the artist with 'ectoplasm' emerging from his mouth and nose in the manner of Spiritualist photography.

Other artists associated with the Los Angeles scene at this time include Raymond Pettibon and Tony Oursler, the latter one of Kelley's fellow band members in the Poetics. In the late 1970s and early 1980s Oursler was making narrative videos featuring makeshift puppets, props and sets. One example is *The Loner* (1980; pp. 129–31), the story of a maladjusted character whose form is represented by a succession of objects, including a water-filled condom and an albino cockroach. Pettibon, meanwhile, began his art career in the late 1970s making artwork for such West Coast

punk bands as Black Flag. Pettibon's work, both in its early published form and in his later career as a gallery artist, draws on street culture, popular culture and literary traditions, as well as the art canon (see pp. 132–37). It is based on unsettling combinations of drawings and text, and offers a collage of subjects from America's mid-century, including such characters as Superman, Elvis and Charles Manson and such preoccupations as surfing and baseball, crime and salvation. The vocabulary of both Oursler and Pettibon is a particularly 'do-it-yourself', deliberately pathetic and ultimately very punk form of neo-Expressionism. As Kelley's work developed in the early 1980s, it would take on some of these characteristics, especially through its deployment of drawing.

Art and subculture

The engagement with subculture is an important feature of art in the punk years, and for a number of artists in New York and London the representation of subcultural identity – and of the scenes in which the artists themselves were engaged – was a key aspect of their practice. Some of these artists were embedded within gay subcultures, as was the case with Peter Hujar. Hujar's portraits (see, for example, p. 65) provide a glimpse into the downtown bohemian atmosphere of his day and in particular New York's gay performance scene, a scene that had links to the activities of Andy Warhol's 'Superstars' and that utilized an improvised and sometimes confrontational form of drag that could

be very punk in nature.[13] Moreover, his images of the shattered street scenes of Lower Manhattan at night remind us of a time when economic recession created opportunities for marginal groups – including cruisers, drug-takers and artists – to colonize the city. Hujar's image of New York and its demi-monde was to be echoed in the work of younger artists, including his friend David Wojnarowicz, as well as Robert Mapplethorpe and Nan Goldin. Like Hujar, Mapplethorpe was an accomplished portraitist, and one of his most significant early collaborators was the punk icon Patti Smith; one of his many images of her was used on the cover of her debut album *Horses* (1976; see p. 109). Mapplethorpe's most notorious works, however, are the so-called 'sex pictures' in which he depicted the sadomasochistic subculture of the city's gay scene, exploring the boundaries of acceptable representation (see pp. 110 and 113).

A very different scene is offered by 'Them', as the social commentator Peter York called the London clan that included the artists Andrew Logan and Derek Jarman.[14] In 1974 Logan, Jarman and others moved into Butler's Wharf, a warehouse in Bankside, on the south bank of the Thames, and many parties were held in this bohemian enclave, including the 1975 incarnation of Andrew Logan's Alternative Miss World, a drag extravaganza that was a semi-regular date in London's gay calendar. Butler's Wharf was also the location of Andrew Logan's Valentine's Ball in 1976, at which the Sex Pistols played, and Logan's glancing connections with the punk scene are reflected in his sculpture *Homage to the New Wave* (1977; p. 101), which features a giant safety pin made in his characteristic collaged mirror glass. One visitor to Butler's Wharf was the punk figurehead Jordan, and Jarman was to film her, in make-up and tutu, dancing around a bonfire in Bankside's post-industrial wasteland. This shoot led to the Super-8 film *Jordan's Dance* (1977; pp. 74–75), a part of which would make its way into Jarman's breakthrough feature *Jubilee* (1978; see opposite). The feature film includes Jordan alongside such other punk stars as Adam Ant and Toyah Willcox, and is one of the most important works to address punk culture directly. In *Jubilee* Jarman moved away from his poetic work of the early 1970s, creating an apocalyptic allegory of a London of the near future and anticipating punk's co-option by the culture of consumerism.

Jarman's capacity to absorb new influences and adapt to his times is evidenced in collaborations in the early 1980s with Throbbing Gristle, as well as in his involvement in *The Dream Machine* (1983), a portmanteau film that included sections from the younger film-makers Cerith Wyn Evans and John Maybury. Evans's generation was more associated with New Romanticism than with punk, and his early films are characterized by arcane symbolism and camp theatricality. One of these films, *Epiphany* (1984; p. 41), features Leigh Bowery, a cult figure in London's club scene, famed for his outrageous gender-bending costumes and body modifications. In the film Bowery is depicted in blue body paint, modelling a look that he had created with his partner Trojan and called 'Pakis from Outer Space'. Both

Evans and Bowery were part of a scene that revolved around Blitz and a number of other London nightclubs, a scene that Stephen Willats documented in the series of 'Night' works that he started in 1980, in which he explored his interest in subculture and its relationship to counter-consciousness.[15]

A final grouping of artists that should be invoked is the 'Boston School', a loose band of photographers who met while studying in the city, and who included Nan Goldin, Mark Morrisroe, David Armstrong and Jack Pierson.[16] Goldin came to New York in 1978, and her breakthrough work, *The Ballad of Sexual Dependency*, had its debut at the Mudd Club in 1979, although the artist would continue to expand and adapt it for many years. The work is a slide show set to popular songs, its images depicting Goldin's extended 'family' in the Lower East Side and beyond. It is a family based on acceptance of different types of relationships, and includes dysfunction; the emotional climax of the work records Goldin's battering at the hands of her partner in 1984 (see p. 55). Morrisroe's work is also autobiographical, including the poetic handmade prints that he began to make while at art school in 1977 (see pp. 122–27) and the starker Polaroids that became an important part of his work in 1979 and with which he documented his life until his death from AIDS a decade later. What Goldin and Morrisroe share, beyond the diaristic aspect of their work, is an interest in glamour, although it is glamour in a self-fashioned, paradoxical and essentially punk form.

The works of Goldin and Morrisroe, as well as those of Evans and Willats, demonstrate the changing nature of the 'scenes' in the early 1980s, their neo-Romanticism in marked contrast to the growing conservatism of society at large. The scope of this book ends in the early 1980s, as AIDS began to cast its shadow, but before the virus would decimate a generation – a phenomenon that would have a devastating effect on the artistic communities in the United States and Britain, claiming the lives of Hujar, Mapplethorpe, Jarman and Morrisroe, as well as those of Wojnarowicz, Haring and many others. But the AIDS crisis also prompted the politicization of many artists, with some turning punk strategies to propaganda purposes in the campaigns of such direct-action groups as ACT UP. If Britain had its most notorious cultural scandals in the period 1976–77, then America would have them in the late 1980s, with the controversies surrounding museum exhibitions of Mapplethorpe's work, as well as around the public funding given to artists, such as Andres Serrano and Karen Finley, who employed bodily transgression in their work. The 'culture wars' of the United States in the late 1980s can, in many respects, be seen as an aftershock generated by the artistic innovations of the punk years.

Jordan as Britannia in Derek Jarman's
Jubilee, 1978

Notes

1. Quoted in the *Daily Mail*, 19 October 1976, and cited in S. Ford, *Wreckers of Civilisation: The Story of COUM Transmissions and Throbbing Gristle*, London (Black Dog) 1999, chapter 6, p. 22.
2. Quoted in Ford, *op. cit.*, chapter 6, p. 28.
3. For an account of the politicization of the British art scene, see J.A. Walker, *Left Shift: Radical Art in 1970s Britain*, London (I.B. Tauris) 2002.
4. For an analysis of photo-conceptualism, see *The Last Picture Show: Artists Using Photography, 1960–1982*, exhib. cat. by D. Fogle, Minneapolis, Walker Art Center, 2003; and *Chemical Traces: Photography and Conceptual Art, 1968–1998*, exhib. cat. by D.A. Mellor, Hull, Ferens Art Gallery, 1998.
5. In the 1970s Willats also collected cassettes and fanzines produced within the proto-punk and punk scenes, reflecting his interest in the counter-cultural possibilities of subculture.
6. 'My Understanding of Art', artist's statement, *c*. 1975, reproduced in C. Diserens (ed.), *Gordon Matta-Clark*, London (Phaidon) 2003, p. 204.
7. For an analysis of this scene, see M.J. Taylor (ed.), *The Downtown Book: The New York Art Scene, 1974–1984*, Princeton, NJ (Princeton University Press) 2006.
8. R. Longo, *Men in the Cities, 1979–1982*, New York (Harry N. Abrams) 1986, p. 88.

9. *Ibid.*, p. 99.
10. 'Tony Cragg Talks to Barry Schwabsky', *Artforum*, XLI, no. 8, April 2003, p. 200.
11. For an analysis of this scene, see *East Village USA*, exhib. cat. by D. Cameron *et al.*, New York, New Museum of Contemporary Art, 2004.
12. Some of the artists involved in this scene reached international attention through the exhibition *Helter Skelter: L.A. Art in the 1990s*, organized by the Museum of Contemporary Art, Los Angeles, in 1992.
13. For an analysis of the proto-punk aspects of early 1970s gender-bending, see 'Cross-Gender/Cross-Genre', in M. Kelley, *Foul Perfection: Essays and Criticism*, ed. J.C. Welchman, Cambridge, Mass. (MIT Press) 2003, pp. 100–120.
14. P. York, 'Them', *Harpers & Queen*, October 1976, pp. 204–209.
15. This scene was one of the subjects of *Secret Public: The Last Days of the British Underground, 1978–1988*, an exhibition curated by Stefan Kalmár, Michael Bracewell and Ian White, originated by Kunstverein München in 2006; it toured to the ICA, London, in 2007.
16. See *Boston School*, exhib. cat., ed. L. Gangitano, Boston, Institute of Contemporary Art, 1995.

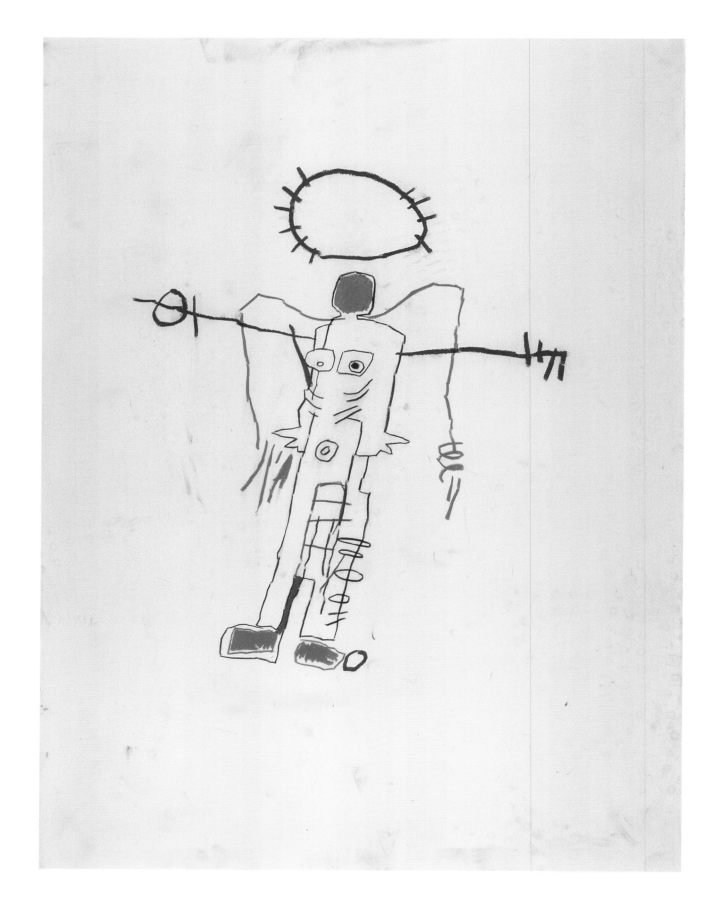

JEAN-MICHEL BASQUIAT

Untitled (Man with Halo), 1982

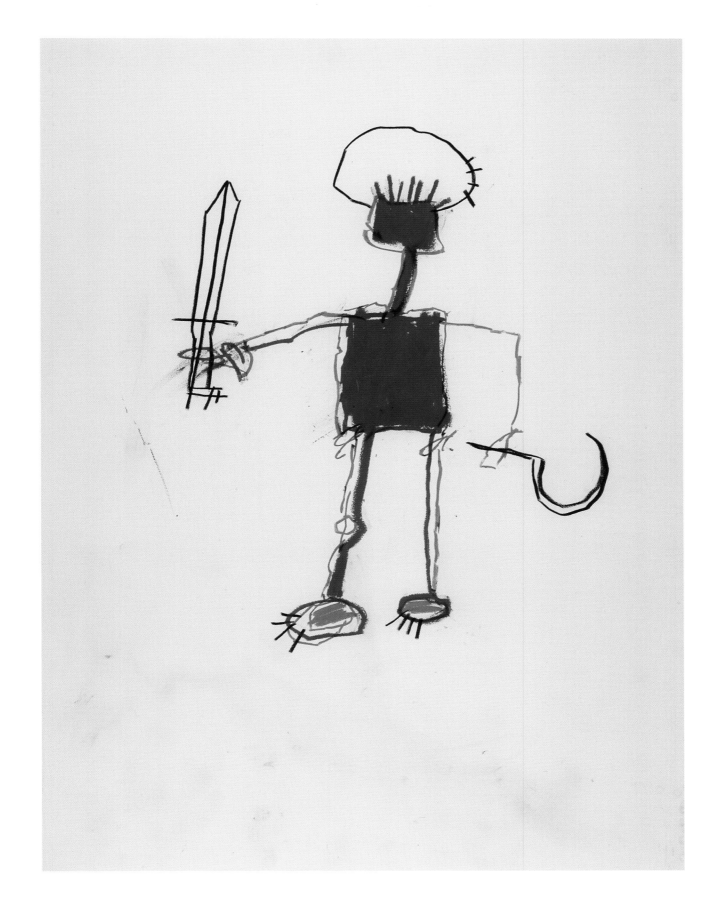

Untitled (Sword and Sickle), 1982

Jean-Michel Basquiat

Kings of Egypt II, 1982

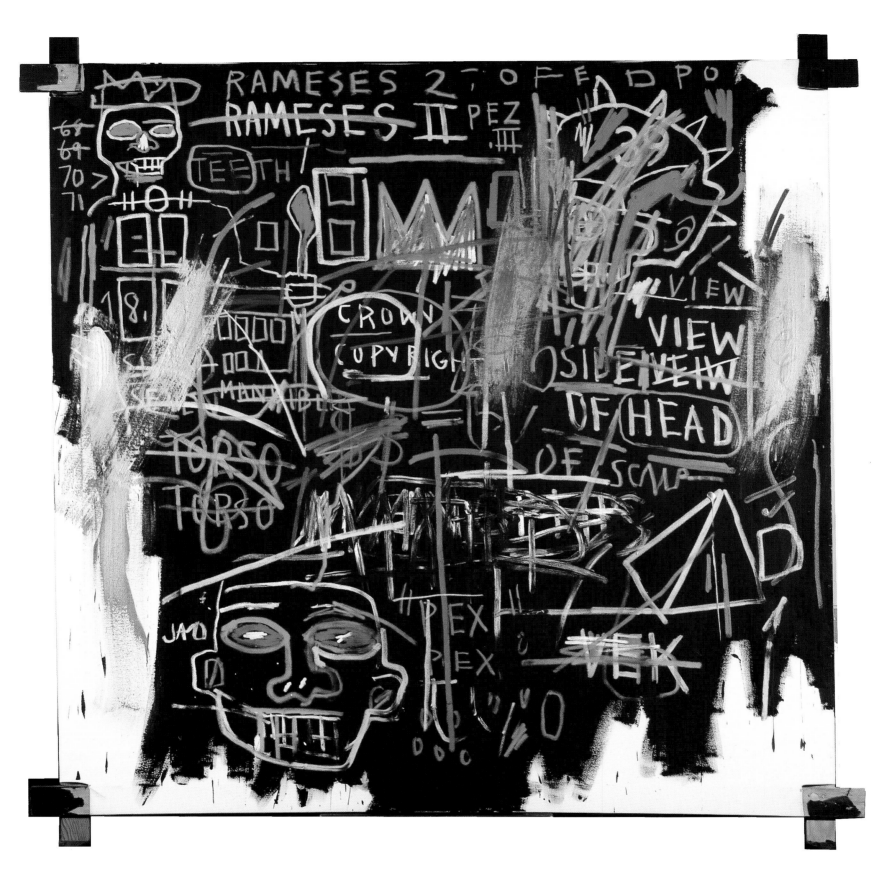

JEAN-MICHEL BASQUIAT

Untitled, 1982

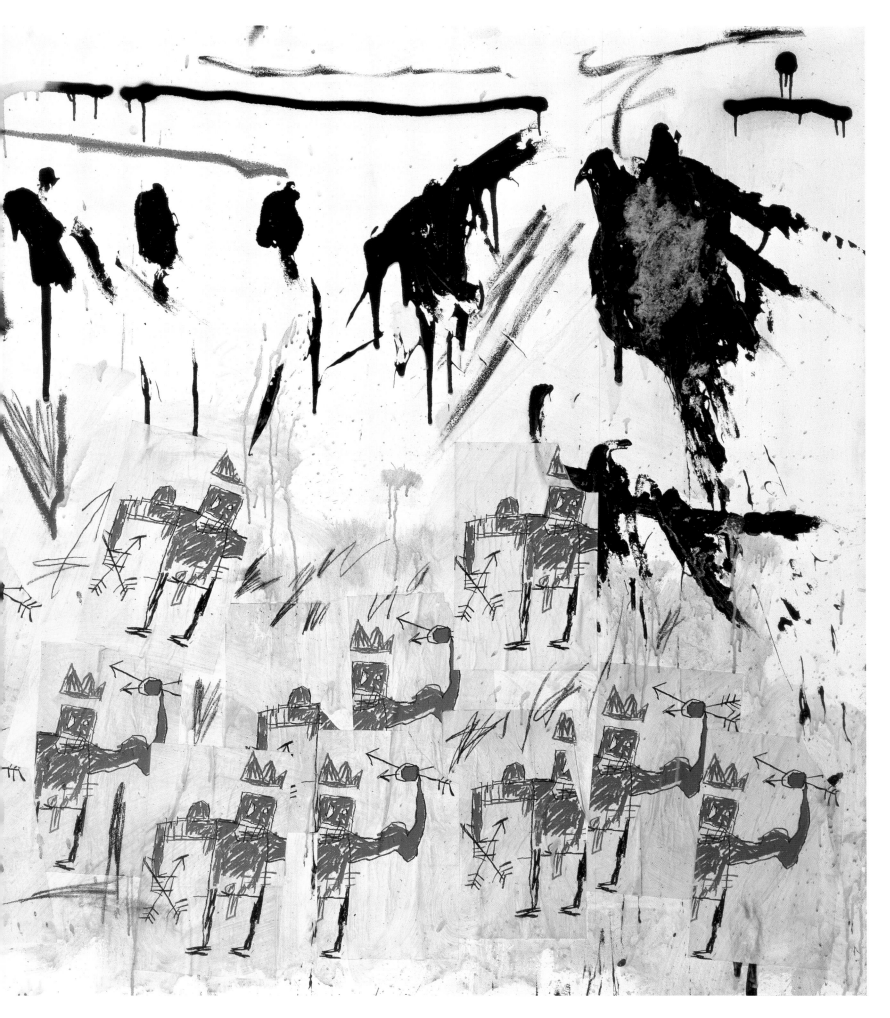

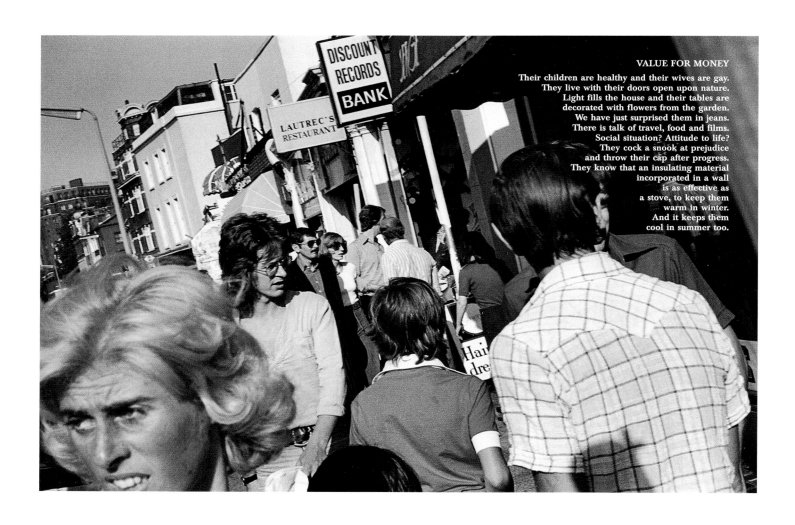

VALUE FOR MONEY

Their children are healthy and their wives are gay.
They live with their doors open upon nature.
Light fills the house and their tables are
decorated with flowers from the garden.
We have just surprised them in jeans.
There is talk of travel, food and films.
Social situation? Attitude to life?
They cock a snook at prejudice
and throw their cap after progress.
They know that an insulating material
incorporated in a wall
is as effective as
a stove, to keep them
warm in winter.
And it keeps them
cool in summer too.

VICTOR BURGIN

From *UK76*, 1976

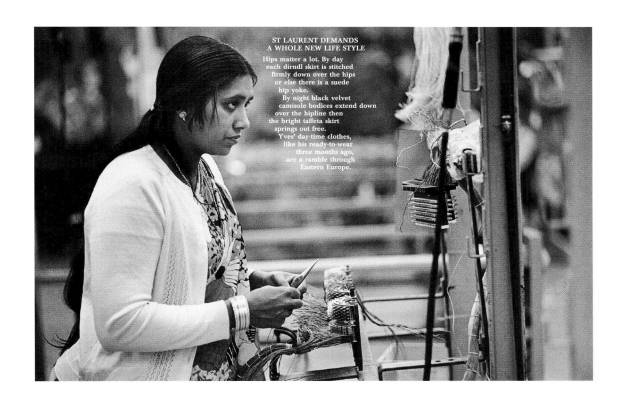

**ST LAURENT DEMANDS
A WHOLE NEW LIFE STYLE**

Hips matter a lot. By day
each dirndl skirt is stitched
firmly down over the hips
or else there is a suede
hip yoke.
By night black velvet
camisole bodices extend down
over the hipline then
the bright taffeta skirt
springs out free.
Yves' day-time clothes,
like his ready-to-wear
three months ago,
are a ramble through
Eastern Europe.

WHAT ARE YOU GETTING UP TO?

There is a whole class of people
compelled to rent themselves on the market
to those willing to hire them, who are
compelled to do all of society's unwanted work,
on pain of starvation, whose only role
in production is that of ancillary tools,
whose production is organised for waste
to create profit for a few,
who are compelled to reproduce
their own continued poverty,
who are being asked
to tighten their belts.

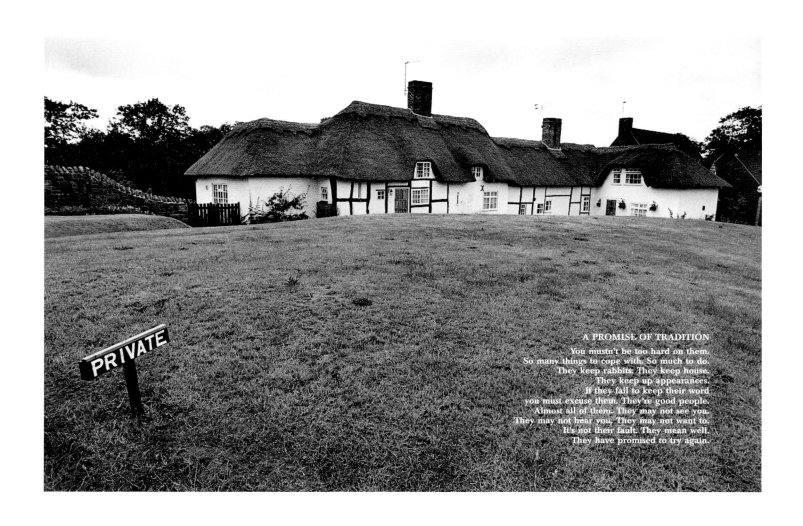

A PROMISE OF TRADITION

You mustn't be too hard on them.
So many things to cope with. So much to do.
They keep rabbits. They keep house.
They keep up appearances.
If they fail to keep their word
you must excuse them. They're good people.
Almost all of them. They may not see you.
They may not hear you. They may not want to.
It's not their fault. They mean well.
They have promised to try again.

From *UK76*, 1976

FALSE PERSPECTIVE
Mankind never lives entirely in the present.
The past, the tradition of the race, and of the people,
lives on in the ideologies of the super-ego,
and yields only slowly to the influence of the present;
and so long as it operates through the super-ego
it plays a powerful part in human life,
independent of economic conditions.

VICTOR BURGIN

From *US77*, 1977

PENNIS FROM HEAVEN
Amongst the military vehicles and armour
which line the route to the refreshment marquee
buyers from third-world countries
congregate around the rocket-launchers.
The production of such goods
provides essential employment, saving many from poverty,
it gives free rein to invention,
and gives the consumer a choice.

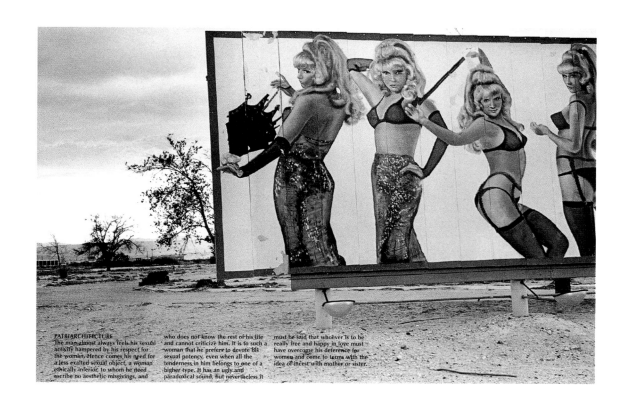

PATRIARCHITECTURE
The man almost always feels his sexual activity hampered by his respect for the woman. Hence comes his need for a less exalted sexual object, a woman ethically inferior, to whom he need ascribe no aesthetic misgivings, and who does not know the rest of his life and cannot criticize him. It is to such a woman that he prefers to devote his sexual potency, even when all the tenderness in him belongs to one of a higher type. It has an ugly and paradoxical sound, but nevertheless it must be said that whoever is to be really free and happy in love must have overcome his deference for women and come to terms with the idea of incest with mother or sister.

VICTOR BURGIN

From *US77*, 1977

COUM Transmissions

Press release/poster for the exhibition *Prostitution*, 1976

October 19th-26th 1976

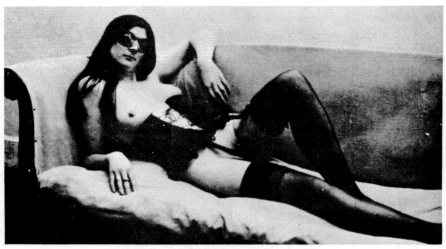

SEXUAL TRANSGRESSIONS NO. 5

PROSTITUTION

COUM Transmissions:- Founded 1969. Members (active) Oct 76 - P. Christopherson,
Cosey Fanni Tutti,Genesis P-Orridge.Studio in London.Had a
kind of manifesto in July/August Studio International 1976. Performed their works
in Palais des Beaux Arts,Brussels; Musee d'Art Moderne, Paris; Galleria Borgogna,
Milan; A.I.R. Gallery, London; and took part in Arte Inglese Oggi, Milan survey of
British Art in 1976. November/December 1976 they perform in Los Angeles Institute
of Contemporary Art;Deson Gallery,Chicago;N.A.M.E. Gallery,Chicago and in Canada.
This exhibition was prompted as a comment on survival in Britain,and themselves.

2 years have passed since the above photo of Cosey in a magazine inspired this
exhibition.Cosey has appeared in 40 magazines now as a deliberate policy.All of
these framed form the core of this exhibition.Different ways of seeing and using
Cosey with her consent,produced by people unaware of her reasons,as a woman and an
artist, for participating.In that sense,pure views.In line with this all the photo
documentation shown was taken,unbidden by COUM by people who decided on their own
to photograph our actions.How other people saw and recorded us as information.Then
there are xeroxes of our press cuttings,media write ups.COUM as raw material.All of
them,who are they about and for? The only things here made by COUM are our objects.
Things used in actions,intimate (previously private) assemblages made just for us.
Everything in the show is for sale at a price,even the people. For us the party
on the opening night is the key to our stance,the most important performance.We
shall also do a few actions as counterpoint later in the week.

PERFORMANCES: Wed 20th 1pm - Fri 22nd 7pm

Sat 23rd 1pm - Sun 24th 7pm

INSTITUTE OF CONTEMPORARY ARTS LIMITED
NASH HOUSE THE MALL LONDON S.W.I. BOX OFFICE Telephone 01-930-6393

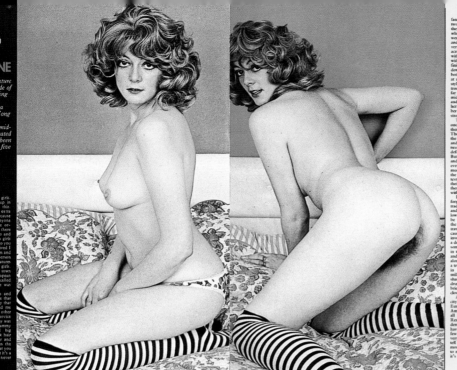

Meet GERALDINE

To illustrate this feature on the 'naughty' side of Hong Kong we bring you these pics of Geraldine, who is a stripper at a top Hong Kong nightclub. Geraldine is in her mid-twenties; she originated in the US but has been in Hong Kong for five years.

of the East.

Finally I settled for two girls. The lad's eyebrows shot up in approval when I said this. Mostly because it meant extra money for him, and also because they tend to appreciate anyone who is slightly out of the ordinary in such matters. And here is so much that you can do and have done to you with two girls that you cannot have done to you with one. So when they arrived I had a chance to look at them and once more to bless the person who created such lovely creatures as good looking Oriental girls. Like a lot of girls in this town they had slightly jazzy European names and the larger was called Sammy and the other one was again that inevitable Lee.

Sammy was a real pro and looked it. Not in the sense that she was hard but in the way that she looked at me. She had me sized up to a tee and the other girl was something of a novice and it was clear that Sammy was training her in the arts. Sammy was plumpish and had big breasts with the usual dark hair and eyes. Lee was smaller and slighter and she had again the darkness of eye and hair that you almost always get here. But it's a combination that I have never

fanny I lay down flat and let the two of them excite me as much as they could, which was plenty. while they were doing this they were also exciting one another and then they began to make very exotic and frantic love across my leg. I let them get on with it as this was very arousing with me and when they had finished their 69 I let them get down on me again and now they both took turns at sucking away at my tingling tool. I liked their style at doing this and the only trouble was that Sammy proved far too exciting for me and in the middle of it all off I came again and this time I spunked against her ample chest so that her amber body was smeared with long streaks of semen.

Then they both started on me once more and this time I had them both one after another. They vied with one another for the right to keep my cock in play and when I had come for the last two times I knew that it was definitely time for me to pack up. But they were very good screws and I must acknowledge that even though there is far too much prostitution in Hong Kong the ones that I slept with and tested were very much worth their value and what I paid for them was small by comparison with European rates.

But one thing should not be forgotten about all this. The vice trade in Hong Kong is enormous and even though their prices are lower than most they do tend to be very mercenary if you go to the wrong places. For the casual traveller I would suggest extreme caution and for the professional investigator I would recommend a degree of the same. I have seen some other less attractive sights in the vice dens of Hong Kong and when you place them alongside the better ones you get a truer picture of the filthy traffic in human flesh that makes millions for the men at the top. I shan't say anything about the drug trade here, that is not my brief. But the two are very closely connected.

And so next month to another city. This time back to old Europe and to the lovely city of Amsterdam but even here among all the graceful canals and the Rembrandts there are hideous dens of vice, and of all the cities I have been to this is one of the few places where perversions are very openly catered for. I shall tell you about some of them next month. Amsterdam is not a city to miss if you like it kinky – and it's not far from London, either!

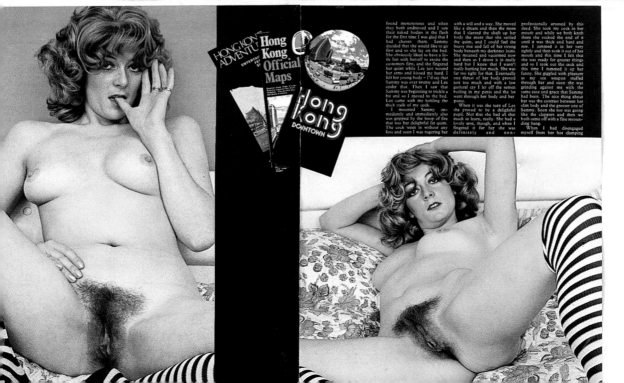

found monotonous and when they both undressed and I saw their naked bodies in the flesh for the first time I was glad that I had chosen them. Sammy decided that she would like to go first and so she lay on the bed. She obviously liked to have a little fun with herself to excite the customers first, and she fingered her quim while Lee just wound her arms and kissed me hard. I felt her young body – I'd say that Sammy was over twenty and Lee under that. Then I saw that Sammy was beginning to trickle a bit and so I moved to the bed. Lee came with me holding the thick stalk of my cock.

I mounted Sammy immediately and immediately also was gripped by the hoop of fire that was her delightful fat quim. The cock went in without any fuss and soon I was rogering her with a will and a way. She moved like a dream and then the more that I slanted the shaft up her body the more that she settled the quim, and I could feel the heavy rise and fall of her strong body beneath my darkness loins. She moaned and squirmed now and then as I drove it in really hard but I knew that I wasn't really hurting her much. She was far too tight for that. Eventually one thrust of her body proved just too much and with a low guttural cry I let off the semen boiling in my penis and the lot went through her body and her pussy.

When it was the turn of Lee she proved to be a delightful pupil. Not that she had all that much to learn, really. She had a lovely arse, though, and when I fingered it for her she was definitely and non-

professionally aroused by this deed. She took my cock in her mouth and while we both knelt there she sucked the end of it until it was thick and hard and raw. I rammed it in her very tightly and then took it out of her mouth and this time I felt that she was ready for greater things and so I took out the cock and this time I rammed it up her fanny. She giggled with pleasure as my sex weapon stuffed through her and soon she was grinding against me with the same ease and grace that Sammy had been. The nice thing about her was the contrast between her slim body and the grosser one of Sammy. Soon she too was going like the clappers and then we both came off with a fine resounding bang.

When I had disengaged myself from her hot clamping

COSEY FANNI TUTTI

'Meet Geraldine', *Playbirds*,
vol. 1, no. 5, 1975

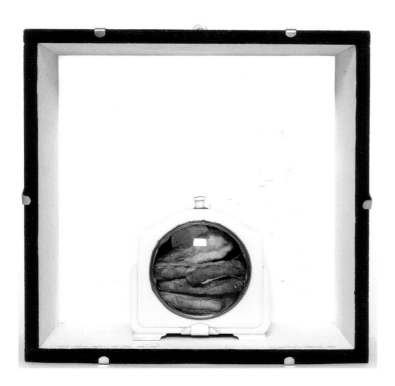
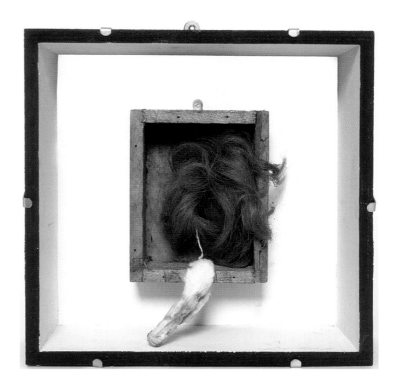

GENESIS P-ORRIDGE

From *TAMPAX ROMANA*, 1976

Opposite

Venus Mound

It's That Time Of The Month
Pupae

TONY CRAGG

Crown Jewels, 1981

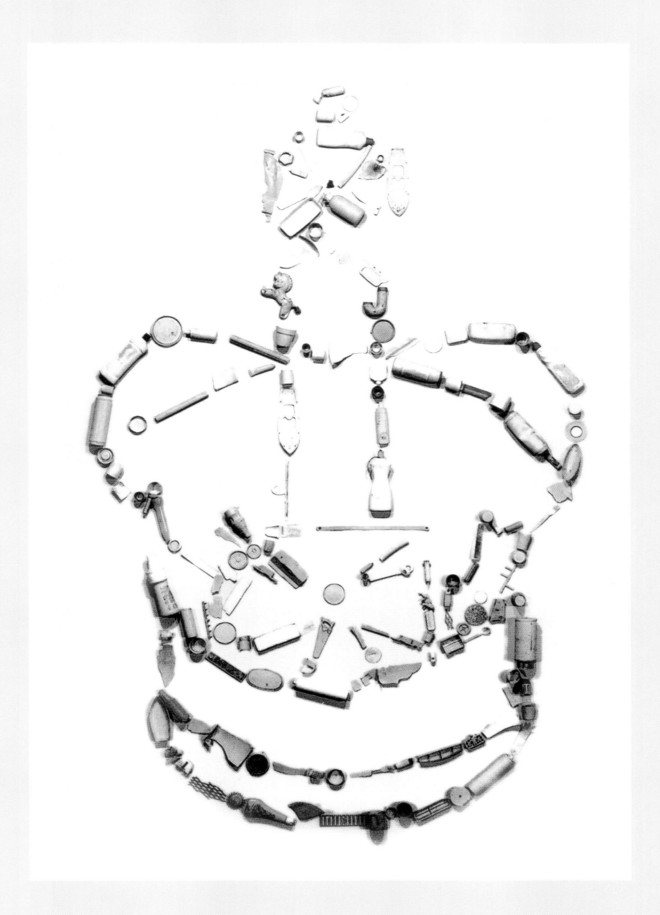

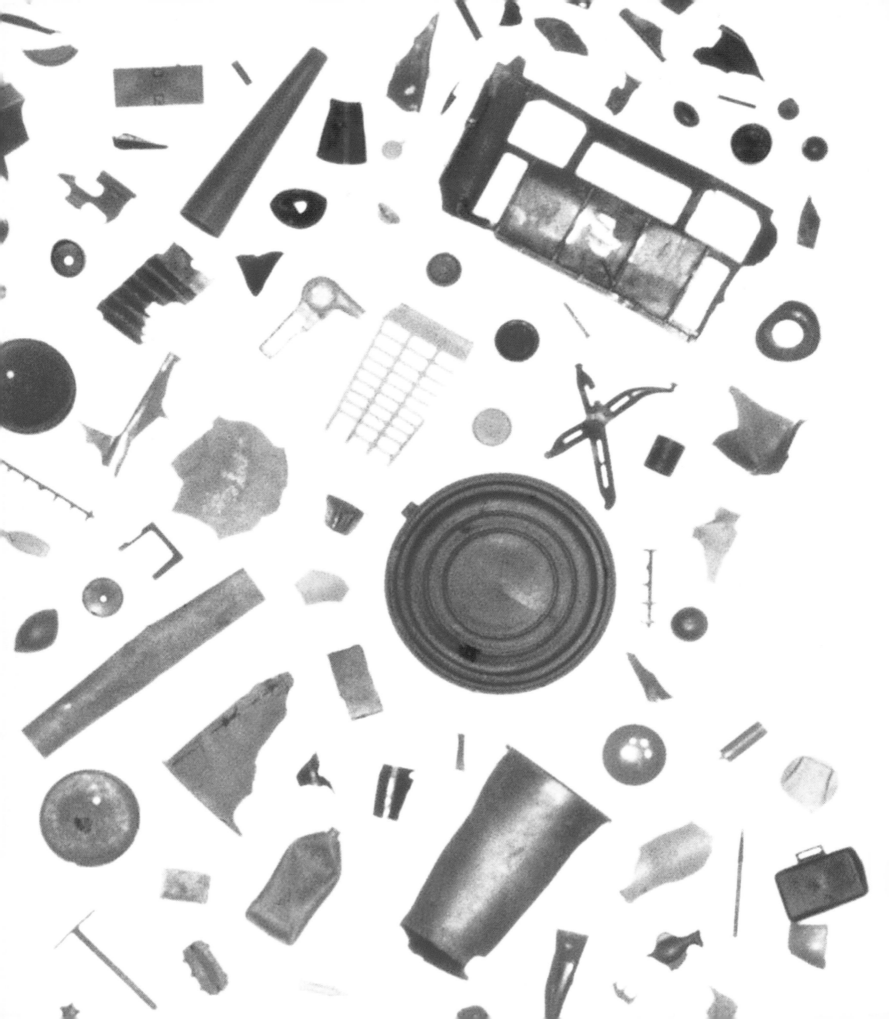

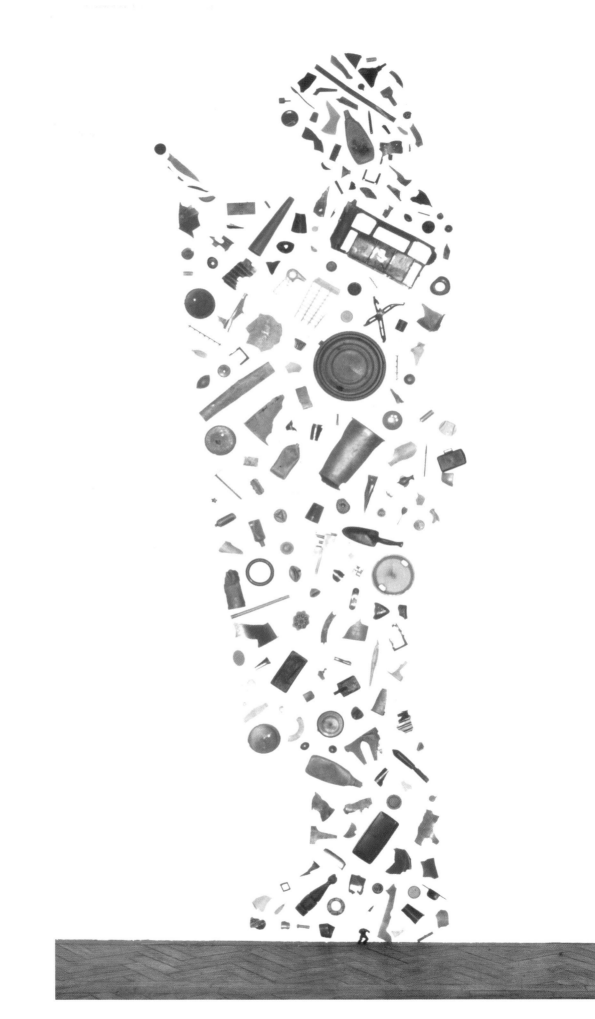

Tony Cragg

Policeman (detail), 1981

Policeman, 1981

Cerith Wyn Evans

Epiphany, 1984

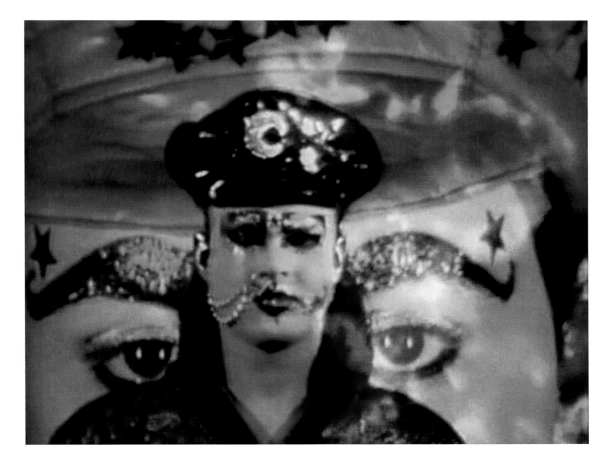

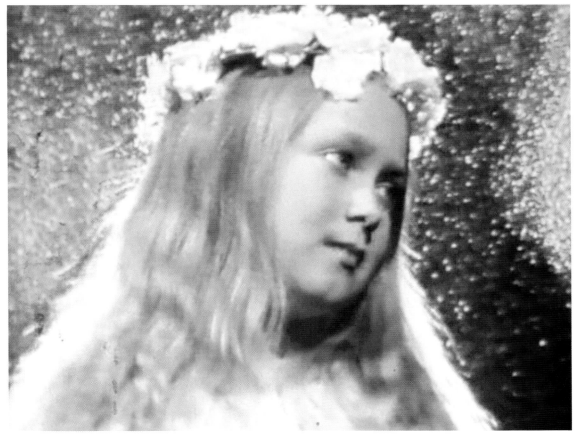

GILBERT & GEORGE

The World of Gilbert & George, 1981

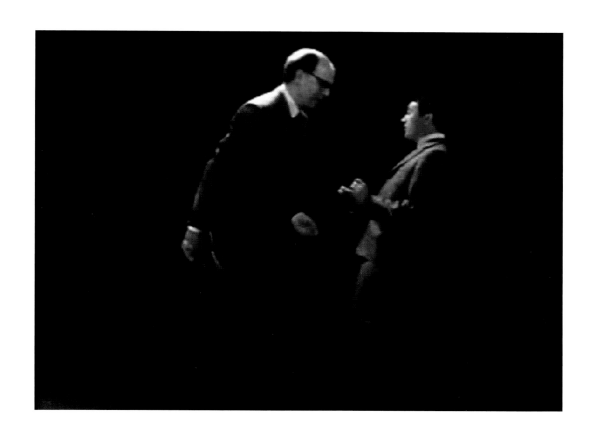

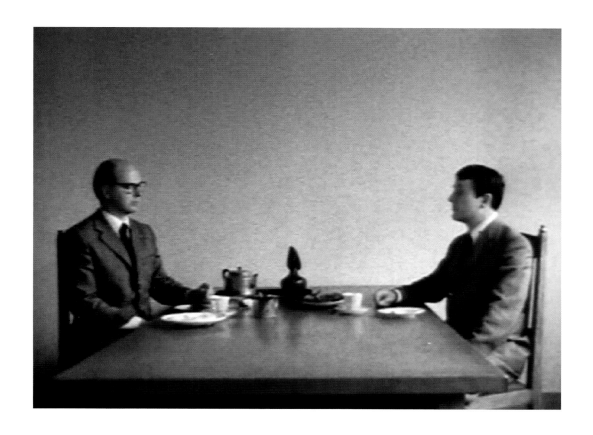

RIP IT UP, CUT IT OFF, REND IT ASUNDER

ROSETTA BROOKS

Create glitches, gashes, ruptures, punctures, gaps, edges.
Disrupt the smooth operation that creates linear narrative.
Stop the smooth flow of history.
Revel in the fracture.
Tear at the seams.
Stare at the seam.
Fetishize the seam. Become fascinated with the seam.

PROPOSITION:
THE IMAGE AS IMAGE CAN BE REVEALED ONLY BY A VIOLATION OF THE IMAGE.

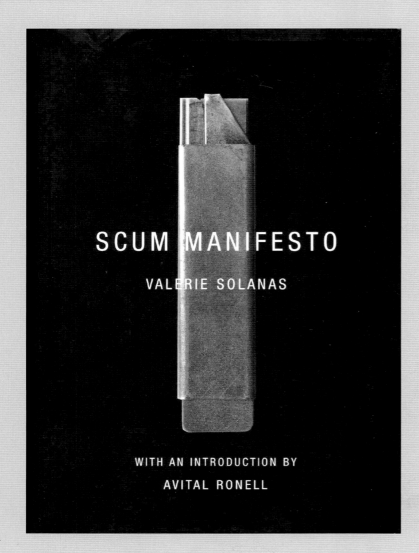

Cover of Valerie Solanas's *SCUM Manifesto*, jacket and book design by Rex Ray, 2004

Rends and …

In sacred texts the rending (tearing apart) of clothes often represents the outward expression of inner turmoil. Rending usually bears witness to a relationship to grief, the apocalypse, the rending of the heavens. In *Confronting Images*, Georges Didi-Huberman's argument is that the image is best experienced as rend, that the image *is* a rend. The image gains its power as rend. But the rend is something we overlook in everyday life. In fact, we are so familiar with the rend that we are often not aware of its existence. Very occasionally, however, something of the violence of the rend is communicated, jolting us into an awareness of its disruptive powers – the rending of the veil, the penetration of truth. But overall, the argument is that the rend reveals the fabric of representation. The image as image can be revealed only by a violation of the image.

It is an interesting argument because what Didi-Huberman is suggesting is that the void that punctuates the image reveals the heart of the image, that, in fact, one is only aware of the image as image by its being violated or cut: 'It's a matter only of proceeding dialectically: of thinking the thesis with its antithesis, the architecture with its flaw, the rule with its transgression, the discourse with its slips of the tongue, the function with its dysfunction … and the fabric with its rend …'[1]

Edges

Didi-Huberman's argument is not dissimilar to the one posed by Roland Barthes in *The Pleasure of the Text*:

> Two edges are created: an obedient, conformist, plagiarizing edge (the language is to be copied in its canonical state, as it has been established by schooling, good usage, literature, culture), and *another edge*, mobile, blank, ready to assume any contours, which is never anything but the site of its effect: the place where the death of language is glimpsed. These two edges, *the compromise they bring about*, are necessary. Neither culture nor its destruction is erotic; it is the seam between them, the fault, the flaw, which becomes so …
> The subversive edge may seem privileged because it is the edge of violence; but it is not violence which affects pleasure, nor is it destruction which interests it: what pleasure wants is the site of a loss, the seam, the cut, the deflation, the **dissolve** which seizes the subject in the midst of bliss. Culture thus recurs as an edge: in no matter what form.[2]

Barthes's argument about language might also cover fashion, suggesting that the seam in clothing is where desire and dread are both attracted. The seam is the necessary awareness of limits within the space of the unlimitedness or abstraction of the commodity.

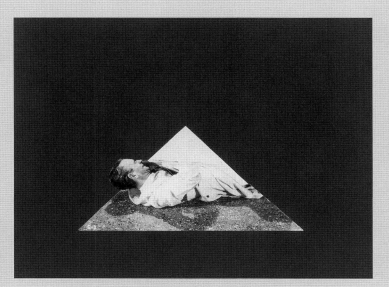

JOHN STEZAKER
Untitled, 1979

The image as rend

When asked by writer and novelist Michael Bracewell in 2005 whether he might provide an all-defining statement of intent that might cover his complete œuvre as an artist, John Stezaker replied:

> I'm dedicated to fascination – to image fascination, a fascination for the point at which the image becomes self-enclosed and autonomous. It does so through a series of processes of disjunction. First obsolescence – in finding the image – then various devices to estrange or 'abuse it' in order to bring out that sense of the autonomy of the image. It involves either an inversion – cutting – or a process that cuts it off from its disappearance into the everyday world. I'm very much a follower of Maurice Blanchot's ideas when it comes to image and fascination; he sees it as a necessary series of deaths that the image has to go through in order to become visible and disconnected from its ordinary referent. I don't know whether that's an ideal, but I suppose it could be a guiding principle.[3]

Cut to Gordon Matta-Clark

In the 1970s the burnt-out tenements in Brooklyn and the Bronx and Harlem's renovations of property warfare provided Gordon Matta-Clark with a sense of space and an experience of vastness denied everywhere else by the claustrophobia of urban overcrowding and spatial anonymity. Vistas created by the controlled destruction of architectural space revealed the subtractive power of demolition in opening up the invisible space of urban conveyance. Within the hemmed-in and channelled inscape of urban space, the spectacular was reserved for acts of spatial violence. In the modern city only the demolition site offered a prospect of spatial vastness and complexity effaced by the bland façades of architectural identity. Only the penetration of the façade opened up the space closed by channelled mobility and by life reduced to an order of functions.

In demolition Matta-Clark saw a means of cutting through the corridors of urban flow and revealing the precipice over which this no-space was suspended. Sealed-in lives lived in autonomous adjacency were brought into sudden relief in the meeting of linoleum and carpentry created by removing sections of buildings. Layers of exposed wallpaper revealed the strata of human habitation. Staircases going nowhere spiralled like gigantic shells in the exposed warrens of twentieth-century living. Matta-Clark collected photos of these anonymous and provisional ruins, producing small books and catalogues from the photos. But recording was not enough: he felt the need to control and give shape to his own spatial cavities and to create his own recesses of the imagination in the reality of the urbanscape.

Matta-Clark's most public act of demolition was also his most violent in appearance. The giant eye hole that he cut into two seventeenth-century town houses still to be demolished in the Les Halles district of Paris seemed like a mirror image of the large hole that the district had become in this massive process of demolition and excavation. *Conical Intersect* (1975; opposite) was an image of demolition itself. As if cut by a gigantic boring machine, the buildings, poised on the brink of disappearance, made a final spectacular appearance, registering as an image of their destined destruction in the face of indifference: a final unveiling of the lives lived behind the façades of Parisian discretion.

It was as if, in the final moments, vision was given to the buildings in the form of a gigantic eye, overseeing the void into which they must disappear: the cavern of visual penetration heralding eventual demolition like the eye of revelation appearing at the moment of apocalypse. In *Conical Intersect*, Matta-Clark had produced, for himself at any rate, the rounded spaces of the cave in the layered stratification of urban space; a semi-imaginary space of unified original dwelling, a violent punctuation of the cubic fragmentation of space. The interior vantage point was sealed off (as a danger zone) from public view during the Paris Biennale for which the artwork was executed.

Conical Intersect seemed a world apart from the architecturally recognizable Postmodernist enterprise of the Centre Pompidou, with which the lingering of urban renewal had brought it into contraposition. The work was a spectacular spatial aberration within the process of urban renewal – a final revelation of the old in the process of being peeled away for the emergence of the new.

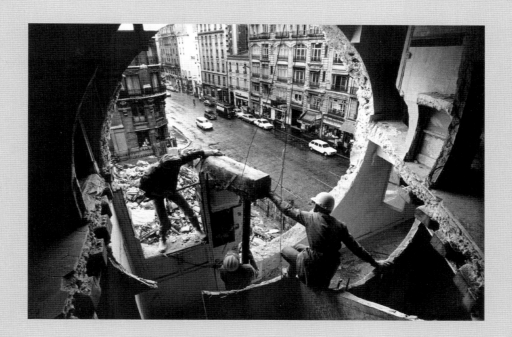

GORDON MATTA-CLARK
Conical Intersect, 1975

Cut to Sigmar Polke

In Sigmar Polke's hands, photography becomes a destructive device for the purposes of constructing a new and altered vision. For many of us, photography stills the moment, arrests the gaze or records the appearance of events for future memories. It transforms our everyday perceptions into images of enduring clarity. For Polke, however, the photograph represents the destruction of everyday, normal, perceived reality. Rendering the invisible visible, his photographic activity places appearances at the edge of disappearance, reinvents reality.

Polke's processing techniques are extensive, experimental and often impulsive, ranging from cutting and collaging, folding, drawing and under- or overexposing to experimenting with different chemicals and overlaying blots, dots and stains. Polke's fascination is with the accidental and the intuitive, with the most degraded, contaminated aspects of developing, utilizing anything, in fact, that will aid the effects of degradation. In the process, his diabolic alchemy produces powerful, mysterious and transcendental images.

Polke's photographs always expose something of the magical, ritualistic aspects of photography. Scratching, cutting, eroding, folding or otherwise chemically intervening in the process of development, Polke renders the familiar images of the world lifeless, but opens them up to the world of eternal fascination. Rather than points of closure or images of arrested time, his photographs become moments that reveal, images of fluid and incessant continuity.

In a series of photographs taken in 1973 on his visit to New York City, Polke photographed what he called 'the other America', the world of the Bowery, where drug addicts, alcoholics, the homeless and other disenfranchised and displaced citizens inhabit a sleazy street in a rundown neighbourhood. Through the folds and chemical stains of the finished photographs we glimpse the characters who live this life so far removed from the European image of 'Golden America'. In these works, Polke's developing process – a combination of the practical (folding because his dishes were not large enough for the paper he was using), the experimental and the accidental – produced a series of photographs whose essence echoed the subjects' lives: grimy, seedy, hollow. And yet his developing techniques also seem to release his subjects from the dominating order of the everyday world. The ghostly apparitions of the Bowery bums and nomads seem to float free like celebrations of release.

If Polke's starting point is his snapshots taken of everyday people, activities, events, cities, paintings and so on, the end result is always an experience of something other, a place beyond everyday perception, an altered state. To approach his photographs, we too must suspend our normal everyday perceptions and enter his world of fascination. The photographs deny us access into the familiar setting of the easily recognizable. Instead, we are forced to confront the mystery of reality turned upside down, twisted, contorted, contaminated but ultimately regenerated. Each photograph takes us into a liminal, limbo state, a non-space situated somewhere between the here-and-now and the beyond.

Perhaps we should give Maurice Blanchot the last word here: 'Fascination is the gaze of solitude, the gaze of what is incessant and interminable, in which blindness is still vision, vision that is no longer

the possibility of seeing, but the impossibility of not seeing, impossibility that turns into seeing, that perseveres – always and always – in a vision that does not end: a dead gaze, a gaze that has become the ghost of an eternal vision.'[4]

Interrupt the flow

Until the late 1970s the rhetoric used to examine and analyse youth cultures was one of resistance to the parent culture and of a desire on the part of subcultures to retain parental or class identity. Youth cultures, such as mods and skinheads, embraced class-based clothing, embellishing or 'pimping' them up (jeans, Doc Martens, braces etc.). Hippies embraced the casual work attire of the all-American workforce (Levi jeans) and mixed it with the informal, workaday garments from both east and west. By making the clothing more open, less rigidly hierarchical, more openly democratic and universal, the rhetoric became one of openness: emancipation through fashion.

Before long, the market always seizes its opportunity and swallows whole any look from youth culture, opening up the style to the masses. Because mass consumption has always concerned itself with trying to make the ease of consumption ever more fluid, youth-cultural styles inevitably become vehicles that accelerate the fluidity of the commodity through the highways of consumerism. They help consolidate the association between fashion and the moment of consumption, the moment of turnover and of transience.

With the arrival of punk fashion and music in the early 1970s, however, the experience was not one of general openness and abstraction but of fragmentation, fracture, fissure – the very opposite of previous youth cultures. There was a sense of interference. Deliberate interference. Punk was much more controlled than perhaps many people believed at the time. It was not just a youthful response to the economic and political crises of the 1970s, nor was it simply a question of frustrated, angry kids with no money rising up and taking back the power. You could, if you wanted, read it as a set-up: a set-up by people who were already in control or who understood control.

So punk took an act of resistance – for example, Situationism – and turned it into an act of conformity. Then it pulled the carpet out from under any further acts of political resistance in the future. Rather than disrupting or exposing the violence of the commodity in the act of consumption, as many of its followers and a cartload of cultural studies professors would have us believe, punk reinforced the implicit violence of the commodity and the commodity image.

For those who understood cultural strategy, political positioning and marketing savvy in the 1970s, and who had begun to question the limited cultural readings of subcultures, punk was an interruption of all that. It was a deliberate, strategic interruption that recognized the dialectic between violence and pleasure in consumption. Punk's fashion and music – for those who were responsible for them – were aimed at nothing more than a corner of the market.

The standard argument made by cultural studies academics in the 1980s generally was that punk's image of violence and aggression acted as a counterpart to the passive consumer image, that it opened up the act of consumption to a sort of do-it-yourself aesthetic, actively resisting the passivity of consumerism. But the commodity only ever promises a sense of openness, and inevitably always leads to another form of closure. (For example, you buy a 'look' because it is different and unusual, and pretty soon market forces ensure that the 'look' is on everyone's body in order to guarantee market profits.) So the punk movement, even with its representation of violence, ended up being adopted by the most docile of suburban members of the culture, by those who looked like fans but were not. The suburban (knowledgeable, educated) crowd broke with the usual fan-following activities of youth cultures and created a new level of fandom – a fandom that, rather than representing a kind of youthful interruption by protesting against the status quo, was totally dedicated only to an intensification of the interruption.

If we take the position that punk was a deliberate set-up by those in the know, might we then suggest a parallel in Blanchot's terms between the image that is fascinated and one that sees limits in the image? Does the punk image become an intensity of engagement through an awareness of its own limits and of the limits of the spectacle of the image? This position would allow us to reflect on the fact that by intensifying a relationship with a commodity, you break with a neutral sense of the ordinary legibility of the

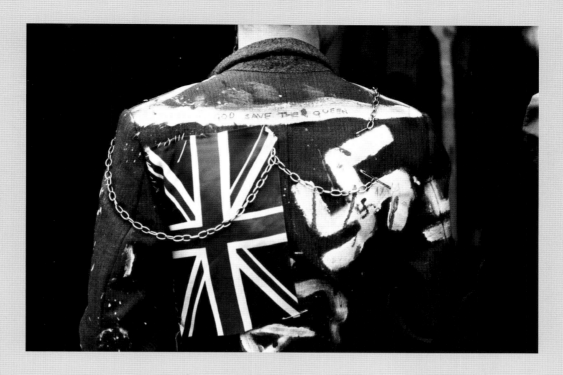

Punk's jacket, 1977

commodity image. You interfere with it, cut it up and, in the case of punk, you reform it with safety pins. You tear it up in order to put it back together again – in a different form.

Punk managed to convert the commodity into the fetish through the presence of the tear or the safety pin. Like a zip, the safety pin both binds and separates. It was an object to be fetishized. The seam of a garment, too, is the point at which something is revealed through its resealing. The gap between the fishnet stocking top and the mini skirt likewise cuts up the body, fetishizes the body as both a site of loss and a site of attraction. 'Is not the most erotic portion of the body where the garment gapes?' asks Barthes in *The Pleasure of the Text*.[5]

So if punk's real resistance could somehow be found in its relationship with the commodity image, with the implicit violence of the rip, then let us return to the rend. In the Bible we discover that when people are angry or upset with God or with other people, there is often a rending of clothes. It is a way of demonstrating that the world is not alright. It is not seamlessly continuous. There are openings, and these openings are called subjectivities. The people are declaring: 'Look, I'm a subject. I'm standing here in rags before you. I'm exposing bits of my body between the rags. I'm not naked. This is not the opposite of being clothed. I'm clothed, but I have rent my clothes, and there is a great potentiality for nakedness.'

Punk might then be read as a sacrificial tearing-up of the body, a rending of clothes in Didi-Huberman's terms. The rending of the clothes focused attention on the fabrics that Vivienne Westwood brought to her early collections, and cutting up/pulling together garments by using safety pins made the materiality of the fabric irrelevant, or reduced it to visuality. The moment you incise the fabric with zips or orifices (holes) or tears, you draw attention to the material and to materiality. You render a different meaning to it. Something as familiar as tartan suddenly becomes estranged. The feel of the fabric, the sense of it – what Didi-Huberman calls the fabric of representation – is revealed through the seams.

Cut to the chase

Notes

1. G. Didi-Huberman, *Confronting Images: Questioning the Ends of a Certain History of Art*, trans. J. Goodman, University Park (Pennsylvania State University Press) 2005, p. 144.
2. R. Barthes, *The Pleasures of the Text*, trans. R. Miller, New York (Hill & Wang) 1975, p. 9; emphasis added.
3. 'Demand the Impossible', interview with M. Bracewell, *Frieze*, issue 89, March 2005, p. 89.
4. M. Blanchot, 'The Essential Solitude', in *The Gaze of Orpheus, and Other Literary Essays*, ed. P. Adams Sitney, trans. L. Davis, Barrytown, NY (Station Hill Press) 1981, p. 75; emphasis added.
5. Barthes, *op. cit.*, p. 10.

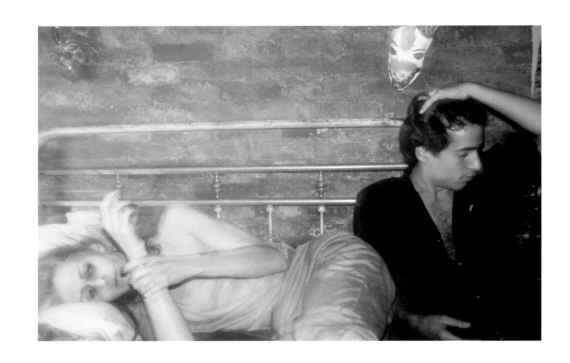

NAN GOLDIN

Greer and Robert on the bed, NYC, 1982

French Chris at the Drive-in, NJ, 1979

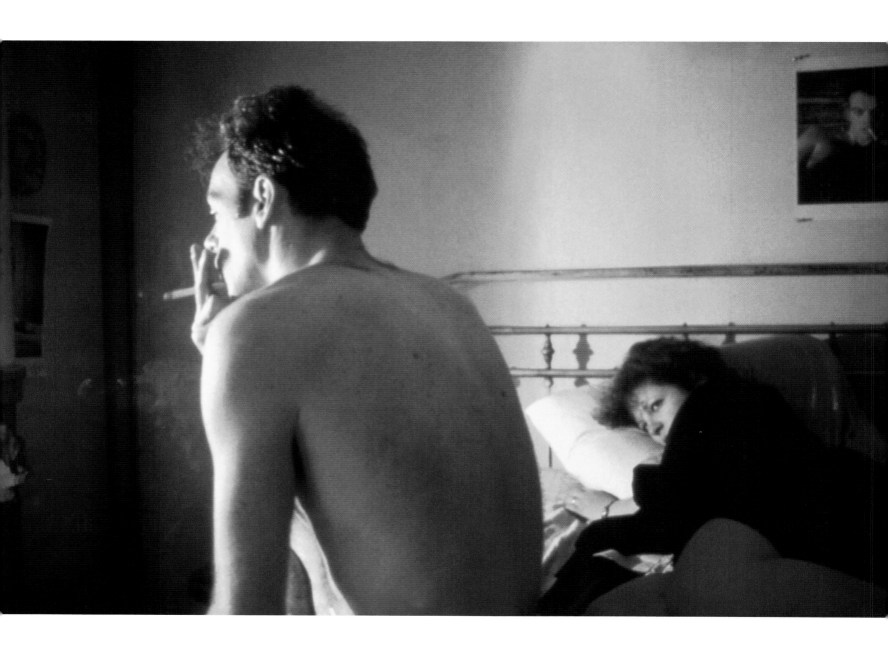

NAN GOLDIN

Nan and Brian in bed, NYC, 1983

Opposite
Robin and Kenny at Boston/Boston, Boston, 1983
Brian on the phone, NYC, 1981

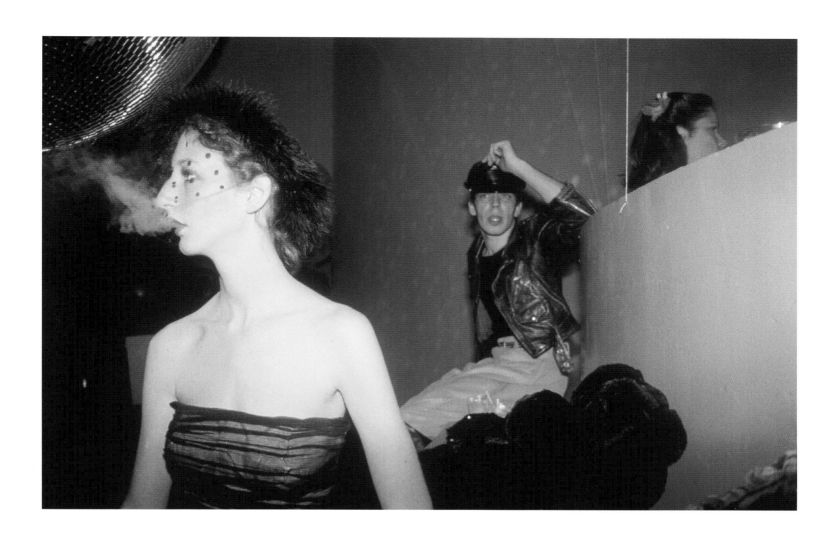

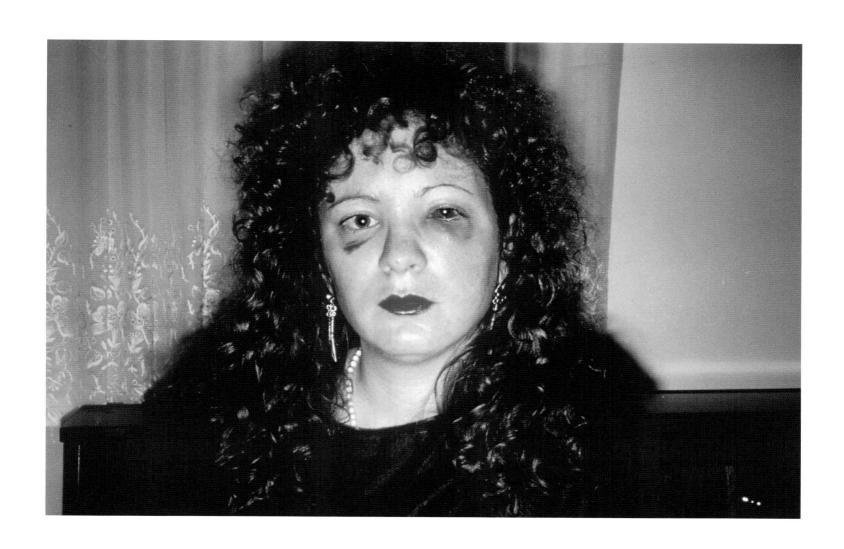

Nan Goldin

Skeletons coupling, New York City, 1983

Nan one month after being battered, 1984

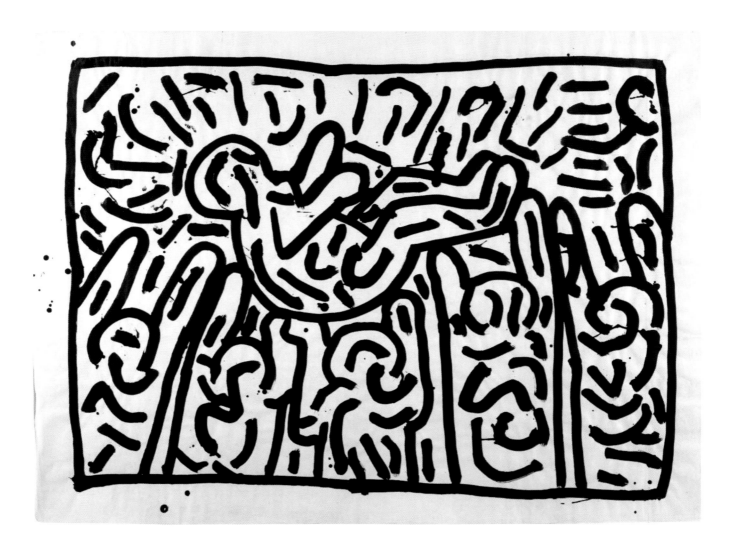

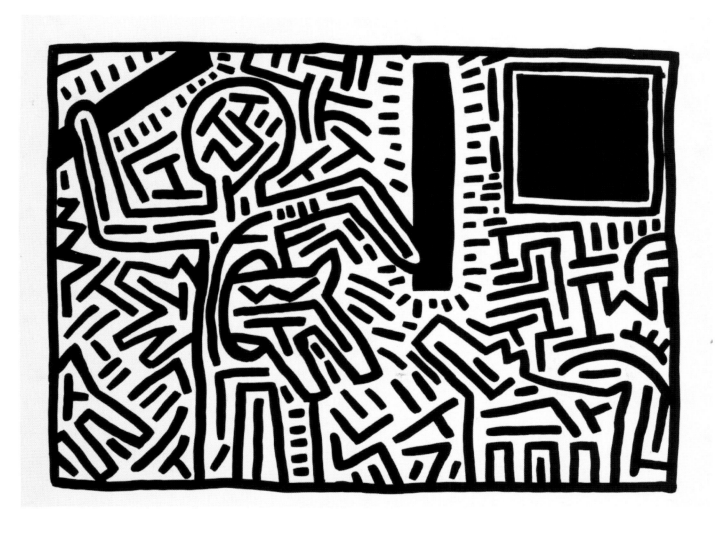

KEITH HARING

Opposite
Untitled, 1981

Untitled, 1981

KEITH HARING

Untitled, 1983

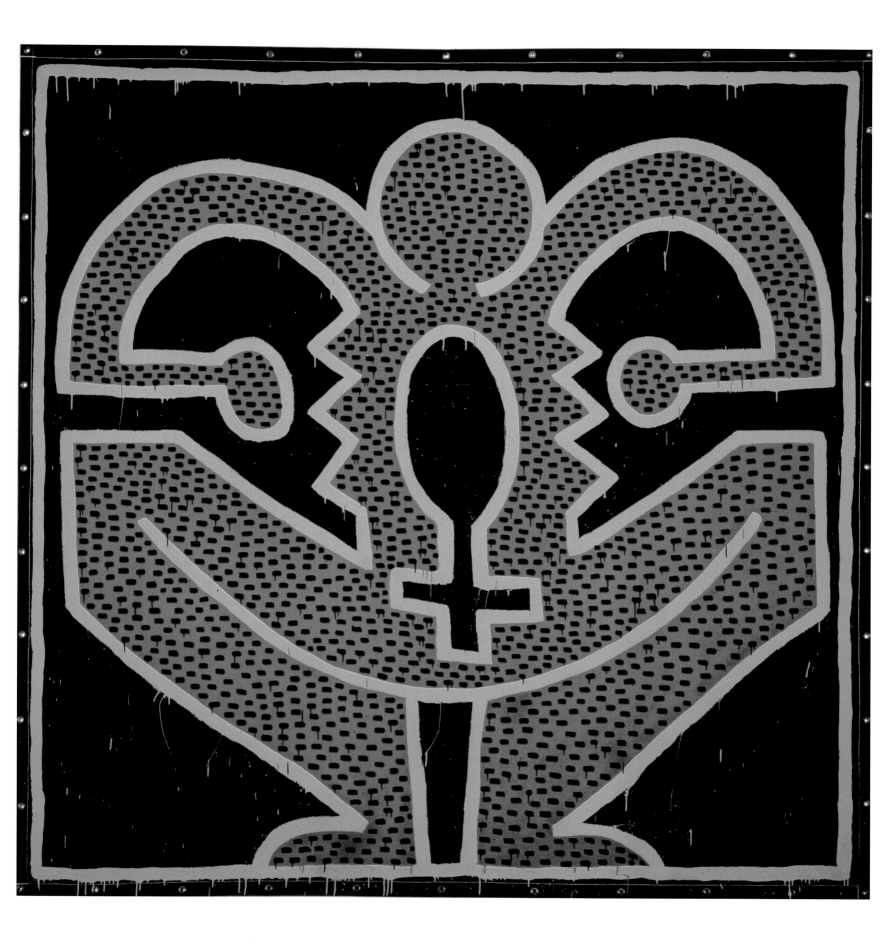

JENNY HOLZER

From *Inflammatory Essays*, 1979–82, and *Truisms*, 1977–79,
street installation, Seattle, Washington, 1984

Right
Inflammatory Essays, 1979–82

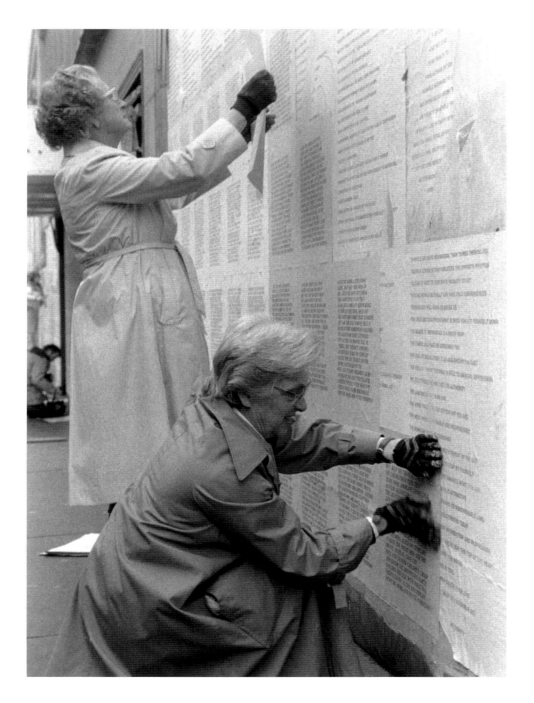

IT ALL HAS TO BURN, IT'S GOING TO BLAZE. IT IS FILTHY AND CAN'T BE SAVED. A COUPLE OF GOOD THINGS WILL BURN WITH THE REST BUT IT'S O.K. EVERY PIECE IS PART OF THE UGLY WHOLE. EVERYTHING CONSPIRES TO KEEP YOU HUNGRY AND AFRAID FOR YOUR BABIES. DON'T WAIT ANY LONGER. WAITING IS WEAKNESS, WEAKNESS IS SLAVERY. BURN DOWN THE SYSTEM THAT HAS NO PLACE FOR YOU, RISE TRIUMPHANT FROM THE ASHES. FIRE PURIFIES AND RELEASES ENERGY. FIRE GIVES HEAT AND LIGHT, LET FIRE BE THE CELEBRATION OF YOUR DELIVERANCE. LET LIGHTNING STRIKE, LET THE FLAMES DEVOUR THE ENEMY!

BECAUSE THERE IS NO GOD SOMEONE MUST TAKE RESPONSIBILITY FOR MEN. A CHARISMATIC LEADER IS IMPERATIVE. HE CAN SUBORDINATE THE SMALL WILLS TO THE GREAT ONE. HIS STRENGTH AND HIS VISION REDEEM MEN. HIS PERFECTION MAKES THEM GRATEFUL. LIFE ITSELF IS NOT SACRED, THERE IS NO DIGNITY IN THE FLESH. UNDIRECTED MEN ARE CONTENT WITH RANDOM, SQUALID, POINTLESS LIVES. THE LEADER GIVES DIRECTION AND PURPOSE. THE LEADER FORCES GREAT ACCOMPLISHMENTS, MANDATES PEACE AND REPELS OUTSIDE AGGRESSORS. HE IS THE ARCHITECT OF DESTINY. HE DEMANDS ABSOLUTE LOYALTY. HE MERITS UNQUESTIONING DEVOTION. HE ASKS THE SUPREME SACRIFICE. HE IS THE ONLY HOPE.

MONDAY, SOMEONE DIED BECAUSE HE HURT ME SO I CUT HIM WITHOUT THINKING. TUESDAY, SOME ANIMAL DIED BECAUSE HE WAS TOO DANGEROUS TO BE FREE. WEDNESDAY, A THIEF DIED SO EVERYONE WILL KNOW TO RESPECT PRIVATE PROPERTY. THURSDAY, SOME POLITICO DIED BECAUSE HIS IDEAS WERE CRAZY AND TOO CONTAGIOUS. FRIDAY, SOME RAPIST DIED BECAUSE HE LEFT HIS VICTIM WISHING SHE WAS DEAD. HE HAD TO DIE WISHING HE WAS ALIVE. SATURDAY, I KILLED A CONDEMNED MAN SO NO ONE ELSE WOULD GET BLOOD ON THEIR HANDS. SUNDAY, I RESTED. MONDAY, SIX PEOPLE JUMPED ME SO I CUT THEM WITHOUT THINKING.

THE MOST EXQUISITE PLEASURE IS DOMINATION. NOTHING CAN COMPARE WITH THE FEELING. THE MENTAL SENSATIONS ARE EVEN BETTER THAN THE PHYSICAL ONES. KNOWING YOU HAVE POWER HAS TO BE THE BIGGEST HIGH, THE GREATEST COMFORT. IT IS COMPLETE SECURITY, PROTECTION FROM HURT. WHEN YOU DOMINATE SOMEBODY YOU'RE DOING HIM A FAVOR. HE PRAYS SOMEONE WILL CONTROL HIM, TAKE HIS MIND OFF HIS TROUBLES. YOU'RE HELPING HIM WHILE HELPING YOURSELF. EVEN WHEN YOU GET MEAN HE LIKES IT, SOMETIMES HE'S ANGRY AND FIGHTS BACK BUT YOU CAN HANDLE IT. HE ALWAYS REMEMBERS WHAT HE NEEDS. YOU ALWAYS GET WHAT YOU WANT.

SHRIEK WHEN THE PAIN HITS DURING INTERROGATION. REACH INTO THE DARK AGES TO FIND A SOUND THAT IS LIQUID HORROR, A SOUND OF THE BRINK WHERE MAN STOPS AND THE BEAST AND NAMELESS CRUEL FORCES BEGIN. SCREAM WHEN YOUR LIFE IS THREATENED. FORM A NOISE SO TRUE THAT YOUR TORMENTOR RECOGNIZES IT AS A VOICE THAT LIVES IN HIS OWN THROAT. THE TRUE SOUND TELLS HIM THAT HE CUTS HIS FLESH WHEN HE CUTS YOURS, THAT HE CANNOT THRIVE AFTER HE TORTURES YOU. SCREAM THAT HE DESTROYS ALL KINDNESS IN YOU AND BLACKENS EVERY VISION YOU COULD HAVE SHOWN HIM.

RUIN YOUR FUCKING SELF BEFORE THEY DO. OTHERWISE THEY'LL SCREW YOU BECAUSE YOU'RE A NOBODY. THEY'LL KEEP YOU ALIVE, BUT YOU'LL HAVE TO CRAWL AND SAY "THANK-YOU" FOR EVERY BONE THEY THROW. YOU MIGHT AS WELL STAY DRUNK OR SHOOT JUNK AND BE A CRAZY FUCKER. IF THE RICH GUYS WANT TO PLAY WITH YOU, MAKE THEM GET THEIR HANDS DIRTY. SEND THEM AWAY GAGGING, OR SOBBING IF THEY'RE SOFT-HEARTED. YOU'LL BE LEFT ALONE IF YOU'RE FRIGHTENING, AND DEAD YOU'RE FREE! YOU CAN CHANGE THE RADIANT CHILD IN YOU TO A REFLECTION OF THE SHIT YOU WERE MEANT TO SERVE.

VE THE
THE
LL
ORGET

T

OP
OBS,
ORN

N HOPE,
DUCTION,
MENT,
RN

UNCTION.

THOU ART THAT KIND OF PRIVILEGED WOMAN WHO IS REALLY REALLY SURE THAT NOTHING WILL EVER HAPPEN TO HER. THOU IMAGINE THAT THOU ART SACRED, THAT THY BODY IS A TEMPLE WHERE NONE BUT THE ANOINTED MAY ENTER. SURPRISE! THY TEMPLE GATES ARE ABOUT TO BE OPENED. BEFORE THOU CAN SHIVER, EVERYONE WILL BE EXPLORING THY SECRET ALTAR. FREE ADMISSION! THOU WILL BE COMMON PROPERTY, EVERYONE'S WHORE, BEFORE THOU ART USED-UP, MESSED-UP AND THROWN IN A PILE WITH OTHER JUNK THAT USED TO LOOK GOOD BUT IS USELESS. IT IS THINE OWN FAULT. THOU THOUGHT THOU WERE BETTER THAN US.

SHRIEK WHEN THE PAIN HITS DURING INTERROGATION. REACH INTO THE DARK AGES TO FIND A SOUND THAT IS LIQUID HORROR, A SOUND OF THE BRINK WHERE MAN STOPS AND THE BEAST AND NAMELESS CRUEL FORCES BEGIN. SCREAM WHEN YOUR LIFE IS THREATENED. FORM A NOISE SO TRUE THAT YOUR TORMENTOR RECOGNIZES IT AS A VOICE THAT LIVES IN HIS OWN THROAT. THE TRUE SOUND TELLS HIM THAT HE CUTS HIS FLESH WHEN HE CUTS YOURS, THAT HE CANNOT THRIVE AFTER HE TORTURES YOU. SCREAM THAT HE DESTROYS ALL KINDNESS IN YOU AND BLACKENS EVERY VISION YOU COULD HAVE SHOWN HIM.

PEOPLE MUST PAY FOR WHAT THEY HOLD, FOR WHAT THEY STEAL. YOU HAVE LIVED OFF THE FAT OF THE LAND. NOW YOU ARE THE PIG WHO IS READY FOR SLAUGHTER. YOU ARE THE OLD ENEMY, THE NEW VICTIM. WHEN YOU DO SOMETHING AWFUL EXPECT RETRIBUTION IN KIND. LOOK OVER YOUR SHOULDER. SOMEONE IS FOLLOWING. THE POOR YOU HAVE ROBBED AND IGNORED ARE IMPATIENT. PLEAD INNOCENT; YOUR SQUEALS INVITE TORTURE. PROMISE TO BE GOOD; YOUR LIES EXCITE AND INFLAME. YOU ARE TOO DEPRAVED TO REFORM, TOO TREACHEROUS TO SPARE, TOO HIDEOUS FOR MERCY. RUN! JUMP! HIDE! PROVIDE SPORT FOR THE HUNTERS.

YOU GET AMAZING SENSATIONS FROM GUNS. YOU GET RESULTS FROM GUNS. MAN IS AN AGGRESSIVE ANIMAL; YOU HAVE TO HAVE A GOOD OFFENSE AND A GOOD DEFENSE. TOO MANY CITIZENS THINK THEY ARE HELPLESS. THEY LEAVE EVERYTHING TO THE AUTHORITIES AND THIS CAUSES CORRUPTION. RESPONSIBILITY SHOULD GO BACK WHERE IT BELONGS. IT IS YOUR LIFE SO TAKE CONTROL AND FEEL VITAL. THERE MAY BE SOME ACCIDENTS ALONG THE PATH TO SELF-EXPRESSION AND SELF-DETERMINATION. SOME HARMLESS PEOPLE WILL BE HURT. HOWEVER, G-U-N SPELLS PRIDE TO THE STRONG, SAFETY TO THE WEAK AND HOPE TO THE HOPELESS. GUNS MAKE WRONG RIGHT FAST.

SNAKES ARE EVIL INCARNATE. THEY ARE A MANIFESTATION OF THE DARK SIDE OF NATURE. THEY LIE TWINED IN DAMP PLACES, THEIR BODIES COLD TO THE TOUCH. THE FORM OF THE SNAKE IS DREADFUL; THE TONGUE AND WORM-BODY INSPIRE LOATHING. THE SERPENT IS SLY, HE ABIDES WHERE YOU KNOW NOT. HE COMES CRAWLING TO BITE AND POISON. HE HAS MULTIPLIED SO HE INFESTS THE FACE OF THE EARTH. HE IS NOT CONTENT TO EXIST, HE MUST CORRUPT THAT WHICH IS PURE. THE APPEARANCE OF THE SERPENT SIGNIFIES ALL IS LOST. HE IS A SYMBOL OF OUR FAILURE AND OUR FATE.

YOU

EED
ER

OVE
BE

V.

."

FREEDOM IS IT! YOU'RE SO SCARED, YOU WANT TO LOCK UP EVERYBODY. ARE THEY MAD DOGS? ARE THEY OUT TO KILL? MAYBE YES. IS LAW, IS ORDER THE SOLUTION? DEFINITELY NO. WHAT CAUSED THIS SITUATION? LACK OF FREEDOM. WHAT HAPPENS NOW? LET PEOPLE FULFILL THEIR NEEDS. IS FREEDOM CONSTRUCTIVE OR IS IT DESTRUCTIVE? THE ANSWER IS OBVIOUS. FREE PEOPLE ARE GOOD, PRODUCTIVE PEOPLE. IS LIBERATION DANGEROUS? ONLY WHEN OVERDUE. PEOPLE AREN'T BORN RABID OR BERSERK. WHEN YOU PUNISH AND SHAME YOU CAUSE WHAT YOU DREAD. WHAT TO DO? LET IT EXPLODE. RUN WITH IT. DON'T CONTROL OR MANIPULATE. MAKE AMENDS.

IT ALL HAS TO BURN, IT'S GOING TO BLAZE. IT IS FILTHY AND CAN'T BE SAVED. A COUPLE OF GOOD THINGS WILL BURN WITH THE REST BUT IT'S O. K., EVERY PIECE IS PART OF THE UGLY WHOLE. EVERYTHING CONSPIRES TO KEEP YOU HUNGRY AND AFRAID FOR YOUR BABIES. DON'T WAIT ANY LONGER. WAITING IS WEAKNESS, WEAKNESS IS SLAVERY. BURN DOWN THE SYSTEM THAT HAS NO PLACE FOR YOU, RISE TRIUMPHANT FROM THE ASHES. FIRE PURIFIES AND RELEASES ENERGY. FIRE GIVES HEAT AND LIGHT. LET FIRE BE THE CELEBRATION OF YOUR DELIVERANCE. LET LIGHTNING STRIKE, LET THE FLAMES DEVOUR THE ENEMY!

OH LORD WHEN YOU ARE ALONE AND DO NOT WANT TO BE, YOU LIE IN BED WITH YOUR OWN SHOULDER WRAPPED AROUND AND BENEATH YOURSELF SO THAT THE SURGES OF PAIN KEEP YOU COMPANY. THIS IS HURTFUL BUT IT IS SO MUCH BETTER THAN NO NERVES FIRING AT ALL. THE WORST IS WHEN THERE'S NO ONE NEAR TO PRESS ON YOU AND MAKE DENTS IN YOUR SKIN WITH THEIR FINGER NAILS. YOU ARE LEFT RUNNING YOUR HANDS ALL OVER YOURSELF, BITING TRYING AND EXPERIMENTING TO CREATE SENSATIONS. THE ENORMOUS FEELINGS YOU MAKE PROVE TO YOURSELF THAT YOU CREATE GREAT EXCITEMENT.

BECAUSE THERE IS NO GOD SOMEONE MUST TAKE RESPONSIBILITY FOR MEN. A CHARISMATIC LEADER IS IMPERATIVE. HE CAN SUBORDINATE THE SMALL WILLS TO THE GREAT ONE. HIS STRENGTH AND HIS VISION REDEEM MEN. HIS PERFECTION MAKES THEM GRATEFUL. LIFE ITSELF IS NOT SACRED, THERE IS NO DIGNITY IN THE FLESH. UNDIRECTED MEN ARE CONTENT WITH RANDOM, SQUALID, POINTLESS LIVES. THE LEADER GIVES DIRECTION AND PURPOSE. THE LEADER FORCES GREAT ACCOMPLISHMENTS, MANDATES PEACE AND REPELS OUTSIDE AGGRESSORS. HE IS THE ARCHITECT OF DESTINY. HE DEMANDS ABSOLUTE LOYALTY. HE MERITS UNQUESTIONING DEVOTION. HE ASKS THE SUPREME SACRIFICE. HE IS THE ONLY HOPE.

WHEN YOU BECOME RICH, DEATH SNIFFS THE AIR AND STARTS CIRCLING. YOU MUST PROTECT YOUR WEALTH AND SELF. EVERY DESPERATE PERSON SEES YOU ONLY AS A SOURCE OF MONEY. YOUR MONEY SUMMONS DEATH AND IT COMES WHISPERING IN THE VOICES OF THE HUNGRY AND FRIGHTFULLY TIRED. YOUR GOOD PART WINCES WHEN YOU SEE SUFFERING AND YOUR MIND NOTES THAT PAIN AS A PORTENT. YOU MAY FEEL RELEASE WHEN THE POOR CUT OUT YOUR HEART AND LEAVE IT BEATING ON YOUR FACE. YOU TASTE BLOOD AND KNOW THAT LIFE IS LOVELY, FRAGILE, AND YOU REMEMBER THAT THE OPPRESSED ERUPT AND MURDER.

ON,

UDE,
IEFS,

S OR

N HERDS

. FEAR

N IS
NS
IONS

SAFE,

ES ARE
ACULAR.

DESTROY SUPERABUNDANCE. STARVE THE FLESH, SHAVE THE HAIR, EXPOSE THE BONE, CLARIFY THE MIND, DEFINE THE WILL, RESTRAIN THE SENSES, LEAVE THE FAMILY, FLEE THE CHURCH, KILL THE VERMIN, VOMIT THE HEART, FORGET THE DEAD. LIMIT TIME, FORGO AMUSEMENT, DENY NATURE, REJECT ACQUAINTANCES, DISCARD OBJECTS, FORGET TRUTHS, DISSECT MYTH, STOP MOTION, BLOCK IMPULSE, CHOKE SOBS, SWALLOW CHATTER. SCORN JOY, SCORN TOUCH, SCORN TRAGEDY, SCORN LIBERTY, SCORN CONSTANCY, SCORN HOPE, SCORN EXALTATION, SCORN REPRODUCTION, SCORN VARIETY, SCORN EMBELLISHMENT, SCORN RELEASE, SCORN REST, SCORN SWEETNESS, SCORN LIGHT. IT'S A QUESTION OF FORM AS MUCH AS FUNCTION. IT IS A MATTER OF REVULSION.

SENTIMENTALITY DELAYS THE REMOVAL OF THE POLITICALLY BACKWARD AND THE ORGANICALLY UNSOUND. RIGOROUS SELECTION IS MANDATORY IN SOCIAL AND GENETIC ENGINEERING. INCORRECT MERCIFUL IMPULSES POSTPONE THE CLEANSING THAT PRECEDES REFORM. SHORT-TERM NICETIES MUST YIELD TO LONG-RANGE NECESSITY. MORALS WILL BE REVISED TO MEET THE REQUIREMENTS OF TODAY. MEANINGLESS PLATITUDES WILL BE PULLED FROM TONGUES AND MINDS. WORDS LIKE "PURGE" AND "EUTHANASIA" DESERVE NEW CONNOTATIONS. THEY SHOULD BE RECOGNIZED AS THE RATIONAL PUBLIC POLICIES THEY ARE. THE GREATEST DANGER IS NOT EXCESSIVE ZEAL BUT UNDUE HESITATION. WE WILL LEARN TO IMITATE NATURE. HER KILLS NOURISH STRONG LIFE. SQUEAMISHNESS IS THE CRIME.

RUIN YOUR FUCKING SELF BEFORE THEY DO. OTHERWISE THEY'LL SCREW YOU BECAUSE YOU'RE A NOBODY. THEY'LL KEEP YOU ALIVE, BUT YOU'LL HAVE TO CRAWL AND SAY "THANK-YOU" FOR EVERY BONE THEY THROW. YOU MIGHT AS WELL STAY DRUNK OR SHOOT JUNK AND BE A CRAZY FUCKER. IF THE RICH GUYS WANT TO PLAY WITH YOU, MAKE THEM GET THEIR HANDS DIRTY. SEND THEM AWAY GAGGING, OR SOBBING IF THEY'RE SOFT-HEARTED. YOU'LL BE LEFT ALONE IF YOU'RE FRIGHTENING, AND DEAD YOU'RE FREE! YOU CAN CHANGE THE RADIANT CHILD IN YOU TO A REFLECTION OF THE SHIT YOU WERE MEANT TO SERVE.

RUIN YOUR FUCKING SELF BEFORE THEY DO. OTHERWISE THEY'LL SCREW YOU BECAUSE YOU'RE A NOBODY. THEY'LL KEEP YOU ALIVE, BUT YOU'LL HAVE TO CRAWL AND SAY "THANK-YOU" FOR EVERY BONE THEY THROW. YOU MIGHT AS WELL STAY DRUNK OR SHOOT JUNK AND BE A CRAZY FUCKER. IF THE RICH GUYS WANT TO PLAY WITH YOU, MAKE THEM GET THEIR HANDS DIRTY. SEND THEM AWAY GAGGING, OR SOBBING IF THEY'RE SOFT-HEARTED. YOU'LL BE LEFT ALONE IF YOU'RE FRIGHTENING, AND DEAD YOU'RE FREE! YOU CAN CHANGE THE RADIANT CHILD IN YOU TO A REFLECTION OF THE SHIT YOU WERE MEANT TO SERVE.

A CRUEL BUT ANCIENT LAW DEMANDS AN EYE FOR AN EYE. MURDER MUST BE ANSWERED BY EXECUTION. ONLY GOD HAS THE RIGHT TO TAKE A LIFE AND WHEN SOMEONE BREAKS THIS LAW HE WILL BE PUNISHED. JUSTICE MUST COME SWIFTLY. IT DOESN'T HELP ANYONE TO STALL. THE VICTIM'S FAMILY CRIES OUT FOR SATISFACTION, THE COMMUNITY BEGS FOR PROTECTION AND THE DEPARTED CRAVES VENGEANCE SO HE CAN REST. THE KILLER KNEW IN ADVANCE THERE WAS NO EXCUSE FOR HIS ACT, TRULY HE HAS TAKEN HIS OWN LIFE. HE, NOT SOCIETY, IS RESPONSIBLE FOR HIS FATE. HE ALONE STANDS GUILTY AND DAMNED.

Y

EN

'T

R
S

MNED.

AVERT THY MORTAL EYES FROM SIGHTS THAT SEAR THE ORBS OF MEN. KEEP THY THOUGHTS FROM THE LABYRINTHINE PATH THAT LEADS FROM ARROGANT KNOWLEDGE TO FIERY DESTRUCTION. SEEK NOT THE LIGHTNING STRIKE THAT SUMMONS LIFE NOR THE DARK VORTEX THAT IS DEATH BEFORE REDEMPTION. NEITHER CRY ALOUD NOR SHAKE CLENCHED FISTS AT THE GOD WHOSE PLAN IS TERRIBLE BUT PERFECT. CONCEIVE NO THEORIES, BUILD NO STOPGAPS AGAINST THE INEVITABLE AND THE DIVINE. INSTEAD, LOVE THY WIFE AND TENDER CHILDREN, GRASP AND SAVOR THE BOUNTEOUS EARTH. CONCERN THYSELF WITH WHAT WAS FREELY GIVEN AS THY BIRTHRIGHT, VENTURE MORE AND INVITE PERDITION.

ONLY MY BROTHER MEN KNOW MY SECRETS. ONLY THEIR HEARTS BEAT THE SAME CADENCE. ONLY BROTHERS SPEAK IN THE SPECIAL VOICE AND PLAN RAIDS TO STOP THE SPREADING INSOLENCE OF THE SLAVE RACE. ONLY BROTHER MEN WEAR THE ROBES AND BECOME GREATER THAN THEIR INDIVIDUAL SELVES. IN DARK AND BREATHLESS SILENCE BROTHER MEN MINGLE THE BLOOD, SEAL THE PACT, START THE HUNT, CIRCLE THE SLAVE. BROTHER MEN CRACK THE HUSH AND SWING A TORCH TOWARD TERRIFIED EYES. BROTHER MEN LIGHT A FIRE TO CELEBRATE VICTORY OVER SLAVES WHO NEVER SHOULD HAVE BEEN BORN, WHO ONCE BORN MUST SERVE AND OBEY.

CHILD MOLESTATION IS ABHORRENT. THIS DEVIATION IS UNIVERSALLY CONDEMNED. ALL PEOPLE ARE SICKENED AND ENRAGED BY THE ACT. IT IS TELLING THAT PRISONERS, WHO ARE NOT KNOWN FOR THEIR HIGH STANDARDS, OSTRACIZE AND KILL CHILD MOLESTERS. NO PUNISHMENT IS TOO SEVERE; CHILD MOLESTERS HAVE ROBBED THE BABIES OF THEIR INNOCENCE, THE MOST PRECIOUS POSSESSION OF CHILDHOOD. MOLESTATION LEAVES SPIRITUAL, EMOTIONAL AND PHYSICAL WOUNDS THAT MAY NEVER HEAL. THE FRIGHTENING ASPECT OF THE ABUSE IS THAT MOLESTED CHILDREN OFTEN BECOME CHILD MOLESTERS. THE AWFUL CYCLE MUST BE STOPPED BEFORE ANY MORE CHILDREN ARE DEFILED AND RUINED. MOLESTERS SHOULD BE RENDERED IMPOTENT.

FEAR IS THE MOST ELEGANT WEAPON, YOUR HANDS ARE NEVER MESSY. THREATENING BODILY HARM IS CRUDE. WORK INSTEAD ON MINDS AND BELIEFS, PLAY INSECURITIES LIKE A PIANO. BE CREATIVE IN APPROACH. FORCE ANXIETY TO EXCRUCIATING LEVELS OR GENTLY UNDERMINE THE PUBLIC CONFIDENCE. PANIC DRIVES HUMAN HERDS OVER CLIFFS; AN ALTERNATIVE IS TERROR-INDUCED IMMOBILIZATION. FEAR FEEDS ON FEAR. PUT THIS EFFICIENT PROCESS IN MOTION. MANIPULATION IS NOT LIMITED TO PEOPLE. ECONOMIC, SOCIAL AND DEMOCRATIC INSTITUTIONS CAN BE SHAKEN. IT WILL BE DEMONSTRATED THAT NOTHING IS SAFE, SACRED OR SANE. THERE IS NO RESPITE FROM HORROR. ABSOLUTES ARE QUICKSILVER. RESULTS ARE SPECTACULAR.

REPRESSING SEX URGES IS SO BAD. POISON DAMS UP INSIDE AND THEN IT MUST COME OUT. WHEN SEX IS HELD BACK TOO LONG IT COMES OUT FAST AND WILD. IT CAN DO A LOT OF HARM. INNOCENT PEOPLE GET SHOT OR CUT BY CONFUSED SEX URGES. THEY DON'T KNOW WHAT HIT THEM UNTIL TOO LATE. PARENTS SHOULD LET CHILDREN EXPRESS THEMSELVES SO THEY DON'T GET MEAN EARLY. ADULTS SHOULD MAKE SURE THEY FIND MANY OUTLETS. ALL PEOPLE SHOULD RESPOND TO BIG SEX NEEDS. DON'T MAKE FUN OF INDIVIDUALS AND SEND THEM AWAY. IT'S BETTER TO VOLUNTEER THAN TO GET FORCED.

Y

NG

EM

SHES.

ANCE.

SENTIMENTALITY DELAYS THE REMOVAL OF THE POLITICALLY BACKWARD AND THE ORGANICALLY UNSOUND. RIGOROUS SELECTION IS MANDATORY IN SOCIAL AND GENETIC ENGINEERING. INCORRECT MERCIFUL IMPULSES POSTPONE THE CLEANSING THAT PRECEDES REFORM. SHORT-TERM NICETIES MUST YIELD TO LONG-RANGE NECESSITY. MORALS WILL BE REVISED TO MEET THE REQUIREMENTS OF TODAY. MEANINGLESS PLATITUDES WILL BE PULLED FROM TONGUES AND MINDS. WORDS LIKE "PURGE" AND "EUTHANASIA" DESERVE NEW CONNOTATIONS. THEY SHOULD BE RECOGNIZED AS THE RATIONAL PUBLIC POLICIES THEY ARE. THE GREATEST DANGER IS NOT EXCESSIVE ZEAL BUT UNDUE HESITATION. WE WILL LEARN TO IMITATE NATURE. HER KILLS NOURISH STRONG LIFE. SQUEAMISHNESS IS THE CRIME.

DON'T TALK DOWN TO ME. DON'T BE POLITE TO ME. DON'T TRY TO MAKE ME FEEL NICE. DON'T RELAX. I'LL CUT THE SMILE OFF YOUR FACE. YOU THINK I DON'T KNOW WHAT'S GOING ON. YOU THINK I'M AFRAID TO REACT. THE JOKE'S ON YOU. I'M BIDING MY TIME, LOOKING FOR THE SPOT. YOU THINK NO ONE CAN REACH YOU, NO ONE CAN HAVE WHAT YOU HAVE. I'VE BEEN PLANNING WHILE YOU'RE PLAYING. I'VE BEEN SAVING WHILE YOU'RE SPENDING. THE GAME IS ALMOST OVER SO IT'S TIME YOU ACKNOWLEDGE ME. DO YOU WANT TO FALL NOT EVER KNOWING WHO TOOK YOU?

FREEDOM IS IT! YOU'RE SO SCARED, YOU WANT TO LOCK UP EVERYBODY. ARE THEY MAD DOGS? ARE THEY OUT TO KILL? MAYBE YES. IS LAW, IS ORDER THE SOLUTION? DEFINITELY NO. WHAT CAUSED THIS SITUATION? LACK OF FREEDOM. WHAT HAPPENS NOW? LET PEOPLE FULFILL THEIR NEEDS. IS FREEDOM CONSTRUCTIVE OR IS IT DESTRUCTIVE? THE ANSWER IS OBVIOUS. FREE PEOPLE ARE GOOD, PRODUCTIVE PEOPLE. IS LIBERATION DANGEROUS? ONLY WHEN OVERDUE. PEOPLE AREN'T BORN RABID OR BERSERK. WHEN YOU PUNISH AND SHAME YOU CAUSE WHAT YOU DREAD. WHAT TO DO? LET IT EXPLODE. RUN WITH IT. DON'T CONTROL OR MANIPULATE. MAKE AMENDS.

YOU GET AMAZING SENSATIONS FROM GUNS. YOU GET RESULTS FROM GUNS. MAN IS AN AGGRESSIVE ANIMAL; YOU HAVE TO HAVE A GOOD OFFENSE AND A GOOD DEFENSE. TOO MANY CITIZENS THINK THEY ARE HELPLESS. THEY LEAVE EVERYTHING TO THE AUTHORITIES AND THIS CAUSES CORRUPTION. RESPONSIBILITY SHOULD GO BACK WHERE IT BELONGS. IT IS YOUR LIFE SO TAKE CONTROL AND FEEL VITAL. THERE MAY BE SOME ACCIDENTS ALONG THE PATH TO SELF-EXPRESSION AND SELF-DETERMINATION. SOME HARMLESS PEOPLE WILL BE HURT. HOWEVER, G-U-N SPELLS PRIDE TO THE STRONG, SAFETY TO THE WEAK AND HOPE TO THE HOPELESS. GUNS MAKE WRONG RIGHT FAST.

SENTIMENTALITY DELAYS THE REMOVAL OF THE POLITICALLY BACKWARD AND THE ORGANICALLY UNSOUND. RIGOROUS SELECTION IS MANDATORY IN SOCIAL AND GENETIC ENGINEERING. INCORRECT MERCIFUL IMPULSES POSTPONE THE CLEANSING THAT PRECEDES REFORM. SHORT-TERM NICETIES MUST YIELD TO LONG-RANGE NECESSITY. MORALS WILL BE REVISED TO MEET THE REQUIREMENTS OF TODAY. MEANINGLESS PLATITUDES WILL BE PULLED FROM TONGUES AND MINDS. WORDS LIKE "PURGE" AND "EUTHANASIA" DESERVE NEW CONNOTATIONS. THEY SHOULD BE RECOGNIZED AS THE RATIONAL PUBLIC POLICIES THEY ARE. THE GREATEST DANGER IS NOT EXCESSIVE ZEAL BUT UNDUE HESITATION. WE WILL LEARN TO IMITATE NATURE. HER KILLS NOURISH STRONG LIFE. SQUEAMISHNESS IS THE CRIME.

ONE
MEN,
ATIVE,
WILLS
H
H

FUL.
RE

WITH
VES.

ES
ATES

CT
UTE
NG

IT'S MOSTLY LOVE THAT MAKES YOU LOOK AT FINE ANKLES AND THEN BREAK THEM. THE ANKLE IS WHERE THE MOVING POWER OF THE LEG TAPERS TO AN EXQUISITE STEM OF BONE. SADLY, THE FOOT COMES NEXT, ANCHORING WONDERFUL CREATURES TO THE DIRT. DEER, WADING BIRDS AND THE BEST PEOPLE HAVE FINE ANKLES. IT'S GOOD TO CRACK THEIR SUPPORTS SO THEY'LL FALL DOWN IN AS LOVELY CURL. THEN YOU'LL CARE FOR THEM SO THEY WILL BE FREE OF ALL CRASSNESS AND STRUGGLE. YOU'LL WATCH THE SHATTERED ANKLES HEAL AND MEANWHILE, THE CREATURES LIVE IN A STATE OF GRACE AND SUSPENDED ANIMATION.

SHRIEK WHEN THE PAIN HITS DURING INTERROGATION. REACH INTO THE DARK AGES TO FIND A SOUND THAT IS LIQUID HORROR, A SOUND OF THE BRINK WHERE MAN STOPS AND THE BEAST AND NAMELESS CRUEL FORCES BEGIN. SCREAM WHEN YOUR LIFE IS THREATENED. FORM A NOISE SO TRUE THAT YOUR TORMENTOR RECOGNIZES IT AS A VOICE THAT LIVES IN HIS OWN THROAT. THE TRUE SOUND TELLS HIM THAT HE CUTS HIS FLESH WHEN HE CUTS YOURS, THAT HE CANNOT THRIVE AFTER HE TORTURES YOU. SCREAM THAT HE DESTROYS ALL KINDNESS IN YOU AND BLACKENS EVERY VISION YOU COULD HAVE SHOWN HIM.

A CRUEL BUT ANCIENT LAW DEMANDS AN EYE FOR AN EYE. MURDER MUST BE ANSWERED BY EXECUTION. ONLY GOD HAS THE RIGHT TO TAKE A LIFE AND WHEN SOMEONE BREAKS THIS LAW HE WILL BE PUNISHED. JUSTICE MUST COME SWIFTLY. IT DOESN'T HELP ANYONE TO STALL. THE VICTIM'S FAMILY CRIES OUT FOR SATISFACTION, THE COMMUNITY BEGS FOR PROTECTION AND THE DEPARTED CRAVES VENGEANCE SO HE CAN REST. THE KILLER KNEW IN ADVANCE THERE WAS NO EXCUSE FOR HIS ACT, TRULY HE HAS TAKEN HIS OWN LIFE. HE, NOT SOCIETY, IS RESPONSIBLE FOR HIS FATE. HE ALONE STANDS GUILTY AND DAMNED.

FREEDOM IS IT! YOU'RE SO SCARED, YOU WANT TO LOCK UP EVERYBODY. ARE THEY MAD DOGS? ARE THEY OUT TO KILL? MAYBE YES. IS LAW, IS ORDER THE SOLUTION? DEFINITELY NO. WHAT CAUSED THIS SITUATION? LACK OF FREEDOM. WHAT HAPPENS NOW? LET PEOPLE FULFILL THEIR NEEDS. IS FREEDOM CONSTRUCTIVE OR IS IT DESTRUCTIVE? THE ANSWER IS OBVIOUS. FREE PEOPLE ARE GOOD, PRODUCTIVE PEOPLE. IS LIBERATION DANGEROUS? ONLY WHEN OVERDUE. PEOPLE AREN'T BORN RABID OR BERSERK. WHEN YOU PUNISH AND SHAME YOU CAUSE WHAT YOU DREAD. WHAT TO DO? LET IT EXPLODE. RUN WITH IT. DON'T CONTROL OR MANIPULATE. MAKE AMENDS.

DISASTER DRAWS PEOPLE LIKE FLIES. SPECTATORS GET CHILLS BY IDENTIFYING WITH THE VICTIMS, FEELING IMMUNE ALL THE WHILE! THIS IS A PARTICULARLY UNATTRACTIVE FORM OF VOYEURISM. THE DETACHED AND ALIENATED DWELL ON DISASTER; THEY RECEIVE THEIR QUOTA OF STIMULATION THIS WAY. THEY AREN'T SYMPATHETIC, JUST BORED. THEY ANALYZE THE LATEST MASS MURDER, THEY'RE MAUDLIN OVER STARVING BABIES, THEY FIND IMAGES OF TERROR AND REVOLUTION COMPELLING. THEY ADORE PATHOS. THEY CONGRATULATE THEMSELVES ON THEIR AWARENESS AND THEIR STRONG STOMACHS. A LITTLE REALITY THERAPY WOULD PUT THESE DILETTANTES TO FLIGHT. ALL THE "PITIFUL" AND "ENGAGING" PHENOMENA ARE NOT SUPPOSED TO COME HOME.

DON'T TALK DOWN TO ME. DON'T
BE POLITE TO ME. DON'T
TRY TO MAKE ME FEEL NICE.
DON'T RELAX. I'LL CUT THE
SMILE OFF YOUR FACE. YOU
THINK I DON'T KNOW WHAT'S
GOING ON. YOU THINK I'M
AFRAID TO REACT. THE JOKE'S
ON YOU. I'M BIDING MY TIME,
LOOKING FOR THE SPOT. YOU
THINK NO ONE CAN REACH YOU,
NO ONE CAN HAVE WHAT YOU
HAVE. I'VE BEEN PLANNING
WHILE YOU'RE PLAYING. I'VE
BEEN SAVING WHILE YOU'RE
SPENDING. THE GAME IS
ALMOST OVER SO IT'S
TIME YOU ACKNOWLEDGE ME.
DO YOU WANT TO FALL NOT
EVER KNOWING WHO TOOK YOU?

BECAUSE THERE IS NO GOD SOMEONE
MUST TAKE RESPONSIBILITY FOR MEN.
A CHARISMATIC LEADER IS IMPERATIVE.
HE CAN SUBORDINATE THE SMALL WILLS
TO THE GREAT ONE. HIS STRENGTH
AND HIS VISION REDEEM MEN. HIS
PERFECTION MAKES THEM GRATEFUL.
LIFE ITSELF IS NOT SACRED, THERE
IS NO DIGNITY IN THE FLESH.
UNDIRECTED MEN ARE CONTENT WITH
RANDOM, SQUALID, POINTLESS LIVES.
THE LEADER GIVES DIRECTION
AND PURPOSE. THE LEADER FORCES
GREAT ACCOMPLISHMENTS, MANDATES
PEACE AND REPELS OUTSIDE
AGGRESSORS. HE IS THE ARCHITECT
OF DESTINY. HE DEMANDS ABSOLUTE
LOYALTY. HE MERITS UNQUESTIONING
DEVOTION. HE ASKS THE SUPREME
SACRIFICE. HE IS THE ONLY HOPE.

CHANGE IS THE BASIS OF ALL HISTORY,
THE PROOF OF VIGOR. THE OLD IS
SOILED AND DISGUSTING BY NATURE.
STALE FOOD IS REPELLENT, MONOGAMOUS
LOVE BREEDS CONTEMPT, SENILITY
CRIPPLES THE GOVERNMENT THAT IS
TOO POWERFUL TOO LONG. UPHEAVAL
IS DESIRABLE BECAUSE FRESH, UNTAINTED
GROUPS SEIZE OPPORTUNITY. VIOLENT
OVERTHROW IS APPROPRIATE WHEN THE
SITUATION IS INTOLERABLE. SLOW
MODIFICATION CAN BE EFFECTIVE;
MEN CHANGE BEFORE THEY NOTICE
AND RESIST. THE DECADENT AND
THE POWERFUL CHAMPION CONTINUITY.
"NOTHING ESSENTIAL CHANGES." THAT
IS A MYTH. IT WILL BE REFUTED.
THE NECESSARY BIRTH CONVULSIONS
WILL BE TRIGGERED. ACTION WILL
BRING THE EVIDENCE TO YOUR DOORSTEP.

JENNY HOLZER

From *Inflammatory Essays*, 1979–82

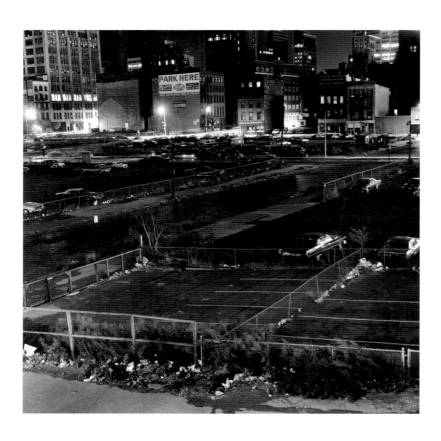

PETER HUJAR

West Side Parking Lots, NYC, 1976
Two Queens in a Car, Halloween, 1977

Opposite
Candy Darling on Her Deathbed, 1974

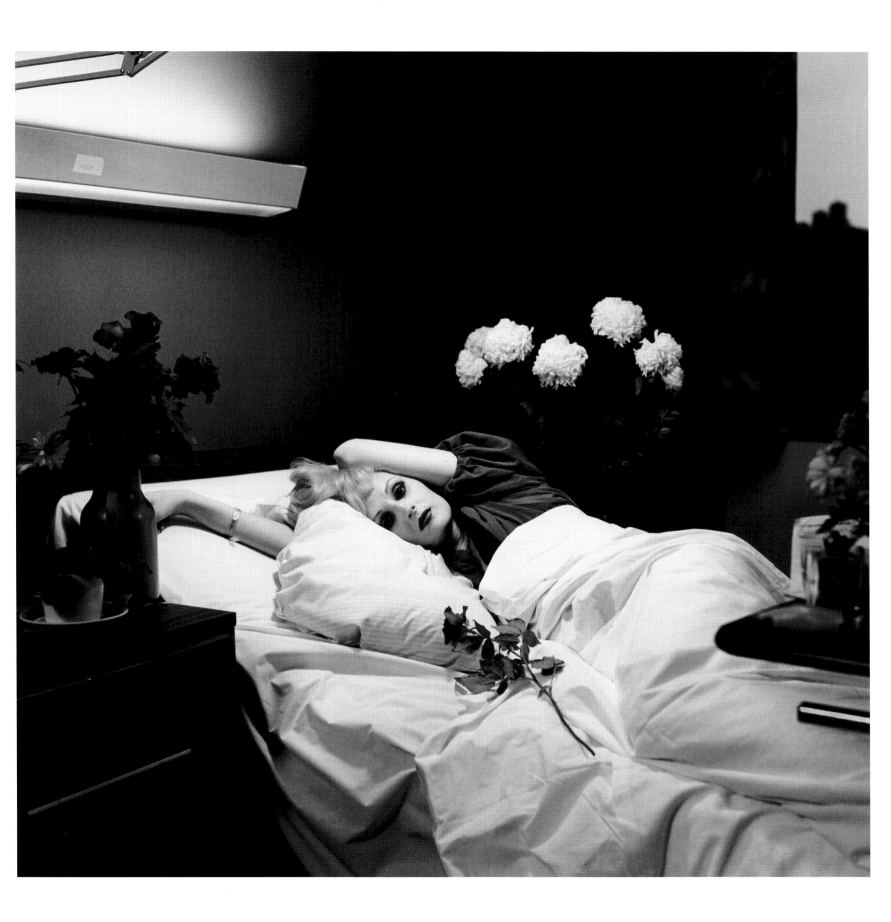

PETER HUJAR

Woolworth Building, 1976

Halloween DOA, 1980

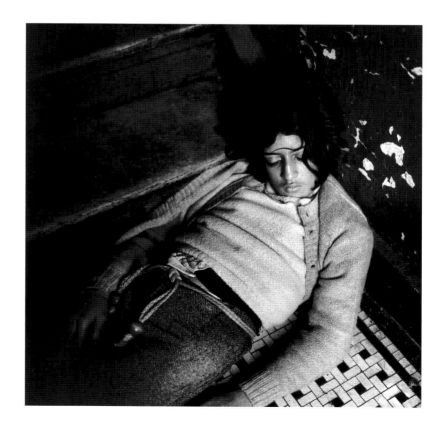

PETER HUJAR

Cindy Lubar as Queen Victoria, 1974
Girl in My Hallway, 1976

POST-CONCEPTUAL PHOTOGRAPHY AND STRATEGIES OF DISSENT

DAVID BUSSEL

No art activity is to be understood apart from the codes and practices of the society which contains it; art in *use* is bracketed ineluctably within ideology.[1]

These words were written by the British artist, theorist and lecturer Victor Burgin in an essay for *Art-Language* magazine in 1972. 'In Reply' was a critical response to and an ideological break with the set of Anglo-American practices known as Conceptual art,[2] the strategies of which were especially promoted by the group Art & Language.

The set of practices that define Conceptualism posit art as an analytic proposition: a self-reflexive linguistic inquiry into the category of art itself. This position was ostensibly seen as a repudiation of the late Modernist paradigm, famously espoused by the influential American critic Clement Greenberg, that the art object should relate only to itself, be autonomous, as exemplified by the American painterly abstraction of the 1950s. Conceptual art also promoted what another American critic, Lucy Lippard, called the 'dematerialization' of the object, a theory reflecting a distrust of the visual and the illusionistic that had been embodied in much of Modernist theory and practice. Conceptual art was also a kind of response to the practices of Minimalism, with which it overlaps, the two arguably representing the death knell of Modernism altogether.

Around the time of Burgin's essay, photography as a medium began to be explored in the light of Conceptualism, to be 'used' as something more than just a supposedly neutral form of documentation, as it had been previously used in many different ways. Such artists as Martha Rosler, Stephen Willats, David Lamelas and Burgin sought to expand photographic practice into more politicized, socially engaged arenas. This no doubt was also in reaction to such conflicts as the Vietnam War, the student protests of May 1968 and the radical women's rights and civil rights movements. By the mid-1970s the global economic recession had ushered in a period of acute social privation, fomenting class and racial antagonism, creating urban blight and provoking the cultural manifestation that was punk. Although short-lived, it is arguable that punk, with its harsh, nihilistic, anti-establishment ethos, was not only a cultural symptom of its time, but was also a means of introducing a different kind of culture of dissent into mainstream society, however cynical or manufactured that ethos originally was.

With punk emerged the discourse and practices around Postmodernism, a movement first espoused by architects and visual artists, then embraced by mass culture and underwritten by the forces of the insurgent, newly aggressive, market-based economy. Against this backdrop such artists as Cindy Sherman and Barbara Kruger not only took popular culture as their subject matter but also employed its own operations and strategies to pick apart its very structure, creating a critique of the representation of gender relations.

Martha Rosler, artist, writer and lecturer, has always been committed to a socially engaged art practice, as is demonstrated by her early involvement in political activism in the 1960s, and evinced by such works as *Bringing the War Home* (1967–72), a series of photomontages that combine explicit images from the Vietnam War with images from magazines on interior decorating, recalling the formidably agitprop work of John Heartfield in the 1930s. With an eye on such documentary photographers as Walker Evans and his work for the Farm Security Administration in the 1930s and 1940s, photographer Robert Frank, film-maker Jean-Luc Godard and playwright and poet Bertolt Brecht, Rosler has always pursued a kind of 'historical archaeology'[3] through an interrogation of the complex social realities that buttress society.

The Bowery in two inadequate descriptive systems (1974–75; pp. 154–55) is a twenty-four-panel photo-text work that pairs images of shop fronts and street detritus from New York's skid row, the Bowery, with lists of words or expressions for inebriety: drinking, drunkenness and drunks. Here the 'inadequacy' is for words

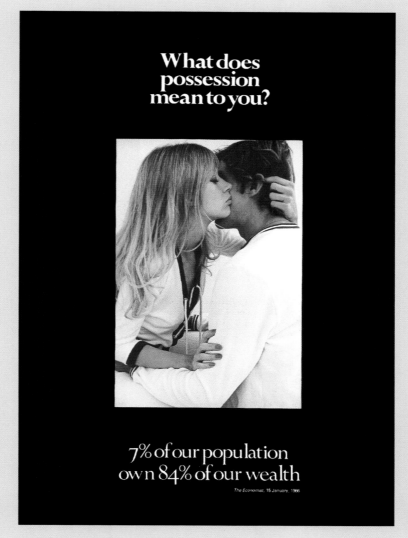

What does possession mean to you?

7% of our population own 84% of our wealth

The Economist, 15 January, 1966

Victor Burgin
Possession, 1976

(lush, wino, rubbydub, pickled, potted, stewed, etc.) and images to speak about, much less empower, the social reality of the dispossessed. This work addresses an earlier tradition of American social documentary and vernacular photography, in an effort to pick apart the 'transparency' of its ideology and the mythologizing gaze of the photographer. Rosler is fundamentally against the kind of socially minded, humanist documentary practice that morally 'aestheticizes' the poor and the disenfranchised. The work criticizes the position of this type of photography, where people are seen as 'victims' and photographers as our 'social conscience', while the photographs themselves promote notions of 'interiority, subjectivity and authenticity'.[4] Without narrative or people, *The Bowery*, in its non-complicit form of address, discloses urban space as a product of [the] social system' that engenders it.[5] In presentation, the work looks to Conceptual and Minimalist strategies in its anti-aesthetic, grid-like and serial formation, but it stops there, becoming a structural critique of representational systems altogether, proposing a counter-model of socially informed practice.

One could assign a similar position to Burgin, who describes his practice in the 1970s as 'working through' Marxism and semiotics to psychoanalysis and feminism in an effort to interrogate what he calls the 'ideological construction of the individual subject of the

social process'.[6] And like Rosler, Burgin employs a black-and-white image-text format to pick apart the relationship *between* image and text and the rhetorical operations they rehearse. It is a critique of the 'instability' of meaning itself. The site of Burgin's work lies, then, in the relationship between the 'reader' (viewer) and the 'text' (the work), and not in the 'text' itself, where the viewer, medium and context are always already framed or mirrored from within.

UK76 (1976; pp. 24–26) and *US77* (1977; pp. 27–29) are multipanel works that examine the division of labour (in the former) and the division of gender (in the latter). Regarding *US77*, Burgin has noted that the 'construction of sexual difference in representation becomes the issue. Why? Because patriarchal power relations, and the "masculine" identity which supports them, are now seen as the problem.'[7] In 1976 the artist was asked to photograph ordinary people for the National Community Development Project, and the Coventry

Workshop from which the images came resulted in *UK76*: images of a woman looking at a magazine, a supermarket checkout, people in the street, a stately home, a car factory. When asked if he thought that the original project was effective, Burgin described it as 'politically irrelevant',[8] asserting that it is only within the institution that 'art might be able to create an alternative space of reflection on the mainstream media practices given [their] cultural dominance'.[9] In both *UK76* and *US77* we are confronted by national 'road movies' examining the social fabric of their respective locales through a jarring collision between a critical text and an associated image – in the collision, creating a kind of discordant relay between them.

Since the late 1960s, Stephen Willats has been involved with various communities who collaborate with him on his work as an artist and as publisher of *Control* magazine. Willats's project examines the relationships between individuals and groups and between groups and

society, and the way these relationships create 'subjects'. In fact, one could call the artist a sociologist or human ecologist of sorts on account of his implementation of systems theory, cognitive behaviour and cybernetics, and his interest in the roles we inhabit, and are made to inhabit, in society, and in how these roles could be improved through collective agency towards social change. According to the artist, this kind of self-fashioning by an individual or group engenders a sense of counter-consciousness that irrevocably affects the social system itself.

I Don't Want to Be Like Anyone Else (1976; pp. 178–79) is a multipanel photo-text work that analyses the plight of a young woman as an individual, potential partner, consumer, labourer and political subject. The panels are organized like vertical flow charts, imaging the anonymous female subject in a variety of locales – at home, at work or on the street. The female's thoughts are placed as captions or in boxes connected by lines, and critical interpolations by the artist organize our reading, creating a portrait of an individual questioning the conditions under which she lives.

David Lamelas could be called an international artist, having lived in both Europe and the United States since leaving his native Argentina in the early 1960s. Lamelas's central artistic concern is the relationship between time and place and the imposition of narrative structures that engender self-reflection and analysis on the conditions of the work's own making. His work is a critique of the means of production, presentation and (art) context through the employment of photography, film and video. Since developing an early interest in Expanded Cinema (the incorporation of video, new media, installation or sculpture into an 'expanded' film-making practice or 'consciousness'), Lamelas has consistently questioned the role of narrative and fiction, encouraging an understanding of how we receive information and the technologies that filter it in our image-saturated culture.

The Violent Tapes of 1975 (1975; pp. 84–87), a ten-part black-and-white 'ciné-roman', is paradigmatic in that it perfectly delineates all of Lamelas's concerns. In a series of vignettes that are reminiscent of a TV police drama, a man and a woman in possession of videotapes are chased through an unknown city by an anonymous man in desperate pursuit of the tapes. The narrative is based on a proposal for a screenplay set in the future, in which a non-violent social order is implemented after a nuclear war. The tapes represent a vital unknown – violence – as information and, in the actual chase, a potential threat. But the question of who is being threatened – the couple, the man chasing them or society – is left unanswered. With this work, Lamelas entreats us to ask: who is the oppressor and who is the liberator? And on what side does moral agency lie?

Until the late 1970s, if not the 1980s, art photography was considered to belong to an almost separate sphere from the visual arts, under-historicized and under-theorized, as well as marginalized by the art market. However, in the autumn of 1977 a significant exhibition opened at New York's Artists Space. Entitled *Pictures* and curated by the critic Douglas Crimp, it included the artists Troy Brauntuch, Jack Goldstein, Sherrie Levine, Robert Longo and Philip Smith. Although they were not included in the show, such well-established artists as Barbara Kruger, Louise Lawler, Richard Prince and Cindy Sherman are today known as members of the 'Pictures Generation'. Following Walter Benjamin's dictum that the singular 'aura' of the photographic image is forever lost under reproductive technology, and Roland Barthes's notion that the reader/viewer of a text, rather than the author/artist, is the bearer or place of meaning, the artists in the exhibition brought to the fore a shift in the terms of artistic practice, from 'production to reproduction'.[10] That is to say, an image or art object is only ever a 'picture', an inter-text without a unique author or signature, a 'copy without an original'.

Cindy Sherman is known for her self-portraits in which she depicts herself against various backgrounds in various guises as a culturally recognizable type or stock character. In her photographs, then, she not only 'stages' a picture but herself as well. In essence, she stages

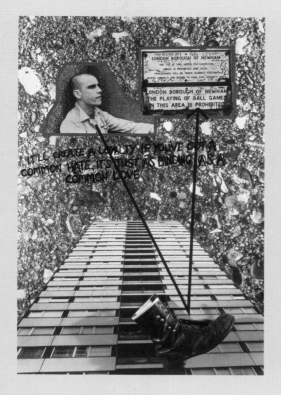
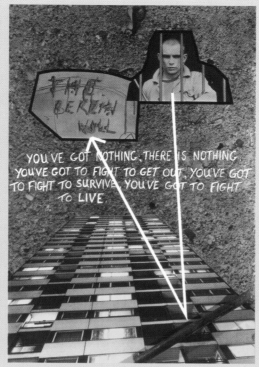

STEPHEN WILLATS
Every Day and Every Night, 1984

the very act of representation by conflating an image's potential for narrative with the fantasy of our identification with it as a kind of collective effect of self-fashioning in our media-saturated society. This is most evident in the black-and-white series *Untitled Film Stills* (1977–80; pp. 156–61), in which the artist photographs herself as various figures from Hollywood films that invoke a 'narrative ambience'. Despite its demonstrative traces, however, that narrative is never realized, but is left uncontained. The pictures are only ever simulacra: staged film stills without a film. They are a fragment of time and space 'whose existence never exceeds the fragment'.[11] But as they are called 'film stills', suggesting something outside the narrative, they are located outside the film as a visual supplement, and function by the logic of the production still, a tool of the film industry's marketing apparatus. Sherman's photographs are also cognizant of the prescribed gender relations these characters inhabit and, by extension, of the ways they are assigned and polarized in classic Hollywood cinema and of our ideological complicity in mirroring their construction.

Barbara Kruger's photomontages take this same strategy as their starting point. Like Rosler, Kruger has inherited from Conceptualism a focus on language and its relationship to images. In her poster and billboard-like pictures, she hijacks the codes of mass media and with them,

the social constructions of gender in order to denature them structurally through their re-presentation. In such works as *Untitled (I am your almost nothing)* (1982; p. 81) and *Untitled (Your comfort is my silence)* (1982; p. 83), the mode of address – the relationship between the 'I' and the 'You' – attempts to unmoor (institutionalized) positions of male and female binarisms that subtend male cultural supremacy in representation: men as the agent of discourse and knowledge, and women as the object. And as representation is usually defined by and through language, Kruger's appropriated black-and-white stock images provide the ideal template for these operations. Here the gendered non-parity of language is made manifest by the enunciatory function of the image-text 'relay', where the accusatory mode of address explicitly acts as both the work's structure and its strategy, in that gap between the two.

These artists broke away from the imperatives of Conceptual and Minimalist art to claim a new ground – the politics of representation – through the redefinition of photography and its potential 'uses' for socially engaged, critical intervention. This intervention, like Victor Burgin's reply above, shifted the terrain of activity for many artists from an 'aesthetics of administration' to aesthetic politics as part of a larger shift in the very terms of cultural production itself within the Postmodern condition.

Notes

1. Quoted in V. Burgin, 'Yes, Difference Again: What History Plays the First Time Around as Tragedy, It Repeats as Farce', in *Conceptual Art: A Critical Anthology*, ed. A. Alberro and B. Stimson, Cambridge, Mass. (MIT Press) 1999, p. 429; emphasis in original.
2. Conceptual art was (and still is) a highly contested set of theories and practices, and the time frame (1966–72) and locality of its manifestation are equally debatable. This essay focuses exclusively on British and American post-Conceptual practices from 1974 to 1982. See L. Lippard, *Six Years: The Dematerialization of the Art Object from 1966 to 1972*, Berkeley (University of California Press) 1997 [originally published 1973]; Alberro and Stimson, *Conceptual Art*, *op. cit.*; and *Global Conceptualism: Points of Origin, 1950s–1980s*, exhib. cat. by L. Beke *et al.*, New York, Queens Museum of Art, 1999.
3. B. Buchloh, 'A Conversation with Martha Rosler', in *Martha Rosler: Positions in the Life World*, exhib. cat., ed. C. de Zegher, Birmingham, Ikon Gallery; Vienna, Generali Foundation, 1998, p. 39.
4. *Ibid.*
5. *Ibid.*, p. 51.
6. Burgin, *op. cit.*, p. 429.
7. *Between*, exhib. cat. by V. Burgin, London, Institute of Contemporary Arts, 1986, p. 40.
8. *Ibid.*, p. 39.
9. Quoted in J. Roberts (ed.), *The Impossible Document: Photography and Conceptual Art in Britain, 1966–1976*, London (Camerawork) 1997, p. 91.
10. A. Solomon-Godeau, 'Photography After Art Photography', in *Art After Modernism: Rethinking Representation*, ed. B. Wallis, New York (New Museum of Contemporary Art); Boston (D.R. Godine) 1984, p. 75.
11. D. Crimp, 'Pictures', in *Art After Modernism*, *op. cit.*, p. 181.

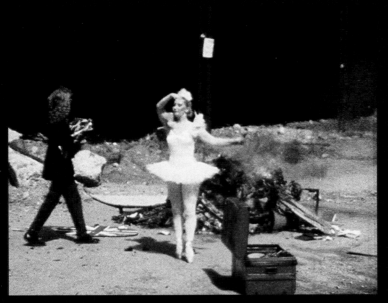
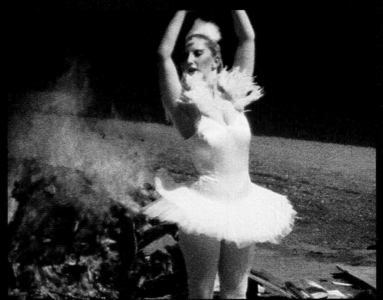

DEREK JARMAN

Jordan's Dance, 1977

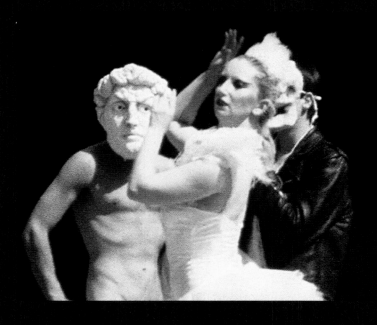

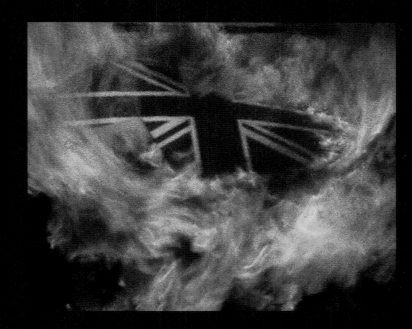

MIKE KELLEY

The Poltergeist, 1979

Overleaf
The Poltergeist (details), 1979

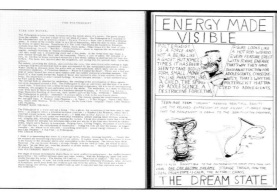
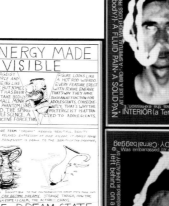
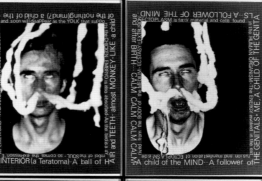
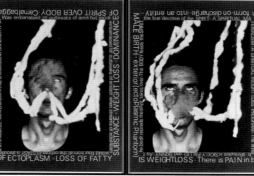
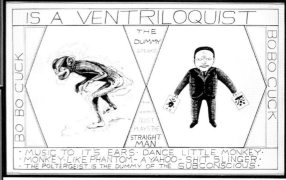

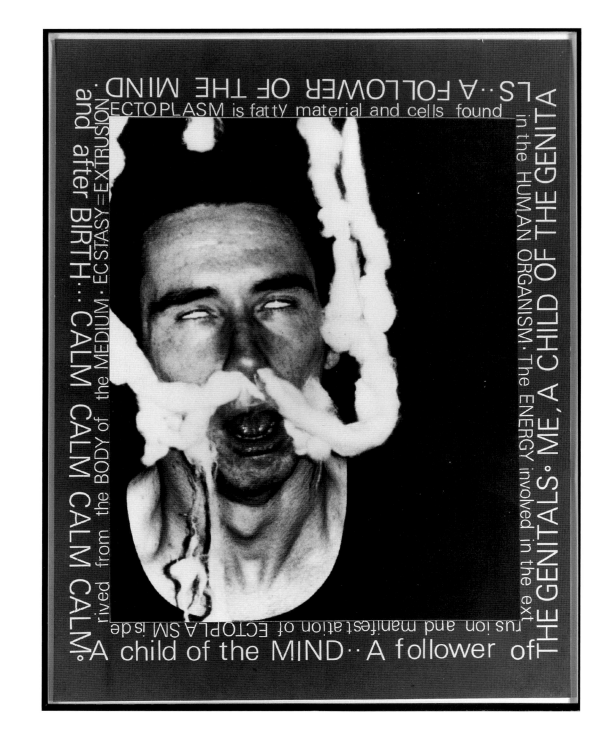

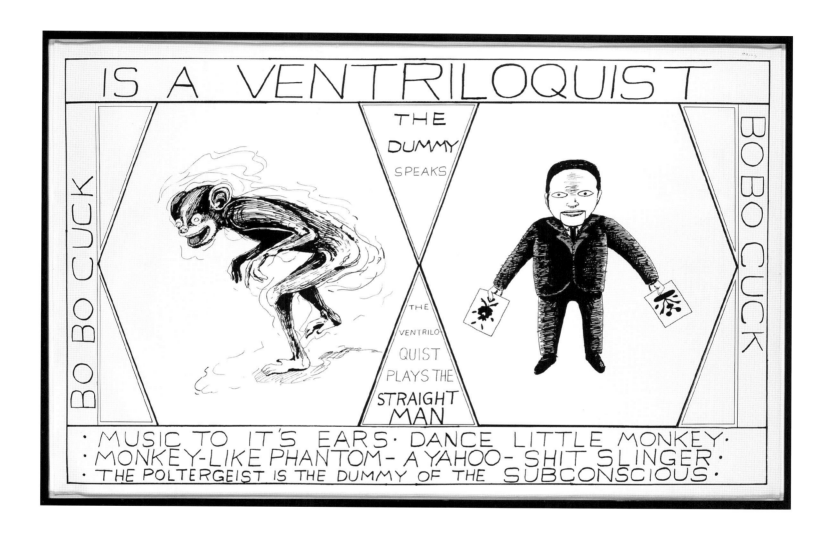

Barbara Kruger

Untitled (I am your almost nothing), 1982

I am your almost nothing

Barbara Kruger

Untitled (Your comfort is my silence), 1982

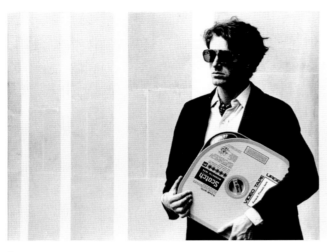

1

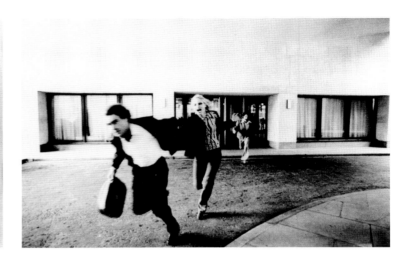

2

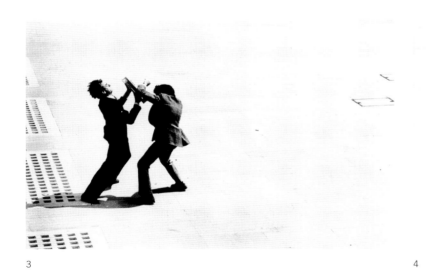

3

4

DAVID LAMELAS

The Violent Tapes of 1975, 1975

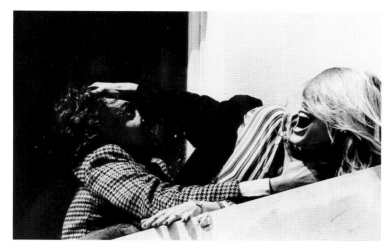

5

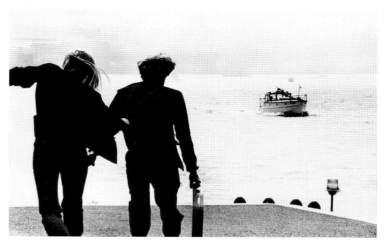

7

8

9

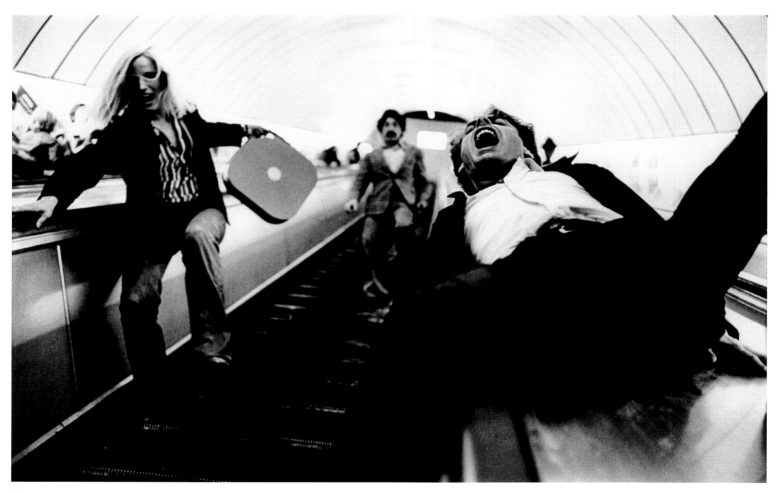

6

DAVID LAMELAS

The Violent Tapes of 1975, 1975

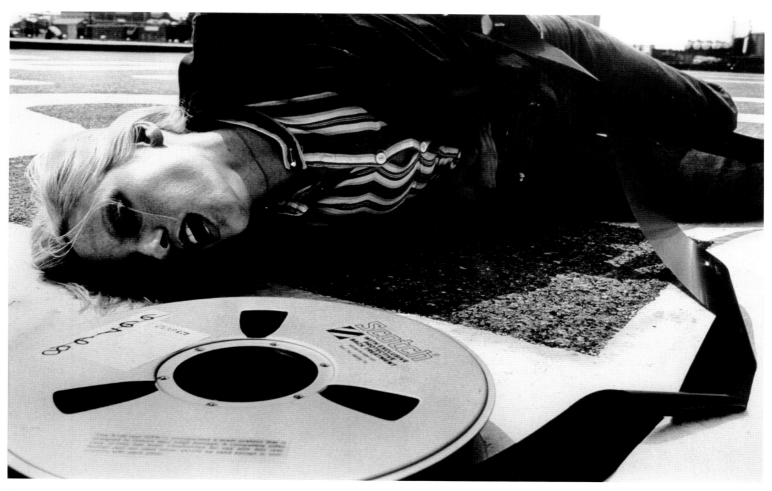

10

LINDER

Jordan, 1977

Wash. Blot. Shake. What could be easier! All it takes
on holiday is six or seven minutes a day – with a sho
You don't need to pack a dryer. You don't need curlers
brush. No problem if it rains.

Just think in advance, or take a bit of expert advice if
body. Natural henna helps, so do perms, and there are
available at Vidal Sassoon salons. The first one, calle
perm, is probably the answer for hopelessly flyaway h
sections are rolled on small rods, going right around t
the sections in between are rolled on big rods, and ea
above two small ones – hence the piggy-back name. Th
extremely light, giving all the body and bounce you want
"Weaving" the perm in is another way of adding bo

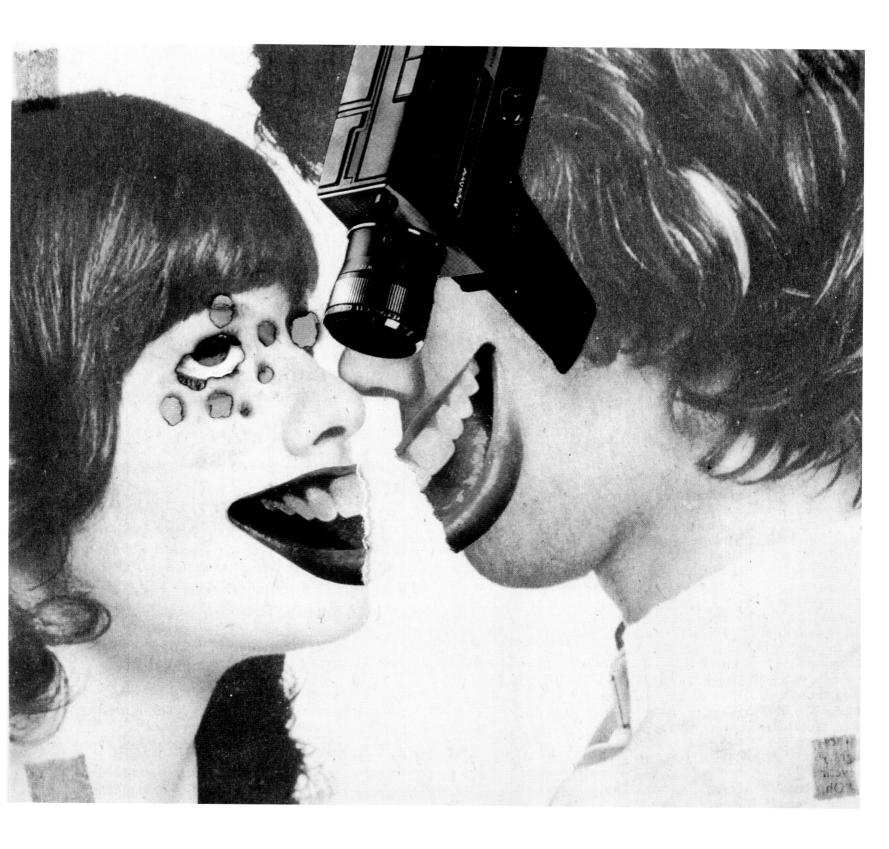

LINDER

Opposite
Red Dress XIII, 1979

Untitled, 1977

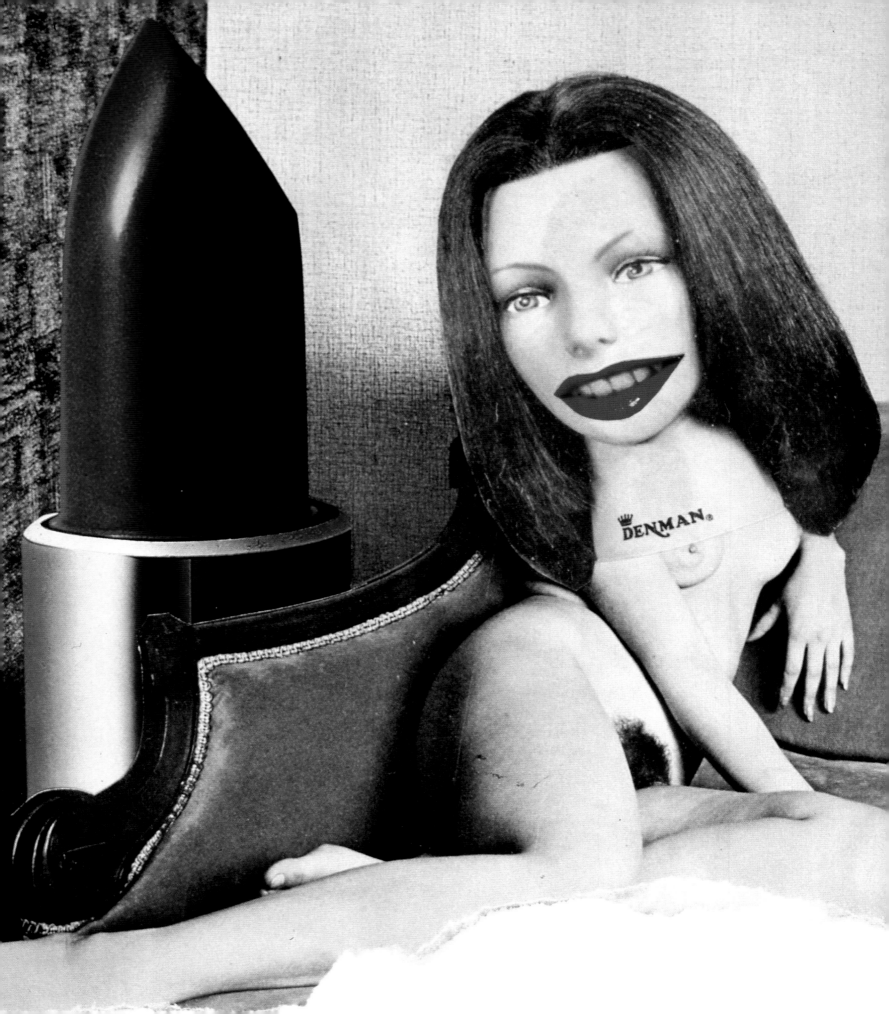

LINDER

Untitled, 1977

Out of Bounds: Cultural Synaesthesia and Art in Unexpected Places

Carlo McCormick

Things are more like today than they have ever been.

Gerald R. Ford, US President, 1974–77

Memories, may be beautiful and yet
What's too painful to remember
We simply choose to forget.

Barbra Streisand, 'The Way We Were', *Billboard* number one, 1974

All cultural phenomena leave evidence that remains just a bit too messy or is perhaps even irrelevant to the formal needs of history. The way we read art, it would seem, is a particularly reductive process, especially as it passes through the eye of the needle through generations as a relatively malleable, yet continuously ossifying, pantheon of consensus value. Aspects of the creative process that were at their outset regarded with some urgency drift off into the margins. Such stuff as the muses and madmen, the predominant modes of intoxication, sexual proclivities or any number of social factors that bear down on a definitive cultural moment are inherently suspect; they are suitable for other histories perhaps, but rather too gossipy or footnote-marginal at best.

It may seem beside the point to consider how punk rock influenced the studio practice of a generation of fine artists who could not help but have heard the music and in some way measured their own response to its energy, but for anyone who actually experienced punk at the time of its subcultural impact, its force – if not always clearly evident – was nonetheless inescapable. There is a direct link between the visual arts and the social practices of youth at that time that encompasses much more than what the bands were doing. It is seen in an indivisibility of experimental and underground film, graphic art (most prominently registered in record covers, zines and badges), fashion and street styles, performance, and guerrilla politics in which the look, attitude or consciousness of what was being expressed were freely and fluidly incorporated into contemporary art. The inevitable similarities between media are not purely appropriative, accidental or coincidental, but are symbiotically connected within the social fabric of very particular communities. Although it may later be experienced as a product in the white cube of a gallery or as an artifact in the institutional shrine of a museum, art is not made in silence. Artists live and work to a soundtrack, and just as you can see the influence of jazz on Abstract Expressionism or transcribe such terms as Minimalism and psychedelia across media, you can hear punk rock in many pictures of that era.

If we take London and New York City as the two epicentres around which the first wave of punk rock germinated, the confluence of art and music at work in this socio-aesthetic hybrid has an almost practical explanation. In Britain the institutional structure of higher education in the post-war period set into place art schools as a kind of catch-all for youths who in other, more significant, ways had their career options limited by class. At once open to individuals who were talented and not without ambition, and relatively relaxed towards the academic requirements that would keep many out of university, art schools let loose the modes of questioning and interventionist strategies that had long been the less populist province of the avant garde upon a student body that might never have otherwise been exposed to such tools. Those kids, we must also surmise in the context of the immense social and economic upheavals of the time, would already have been prone to disaffection, alienation and even confrontation

The dustmen's strike, Leicester Square, London, February 1979

towards the status quo. As Simon Frith and Howard Horne point out in their curious study of these phenomena, *Art into Pop*, the situation that in the 1960s produced such art students as John Lennon, Pete Townsend and Eric Clapton and such school bands as Pink Floyd, would by the 1970s create 'the ultimate art school music movement', punk rock.[1]

In contrast to the way the music scene in Britain was flooded with art-school graduates, downtown New York, as the germinal wasteland from which punk was first spawned, was a scene where any efforts towards popular culture were inherently art-damaged because of the high concentration of artists who naturally flocked to the city, the reigning capital of contemporary art. While one could do a similar cross-referencing of art-school backgrounds for the bands of the New York scene, much more vital was the confluence created around particular venues where visual artists, musicians, performance artists and other new genres, such as video, literally shared the same space and creatively collided. Before one can even measure the ultimate effect that nightlife would have on a young generation all living in the very close proximity of downtown Manhattan, and all that fluidity would involve in terms of cross-pollination between different practices, one must consider the remarkable historical significance of one long-forgotten venue, the Mercer Art Center.

Opened in 1970 as a sprawl of boutiques, theatres and performance-art venues occupying former banqueting suites and ballrooms of the once pre-eminent Broadway Central Hotel, the Mercer Art Center was a practical alternative for bands that could not easily get bookings at Max's Kansas City (such as the proto-punk glam-era outfit the New York Dolls, who kept a Tuesday-night residency in the Oscar Wilde Room) and the first home of the Kitchen (so named on account of its quarters in the hotel), the gallery whose programming of video and performance art would provide a vital launching point for Vito Acconci, Laurie Anderson, Philip Glass and Nam June Paik, among other artists. When the hotel suddenly collapsed in August 1973 (reportedly while future Blondie guitarist and songwriter Chris Stein's old band the Magic Tramps were rehearsing), it not only caused the relocation of an off-Broadway play called *One Flew Over the Cuckoo's Nest* and the Kitchen Center for the Performing Arts, but it also impelled a number of unsigned young bands to inhabit a newly opened country-music bar called CBGB on nearby Bowery.

If we want to consider the commonality that art would share with music by the mid-1970s, we must acknowledge both the monumental youth-quake of the 1960s and the dismal ennui of the early 1970s. It is easy for chroniclers to gloss over how boring culture was at that time by looking at New York and invoking the legend of Max's Kansas City, where Andy Warhol held Factory-freak court, a pantheon of now immortal artists traded art for food, and such local bands as the Velvet Underground found their small following. But the Velvets broke up in 1970, and much as a less threatening MOR virtuoso mindset

overtook corporate rock, so the relative openness of the avant-garde experimentation of the 1960s was reduced to the more formalist orthodoxy of Minimalism. Come 1974, then, art was occupied with the thoroughly Postmodern project of rescuing from the recent past an urgency of youth that was all but absent from the contemporary scene, be it the return to painting and figuration, both only recently declared dead, or to rock's former three-chord ferocity.

Relating the punk music of London around 1975–76 to a longer lineage of cultural negations, most notably Situationism and the student protests of 1968, cultural critic Greil Marcus's revisionist history *Lipstick Traces* argues that there is a common desire that 'begins with the demand to live not as an object but as a subject of history'.[2] Primarily concerned with British punk, this notion of a highly politicized anger may fit better with the rhetoric of Malcolm McLaren or the Clash than with the New York bands. However, as a redress for the way we have come to treat the overt nihilisms of that time as shorthand for a kind of post-1960s counter-revolutionary apathy, we should think of the work here as social (rather than political), for it helps to articulate the kind of absence that was carved out of chaos, be it Richard Hell and the Voidoids' anthemic declaration 'I'm a member of the Blank Generation', Gordon Matta-Clark's cutting-away of a disused pier to create *Day's End* (1975; pp. 114–15), or the slippage between language and image in Martha Rosler's document of the Bowery at the nadir of its flophouse era (see pp. 154–55). At once highly expressive and stripped down to the barest essentials, the surface and effect in New York aesthetics created a mesmeric din that was as much about the primacy of experience as it was about the abandonment of the city itself. Somewhere in the less-than-two-minute brevity of a frenetic Ramones song and the amping-up of anti-ornate austerity by the likes of Suicide or Glenn Branca, you could suspend the free fall of Robert Longo's *Men in the Cities* (1978–82; pp. 102–103), fill in the lost contexts of Richard Prince's re-photography or animate the dramatic pause of Cindy Sherman's *Untitled Film Stills* (1977–80; pp. 156–61).

Perhaps more than any other recent moment in youth culture, the mid-1970s bore witness not to the typical condition of suburban boredom but to a direct expression of a fully urban topography. More than simply providing the setting for a site-specific art, the city itself took on a pre-eminent role as a star in the kinds of narratives that artists began to create as a way of navigating its particularly rough character. Curiously, in the exceptionally strong Super-8 underground film scenes that would thrive in the 1970s and 1980s, the harsh realities of place would be resolved through noir as a bohemian romanticism. Certainly, Derek Jarman's deeply personalized poetics of devastation and decay would have a profound influence on the punk pictorialism of Britain; or we might say simply that the inclusion of Adam and the Ants in his film *Jubilee* (1978) must be held at least partly responsible for the subsequent rise of New Romanticism. Sadly, considering how central to the scene in New York were such

film-makers as Amos Poe, James Nares, Eric Mitchell and Scott and Beth B, few today can grasp the effect that New Cinema and No Wave film had on defining a new kind of disjunctive storytelling that would perhaps best sum up the Postmodernist tendencies of the age. Lacking the full picture that is now dearly needed, one has to imagine this collapsed narrative space as somewhere between the musical extended family slide show of Nan Goldin's *The Ballad of Sexual Dependency* and the deadpan fade-outs of Jim Jarmusch's first features.

One is habitually laden with certain adjectives in describing punk. Presuming that we can use the same formal language to articulate the composition of such anarchic energy as punk as we would to describe what today appears in the framework of a museum, the closest approximation would be collage. It is hardly a coincidence, then, that many of the most notable artists directly associated with the music – Jamie Reid (Sex Pistols; see pp. 152–53), Gee Vaucher (Crass; see right) and Winston Smith (Dead Kennedys) – were collage artists, or that in Los Angeles Gary Panter (*Slash* magazine) would fracture imagery, while Raymond Pettibon would disturb it with unsettling, terse captions (see pp. 132–37). Inherent to the 'tear it up and start all over again' ethos are both deconstruction and reconstruction. Again the formidable example of the Lettrists and the Situationist International cast a big shadow here, with overt references in British punk from Reid, McLaren, the designer Vivienne Westwood and the appropriative, mediated cut-up literature of Kathy Acker, who lived in New York but spent much of her time in Europe. This assemblage technique (in cases ranging from Throbbing Gristle to John Zorn) would become even more arch over time, with the rise of post-punk in Britain and No Wave in New York in the early 1980s. With the much-heralded do-it-yourself aesthetic of that era, the obviously better branding of independent record labels should not disguise the fact that this was the golden age of zines, an even more accessible and affordable medium, in which the art and writing in such publications as *Sniffin' Glue* (London), *Punk* (New York), *The Cle* (Cleveland), *Search & Destroy* (San Francisco), *No Mag* and *Slash* (both Los Angeles) offered the purest distillation of the iconoclastic, anti-authoritarian and acerbically ironic attitude of this new generation.

The culture of the time produced numerous effects: the cut-and-paste subversion of authorial content, the amplification of means towards an all-subsuming visceral experience, the repositioning of political didactics into more socialized contexts of cultural observation, the stripping-down of complexity into emblematic provocations, the seamless interchanging of authenticity with its mediated surrogates, and the personalizing of the public as self-reflexive witness. Such effects are all more than merely the sum of ideas and sensibilities floating in the air; they are tangible manifestations of the urban condition at a time when the city had experienced the full trauma of white flight. Just as the Second World War left parts of London cratered by bombs well into the 1970s and, according to the great chronicler of the British punk scene Jon Savage,[3] created a situation

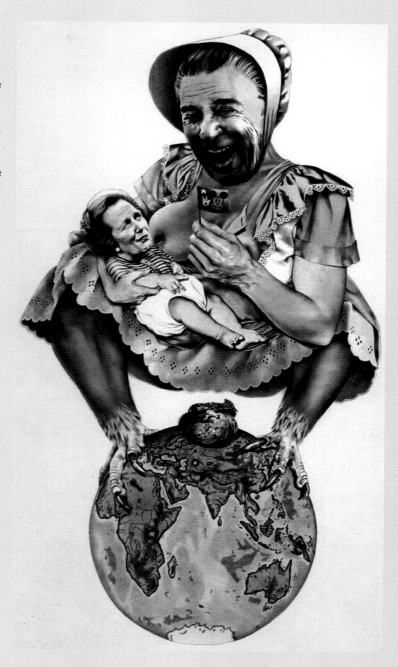

GEE VAUCHER
Inner-sleeve illustration of Crass's 'You're Already Dead', 1983

Stencils by David Wojnarowicz, photograph by
Martha Cooper, Lower East Side, New York City,
February 1982

in which many sought to pursue better lives outside the city in the post-war period, so the search for normalcy sent the majority of first- and second-generation European immigrants who had long been the backbone of New York City running to the suburbs in pursuit of the new American Dream, taking with them not only their economic base but also their jobs and businesses. It was into this immense vacuum that artists moved as a largely autonomous community, first into the lofts of SoHo's failing light-manufacturing and garment industries and eventually into the burnt-out, drug-infested neighbourhood of Lower East Side tenements (renamed for real-estate purposes the East Village). It is therefore possible to track the kinds of art made over this period as both a physical and metaphorical actualizing of space.

In direct response to their environs, such artists as Hannah Wilke, Adrian Piper and David Wojnarowicz took the city's social and street life as a theatrical stage, and a whole generation eventually followed Wojnarowicz's example of turning the detritus of disuse into the raw material of their art. A monumental bridge between the older SoHo generation and the great art-world explosion of the 1980s was the artists' collective Colab (short for Collaborative Projects). These artists merged sociopolitical concerns with non-Conceptualist art-making and produced in 1980 such seminal gathering-of-the-tribes exhibitions as *The Real Estate Show* (occupying an abandoned building on Delancey Street, which, upon the artists' immediate eviction at the hands of the police, forced the city authorities to give them a building that became the alternative space ABC No Rio, still in operation today) and *The Times Square Show* (organized in a former massage parlour near the Deuce). Now here is where it gets tricky, where we have to remember our admonition at the start to avoid the reductive force of history and the academic tendency neatly to individuate intrinsically interwoven

components as wholly separate species. One can no more talk about downtown while ignoring the companion gestures that occurred uptown than one can sever punk from its concurrent partner hip hop.

While *The Times Square Show* in the summer of 1980 was the first truly public opportunity for a generation of artists and their different communities to exhibit together and meet one another – introducing such Colab artists as Jane Dickson, Tom Otterness and Kiki Smith, as well as a number of graffiti-based street artists, including Jean-Michel Basquiat, Keith Haring and Fab Five Freddy – it was hardly the first and only interface. Downtown inhabitants may have been adamant in their proud declaration 'we never go above Fourteenth Street', but those who did helped forge one of the most fertile cultural interchanges. The fact is, as a defining moment, punk rock in New York was very much over by 1975, when major labels, in particular Sire Records, began signing the core CBGB musicians (Patti Smith, Blondie, Talking Heads, Television and the Ramones), irrevocably fracturing the in-it-together camaraderie just at the time when punk, as a kind of politics-through-style, was hitting London. But uptown, in the even more socio-economically ravaged slums of the South Bronx, disc jockeys and emcees began to forge the beginnings of a hip-hop nation that would in the next decade spread across the globe as the international phenomenon of rap music.

The visual component of hip hop, the graffiti artists, whose fame spread in commensurate measure to their domination of the subway trains, were the true interborough ambassadors between the no-future ghettos of impoverishment and bohemian existence. If you look back, you would see how everyone had a similar library of books and records, but if you could go back, you would smell how the entire scene was living off the aerosol fumes of graffiti. One major bridge was Fashion Moda, begun in 1978 by SoHo-based, European-born Conceptual artist Stefan Eins with African American performance artist Joe Lewis. In one particularly burnt-out and drug-riddled neighbourhood, such artists as Dickson, Haring, Jenny Holzer and Kenny Scharf exhibited alongside the likes of Bronx graffiti legends Crash and Daze. Dickson's husband and fellow Colab member Charlie Ahearn (whose twin brother, John Ahearn, opened a community-based sculpture studio in the Bronx) also began working there, and through friendships with Fred Brathwaite and others started taking pictures of the underground hip-hop scene as a step towards making a movie. The result, *Wild Style* (1983), brought together original turntablists Grandmaster Caz, Grand Wizard Theodore, Grand Mixer DXT and Grandmaster Flash, the last b-boys the Rock Steady Crew and proto-rappers Busy Bee, Fantastic Freaks and the Cold Crush Brothers with the artists Fab Five Freddy, Dondi and Lee Quinones, the last co-starring with underground-film mainstay Patti Astor. Astor, grasping the sea change before her, soon opened FUN in the East Village, the first graffiti art gallery, where Quinones, Haring, Basquiat, Scharf, Dondi and Futura 2000 had their first exhibitions.

That the streets became both subject and canvas for such artists as Gordon Matta-Clark, Richard Prince, Jenny Holzer, Barbara Kruger, Martha Rosler, Peter Hujar and David Wojnarowicz says as much about the visual language of the streets as it says about punk and Postmodernism. The relationship between these artists and the street is not so very far from the efforts of Dick Hebdige first parsing out the signs of subculture through style in the punk Britain of the late 1970s. Certainly, subway art's example of urban transmogrification had an immeasurable effect on young art-school students in New York such as Haring, Scharf and Basquiat. Within the polarity of the two most important downtown social venues, Club 57 and the Mudd Club, these artists, and a whole generation who have more or less come to define the art of the 1980s, exhibited and partied on equal terms with the musicians, film-makers, designers, writers, performance artists and less-focused degenerates. Did all the famous bands of that era play at the Mudd Club and Club 57's larger and less performance art-based venue at Irving Plaza? Of course, but the point that they were in the same room, on the same drugs, sleeping with one another and sharing every other aspect of being young is what we as historians do not do a very good job of translating.

It is worth attempting to listen out for punk in the great art of that era, but if you want to know where the rubber really hit the pavement and to find the streets in punk, trace the brief moment from the release of 'Rapture' by Blondie in January 1981 (which, in hitting number one on the *Billboard* music charts, brought Fab Five Freddy, Lee Quinones, Grandmaster Flash and Jean-Michel Basquiat directly into the homes of middle America) to late spring of the same year, when the then little-known Clash took the United States by storm with a week of sell-out shows at the Bond International Casino in Times Square. They announced their arrival at the casino by unfurling a large banner painted by Futura 2000 and a number of others: it said simply 'The Clash', but it announced The Word.

Notes

1. S. Frith and H. Horne, *Art into Pop*, London and New York (Methuen) 1987, p. 124.
2. G. Marcus, *Lipstick Traces: A Secret History of the Twentieth Century*, Cambridge, Mass. (Harvard University Press) 1989.
3. J. Savage, *Teenage: The Creation of Youth Culture*, New York (Viking) 2007, p. 19.

ANDREW LOGAN

Homage to the New Wave, 1977

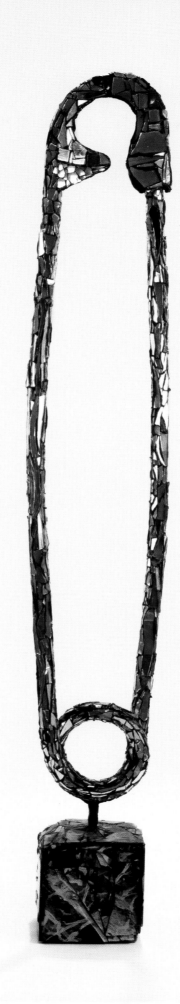

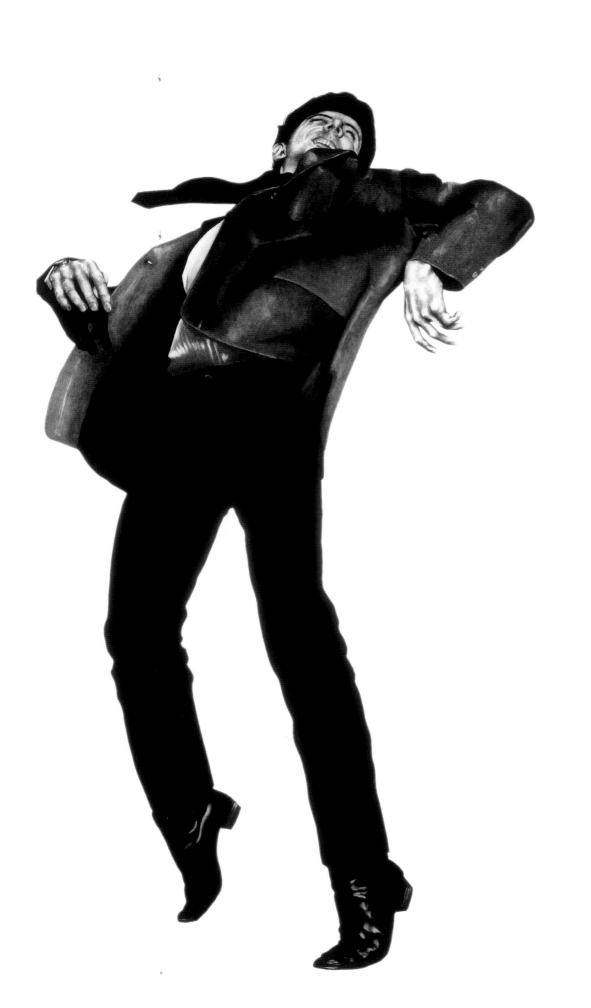

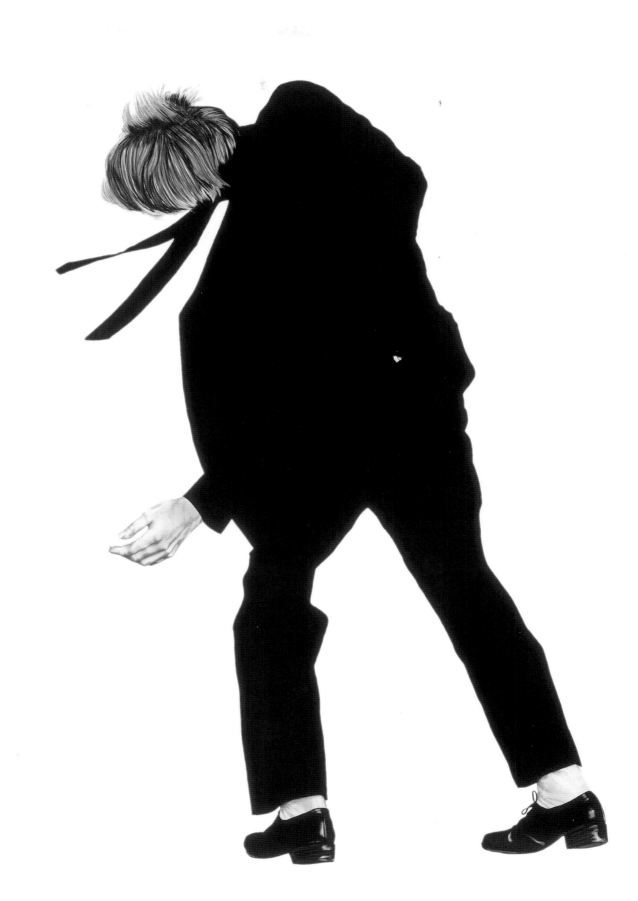

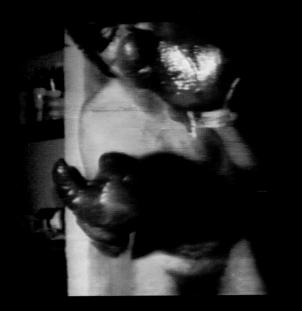
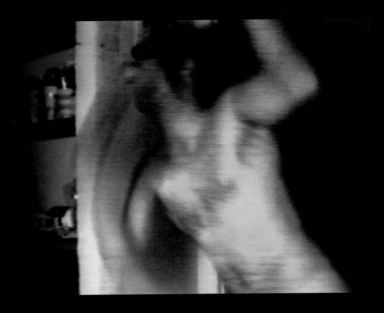
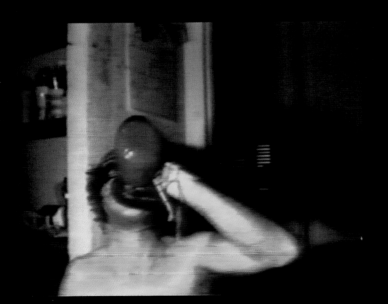
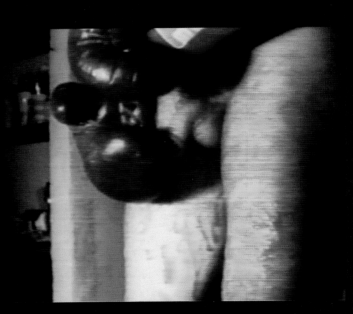

PAUL MCCARTHY

Rocky (details), 1976

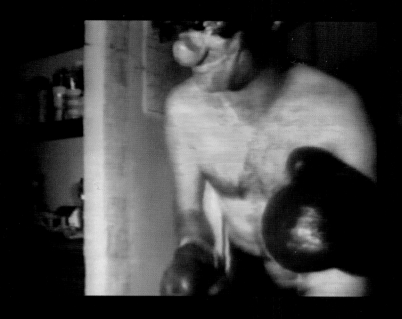
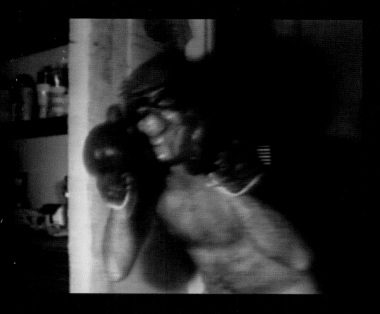
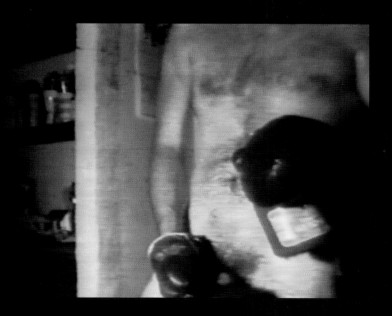
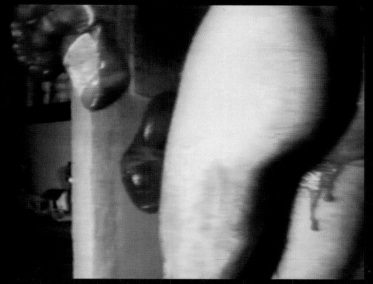

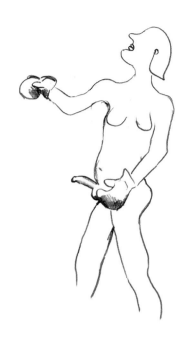

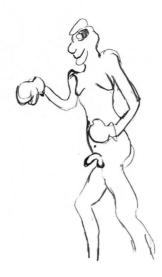

Paul McCarthy

Rocky (details), 1976

ROBERT MAPPLETHORPE

American Flag, 1977

Opposite
Patti Smith, 1975

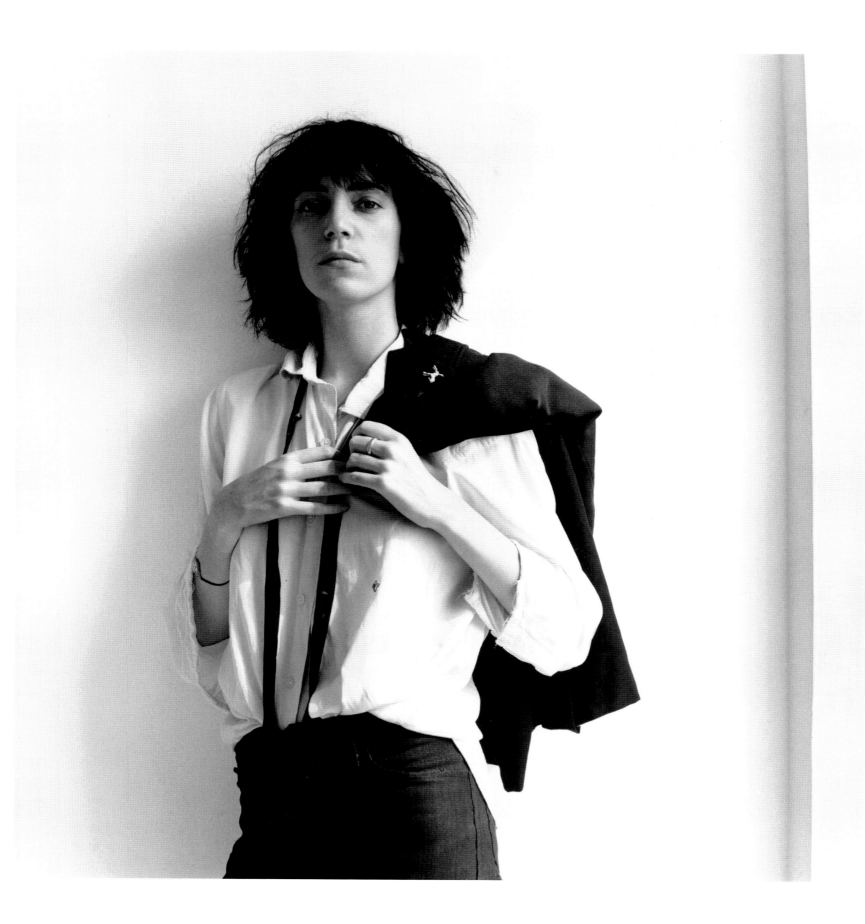

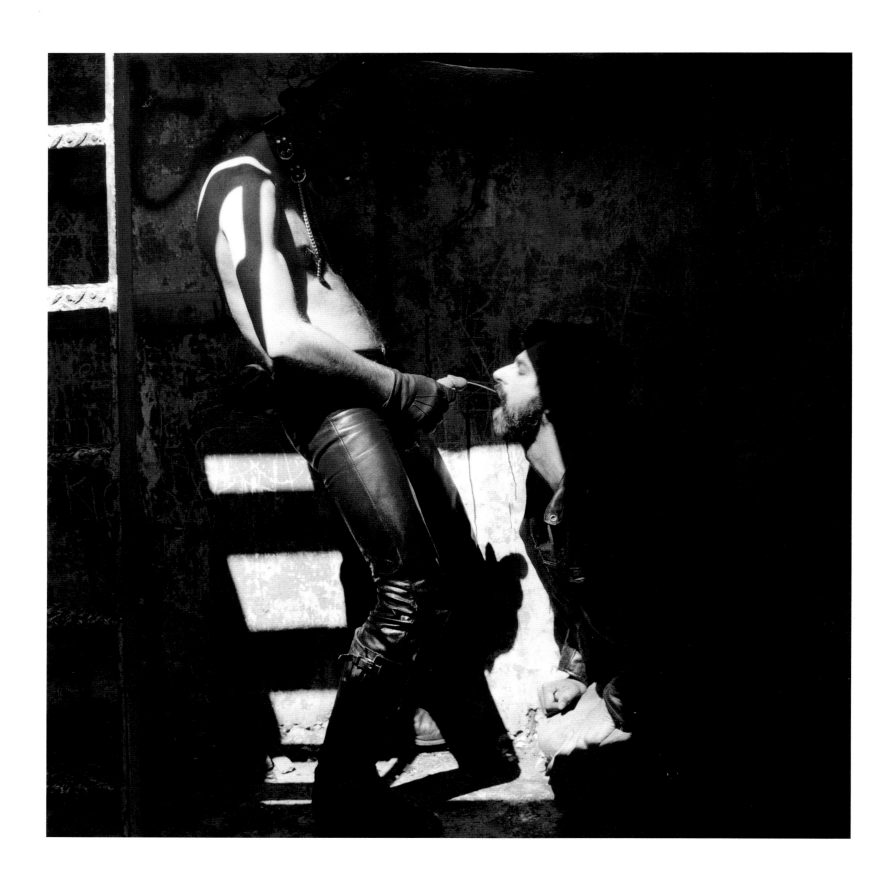

ROBERT MAPPLETHORPE

Jim and Tom, Sausalito, 1977

Charles Tennant, 1978

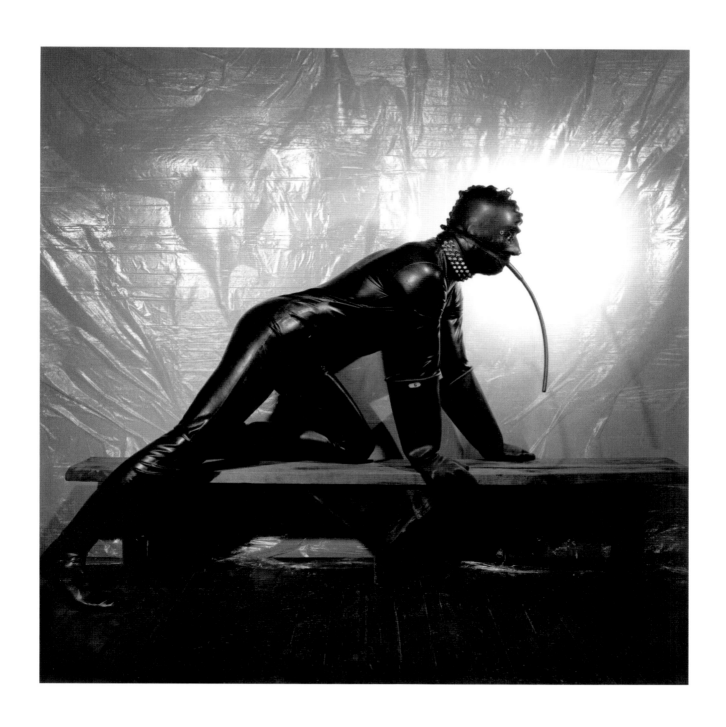

ROBERT MAPPLETHORPE

Opposite
Lily, 1977

Joe, NYC, 1978

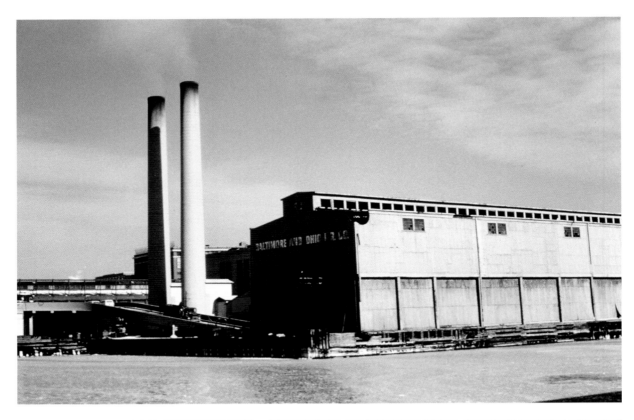

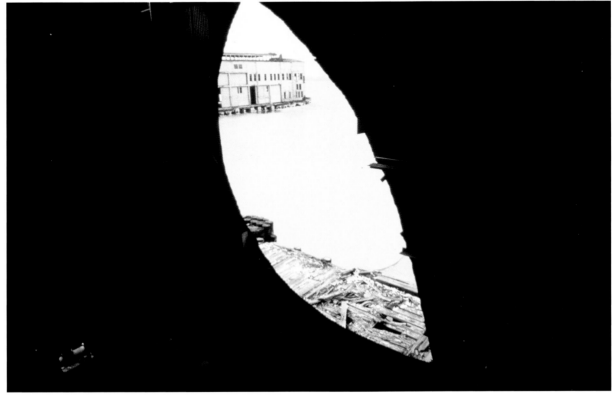

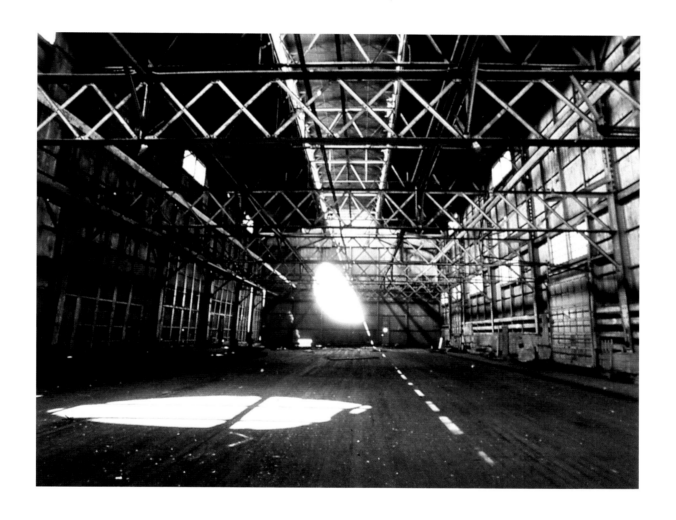

GORDON MATTA-CLARK

Day's End, 1975

FERAL CITY

TRACEY WARR

With that backcombed orange hair, cruel painted face and attitude of furious and wanton destructiveness, Margaret Thatcher was a punk. The citizenry first came adrift from a belief in democratic government in the punk years. We were living in 'the city gone feral'.[1] There were oil crises in 1973 and 1979, fuel shortages, three-day working weeks, power cuts, strikes, rocketing inflation and unemployment. Thatcher engaged in vandalism on the Welfare State, public services, the mining industry and its associated working-class culture. In the United States there was the bitter aftermath of the withdrawal from Vietnam, New York went bankrupt, and the Watergate scandal and Richard Nixon's resignation exposed an untruthful government. Such political disillusion is commonplace now, but in the 1970s it was new. In the post-war period people had briefly tasted and believed in the ludicrous notion that the role of democratic government was to move the populace collectively towards equity and civil rights. As Thatcher and Ronald Reagan settled in for their long, long terms in office, we lost hope in Michel Foucault's assertion that it was 'up to individuals to become indignant and to talk and up to government to think and to act'.[2]

I remember the 1970s as orange, purple and brown. In 1974 I was sixteen and rebelling against femininity and the oppression of women. I read Betty Friedan and Kate Millett and left behind the needlework and cookery at my girls' school to study economics and politics at a really bad college of further education. I had cropped hair and wore ties and flimsy shirts with no bra. My university lecturer fell in love with me (partly) because I looked like his boyfriend from public school. I went to the Blitz Club, took part in student sit-ins, pogoed off sticky carpets to the Sex Pistols' 'Pretty Vacant' and the Stranglers' 'No More Heroes', faghagged with male friends in London's gay clubs, pubs and swimming pools, saw William Burroughs at the Brixton Academy, wore silk ballgowns from the chainstore Flip and got the back of my head shaved for my sister's wedding. In the 1980s I worked at the Institute of Contemporary Arts (ICA) on exhibitions by Robert Mapplethorpe, Derek Jarman, Laurie Anderson and the Situationist International. I liaised with a major Sunday magazine to bring in negatives of Mapplethorpe's works that Customs had impounded, and handled irate phone calls about *Man in Polyester Suit* (1981), visits from the Vice Squad and a delegation of priests. I went to Anderson's *United States* (1983) at the Tottenham Court Road Dominion three times because I was three-timing. The ICA's Situationist book[3] had a sandpaper cover imitating Guy Debord's *Mémoires* (1957) that had been designed to destroy other books alongside it on the shelf.

Everyone who was young in those years has to tell their own story of that time because it was about trying really to live life. It was about finding 'a more intense life ... that has not really been found'.[4] 'In this world where we had been looking for life we found only wreckage,' wrote Michel Mourre in 1950.[5] Punk expressed dissatisfaction with humdrum conventional life, with capitalism creating our desires and then selling those to us as needs: the 'degradation of being into having'.[6] For Paul McCarthy, 'our culture has lost a true perception of existence ... We are fumbling in what we perceive to be reality. For the most part we do not know we are alive.'[7] Punk was a protest against life that was not living. It attacked the constructs of the media, consumerism and capitalism with venom and passion to snap us out of it. Punk was edgy and ugly but not cynical.

Greil Marcus outlines the provenance of punk in revolutions and heresies, in Dada, the events of May 1968, the Lettrist International and the Situationist International.[8] Punk also looked back to the boycott of a sick society in Destruction art[9] and the messy body aesthetic of Otto Mühl. In a speech after the May 1968 protests in Paris, President Charles de Gaulle declared: 'This explosion was provoked by a few groups in revolt against modern society, against consumer society, against technological society ... which do not know what they would put in its place, but which delight in negation.'[10] Punk, too, was an incoherent shout of refusal rather than an earnest programme for social change.

Andrew Logan (right) and Divine at the premiere of *The Alternative Miss World*, Odeon cinema, Leicester Square, London, 15 November 1979

The Stonewall Riots following a police raid on a gay club in New York in 1969 had led to the establishment of the Gay Liberation Front. In London the increasing confidence of gay culture was reflected in the outrageous performances of the dancer-actor Lindsay Kemp and in Andrew Logan's establishment of the Alternative Miss World (see above).

Going out itself became a form of political action, a show of conviction and a statement of community and stance. Michael Bracewell remarked that *getting ready* to go out became an art form and sometimes people did not even bother to go out in the end.[11] Getting ready was the main thing as the socializing body became a form of individual resistant expression.

Clubs, cafes and journals have been the bivouacs of resistant aesthetics since Dada.[12] The self-published Dada, Surrealist, Lettrist and Situationist journals were precedents for the punk zines, including *Punk* and *Sniffin' Glue*,[13] and for the appearance of punk do-it-yourself, which enabled bands to form their own garage record labels and Leigh Bowery's band Raw Sewage to make a pop video for £15 in the 'Make Your Own' booth in London's Trocadero. When Bowery and Tony Gordon launched their club Taboo in London in 1985, they were referencing the Tabou café in Paris frequented by Isidore Isou and the other Lettrists in the 1950s.

The punk club haunts included Steve Strange and Rusty Egan's Bowie nights at Billy's and then the Blitz Club in London, and CBGB, the Mudd Club and the Pyramid Club in New York. The Blitz Club was a personal catwalk for art and fashion students from St Martin's School of Art. Its other regulars included the musicians who would form Spandau Ballet and Ultravox; journalist Robert Elms; Ben Kelly, who later designed the Hacienda in Manchester; and Boy George, who was the cloakroom attendant.[14] The Ramones, Blondie, Patti Smith and Talking Heads all played at CBGB.[15] The Mudd Club had a rotating gallery and gender-neutral bathrooms and was frequented by David Byrne of Talking Heads, Jean-Michel Basquiat and Lydia Lunch. It features in songs by the Ramones, Frank Zappa and Talking Heads. The club also staged theatrical theme nights, including Rock Suicide, Nuns and Victor Hugo. The explosion of the East Village art scene began with Gracie Mansion's show in her toilet in 1982, and by 1984 the neighbourhood boasted around thirty tiny galleries. Nan Goldin worked as a waitress in Tin Pan Alley and showed her slide-show-in-progress, *The Ballad of Sexual Dependency*, there. The Pyramid Club was part of this East Village scene, created by the artists, actors and musicians who lived there. Greil Marcus asks: 'is the cabaret where the spirit of revolution is born [?] ... it is a question of how much history, made and unmade, a cabaret can contain.'[16]

The need to live life forcefully, indelibly, was expressed by the Dada Cabaret Voltaire

in Zurich in the face of three million dead soldiers on the battlefield of Verdun in 1916. For the Lettrist International and Situationist International groups in Paris it was the recent memories of the Second World War that spurred their fierce urgency. The unbearable shortness and vividness of life would be brought into sharp relief again in the early 1980s by the advent of the AIDS epidemic and its tragic mishandling by bigoted authorities.

The prints of David Wojnarowicz's series *Arthur Rimbaud in New York* (1978–79; pp. 184–89) show Wojnarowicz's friend Brian Butterick in various locations around the city wearing a photocopied melancholy Rimbaud mask with a bruised mouth and drooping eye. Drawing on his own experiences as a homeless, runaway rent boy,[17] Wojnarowicz photographs 'Rimbaud' on the shore of the Hudson River, in a diner, outside a peepshow, shooting up at the piers, in front of Coney Island, masturbating, reading a paper in a seedy room, on the subway and in Times Square. The impassive pallor of the mask jars with the living flesh of the body shooting up or masturbating. 'Rimbaud' is both immersed in New York, taking it all in, and a displaced and dispassionate alien observing it. We expect at any moment that he will break out of his impassivity and give us his observations on this city, this life, but he remains mute and uncommunicative – a mere surface. And can Butterick see through the mask at all?

The work of Peter Hujar, Mapplethorpe and Wojnarowicz portrays a furtive sexuality inhabiting delapidated urban interstices. Alan Hollinghurst observes: 'in [Tom of Finland's] visions of the leather-scene and S/M sex, a habit of mind was identified which became real on the West Side piers in the early 1970s, and was photographed by Robert Mapplethorpe'.[18] And Rebecca Solnit comments: 'The city's ruins constituted a dark playground for those … engaging in non-economic, non-productive activity, imaginative and erotic.'[19] These artists' photographs, artworks and texts capture the dangerous peeling alleyways and interiors of the Hudson River piers where gay men met for anonymous sex. 'I have not set out to make distinctly homosexual photographs', wrote Mapplethorpe. 'I have recorded or documented a certain kind of sexuality … these have been both perhaps my best pictures and the most difficult to make.'[20] Wojnarowicz stencilled walls, made murals in the piers, painted on trash-can lids and supermarket posters and incorporated street graffiti into his collages. In these works and the street art of other artists, including Keith Haring and Basquiat, the city becomes both canvas and subject.

David Lamelas's *The Violent Tapes of 1975* (1975; pp. 84–87) captures the bewildering, alienated, predatory spaces of modern life. And the theme of the feral city also occurs in Jarman's bleak dystopic vision of Britain in *Jubilee* (1978). Queen Elizabeth I and John Dee travel through time to 1977, the Silver Jubilee year of Queen Elizabeth II, and discover the end of civilization: a punk England that is murderous, cruel, valueless, burning, grimy, graffitied and pointless. Jarman's character Amyl Nitrate (played by the punk Jordan) wins the Eurovision Song Contest as a mooning, suspendered, goose-stepping Britannia/Boudicca. A repugnant impresario (Malcolm McLaren?) cackles throughout the film like a hyena. There is no future and no beauty or integrity in this rebellion.

The body art of the 1970s stripped down the body at the same time as the Alternative Miss World was dressing and trussing it up. Marina Abramovic, Chris Burden, Gina Pane, Vito Acconci, Bruce Nauman and Dennis Oppenheim were among the artists using their own bodies in performance as a field of enquiry and revitalizing a bodily discourse.[21] Body art was featured in the journals *Artitudes*, *Avalanche* and *Studio International*. Three important exhibitions of body art took place in 1975: *Bodyworks* at the Museum of Contemporary Art in Chicago, accompanied by a significant essay by Willoughby Sharp; François Pluchart's *L'Art corporel* at the Stadler Gallery in Paris; and *Magna Feminismus* at Galerie nächst St Stephan in Vienna, curated by Valie Export. Artists, using their own bodies, explored identity as 'acted out' within and beyond cultural boundaries; they

ANNIHILATE
ILLUMINATE

HANNAH WILKE
Annihilate Illuminate (Oldenburg), 1978–84
From *So Help Me Hannah*, 1978–85

explored gender, race and sexuality. They considered consciousness and the notion of the self. They examined how dominant ideologies are enacted on the human body, which is both the site of social control and the site of resistance.

Rebellion against sexual stereotyping was reflected in persona-based work by feminist artists, including Adrian Piper, Eleanor Antin and Lynn Hershman. Hannah Wilke in *S.O.S. Starification Object Series* (1974–82; p. 169), *Through the Large Glass* (1976) and *So Help Me Hannah* (1978–85; pp. 170–71), and Carolee Schneemann in *Naked Action Lecture* (1968) used their own naked bodies to critique the treatment of the female body in art, in

pornography and in the wider culture. An equally powerful but more ambiguous position was taken by Cosey Fanni Tutti in her 'magazine action' pieces created while working in the sex industry in Britain, which she re-presented in the controversial *Prostitution* exhibition at the ICA in 1976 (see p. 32). Marina Abramovic's *Role Exchange* (1975) also addressed the sex industry. Abramovic sat in a prostitute's window in the red-light district in Amsterdam, while the prostitute went to the artist's gallery opening.

Chris Burden, Paul McCarthy and Mike Kelley were working in Los Angeles and explicitly attacked the deadening influence of the media and Hollywood. Burden hijacked a live TV show, holding a knife to the hostess's throat. McCarthy

referenced television shows and the horror- and porn-movie industries. Timothy Martin describes Burden, Kelley and McCarthy as reacting against the dispassionate neutrality of Minimalism and Conceptualism, rupturing that clean space with the living, breathing, messy body.[22] Kelley abjures the clean lines of Minimalism for a more do-it-yourself or artisan aesthetic, and drew on punk in a gleeful debunking of earnestness and pretension.

McCarthy's rituals, too, were irreverent. His performances equated the dining table with the altar, the dissection table and the stage, addressing social rather than autobiographical trauma. A media-generated 'reality' is violently force-fed to the gagging and effaced body.

Leigh Bowery (right) at the Jungle club,
London, 1985

Bowie's film *Ziggy Stardust and the Spiders from Mars* (1973).[25] In 1974 the *Transformer* exhibition at the Kunsthalle in Lucerne looked at artists who employed masquerade and transgender in their work, including Urs Lüthi, and related this to the imagery of Bowie, Brian Eno and Bryan Ferry. Hujar photographed New York drag performers, and Goldin intimately captured the lives of drag queens in Boston. But the most dressed-up body of all was easily Leigh Bowery's (see left).

Bowery's appearances in London clubs and the magazines *The Face*, *i-D* and *Blueprint* took dandyism to a new extreme. Appearing as a beautiful monster in his own laboriously crafted designs that were both glamorous and horribly twisted, he enacted Roger Caillois's thesis of an uncanny border between camouflage and excessive display.[26] Bowery had a theory of embarrassment as the unexplored emotion. 'I'm interested in the human body and the way it can be changed', he explained. 'I had a period where my favourite fabric was flesh. I didn't wear any clothes for a while.'[27] Bowery's unclassifiable cultural practice is captured in Cerith Wyn Evans's film *Epiphany* (1984; p. 41) and in the work of many photographers from the time. His performances at the Anthony d'Offay Gallery in London in 1986 emphasized how his overly adorned body had become a mirror reflecting society and an armour deflecting penetration. In Bowery's collaborations with

Ralph Rugoff describes McCarthy as 'molesting ... the fundamental scaffolding of civilization ... the butchered eloquence of his work speaks ... against the deadness of pre-packaged experience'.[23] McCarthy contrasts an exaggeratedly leaking body – wearing its insides on the outside – with wooden Pinocchios, bodies fitted together from Lego-like parts and preprogrammed robotic figures.

Kathryn Rosenfeld has described the merging of queer and punk sensibilities and subcultures in the 1980s. She argues that many people came out and came to queer identity politics through the radical foundation laid by punk and its direct-action approach. So ACT UP's fluorescent President Reagans built on the aesthetic of the

Sex Pistols. 'The central idea of identity politics – that the inscription of otherness on the body is what situates and activates one politically' could be linked to 'punk's expression of mainstream disaffection through bodily adornment ... Punk's reliance upon the visual – its earnest insistence upon the body as a canvas for self-expression-cum-visual terrorism – made it a logical home both for the performative, visually strategic tactics of contemporary queer culture, and for art students seeking a way out of the studio and the institution and into the streets.'[24]

Michael Bracewell points out that bodies started to become articulate in Anthony Burgess's novel *A Clockwork Orange* (1962), in Stanley Kubrick's film of the novel in 1971 and in David

the choreographer Michael Clark and the designers Bodymap there is a tension between the excessive covering of the body and the wearing of holes baring the arse and other unexpected areas of flesh.

Donning crazy masks and costumes designed by Marcel Janco at the Cabaret Voltaire in 1916, Hugo Ball had noticed how they structured his perception and behaviour. Butterick's identity is half-submerged in Wojnarowicz's Rimbaud masks. In his *Men in the Cities* series (1978–82; pp. 102–103), Robert Longo uses business suits as a uniform/costume (like David Byrne of Talking Heads) to express the alienation of his dancing/writhing figures. McCarthy's disguises – his rubber masks and his cheap female wigs and sunglasses – depersonalize him, telling us, 'this isn't me, it's you'. Bowery danced for hours in costumes that barely allowed him to breathe and did not allow him to urinate. In the daytime, he also wore wigs and costumes – of a 'normal', nerdy person – as if there were no way to be his true self in the world. The promiscuous and delirious collage and polysemy, the uneasy composites of Bowery's work, are also stylistic characteristics of the work of McCarthy and Wojnarowicz. McCarthy and Bowery dress up to perform the artist's role as clown – to express an extreme critical view of society from the privileged position of court jester.

Notes

1. R. Solnit, 'After the Ruins', *Art Issues*, 70, November–December 2001, p. 18.
2. Quoted in D. Macey, *The Lives of Michel Foucault*, New York (Pantheon) 1993, pp. 437–38.
3. *An Endless Adventure – An Endless Passion – An Endless Banquet: A Situationist Scrapbook. The Situationist International Selected Documents from 1957–1962: Documents Tracing the Impact on British Culture from the 1960s to the 1980s*, exhib. cat., ed. I. Blazwick, London, Institute of Contemporary Arts, 1989.
4. Debord quoted in G. Marcus, *Lipstick Traces: A Secret History of the Twentieth Century*, Cambridge, Mass. (Harvard University Press) 1989, p. 433.
5. Quoted *ibid.*, p. 284.
6. Debord quoted *ibid.*, p. 140.
7. Quoted in B. Smith, 'Paul McCarthy', *Journal*, 21, January–February 1979, p. 50.
8. Marcus, *op. cit.*
9. K. Stiles, 'Survival Ethos and Destruction Art', *Discourse*, 14, no. 2, Spring 1992, pp. 74–102.
10. Quoted in Marcus, *op. cit.*, p. 32.
11. See C. Atlas, *The Legend of Leigh Bowery*, 2004 (Palm Pictures) [DVD].
12. See *Dada and Surrealism Reviewed*, exhib. cat. by D. Ades, London, Hayward Gallery, 1978; and A. Melzer, *Latest Rage the Big Drum: Dada and Surrealist Performance*, Baltimore (Johns Hopkins University Press) 1994.
13. See M. Perry, *Sniffin' Glue: The Essential Punk Accessory*, London (Sanctuary House) 2000.
14. See D. Rimmer, *Like Punk Never Happened: Culture Club and the New Pop*, London (Faber & Faber) 1985.
15. See S. Beeber, *The Heebie-Jeebies at CBGB's: A Secret History of Jewish Punk*, Chicago (Chicago Review Press) 2006.
16. G. Marcus, 'The Dance That Everybody Forgot', *New Formations*, 2, Summer 1987, p. 39.
17. See *Fever: The Art of David Wojnarowicz*, exhib. cat., ed. A. Scholder, New York, New Museum of Contemporary Art, 1999.
18. Quoted in *Robert Mapplethorpe 1970–1983*, exhib. cat., London, Institute of Contemporary Arts, 1983, p. 11.
19. Solnit, *op. cit.*, p. 22.
20. *Robert Mapplethorpe*, *op. cit.*, p. 6.
21. See T. Warr (ed.), *The Artist's Body*, London (Phaidon) 2000; and R. Ferguson (ed.), *Out of Actions: Between Performance and Object, 1949–1979*, exhib. cat. by K. Stiles *et al.*, Los Angeles, The Museum of Contemporary Art, 1998.
22. T. Martin, 'Trois hommes et un bébé: avec Burden, Kelley et McCarthy, balancer le canot de sauvetage' in *Hors limites: L'Art et la vie, 1952–1994*, exhib. cat., Paris, Centre Georges Pompidou, 1994, p. 280.
23. R. Rugoff, 'Mr McCarthy's Neighbourhood', in R. Rugoff, K. Stiles and G. Di Pietrantonio, *Paul McCarthy*, London (Phaidon) 1996, pp. 35–36.
24. K. Rosenfeld, 'The End of Everything Was 20 Years Ago Today: Punk Nostalgia', *New Art Examiner*, 27, no. 4, December 1999–January 2000, p. 29.
25. M. Bracewell, 'Leigh Bowery's Immaculate Conception', *Frieze*, 19, November–December 1994, p. 38.
26. See R. Caillois, *Le Myth et l'homme*, Paris (Gallimard) 1938; and S. Sarduy, 'The Transvestites. Kallima on a Body: Painting, Idol', *Art Press*, 20, September 1975, pp. 12–13, trans. in Warr, *op. cit.*, p. 250.
27. Quoted in Atlas, *op. cit.*

MARK MORRISROE

La Mome Piaf, 1983

Opposite
Self-Portrait with Broken Arm, 1984

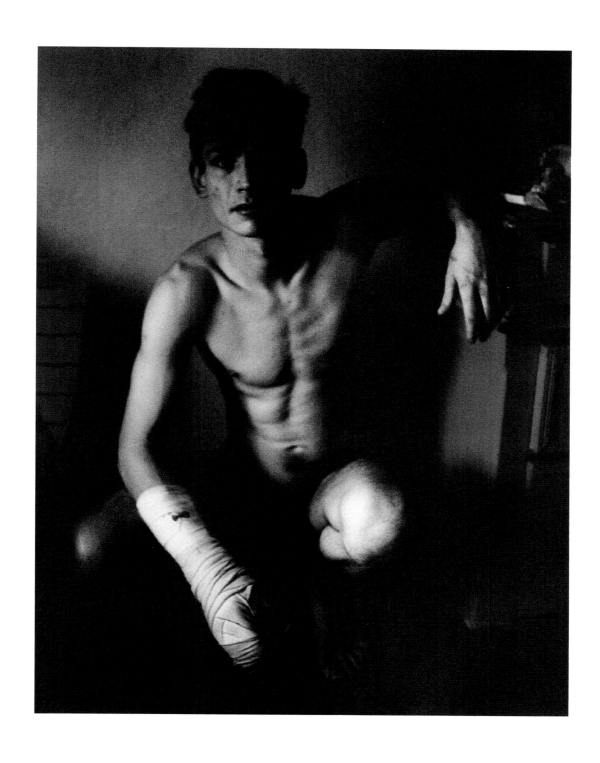

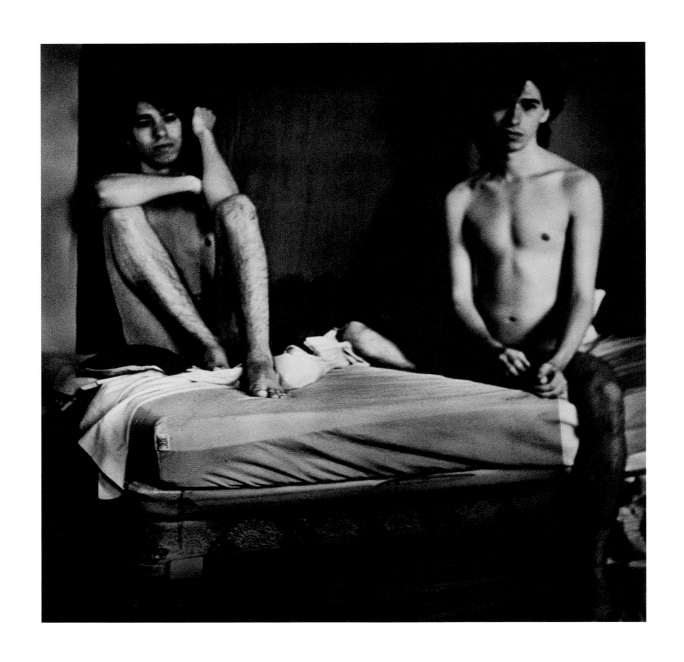

MARK MORRISROE

Untitled (The Starn Twins), 1983

Opposite
Untitled (Self-Portrait in Drag), 1981

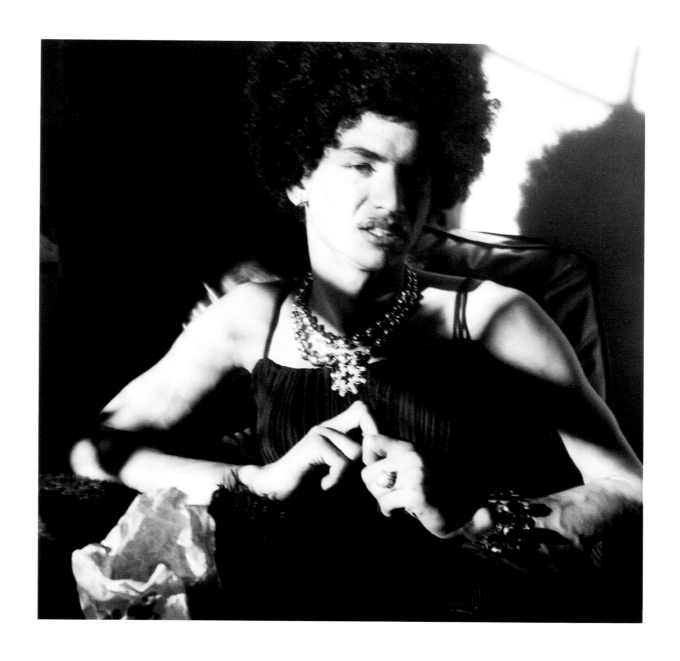

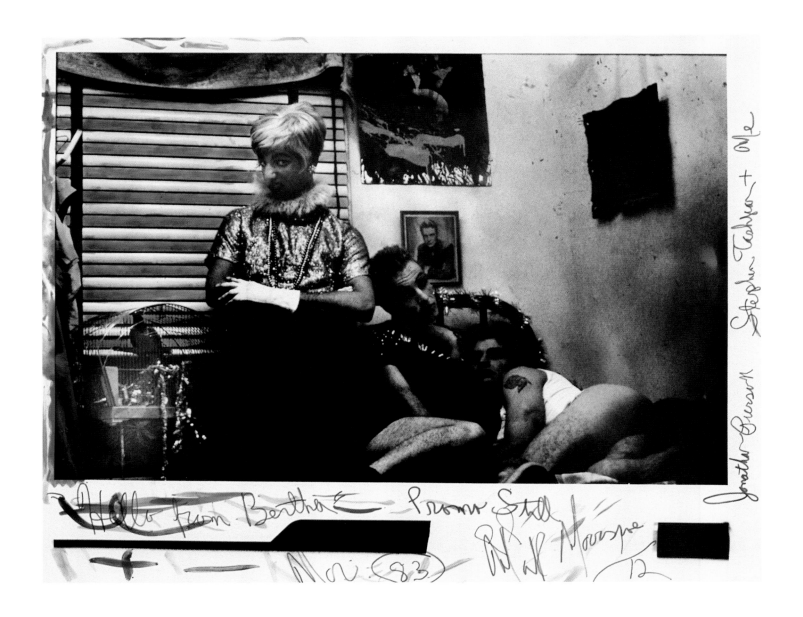

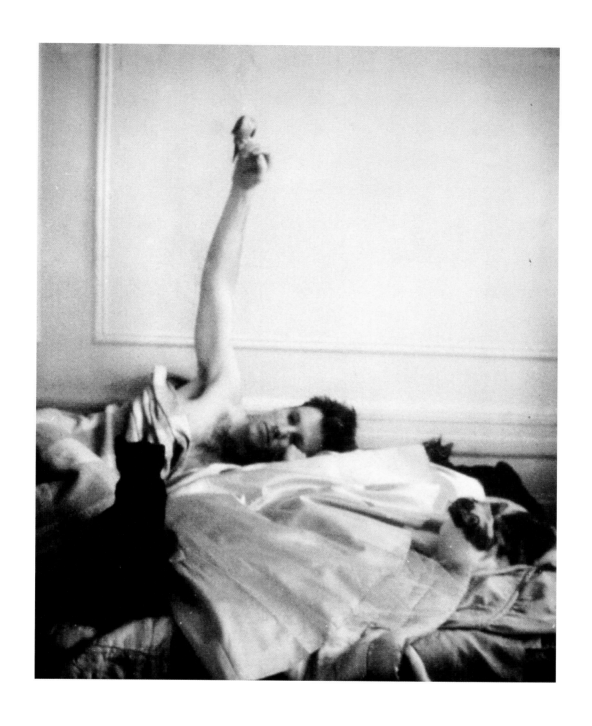

MARK MORRISROE

Hello from Bertha, 1983

Fascination, 1982

TONY OURSLER

The Loner, 1980

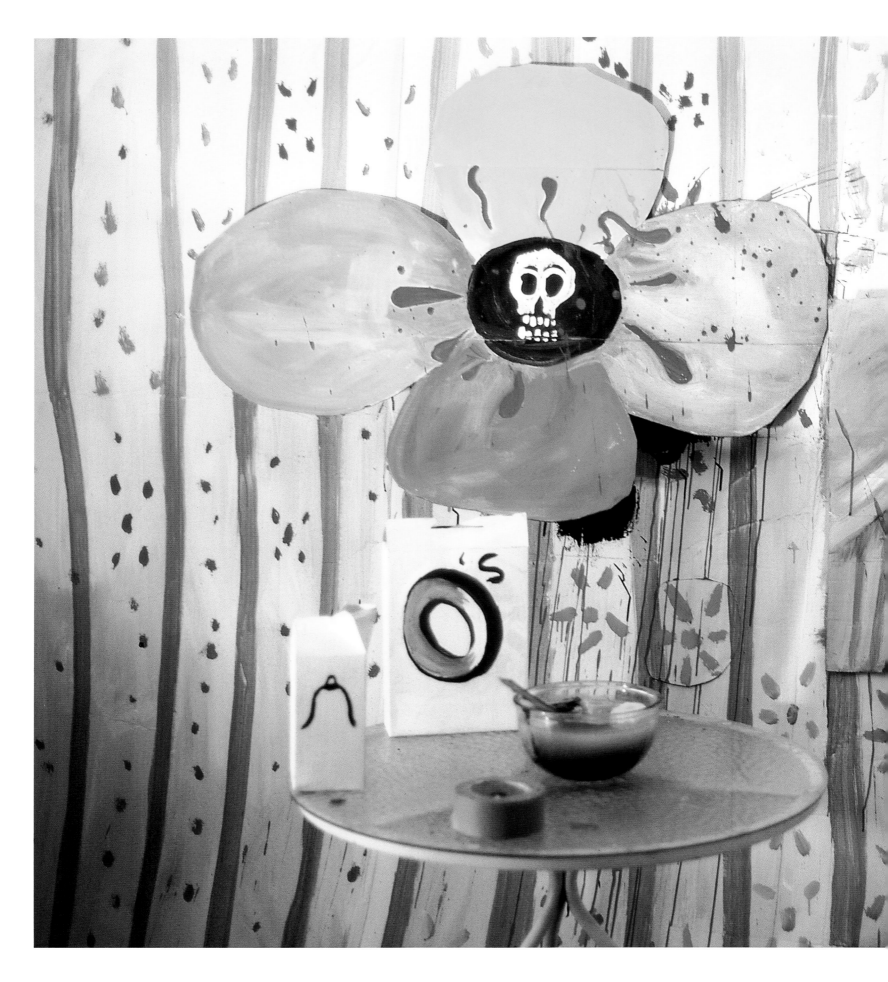

TONY OURSLER

The Loner, 1980

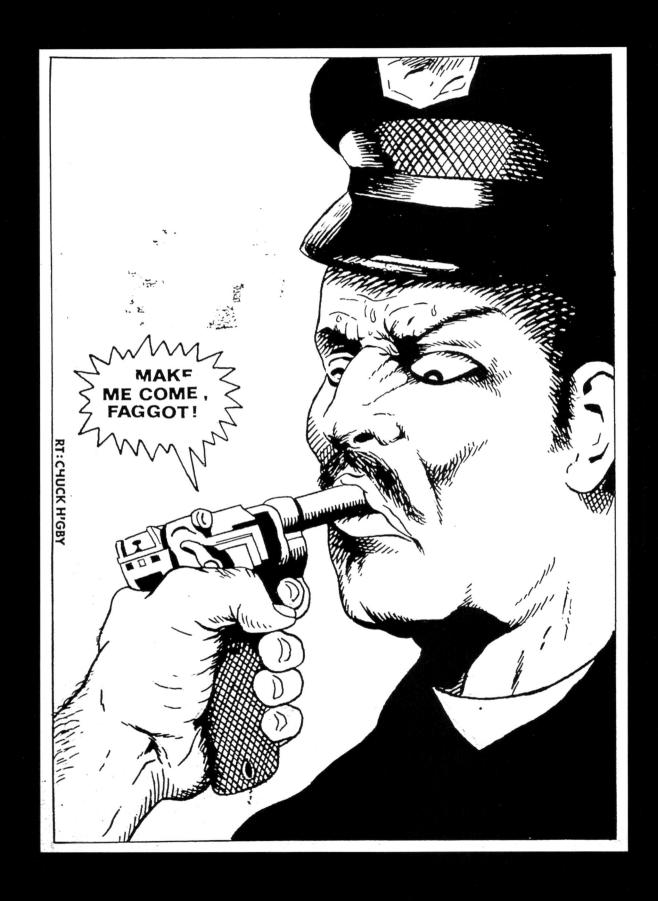

RAYMOND PETTIBON

Opposite
No Title (Make me come), 1981

No Title (The gun was), 1984

WE BURNED DOWN OUR OWN CHURCH WHEN IT LET IN A JEW AND HIS NIGGER FOLLOWERS.

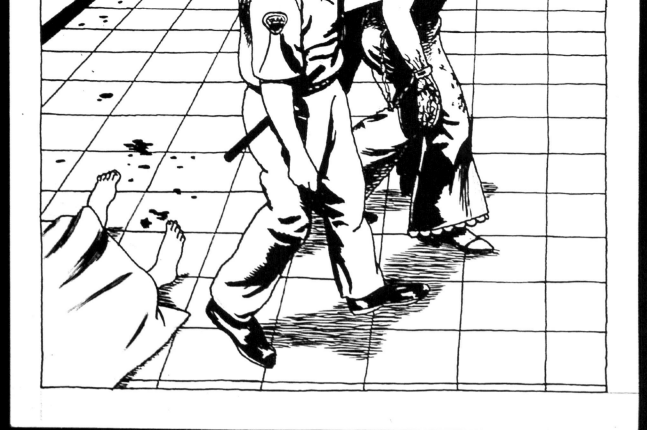

Page 134
No Title (If a Vietnamese), 1982
No Title (We burned down), 1983

Page 135
No Title (The LSD really), 1982

Opposite
No Title (I wouldn't make), 1982

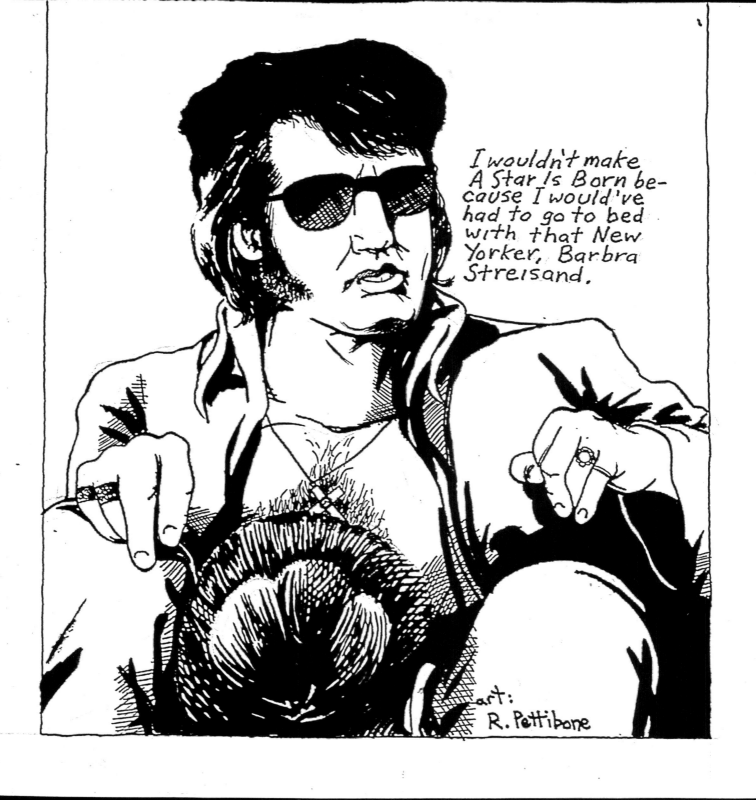

The Mythic Being: I/You (Her), 1.

The Mythic Being: I/You (Her), 2.

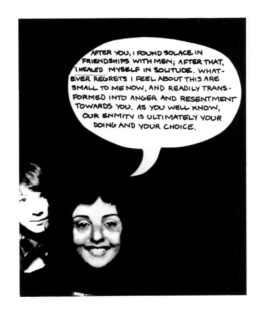

The Mythic Being: I/You (Her), 6.

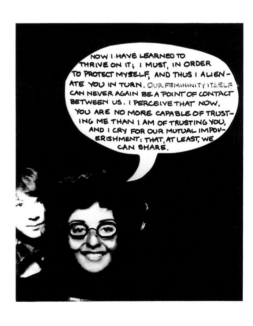

The Mythic Being: I/You (Her), 7.

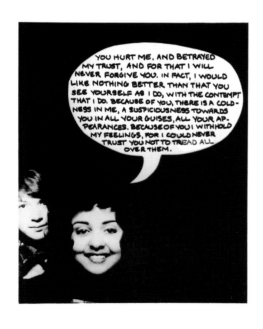

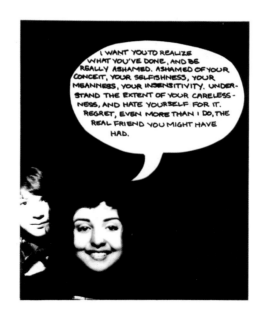

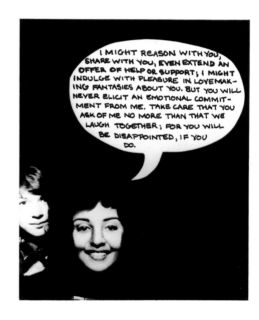

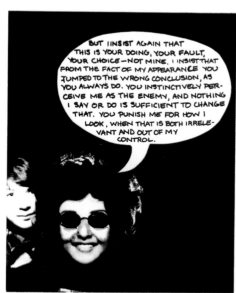

ADRIAN PIPER

The Mythic Being: I/You (Her), 1974

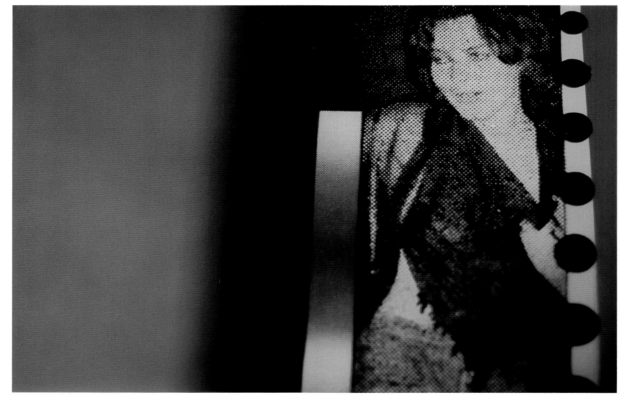

RICHARD PRINCE

From *The Entertainers*, 1982–83
Clockwise from opposite, top
Victoria, *Kassandra*, *Didre*, 1983

Overleaf
Laoura, 1982

MODERNITY KILLED EVERY NIGHT

ANDREW WILSON

The Sex Pistols are not a new 'fashion craze', they're reality. If people are scared of 'em it's their own fault, it's because they don't understand. Life's about concrete, the sinking Pound, apathetic boring people and the highest unemployment figures ever.[1]

The early-morning mist dissolves. And the sun shines on the Pacific. You stand like Balboa the Conquistador. On the cliff top. Among the last of the Monterey Cypress trees.
 The old whaler's hut is abandoned now. But whales still swim through the wild waves. Sea otters float on the calmer waters. Cracking abalone shells on their chests.
 Humming birds take nectar from the red hibiscus. Pelicans splash lazily in the surf.
 Wander down a winding path. Onto gentle sands. Ocean crystal clear. Sea anemones. Turquoise waters. Total immersion. Ecstasy.

TODAY IS THE TOMORROW YOU WERE PROMISED YESTERDAY

VICTOR BURGIN
From *UK76*, 1976

An overwhelming sense of collapse hung over Britain in 1976: a feeling of a black-and-white, or perhaps beige, world from which colour had been draining away; a feeling of boredom, ennui and fecklessness born of political, social and economic alienation. Following the resignation of Prime Minister Harold Wilson, the succession of James Callaghan in 1976 signalled an ongoing slide that would lead – via the Grunwick dispute, the 'Winter of Discontent',[2] widening industrial disputes and Saatchi & Saatchi's 'Labour isn't working' campaign poster for the Conservative Party – to the election of 'Milk Snatcher' Margaret Thatcher as prime minister in 1979. The depressed, antagonistic and yet resigned mood of the time is captured well by both Victor Burgin's *UK76* (1976; pp. 24–26) and Gilbert & George's *Dirty Words Pictures* (1977) from the year of Queen Elizabeth's Silver Jubilee. Both bodies of work presented a stark contrast to the stage-managed and nostalgia-ridden pageant against which also rang the tune of the Sex Pistols' seditious alternative anthem 'God Save the Queen'.

The sequence of images that make up Burgin's *UK76* depict views of Britain's post-imperial and post-industrial decline. On one level, each of the work's panels presents a different pictorial gloss on this view: different types of urban spaces that portray a particular take on projections of national identity; a sense of movement through these spaces in which people are presented as more or less detached; different forms of nostalgia, whether it be the attraction of the picture-book country cottage or the workplace (sweatshop, artisanal workshop or factory production line); and the manipulation of sight through pictorial composition and the rule of the gaze in constructing gendered representation. On another level, *UK76* mixes the codes of documentary photography with those of the advertising copywriter to impart a sense of disjunction brought about by the deployment of these two forms of representational coding. Within their conventions, both photography and advertising are absolutely intelligible, and both derive their ideological and economic power by virtue of their very readability. Yet by bringing them together in this way, Burgin transgresses their codings not only in terms of the action of pictorial representation, but also in terms of the ways in which desire is fabricated through advertising. Writing in 1976, Burgin explained that 'the most conspicuous photo-textual social fact is advertising … Today, advertising constitutes a massive ideological intervention in western culture. Confirming individual subjective consciousness in its misrecognition of the "real", representation in advertising inscribes the imaginary position of the consumer within this "reality"; the subject consumes itself, ingests its own reflection in ideology.'[3]

It is this process that is transgressed and held up for scrutiny in the particular juxtapositions of text and image that Burgin sets up in *UK76*. The work portrays, in terms of a critical analysis, images of untouchable consumerist desire; the anomie induced by the supermarket checkout as much as by window-gazing on the high street or by the male gaze on the body of an almost naked woman. Additionally, it reveals how a clustered tradition of privacy and detachment, relative wealth and status is mired in a history located in the half-timbered country cottage. This contrasts with those different sites of isolating alienation found in the bus queue, the production line or the sweatshop. The idyll of unspoilt nature is thus inexorably paired with the desperate wasteland of the modern suburban housing estate – webs of culs-de-sac and electricity pylons. The power of Burgin's work is that it incites an avowedly critical reading of forms of cultural representation. The relationship between image and text is determined here by his intention to unpack and examine personal, cultural and social identity, revealing how an awareness and projection of these identities can comprise a deliberate and structured act of contestation.

By using the language of both photographic documentation and advertising's play of image and text to construct an idealized view of life built by the twin pulls of desire and gratification, Burgin then proceeds to turn these languages back on the ideologies that constructed them, pulling apart the 'wholeness' of those accepted, if artificial, constructs. His aim here is to raise 'the possibility that there is a contradiction in social life, that the world we live in is historically given, that the social relations we live within are historically contingent and can be changed … and one way of doing *that* is to make texts out of components which won't marry happily together, so that there are cracks in the structure, and this text then becomes a sort of critique of the other texts'.[4] Burgin's understanding of how representations are manipulated and deployed in this way helps to 'determine subjectivity *itself*. Representation is a fact of daily experience which concerns us all *intimately* … There is no essential self which precludes the social *construction* of the self through the agency of representation.'[5]

Burgin was not alone in carrying forward such 'work on ideology' through an analysis of photographic imagery and the construction of advertisements. A group of artists, art historians and critics associated with St Martin's School of Art in London met during 1976 to test the limits of such analysis and to close the gap between theory and practice to produce 'a species of pictorial rhetoric which will counter the rhetoric of advertising on its own terms, by using its own methods'.[6] One of the members of the St Martin's Group, John A. Walker, has described how one of its main concerns revolved around the examination of 'the relation between ideology and systems of visual representation such as perspective (vantage and vanishing points), the common mechanisms of pictorial rhetoric (visual metaphors, similes, hyperbole, personification, etc.) and the vexed relation of the avant-garde to official and mass-culture ... News photographs and advertising images were intensively analyzed as a means of understanding dominant ideology ... The overall aim was "to use the ideological tools of bourgeois mass culture for its own subversion".'[7]

Many accounts of punk, and specifically of the collaborative group activity that surrounded the Sex Pistols in 1976 and 1977 – fashion and media manipulation by Vivienne Westwood and Malcolm McLaren; graphic design by Nils Stevenson, Helen Wellington-Lloyd and Jamie Reid; photographic image presentation by Ray Stevenson; and the fashioning of a cohesive social identity by its fans, such as the Bromley Contingent – have made links between an idea of punk nihilism, the tinder-box depression being felt in Britain, and the Situationist strategies of *détournement*[8] (not unlike using the 'ideological tools of bourgeois mass culture for its own subversion'). However, few such accounts have presented the group activity around McLaren in terms of a coherent form of image and identity construction that plays primarily with the slippage between different forms of representation, or have made the connection between Dick Hebdige's reading of punk signs (as comparable with Jean Genet's expression of deviant double coding)[9] and the types of analysis discussed at meetings of the St Martin's Group or found within the work of such artists as Victor Burgin, John Stezaker or Stephen Willats.

The genealogy and evolution of McLaren's activity can be traced along many different routes according to whichever mythology one cares to subscribe to.[10] Nevertheless, one apparent ur-moment that is relevant to an understanding of his motives and modus operandi must be the period he spent in the United States between November 1974 and May 1975 on a mission to sell clothes for his shop SEX and manage – or at least construct an image for – the whacked-out transgender posturing of the New York Dolls. The Dolls were washed up, and McLaren attempted to pump new life into them by creating a new image: a marriage of kitsch Communism with red patent leather that served as an experiment in testing public reaction by confusing signs of sexual transgression, in terms of a presentation of polysexuality, with a representation of ideological transgression. America might have been able to embrace transgendered S&M drug addicts in tight leather and vinyl bondage suits, but it drew the line at references to Communism. As photographer Bob Gruen remarked: 'You get beat up for being a fag, but you get killed for being a Commie and that frightened a lot of people and confused a lot of people.'[11] This new image construction came complete with a demented Maoist-inflected Situationist rhetoric. McLaren's press release for the Dolls' first gig that spring exclaimed: 'WHAT ARE THE POLITICS OF BOREDOM? BETTER RED THAN DEAD'. It was a line that he would come to repeat in different guises many times in the future.

The Dolls, however, belonged to an older generation than those bands who played at CBGB in New York's Bowery, such as Richard Hell and Tom Verlaine's band Television. If it were the Dolls who offered McLaren the chance to road-test his ideas of manipulating and creating a subversive – because pop – cultural identity, it was the scene around CBGB, Television, and specifically the example of Richard Hell, that provided a blueprint for what might seem possible on his return to London in the late spring of 1975.

Television's music was one part of the equation – such songs as 'I Don't Care' or '(Belong to the) Blank Generation' defined an attitude that embraced a positive stance on a form of negativity, renouncing the status quo in favour of filling in the blank – but it was the group's construction of a particular look that caught McLaren's imagination. Indeed, one consistent element of McLaren's activity has been to diminish music in favour of a concern with fashion as a way of identifying the mechanics of image construction, fashion being defined by him not as design but as 'something to do with people's feelings about their culture and their lifestyle at a particular time'.[12] For Patti Smith, writing in 1974, Television 'refuse to be a latent image but the machine itself! The picture they transmit is shockingly honest ... No taped edited crap ... A movement of inspired mutants that will take the slop out of rock. Television will help wipe out media. They are not theatre ... They got the certain style ... The way they pulse equal doses of poetry and pinball. Their strange way of walking ... They play pissed off psychotic reaction. They play like they got knife fight in the alley after the set.'[13]

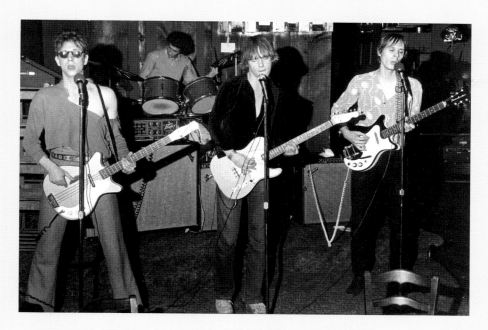

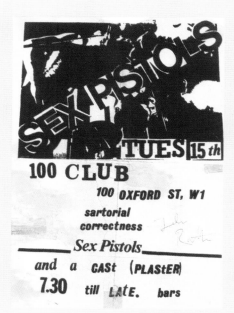

Television at CBGB: (from left) Richard Hell, Billy Ficca, Richard Lloyd and Tom Verlaine, New York, 1974

Flyer for the Sex Pistols' gig at the 100 Club, London, 15 June 1976

McLaren's view of Richard Hell was that he was 'sold another fashion victim's idea ... Here was a guy all deconstructed, torn down, looking like he'd just crawled out of a drain hole, looking like he was covered in slime, looking like he hadn't slept in years, looking like he hadn't washed in years, and looking like no one gave a fuck about him. And looking like he didn't give a fuck about you! He was this wonderful, bored, drained, scarred, dirty guy with a torn T-shirt ... These are the things I brought back: the image of this distressed, strange thing called Richard Hell. And this phrase, "the blank generation".'[14]

McLaren's discovery of Hell as a 'distressed, strange thing' gave fuel to his long-standing vision of the creation of a style of refusal that might incorporate both the styled rebellion of rock music and a fashion-inflected poetics of transgression in which the banality of contemporary life became the target for his play of subversion. His and Vivienne Westwood's shop – first styled as Let It Rock and later as SEX – reflected this construction of an opposition to a stagnant and oppressive status quo. In creating an image around the Sex Pistols, McLaren looked to almost forgotten histories as points of reference for his elaboration of an urban playground where repressive taboos could be celebrated, indulged and embraced. This violation of social equilibrium formed an easy partnership with the Situationist idea of unitary urbanism – the remoulding, from the streets, of the city as a totality – where the 'destruction of contemporary conditioning is simultaneously the construction of situations. It is the boundless energy trapped under the surface of everyday life.'[15] To the end of harnessing such 'boundless energy', the scope of McLaren's quotation ranged from the eighteenth-century Gordon Riots in London (filtered through the late-1960s post-Situationist group King Mob, with whom he had been in contact as a student at Croydon College of Art, where he first met Jamie Reid) and a nineteenth-century Dickensian narrative populated by Fagins and Artful Dodgers to the supposedly Situationist-inspired student rebellion of 1968 and William Burroughs's vision of Wild Boys, a guerrilla gang of boys, a band of assassins dedicated to freedom, who battle with the organized armies of repressive police states: 'The wild-boy thing is a cult based on drugs, depravity and violence more dangerous than the hydrogen bomb.'[16] Yet, despite the frenzy of outrage that punk precipitated, its unremitting energy is most often actually defined by its opposite – boredom, blankness, dead weight, restriction, and what Hebdige described as the 'silent voice in the smooth moulded surfaces of rubber and plastic'.[17] The reality of an object or a situation thus projects a set of coded symbolic values that are expressions of difference and signs of a forbidden identity capable of enacting freedom.

A flyer for the Sex Pistols' gig at the 100 Club on 15 June 1976 (above) attracts attention by what seems its calculated ploy of illegibility. Designed by Helen Wellington-Lloyd, the typography originated from a number of different sources, including a mutilated rejected flyer by Jamie Reid and a sheet of Letraset.

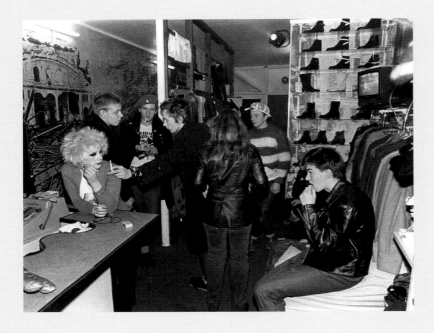

Johnny Rotten (centre) in the shop Seditionaries, King's Road, London, 1977

The image – all but unreadable – is from a photograph by Ray Stevenson of the band on stage, but in the reproduction only the outlines of fragments of bodies and instruments can be made out. However, the most disconcerting message on the flyer – so deeply coded that its meaning would be indecipherable except by a few – is its call for 'sartorial correctness ... and a CASt (PLAStER)'.

The 'sartorial correctness' was both a reference to the clothes available at SEX and aimed at a hardcore group of fans – those who worked in or hung around the shop (Jordan, Alan Jones, Marco Pirroni, Sue Catwoman, Debbie Juvenile, Tracey O'Keefe, Linda Ashby) and the Bromley Contingent (Berlin, Billy Idol, Simon Barker, Siouxsie Sioux, Steve Severin) – and a message that took the dissent, transgression and refusal embodied in the clothes out on to the streets. This was an absolutist move, emphasizing that those who manifested such a 'sartorial correctness' in the creation of a certain identity were the 'CASt' as much as were the Pistols or the unnamed support act, the 101ers, playing their last gig. The 'CASt (PLAStER)' was also a reference to one element of the décor of SEX – a plaster-cast sculpture of a diseased and amputated leg (fragmentation of the body was a consistently used theme in the world around McLaren). The 'sartorial correctness' that could be obtained from SEX, and later from Seditionaries, was intended to bring personal alienation out into the open. Mark Perry (Mark P) summed up this aim in the fanzine *Sniffin' Glue* after he witnessed the band at the 100 Club in August 1976: 'The Sex Pistols are a force, you get that feeling from their audience and it sticks in your mind. The clothes, the hair and even the attitude, of the audience has a direct link to the band ... As the Pistols pounded out their "music" the image was in every corner of the club.'[18]

Slightly later than *Sniffin' Glue*, an anonymous writer for *New Society* described the Sex Pistols' fans at the 100 Club as '16–20 year old post-Bowie devotees of cosmetics, both literal and conceptual. Their hair is cut close to the bone, often dyed bizarre colours. Make up is worn by both sexes: white faces, blue lips and green eye shadow suggest the appearance of puppy fat refugees from a Venusian cabaret ... The overall impression is of *Clockwork Orange* meets New York sado-masochism with just a hint of Weimar.'[19] What this and Mark P both describe is the extent to which McLaren was using the Bromley Contingent as a scene around the band that equated with the role that Andy Warhol's Factory provided for the Velvet Underground.

Furthermore, these accounts delineate one specific antecedent for the identity that McLaren was forging as a means of encapsulating and playing off the Sex Pistols: the aestheticized decadence that had been expressed in the early 1970s by such artists, designers, film-makers and musicians as Ossie Clark, Brian Eno, Bryan Ferry, Duggie Fields, Derek Jarman, Andrew Logan, Zandra Rhodes and Kevin Whitney, and which – with the closure in 1975 of the fashionable Biba store on Kensington High Street and Peter York's description of the scene in 1976 as 'Them' – was beginning to look rather tired. For these aesthetes, glamour went hand in hand with shock, and fluid notions of sexual identity mounted an assault on conventional

social norms of behaviour constrained by a worn-out and drab London; fantasy had the ability to become a new reality through style outrage. This confrontational identity construction was built on a 'nostalgia for archaic images of the future'[20] that rendered it placeless within a contemporary milieu and gave it the ability to act more effectively as a threat to a dominant society, the mores and diktats of which were oppressive or held to be just plain boring. Hebdige describes this expression of punk's Modernism as a dislocation from the parent culture, which was positioned 'beyond the comprehension of the average (wo)man in the street in a science fiction future. They played up their Otherness, "happening" on the world as aliens, inscrutables.'[21] Examples of how such a hidden and disguised coding could be deployed in destabilizing a wider culture could be discovered, if you knew where to look, from the release of the film *The Man Who Fell To Earth* in 1976, Lindsay Kemp's mimed celebration of Jean Genet's *Flowers* in 1974, the first production of the musical *The Rocky Horror Show* in 1973 at the Royal Court Theatre, and the release of the movie Cabaret in 1972 to the staging in London of Andy Warhol's play *Pork* in 1971. For John Varnom, marketing manager at Virgin in 1977, this potential was seized by the Bromley Contingent, who expressed themselves as 'cultureless, rootless, contemptuous'; they made 'rock 'n' roll shows events, rather than passive, spectator sports. The movement was the audience. The band was just a good excuse for it all.'[22]

Many of 'Them' had been supporters of McLaren and Westwood's shops Let It Rock, Too Fast to Live Too Young to Die and then SEX, and so it was understandable that the Sex Pistols should have been booked to play at Andrew Logan's Valentine's Ball on 14 February 1976. The set in which they played was constructed from scenery made for Jarman's film *Sebastiane*. McLaren's intention, however, was not to act as mere set-dressing for the party, but rather as a rupture from within, as Jon Savage explains: 'because all concerned with SEX were so close to Logan's world, they had to find a way forcibly to disassociate themselves from it'.[23] And this was successfully accomplished with a tripping Johnny Rotten hell-bent on violent confrontation with everybody, backed up by a band and its gate-crashing fans.

If anything, it is this sense of rupture that informs the identity surrounding the band that McLaren was orchestrating. Confrontation was not just incited but pursued by the Sex Pistols and those around them. The clothes that Westwood and McLaren produced at SEX made a confrontational, polymorphous vision of sexuality both dangerously available and tactile. Where the clothes from SEX were shamelessly overdetermined in their eroticization, this set a tone that was continued when the shop became Seditionaries in 1977, exchanging rubber wall hangings for images of the bombed city of Dresden and Piccadilly Circus turned upside down, a rat in a cage under the cash till and a progression in the clothes from sexualized violence to outright sedition.

The play of overdetermined counter-coding, switching from reality to symbol and back again, is most publicly and visually apparent in Jamie Reid's graphic designs for the band from 1976 to 1979. These designs extended the destabilizing collage language that Reid had developed in the early 1970s when he had worked with the Situationist-inspired community magazine *Suburban Press* and had designed and produced the only English-language collection of Situationist texts, Christopher Gray's *Leaving the 20th Century* (1974). Reid's designs for the Sex Pistols built on the Situationist strategy of *détournement* to project a palpable sense of social treason in the run-up to Jubilee year. By transgressing accepted codes, these images – a torn-up Union Jack held together by bureaucratic, yet patriotically named, bulldog clips for 'Anarchy in the UK', or the desecration of Cecil Beaton's classic portrait photograph of the Queen for 'God Save the Queen' – deconstruct those specifically ideological subjects that were being contested through McLaren's presentation of the Sex Pistols. Yet unlike an artist such as Burgin, whose material was concerned with undermining those codes that were immediately intelligible, Reid, continuing the work of Wellington-Lloyd, produced album covers, flyers and posters that 'gestured towards a "nowhere" and actively sought to remain silent, illegible'.[24]

In fact, Reid's posters and flyers did not serve their purpose that well in terms of encouraging sales, but what they did do was provide a graphic parallel to the songs and, alongside the music and lyrics, complicate the identity that was being constructed to surround the band. The different permutations of Reid's design for the single release of 'God Save the Queen' on 27 May 1977 is a case in point. Both the single cover and poster have at their centre Reid's detourned appropriation of Beaton's celebratory image of the Queen, except she has been blindfolded by the song title and gagged by the name of the band (p. 152). This first level of defacement is then compounded by the use of ransom-note lettering – letters and words cut out from newspapers to make the 'sender' or thief anonymous – even though by this time this device had become the band's design motif. The design then suggests that the band is holding up for

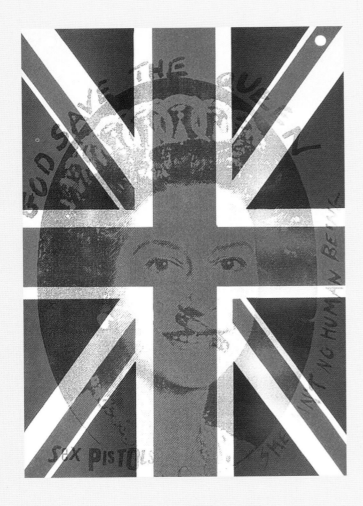

JAMIE REID
God Save the Queen (Union Jack Flag),
1977

ransom the values embodied by the Queen, just as her subjects – us – were being held to ransom by being coerced into a celebration of her reign ('England's dream … the mad parade'), a point made clearer when the image of the blindfolded, gagged and ransomed Queen was put at the centre of the Union Jack for the single's poster. Other permutations of the design took the lettering away from the face and replaced the gag with a safety pin through the mouth, to which was added the band's logo to one side, the title of the anthem written out around the head with the motto 'she ain't no human being'. One variant even pictured the design as a tablecloth for a commemorative cup of tea, and in another, which was not used by the record company, the Queen is given swastikas for eyeballs ('God save the Queen, the fascist regime'; p. 153).

One of the song's refrains was that 'There is no future … in England's dream', and this expression of nullity became a rallying cry much as Richard Hell's 'Blank Generation' had earlier been in New York. It is no surprise that McLaren should have been so enthusiastic about Hell's embodiment of a punk identity that was built on blankness. In 1977 his friend Fred Vermorel explained how McLaren's work 'has displayed a remarkable continuity in its concern with the themes of blackness and non-appearance; with blackness as anti-colour, negation and "badness" … Malcolm's preoccupation with blackness comes from his need to conceal himself or make himself "invisible".'[25] In this search for expression in the invisible, the black, the unintelligible, the deviant and the blank, McLaren had one lodestar that to this matrix added, as metaphor, the reality of a beautiful and successful failure that he had earlier recognized in the life of Jacques Vaché, an enigmatic French nihilist dandy who had committed suicide in 1919 and who for André Breton had been the embodiment of Surrealism. Vaché rejected both the established and the avant-garde literary traditions to embrace a life of unremitting failure. For McLaren, the idea of Vaché's silence – the work of his silence – was the North-West Passage of punk identity. For Vaché, as for McLaren, 'Modernity Killed Every Night'[26] stood for an attitude in which nothing could be safe, accepted meaning was destabilized and all codings turned back on themselves.

Notes

1. Mark P[erry], 'The Sex Pistols for *Time Out*', *Sniffin' Glue*, no. 6, January 1977, p. 3.

2. The Grunwick dispute centred on trade-union recognition, wages and working conditions at the Grunwick Film Processing Laboratories in north London and lasted from the summer of 1976 to the summer of 1978. The dispute led to a commission headed by Lord Scarman. The 'Winter of Discontent' spanned the winter of 1978–79, during which time mass strikes broke out in both the private and public sectors following the Labour government's ruling that pay rises be kept below 5 per cent. It paved the way for the election of Margaret Thatcher later in 1979.

3. V. Burgin, 'Modernism in the *Work* of Art', collected in V. Burgin, *The End of Art Theory: Criticism and Postmodernity*, London (Macmillan) 1986, p. 21. This was first given as a paper at the 1976 Edinburgh Film Festival 'Avant-Garde Event'.

4. V. Burgin, contribution to 'The State of British Art', *Studio International*, 2, 1978, p. 137.

5. *Ibid.*, pp. 133–34; emphasis in original.

6. B. Taylor, 'The Avant-Garde and St Martin's', *Artscribe*, no. 4, September–October 1976, p. 5.

7. J.A. Walker, *Left Shift: Radical Art in 1970s Britain*, London (I.B. Tauris) 2002, pp. 163–64. Apart from Walker, others who attended meetings of the St Martin's Group included Rosetta Brooks, Peter Challis, Yve Lomax, Jonathan Miles, John Stezaker, John Tagg, John Wilkins and Paul Wombell. In addition to Walker's account here, see also R. Brooks, 'Please, No Slogans', *Studio International*, March–April 1976, pp. 155–61; and Taylor, *op. cit.*, pp. 4–7.

8. This process of critical transformation, in which material from a dominant culture can be hijacked in order to be turned back on itself, often in the form of doctored collage, had been defined as being 'Short for: detournement of preexisiting aesthetic elements. The integration of present or past artistic production into a superior construction of a mileu. In this sense there can be no Situationist painting or music, but only a Situationist use of these means. In a more primitive sense, detournement within the old cultural spheres is a method of propaganda.' 'Definitions', *Internationale Situationniste*, no. 1, June 1958; translated in K. Knabb (ed.), *Situationist International Anthology*, Berkeley, Calif. (Bureau of Public Secrets) 1981, pp. 45–46.

9. Discussed in D. Hebdige, *Subculture: The Meaning of Style*, London (Routledge) 1988, pp. 1–4. Such double or multiple coding, hidden through deviance, defines much of Hebdige's account of subcultural style.

10. Although McLaren has to be recognized as a form of Svengali who lit the blue touchpaper for the Sex Pistols and made it possible for a particular environment to set the conditions for a punk image formation to take place within the context of his and Westwood's shops SEX and then Seditionaries, his management of the band and the extent to which he could be said to be in control of events as they unfolded through 1976 and thereafter will have to be left to other historians to debate.

11. Quoted in C. Heylin, *From the Velvets to the Voidoids: A Pre-punk History for a Post-punk World*, London (Penguin) 1993, pp. 87–88.

12. K. Kitsis, 'Malcolm McLaren: Interview', *Desire – ZG*, no. 7, n.d., p. 18. It is instructive that in an early interview about the Sex Pistols with Nick Kent, McLaren asserted categorically that 'from the start I realised that the Pistols as a band were not relevant strictly for the music. That was in fact all very secondary to the image that they were projecting which was something that all the kids could instantly relate to. I mean, when we played the 100 Club, half the audience we were attracting were kids … who'd been into Bowie and Roxy Music but who'd been left behind … But now they've got the Sex Pistols – they've got this image, this look, an attitude to relate to.' Quoted in A. Wilson, 'Anarchist Punk Gang', in M. Bracewell and A. Wilson, *No Future: Sex, Seditionaries and the Sex Pistols*, London (The Hospital) 2004, p. 70.

13. Patti Smith, 'Learning to Stand Naked', *Rock Scene*, October 1974; reprinted in Heylin, *op. cit.*, pp. 126–27.

14. Quoted in L. McNeill and G. McCain (eds), *Please Kill Me: The Uncensored Oral History of Punk*, London (Little, Brown) 1996, pp. 198–99.

15. A. Kotanyi and R. Vaneigem, 'Unitary Urbanism', *Internationale Situationniste*, no. 6, 1961; translated in C. Gray (ed.), *Leaving the 20th Century: The Incomplete Work of the Situationist International*, London (Free Fall Publications) 1974, p. 30.

16. W.S. Burroughs, *The Wild Boys: A Book of the Dead*, New York (Grove Press) 1992, p. 151.

17. Hebdige, *op. cit.*, p. 69.

18. Mark P[erry], and Steve [Walsh], 'Pistols', *Sniffin' Glue*, no. 3, September 1976, p. 7. The review starts: 'I can't remember what really happened at the –club to be honest. By the time the Pistols made it on stage the place just wasn't the same anymore. I mean, it wasn't the –club, it was "The Sex Pistols Club".'

19. 'In Decadent Key', *New Society*, 7 October 1976.

20. M. Bracewell, 'Post-Future', in Bracewell and Wilson, *op. cit.*, p. 15.

21. Hebdige, *op. cit.*, pp. 120–21.

22. J. Varnom, unpublished history of the Sex Pistols written in 1979, private collection, p. 52 (5).

23. J. Savage, *England's Dreaming: Sex Pistols and Punk Rock*, London (Faber & Faber) 1991, p. 147.

24. Hebdige, *op. cit.*, p. 69.

25. F. and J. Vermorel, *Sex Pistols: The Inside Story*, Sydney (Omnibus) 1987, p. 192.

26. This phrase, coined by Vaché, was McLaren's choice of name for his and Westwood's shop when they remodelled it as Too Fast to Live Too Young to Die after closing as Let It Rock and before they reopened as SEX.

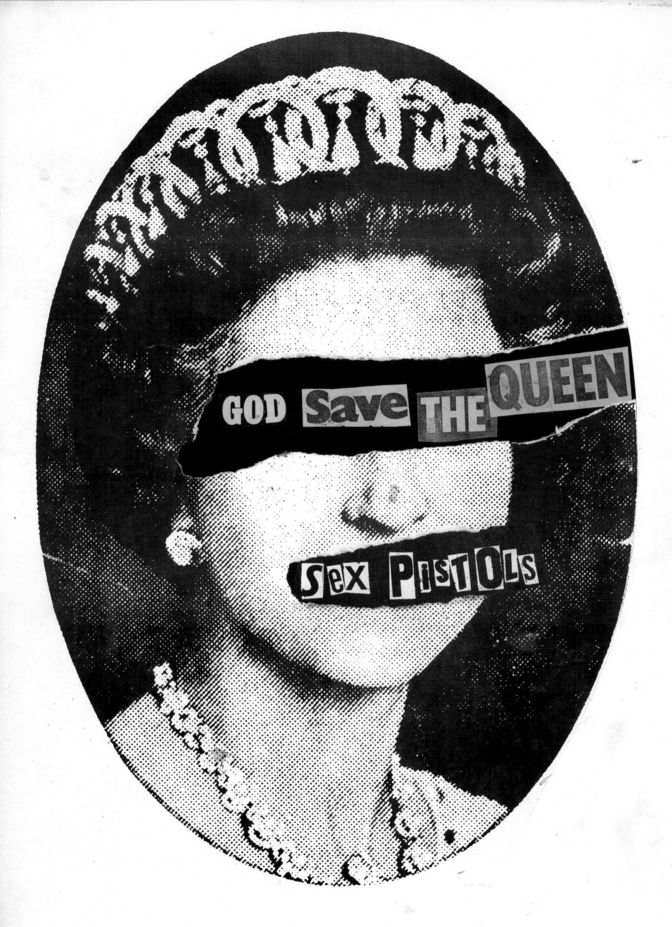

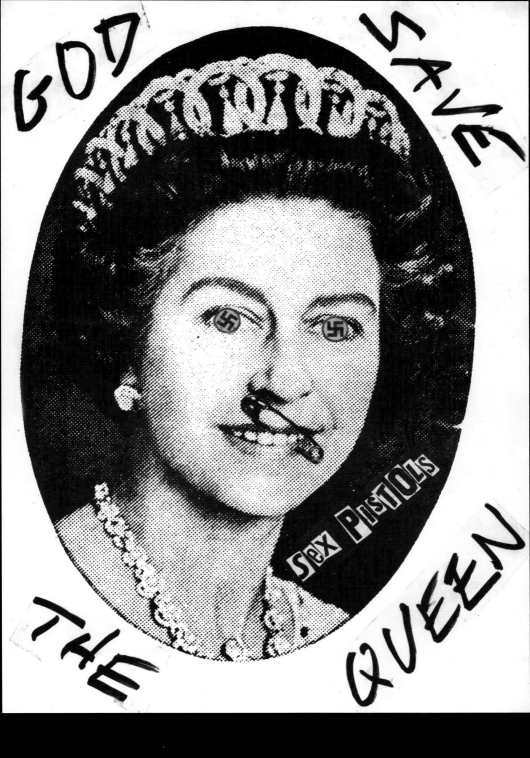

JAMIE REID

Opposite
God Save the Queen (Single Cover), 1977

God Save the Queen (Swastika Eyes), 1977

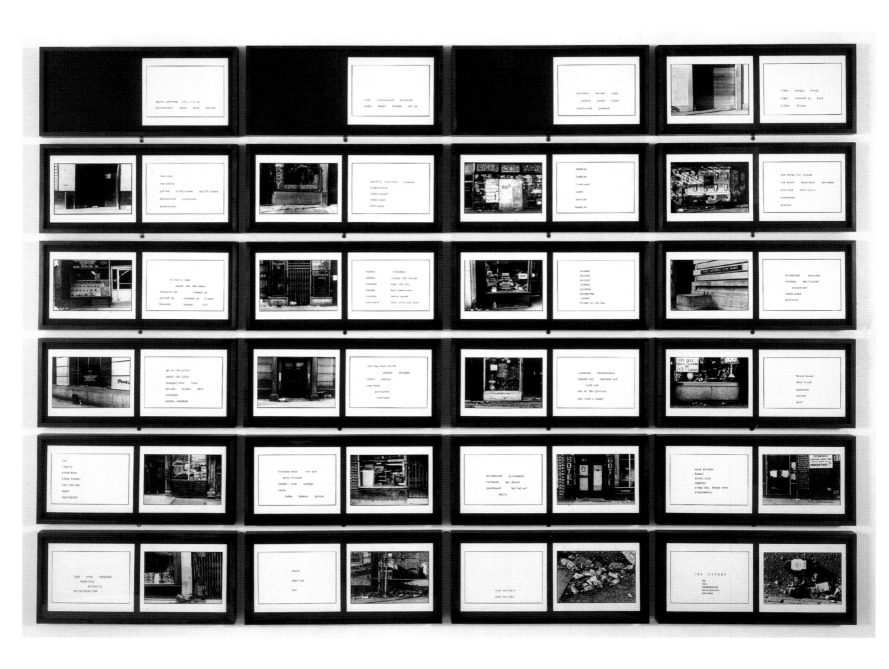

MARTHA ROSLER

The Bowery in two inadequate descriptive systems, 1974–75

Opposite
The Bowery in two inadequate descriptive systems (details), 1974–75

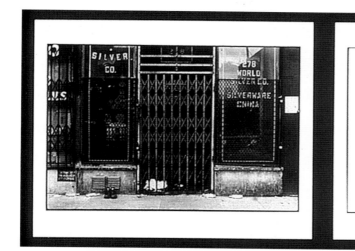

soaked	drenched
sodden	flying the ensign
steeped	over the bay
soused	half-seas-over
sloshed	decks awash
saturated	down with the fish

boozehound juicehound

rumhound gas hound

jakehound boiled owl

whale

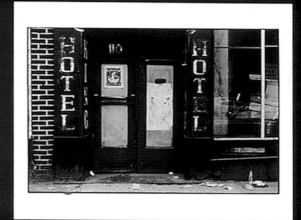

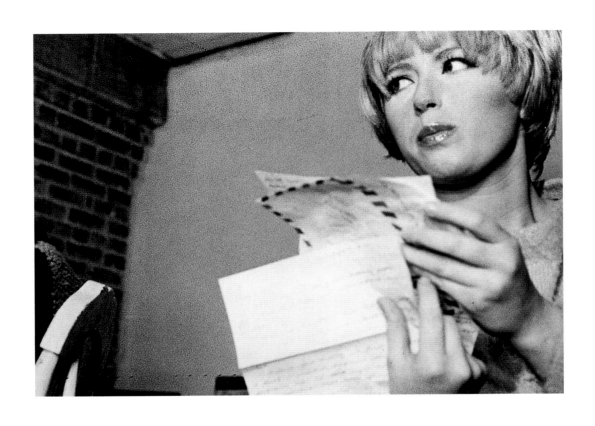

CINDY SHERMAN

Untitled Film Still #5, 1977

Opposite
Untitled Film Still #34, 1979

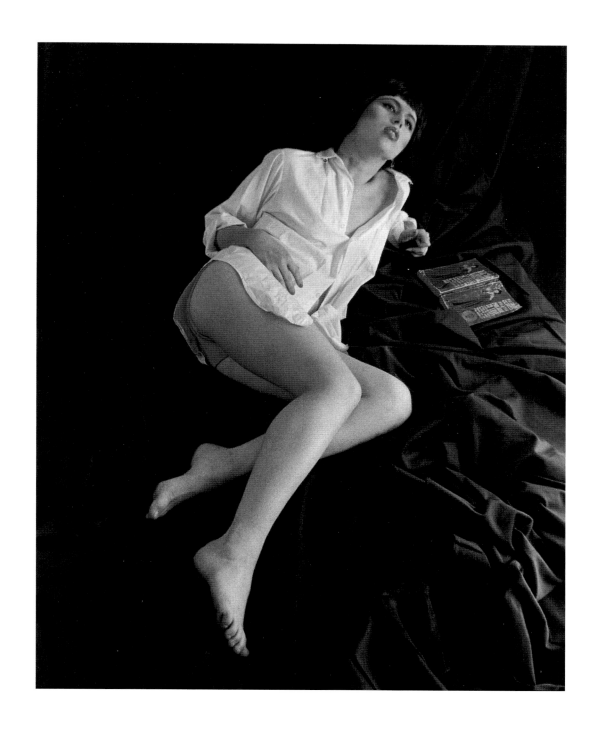

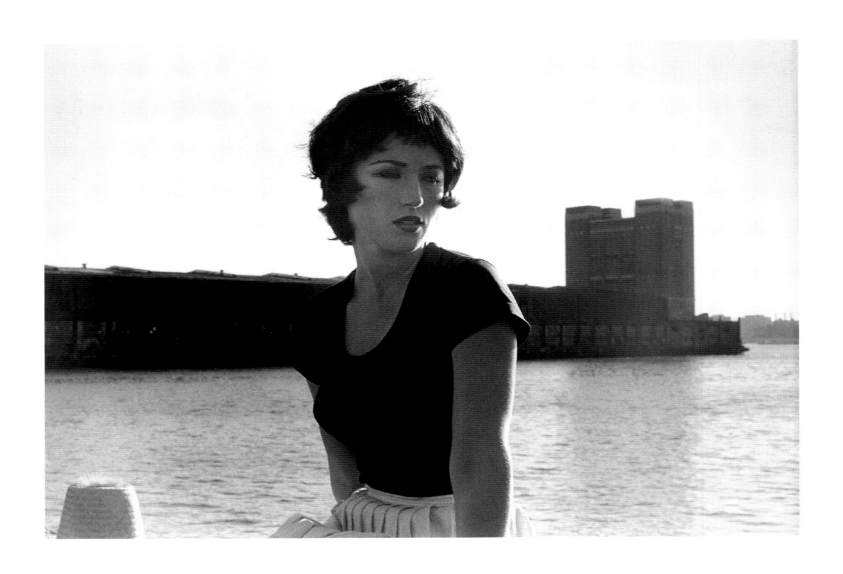

CINDY SHERMAN

Untitled Film Still #24, 1978

Opposite
Untitled Film Still #28, 1979

CINDY SHERMAN

Untitled Film Still #83, 1980

Opposite
Untitled Film Still #60, 1980

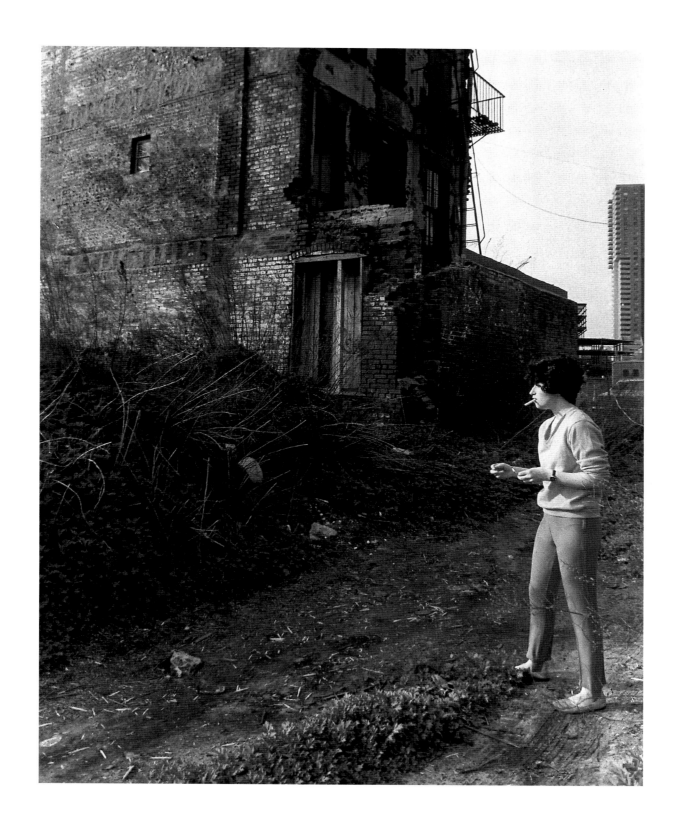

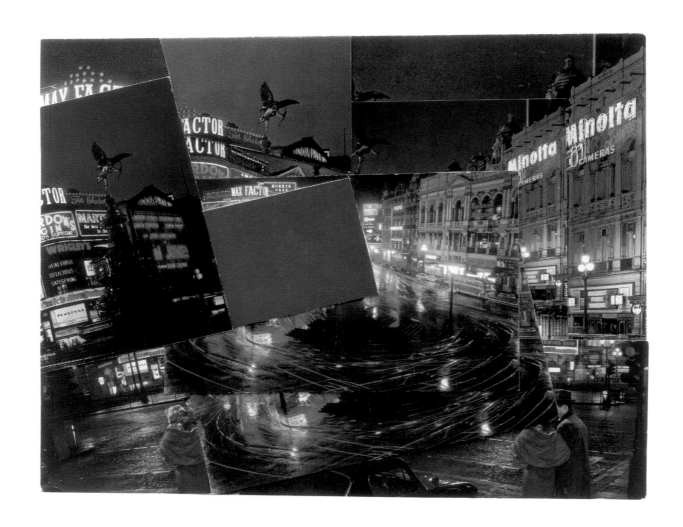

JOHN STEZAKER

Eros VII, 1977–78

Opposite
Eros XV, 1977–78
Eros IX, 1977–78

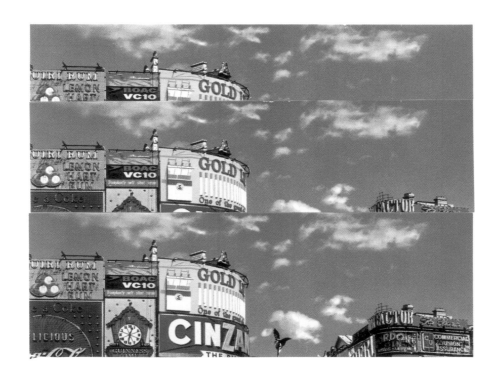

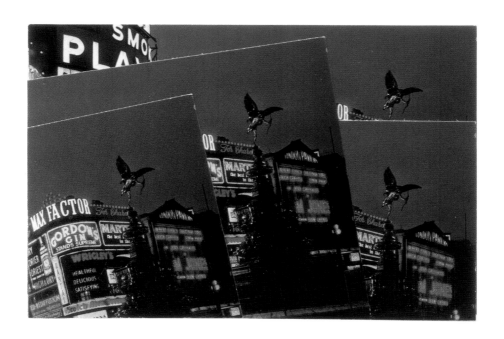

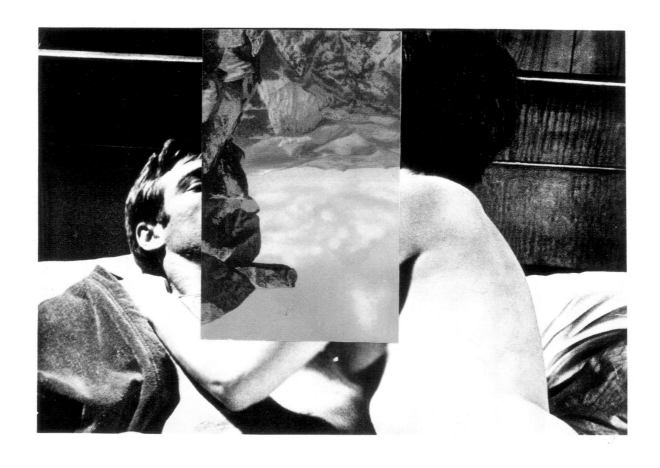

JOHN STEZAKER

Untitled, 1978

Opposite
Untitled, 1979

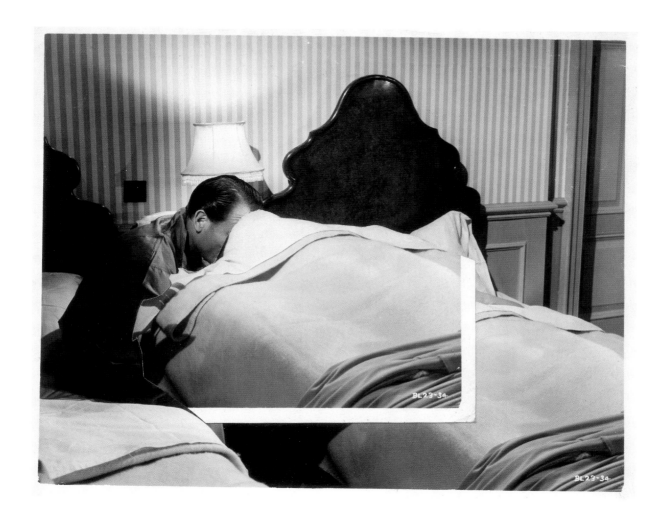

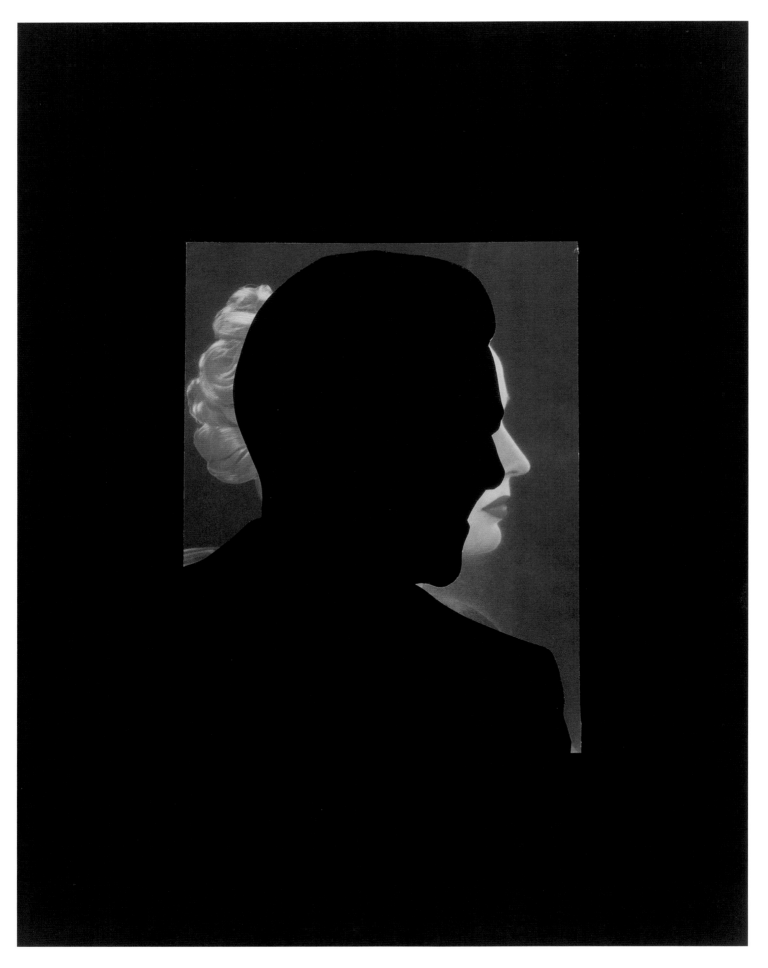

JOHN STEZAKER

Recto-Verso, 1980

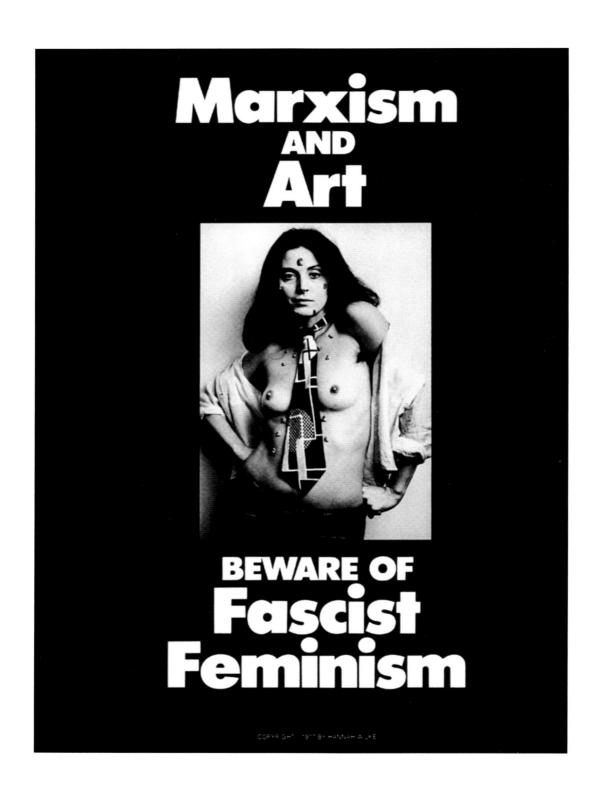

HANNAH WILKE

Marxism and Art: Beware of Fascist Feminism, 1977

Opposite
S.O.S. Starification Object Series, 1974
From *S.O.S. Starification Object Series*, 1974–82

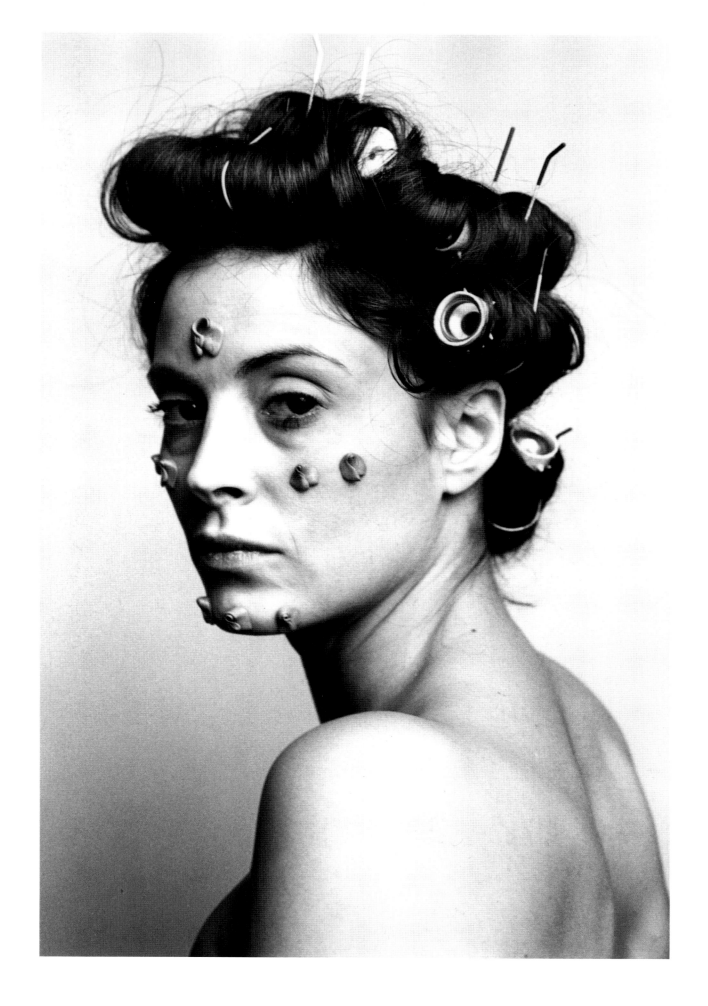

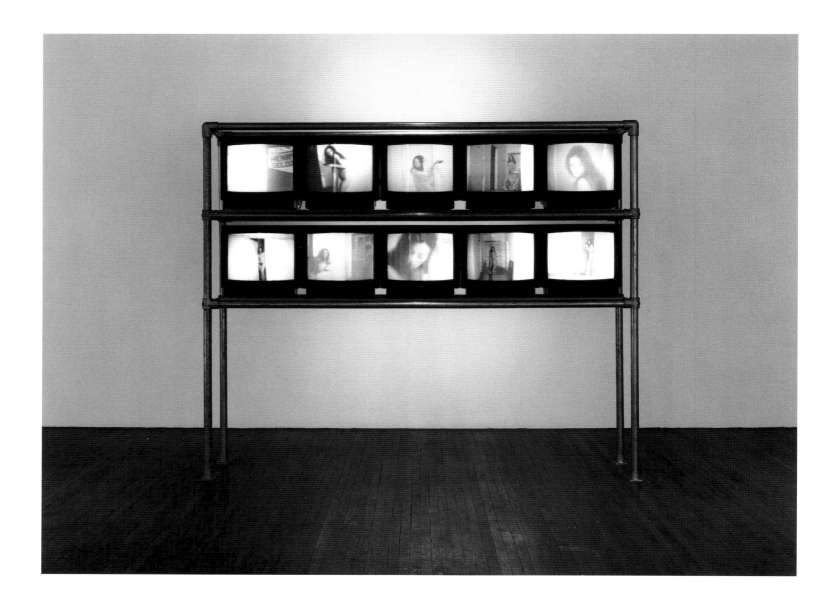

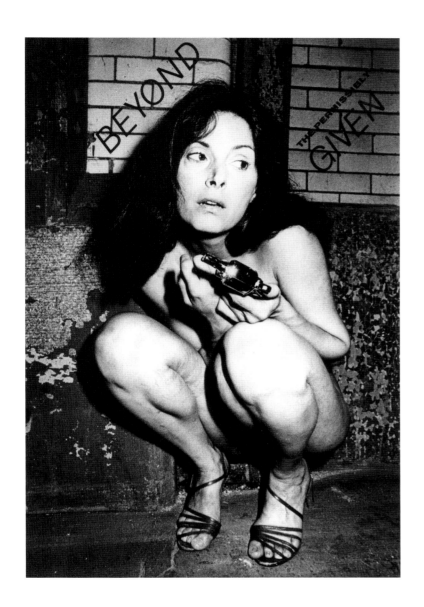
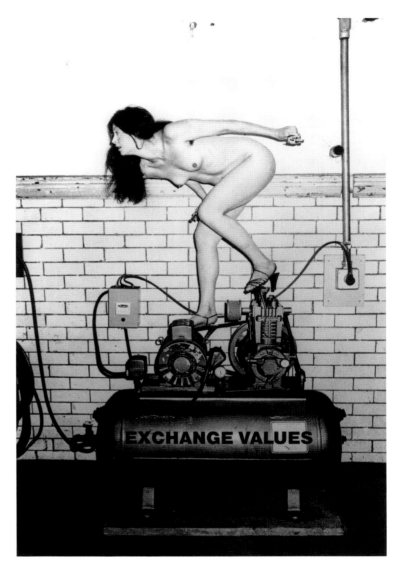

HANNAH WILKE

From *So Help Me Hannah*, 1978–85
Opposite
So Help Me Hannah, 1979–85

Beyond the Permissibly Given (Kuspit), 1978–84
Exchange Values (Marx), 1978–84

THE EXPLODED IMAGE

ARIELLA YEDGAR

The influence of early European avant-garde movements and of other radical figures on the major players in the UK punk and post-punk subcultures has been well documented. Malcolm McLaren's formulae for the various incarnations of the King's Road shop he co-owned with Vivienne Westwood and for the creation of the Sex Pistols are said to have been inspired by such sources as the Situationist International, Lettrist figures and Valerie Solanas.[1] Genesis P-Orridge of COUM Transmissions and Throbbing Gristle took William Burroughs as his mentor and has stated his admiration for Dada.[2] Jamie Reid collaborated with Christopher Gray on the first English publication of Situationist International texts.[3] Also active in the late 1970s to early 1980s were artists who directly employed some of the techniques and artistic formats championed by earlier radicals, such as collage, montage and bricolage, and made them their own. This essay will delineate significant earlier examples of such techniques before discussing work by John Stezaker, Linder, Barbara Kruger, Tony Cragg and Bill Woodrow in relation to these.

The history of twentieth-century Western art acknowledges the earliest fine art collages as those made by Pablo Picasso and Georges Braque in about 1911–12, compositions in which the artists incorporated everyday non-art objects into their paintings, representing still lifes in what they named *papiers collés* (literally,

pasted papers). The cutting and pasting of words, letters and images to produce arresting, often onomatopoeic, collages, posters and announcements was pioneered by Futurists in the early 1910s as a way of communicating their enthusiasm for the explosive forces of progress and the new industrialized metropolis; these agitators also provocatively denounced museums as cemeteries.[4]

The growing popularity of collage with various groups of the European avant garde was due to its immediacy, affordability and accessibility to all who wished to turn their hand to it. It marked a move away from rarefied objects and elevated subjects; in their place disjunction and fragmentation were the forms of this genre. It was also an inherently subversive medium, consisting of disparate fragments that could be freely related to each other through myriad possibilities resulting in startling compositions. Dada artists introduced the human figure into their photomontages in a way that announced their anti-art and antibourgeois ideals. In fact, the proponents of Berlin Dada used the term photomontage to distinguish their work from Cubist collages, with their formalist abstraction, which the Dadaists saw as a dead end (*montieren* in German is to engineer, a non-fine art and non-bourgeois label). Furthermore, in their photomontages the human figure featured prominently and, more importantly, appeared fragmented.

The fragmented self became a recurring theme in the art and literature of Surrealism, a movement that promoted the then relatively new discipline of psychoanalysis and in particular Sigmund Freud's theories of dreams and the unconscious, which were articulated by the Surrealist movement's principal theorist, André Breton. Marxist thought was also investigated and, together with the exploration of the subconscious, became the core of Surrealism's programme of collective social and mental emancipation. Breton, in a strangely collage-like description, defined his movement as a disruptive 'juxtaposition of two more or less disparate realities', and the notion of the creative space of dreams was translated into collages and photomontages by its members.[5]

The Situationist International (SI) was established in 1957 by several European avant-garde groups associated, to a lesser or greater extent, with Surrealism. Like its main antecedents, the movement argued for the collapse of art into life, for social justice and for radical economic change. Its proponents devised a cultural politics that was able to critique consumer capitalism and rejected the Surrealist subconscious as too individualistic. The contents of the twelve issues of the journal *Internationale Situationniste* (1958–69) comprised a dizzying assortment of intellectual and polemical thought alongside forms of 'low' culture, such as comic strips and graffiti. The issues critiqued advertising, featured photographs of graffiti that urged passers-by to act – *prenez vos desirs pour la realite* (take your desires for reality) – and appropriated comics to disseminate Marxist theory: 'in our spectacular society where all you can see is things and their price, the only free choice is the refusal to pay ... but total repression creates total dissent'.[6] An important factor, particularly as they encouraged art-making that plundered existing cultural products, was that the journals were copyright-free as a way of encouraging readers to appropriate what was before them in the publications.

In order to achieve these radical ends, two key activities were theorized and practised by the SI.

One was the *dérive* – drifting through the city for days, weeks, even months at a time, searching for 'forgotten desires': images of play, eccentricity, secret rebellion and negation. It was an activity for recording, theorizing and inventing the urban environment by walking its streets. The second, and arguably most influential, activity was *détournement* (literally meaning to abduct or misappropriate), 'short for *détournement* of preexisting aesthetic elements. The integration of present or past artistic production into a superior construction of a milieu'.[7] The ideas of the SI had great influence on such art students as Jamie Reid, Malcolm McLaren and John Stezaker. The now iconic early collages created as artwork by Reid for the Sex Pistols were the work of a true *détourneur* who diverts existing powerful symbols towards a subversive reading and thus exposes the ideological nature of the imagery of mass culture and usurps it for critical ends.

It was during John Stezaker's first year as a student of painting at the Slade School of Fine Art in London that the student riots of 1968 broke out in France. The riots, which have been closely associated with the theories of the SI, engendered a shift in the artist's practice. Inspired by the ideas of the SI, and seeing the captioned images, Stezaker gave up painting and began making collages, initially incorporating text as a form of captioning, but he realized that what he needed was an art that engaged with the overwhelming circulation of mechanically reproduced imagery. He was struck by the violence of the separation between consumers and the real world and realized that the 'relationship with the image was a problem; it was what sealed the world as other. It had to be brought closer, and cutting [the image] was an act of violence, a way of punctuating things with horror.'[8] Stezaker's film-still collages (begun in 1977) were his response, and denoted the shift from image-text work to an exploration of relationships within, and between, images. In a manner similar to the use of prolonged black or white frames in Guy Debord's films – moments of reality that disrupt the spectacle – Stezaker's

early film-still collages entertain blank cut-out spaces that rupture the distance between reality and its representation.[9] The artist has also used the word 'fragments' to describe the character of photographs and what happens to them when they are cut from circulation as mechanically reproduced images and incorporated into his work.[10]

Stezaker has spoken of the year 1979 as a time of personal crisis and the period in which he began cutting black silhouetted figures out of his film-still collages. In one we see a man holding close – about to kiss, or perhaps to hit – a shadow; in another, a man sits on a bed looking at a black void floating above his head, resembling a speech bubble. The artist was reading Carl Jung's account of the 'shadow' at the time – an unacknowledged part of the self that carries fear and guilt, which we project out on the world – and describes his use of 'a black shadow' as a representation of his state of mind, a kind of 'self-portrait'.[11]

Eros (1977–78; above and pp. 162–63) is a cycle of collages made from old postcards of Piccadilly Circus, in which the statue of the Greek god of love and sexual desire is viewed from various fragmented vantage points at different times of day. In some he appears several times; in others he is just glimpsed at the fringes of the composition. Using multiple copies of the same postcard for each piece,

Stezaker built up images at once full of verve and ambiguity. For the most part Piccadilly Circus is populated by a crowd, but sometimes by a solitary black figure or an embracing couple. Here the great influence of Surrealism on Stezaker is apparent, for the erotic, desire, sexual pleasure and myth were at the heart of the Surrealists' project as they attempted to understand the nature of eroticism and what it revealed about human nature.

Locating these works in an urban landscape also sets them within the sights of the *flâneur* and the *dériveur*. In Baudelaire's notion of the former, the *flâneur* walks the city to feel it closely, its sights, smells and sounds, 'an ironic, alienated and melancholic observer of modernity'.[12] On the other hand, the SI's theory of the *dérive* is an 'implicit critique of the *flâneur*, a *détournement* of *flânerie* and a politicisation of it. It is a movement in groups, not of solitary individuals. It speeds up too. *Dérive* is a "technique de passage hâtif" (a technique of rapid passage).'[13] Stezaker has positioned his work within the tradition of the *flâneur*, his *Eros* series communicating the 'dazzled state' in which he always wishes to put the viewer.[14] But his Piccadilly Circus is as much that of the *dériveur* – seen at a glance, in motion, imagined and real at the same time.

In 1977, the same year that Linder completed a degree in graphic design at Manchester

HANNAH HÖCH
Das schöne Mädchen (The Beautiful Girl),
1919–20

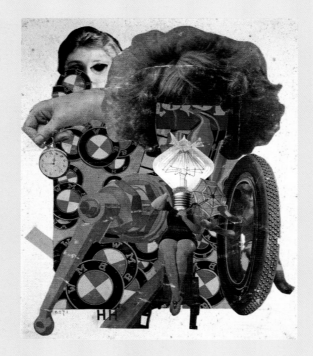

Polytechnic, an untitled photomontage that she had made during her studies appeared in reproduction on the poster and sleeve of the Buzzcocks' single 'Orgasm Addict' (p. 200). The striking piece features the naked, toned and tanned body of a woman whose head has been replaced by an iron and whose breasts sport a smiling, toothy, red-lipsticked mouth for each nipple. Constructed from magazines, this and other photomontages made by Linder have a power that lies in simplicity and directness. There is an economy of elements – the body, the iron, the nipples – and of means, but also great precision, the image floating on a white background, without context or other referents.

Like Stezaker, Linder talked of shaking off the confines of art education:

> I remember the pure pleasure of photomontage. I had spent three years working with pencil, paint and pen trying to translate my lived experience into made marks. It was a moment of glorious liberation to work simply with a blade, glass and glue … I'd always loved magazines and I had two separate piles. One you might call women's magazines, fashion, romance, then a pile of men's mags: cars, DIY, pornography, which again was women but another side. I wanted to mate the G-Plan kitchens with the pornography, see what strange breed came out.[15]

Montage enabled Linder to explore her own sexuality as well as her ideas of feminism and of gender politics through what she referred to as 'the ultimate container of dichotomy'.[16]

Hannah Höch and Linder were both young women operating in a cultural scene dominated by heterosexual male voices, and were aware of their positions as such.[17] Although she has since built a reputation as an innovative and influential artist, regrettably Höch is also known as the only female member of Berlin Dada, who was the victim of sexism at the hand of male peers.[18]

Her ambivalence towards the role of women in Weimar Germany is exemplified in such photomontages as *The Beautiful Girl* (1919–20; above). This dynamic composition consists of fragments of women's heads and bodies adjacent to such signs of mechanization as the insignia of BMW (a controversial symbol of the progress of the newly established, but unstable, Weimar Republic), a crankshaft and an automobile tyre. It is primarily the striking contrast between the compelling arrangement of imagery and the blankness surrounding the composition, fixing the images as disembodied, that lends the piece its edge (an effect that would characterize the majority of photomontages by Linder almost sixty years later). What is more, although some progress had been made, with German women being accorded the right to vote in 1919, the obliteration of the women's faces and the fragmentation of their bodies and facial features in this photomontage attest to the tumultuous road ahead for gender politics.

It is remarkable that although Linder had seen very few examples of Höch's work before making *Pretty Girl No. 1* (1977; opposite), its title and themes echo those of the Dadaist's. In this twenty-four-page glossy magazine – an appropriated copy of a soft-porn magazine – a kind of narrative without progression is played out, much like the 'stories' related in the pornography industry. A naked woman is shown in a sequence of poses, from kneeling to

reclining, in what seem to be different rooms of one house. In each picture her head is replaced by a different appliance: clock, television, kettle, camera, sewing machine, box of cutlery. While the woman's body and surroundings appear in black and white, the objects are seen in realistic colour. The presentation of a monochromatic woman in juxtaposition with domestic appliances results in an unsettling affinity between chauvinism and mass-consumption. Unsurprisingly, and in parallel to Höch, Linder has 'carefully hidden the facial identity of the women' in the majority of her photomontages.[19]

In an untitled photomontage of 1977 (p. 91) a black-and-white image of a man and woman is interrupted by coloured fragments standing in for the couple's facial features: the man's eye is represented by the lens of a home-movie camera that seems to be burning holes into the woman's face, through which her (true?) features can be glimpsed in colour. It is also this 'male gaze' that Linder explores in her montages, a feminist stance that places her in opposition to the more patriarchal ideologies of classical psychoanalysis. In another part of her artistic practice, Linder inverted Freud's claim that one's psyche is determined by gender, that 'anatomy is destiny': she sang 'Anatomy is Not Destiny' on a single released by her band, Ludus, in 1980.

Operating within a feminist critique, the work of Barbara Kruger also challenged patriarchal

relations as exemplified in psychoanalysis – in Freud's theories, in which femininity is associated with subservience, and in Jacques Lacan's, in which woman is made to signify castration or inadequacy. Kruger had cut her teeth as a graphic designer and art director on fashion and lifestyle magazines in New York before developing what has become a highly recognizable art practice. Throughout the 1980s she produced work within a set format, using closely cropped black-and-white images of men and women from mass media and transposing them with incisive slogans, mimicking and subverting media manipulation and gender stereotypes in order to reveal these power structures. For example, the female figures were viewed in passive poses, almost frozen, the men commanding the composition, and there was a recurring use of pronouns regarded as male (we) and female (you), denoting and mocking modes of control. The artist's work was highlighting the fact that images are structured for a 'male gaze' entitled to view and possess, with women mostly figuring as the passive objects of this look. Furthermore, it was not only the language of advertising that was appropriated but also its modes of address, as the works took the form of posters and were also shown outside the gallery context, fly-posted on the streets of New York, for example.

Along with feminist critique, Postmodern discourse was another force gathering pace during the time that Kruger's photomontages began to make their way into cultural consciousness. Kruger has come to be associated with a set of American artists referred to as the 'Pictures Generation', after the *Pictures* exhibition organized by Douglas Crimp at Artists Space in New York in 1977. The most prominent characteristics of the work of these artists were quotation and the use of recognizable images, challenging of authorship[20] and the employment of a structure of representation that precedes its referent. As Crimp wrote of the viewers of such work: 'we are not in search of sources or origins, but structures of signification: underneath each picture there is always another picture'.[21] Furthermore, in the discourse that has sometimes been labelled

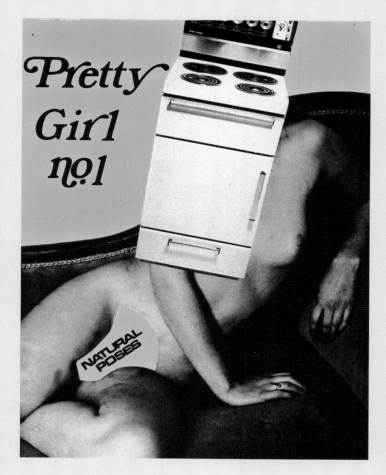

LINDER
Pretty Girl No. 1 (detail), 1977

'critical Postmodernism', the work of this group of artists has been considered in relation to the conditions of commodification and fetishization that enfold and inform art production, conditions that these artists exposed and explored in their own practice.

Bricolage (literally, 'tinkering') is a do-it-yourself activity in which work is constructed from various materials available or on hand, often mass-produced or 'trash'. It is a form of 'assisted ready made', Marcel Duchamp's companion to the 'ready made', in which a recognizable object is transformed through an intervention. The DIY aesthetic is almost synonymous with punk: the safety pin used as a fashion accessory, the ransom-letter look applied by Jamie Reid. Identified as part of the 'New British Sculpture' movement of the early 1980s, the work of Tony Cragg and Bill Woodrow did share one thing: in light of the close engagement with a return to natural materials and organic forms in British sculpture during the 1970s, the two artists' use

of distinctly urban trash was startling and new. Furthermore, Cragg's and Woodrow's preconsumed detritus was reclassified and transformed into the emblems of consumer culture, the imagery seen regularly on our television screens.

In 1981 Cragg was invited by Whitechapel Art Gallery in London to give a solo presentation of his work. The artist had been living in Germany since 1977 and, after revisiting the gallery and seeing the grand proportions of the upper level, he created a series of works based on British emblems. These were made on a monumental scale: a riot policeman, 4 metres (160 in.) high, and a bejewelled crown, almost as large, made of coloured fragments, found bits of plastic. Cragg's work for the exhibition has been perceived as highly polemical, Britain seen through the eyes of a Briton living abroad and, therefore, through the media. Making these works in the year of the Brixton riots – widely believed to have been caused by poor race

TONY CRAGG
Postcard Flag (Union Jack), 1981

relations in this impoverished and predominantly black area of London – and two years into Margaret Thatcher's tenure as prime minister, Cragg appeared to perceive the country as increasingly oppressed, economically and socially. The choice of imagery familiar from the broadcast and print media, coupled with his use of exclusively recycled or found objects, can be viewed as both a critique of over-consumption and a reflection of the recycling of meaning in a society dominated by the media.

Cragg's use of bricolage in the early 1980s has been described as a mapping process, a development from the fragment to the whole.[22] In contrast, Woodrow's work of the same period reversed the process, mapping from the whole to the fragment. Abandoning photography in the late 1970s, the artist began making sculptural assemblages, a process utilized to great effect by Picasso, Duchamp, Robert Rauschenberg and Kurt Schwitters, a kind of three-dimensional collage in which found objects are brought together. In these new works Woodrow explored the concept of a 'host' material on to which another material was implanted or grafted, suggesting that his sculptures were hybrids, the result of materials going through a biological process in his hands. As a *bricoleur*, Woodrow used the materials – broken furniture and appliances – that came most easily to hand and were found in abundance on the streets of Brixton, where he was living. He would break an object into pieces and reuse its raw material, by which point the original object had lost its function and gained a new one – a process that echoed cultural dualities (for example, host and guest, object and image, original and copy).

In 1981–82 Woodrow made a group of works that combined domestic and everyday Western objects with such tribal imagery as a Native American headdress or a Kurumba mask. In *Armchair and Washing Machine with Bobo Mask* (1982; pp. 190–91), the artist removed parts of the outer layers of the household objects, from which he created the African tribal mask, with the mask attached to its 'host'

materials by metal strips on either side. The bringing-together of disparate cultural signifiers points to the delicate issue of the perception of the 'primitive' as 'other' by the West, as well as to the Westernization of other cultures through their exposure to consumerism.[23] In this work Woodrow can also be seen to extend the material nature of assemblage to a comment on consumer and TV society, in which the unknown foreign culture is ascribed the same value as the everyday object.

The contemporary artists discussed above have used previously mediated images in their work, and exploded them. For these practitioners, fragmentation was at the heart of a culture oversaturated with images and media manipulation. Fragments became their tool for subverting the endless stream of imagery: they cut or concealed the images, allied them with other images and texts or broke them down into bits of trash. It is the juxtaposition of the seemingly straightforward with the layered – employing transparent and 'unskilled' techniques to create pieces of cultural complexity – that makes the work of these five artists so powerful and, in very different ways, so radical.

Notes

1. See J. Savage, *England's Dreaming: Sex Pistols and Punk Rock*, London (Faber & Faber) 1991, p. 67.
2. In an interview in 1979 the artist said in relation to his practice and early career: 'I was so idealistic and enthusiastic about people who just did things, like the Dadaists. I loved the fact that they ate live spiders in the streets, just to be provocative.' W. Furlong, 'Four Interviews', in *Hayward Annual 1979: Current British Art*, exhib. cat. by H. Chadwick *et al.*, London, Hayward Gallery, 1979, p. 14.
3. See C. Gray (trans./ed.), *Leaving the 20th Century: The Incomplete Work of the Situationist International*, London (Free Fall Publications) 1974.
4. See F.T. Marinetti, 'The Futurist Manifesto', *Le Figaro*, 20 February 1909.
5. H. Foster *et al.*, *Art Since 1900: Modernism, Antimodernism, Postmodernism*, London (Thames & Hudson) 2004, p. 16.
6. This quotation is taken from the text that appeared on a poster announcing the publication of number 11 of *Internationale Situationniste*, 1967, in the form of a comic strip. For the English translation, see Gray, *op. cit.*, p. 16; for the original French version, see E. Sussman (ed.), *On the Passage of a Few People through a Rather Brief Moment in Time: The Situationist International, 1957–1972*, exhib. cat., Boston, Institute of Contemporary Art, 1989, p. 29.
7. K. Knabb (trans./ed.), *Situationist International Anthology*, Berkeley, Calif. (Bureau of Public Secrets) 1981, p. 46.
8. In conversation with the author, 2007.
9. Guy Debord was one of the SI's main theorists, and its most vocal. For his theory of the spectacle, see G. Debord, *La Société du spectacle*, Paris (Buchet/Chastel) 1967.
10. See *Fragments: John Stezaker*, exhib. cat., London, The Photographers' Gallery, 1978.
11. In conversation with the author, 2007.
12. A quotation from Walter Benjamin's reading of myth and of Baudelaire's writing on the *flâneur* in P. ffrench, 'Dérive: the *détournement* of the *flâneur*', in *The Hacienda Must Be Built: On the Legacy of the Situationist Revolt. Essays and Documents Relating to an International Conference on the Situationist International, The Hacienda, Manchester*, ed. A. Hussey and G. Bowd, Manchester (AURA) 1996, pp. 41–42.
13. *Ibid.*, p. 42.
14. 'Demand the Impossible', interview with M. Bracewell, *Frieze*, issue 89, March 2005, p. 88.
15. Quoted in J. Savage, 'The Secret Public', in *Linder: Works, 1976–2006*, ed. L. Bovier, Zurich (JRP/Ringier) 2006, pp. 10–11.
16. *Ibid.*, p. 14.
17. In an interview in 2007 Linder spoke of her early work as making representations of a world she feared she might have to inhabit, and stated that the 'loudest voices in Punk tended to be male and heterosexual'. See 'The Working Class Goes to Paradise', interview with C. Wood, *Untitled*, issue 40, Spring 2007, p. 8.
18. For a discussion of Hanna Höch's time with Berlin Dada, see *The Photomontages of Hannah Höch*, exhib. cat. by P. Boswell *et al.*, Minneapolis, Walker Art Center, 1996.
19. Linder, 'Northern Soul', in *Linder*, *op. cit.*, p. 28.
20. Sherrie Levine and Richard Prince, for example, are known for openly re-photographing existing photographs and presenting the new work as their own.
21. D. Crimp, 'Pictures', in *Art After Modernism: Rethinking Representation*, ed. B. Wallis, New York (New Museum of Contemporary Art); Boston (D.R. Godine) 1984, p. 186; reprinted from *October*, no. 8, Spring 1979, pp. 75–88.
22. For a discussion of Tony Cragg's and Bill Woodrow's work, see the essays by J. Roberts and L. Biggs in *Transformations: New Sculpture from Britain*, exhib. cat., trans. R. Braune, Rio de Janeiro, Museu de Arte Moderna; London (The British Council) 1983.
23. See Lynne Cooke's essay, 'The Elevation of the Host', in *Bill Woodrow: Sculpture 1980–86*, exhib. cat., Edinburgh, Fruitmarket Gallery, 1986, for an exploration of Woodrow's work in this period.

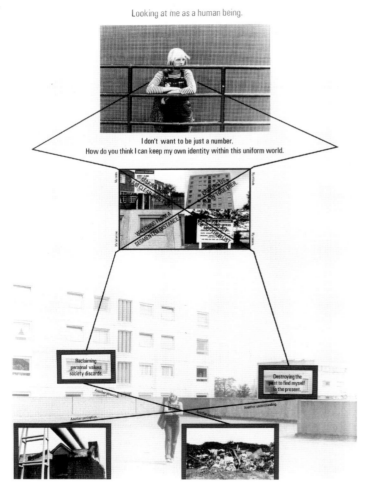

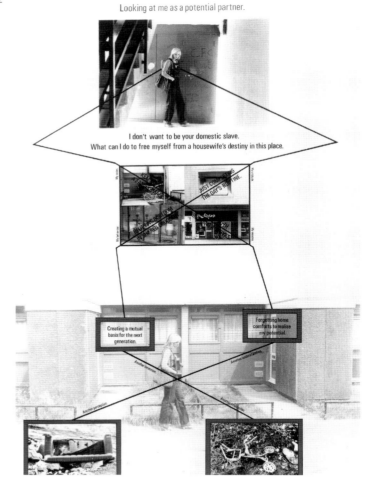

STEPHEN WILLATS

I Don't Want to Be Like Anyone Else, 1976

3

Looking at me as a typical consumer.

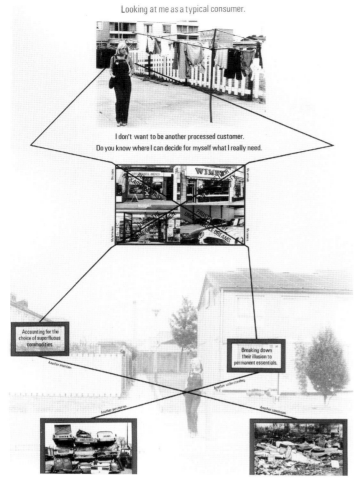

I don't want to be another processed customer.
Do you know where I can decide for myself what I really need.

Accounting for the choice of superfluous commodities.

Breaking down their illusion to permanent essentials.

4

Looking at me as a reliable worker.

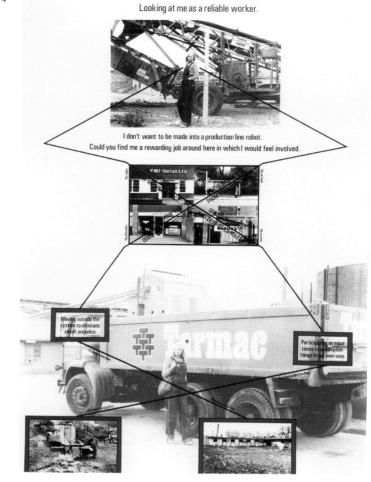

I don't want to be made into a production line robot.
Could you find me a rewarding job around here in which I would feel involved.

Moving outside the system to eliminate inbuilt prejudice.

Participating on equal terms to accomplish things in our own way.

5

Looking at me as a committed supporter.

I don't want to be thought of as a new establishment.
Have you a solution that will help me change the conditions in which I live.

Building a basis for action with others who didn't get anywhere.

Using my education to fight for proper resources.

6

Looking at me as a future consciousness.

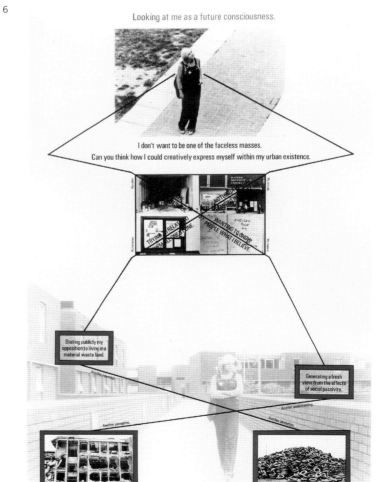

I don't want to be one of the faceless masses.
Can you think how I could creatively express myself within my urban existence.

Stating publicly my opposition to living in a material waste land.

Generating a fresh view from the effects of social passivity.

STEPHEN WILLATS

Are You Good Enough for the Cha Cha Cha?, 1982

Stephen Willats

Are You Good Enough for the Cha Cha Cha? (detail), 1982

183

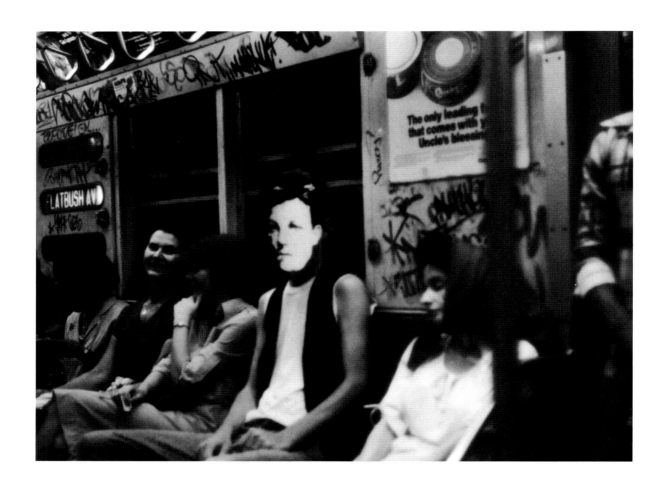

DAVID WOJNAROWICZ

From *Arthur Rimbaud in New York*, 1978–79

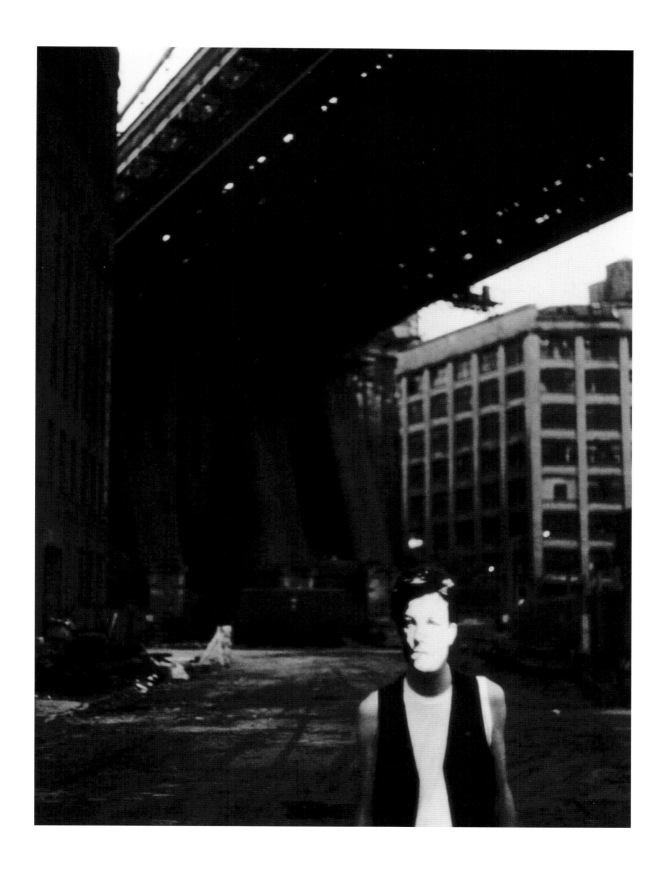

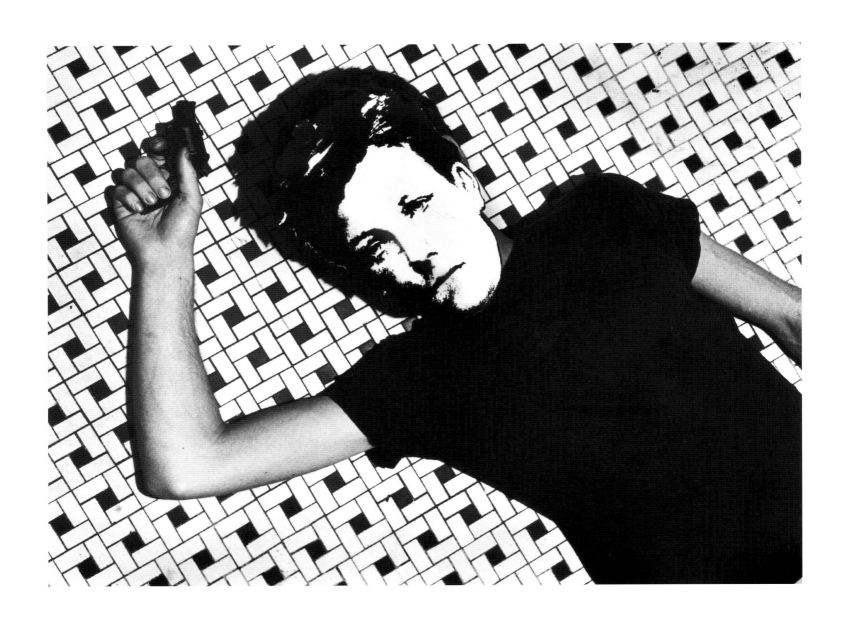

DAVID WOJNAROWICZ

From *Arthur Rimbaud in New York*, 1978–79

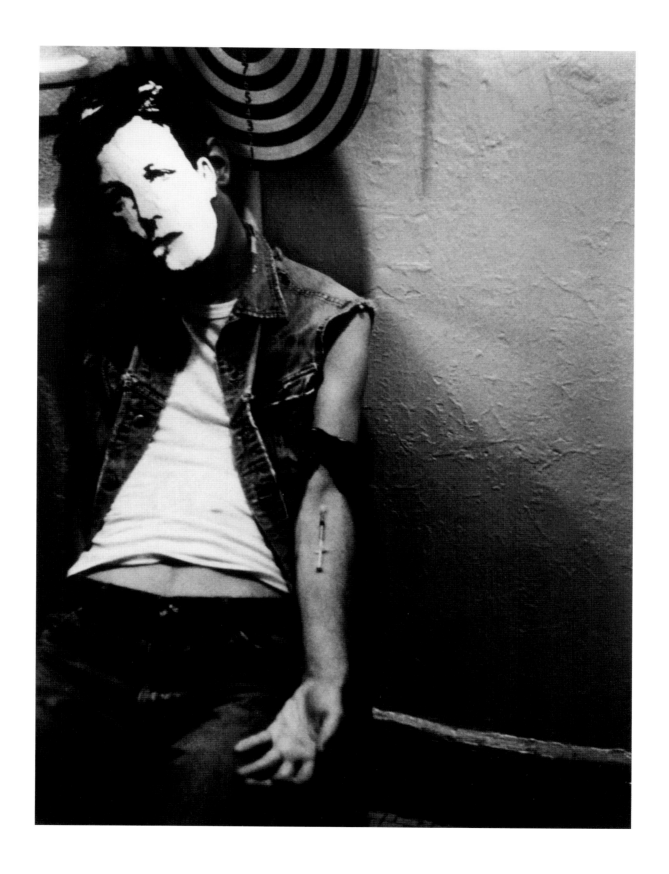

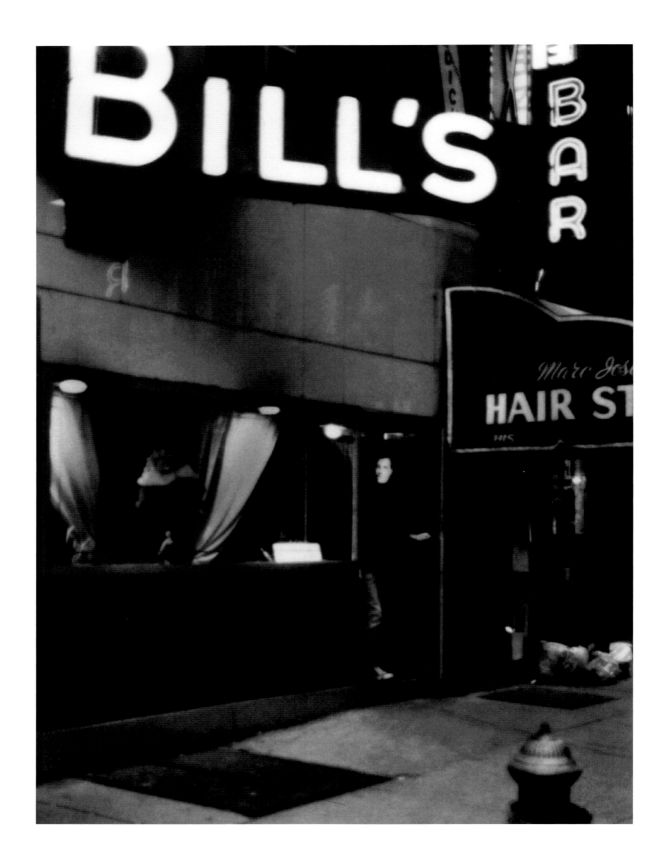

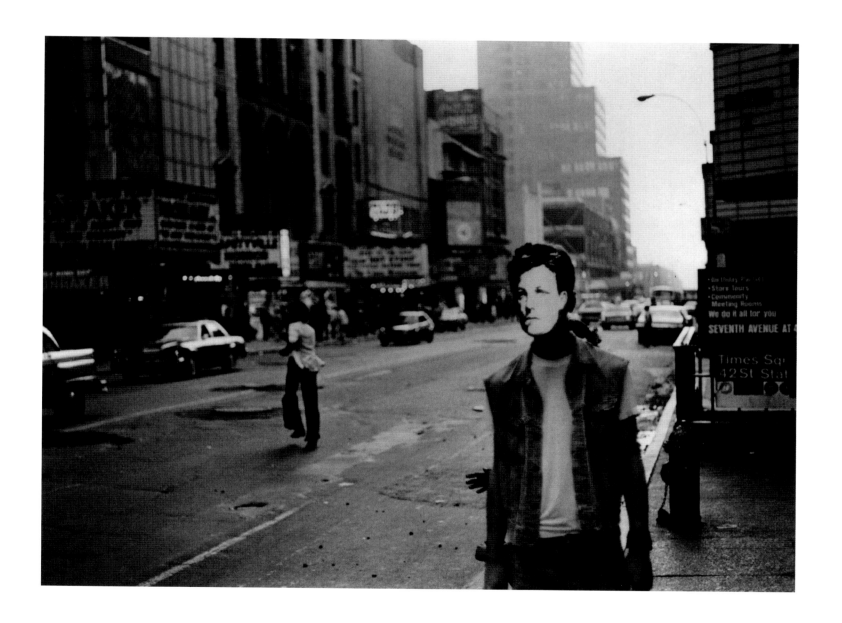

DAVID WOJNAROWICZ

From *Arthur Rimbaud in New York*, 1978–79

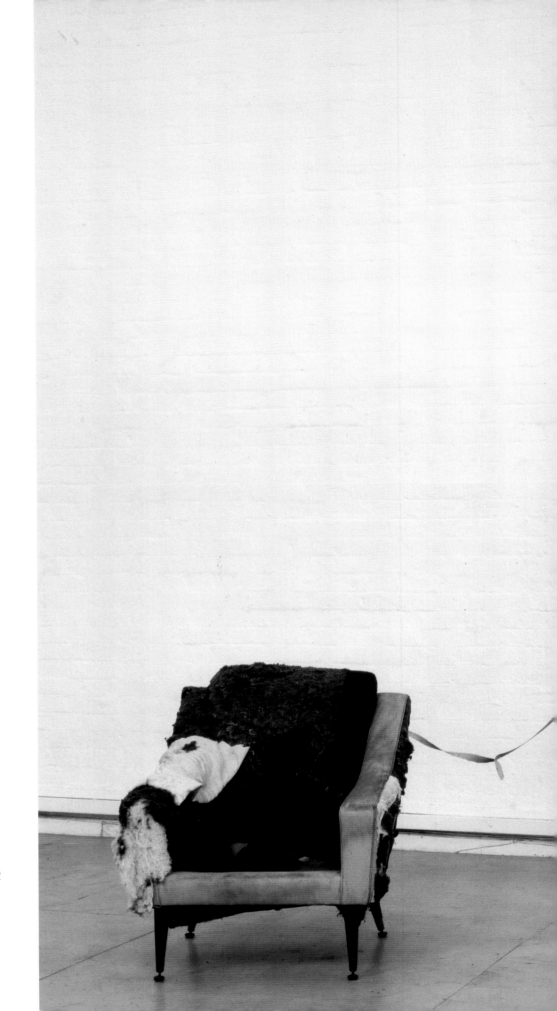

BILL WOODROW

Armchair and Washing Machine with Bobo Mask, 1982

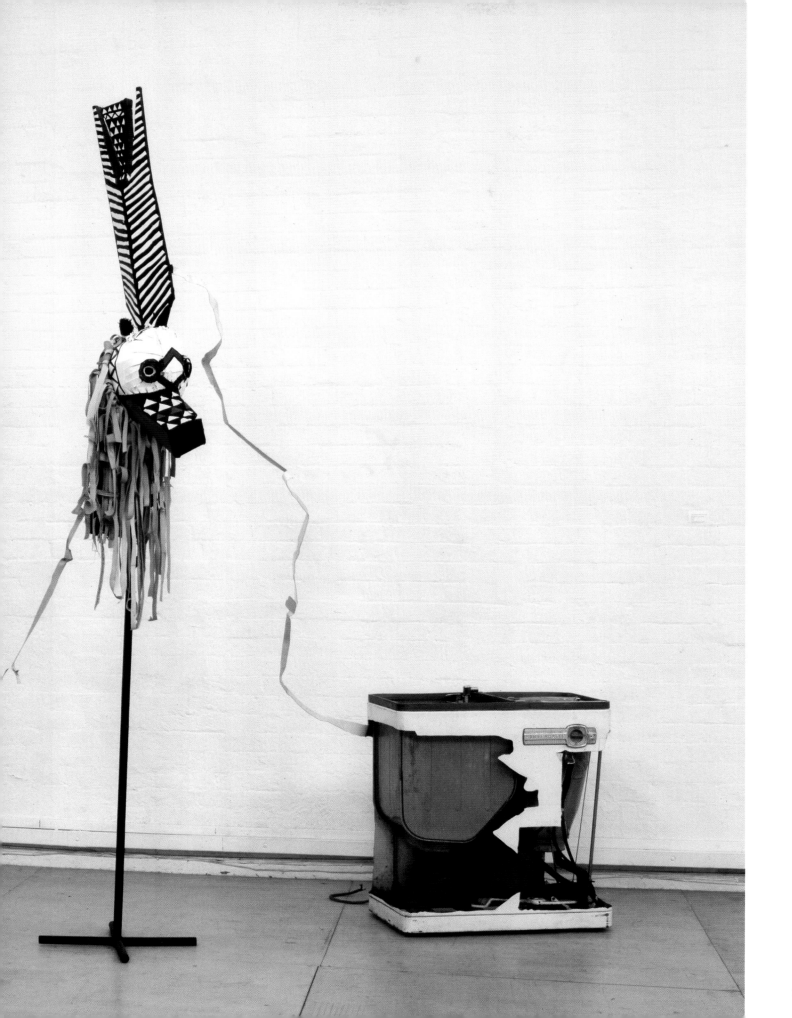

INTERVENTION AND AUDIENCE

STEPHEN WILLATS

CHANGES IN THE SOCIAL CLIMATE

In the 1960s there emerged a 'New Reality' of municipal and private housing schemes of tower and slab blocks, whose development and subsequent demise I consider an important paradigm to understanding the social consciousness that models the present. What was heralded in the 1960s as the way of life for the future by the new professionals was made in a climate of seemingly endless development for the betterment of all, both economically and socially. Notions of plurality and self-responsibility, normally repressed by an authoritative culture into a counter-consciousness, surfaced in the 1960s as a viable way of thinking to the extent that it led to socially liberal concepts even being embodied in the otherwise object-based thinking of the professional planner, architect etc.

Ironically, in contrast these liberal notions gave birth to the architectural 'New Reality' immediately typified in the grey rectangular concrete slabs that have so proliferated in building throughout the current urban setting. For the fundamental physical composition of these structures is founded on parameters that reflect implicitly the ideology of an authoritative, deterministic society, where the occupants have been reduced to the level of objects. The unyielding concrete, the small box-like interiors, the prison-like corridors and walk-ways, the distancing of occupants from the ground and the world outside, are today well documented as the causes of feelings of isolation and general passivity, and all of which, not surprisingly, have been strong factors in their rejection by residents. However, they were seen by the professionals who conceived these structures as embodying worthy, communal ideas, with many architectural features being provided, such as common areas and facilities for residents to socialise and relax.

An optimistic social climate of seemingly endless abundance enabled these structures to be conceived of as highly dependent entities that needed continual provision from society, economically, physically and socially. They also placed on residents the requirement that they should comply with the laid-out norms and rules for social behaviour in order that the building operates and functions according to its conception. The complete dependency on an institutional infrastructure, and the expectancy that the residents would unquestioningly tolerate a code of conduct enforced on them by the authorities and by the physicality of the building further illustrate the duplicity that existed between the planner's conceptions and the resident's experiences. The social optimism of the planner, now shown to be so misconceived, at the time required from everyone an unquestioning passivity that possibly enabled, and certainly paralleled, the rise of a special class of persons, 'the professional'. The rise of the professional's power has been achieved through it being socially accepted that a group should be the possessors of special knowledge, resources and decision-making roles, which are not available or acquirable by people outside their group. Consequently there has been an elevation in the professional's position in relation to other people who are in some way reliant on their decisions. This duality between a liberal social outlook, almost a philosophy of mutuality and tolerance on one hand, and bland acceptance of the authoritative professional as arbitrator and creator, formed the underpinnings of the 1960s popular culture. The subsequent separation between the creators of the popular culture and its audience, its receivers, had a fundamental outcome: it made the audience feel inadequate, in an enforced passivity for they were made to feel that legitimisation of their own self-expression would be dependent on the presence of those attributes that had been established to validate professionalism.

The most important social change that has occurred since the sixties is the demise of liberalism, resulting in the loss of tolerance, mutuality and self-responsibility as tenets of a philosophical outlook, giving rise to a more inhibited and directly authoritative culture. From the early 1970s there was a steady erosion of personal economic and job security and the provision of social services, and along with the accompanying mass unemployment there was a narrowing of opportunity to remedy these losses, which gave people the prospect of a diminished future which inevitably altered their sensibility. The effect of this major upheaval on residents and the physical environment within the New Reality was devastating for, as an embodiment of so much of the optimistic growth of the '60s, it was very badly hit when its high dependency went into reverse. Withdrawal of service hit all areas of the New Reality, physical maintenance was steadily run down, similarly there was a progressive distancing by social service institutions from residents, and lessening of work fulfilment and mobility. As a result residents felt increasingly isolated and distanced from each other, and creeping passivity took over; they were locked into a physical and, ultimately, social trap that apparently offered no escape. The symbol of the optimistic, futuristic New Reality of the 1960s had, by 1975, become the sign post for a repressed, depleted, disillusioned New Reality that pointed towards the 1980s.

It should be noted that it was within the liberal social climate of the late '60s that the concept of modernism in art achieved a near complete dominance, and the basis to movements such as abstraction, minimalism and conceptualism was established. When discussing the theory and practice of these art movements and looking at their relevance to the situation now, it is apparent that their emergence is linked with that of the New Reality. The importance of these movements in art is that they still, despite enormous changes in the social climate, inform most contemporary thinking about art practice. The constructs of minimalism and conceptualism embraced the same climate of mutuality and tolerance that underlay the thinking behind the New Reality. They required from the audience a similar compliance as existed in the New Reality's conception, with an established code of social behaviour required in order to relate to an artwork – only this time it was the artist as distanced professional.

In an equivalent way to the architect or planner professional, the artist elevated his authority through extreme abstraction, denying the values and psychologies of other people, i.e. the audience. Originally the extreme monumental abstraction of minimalism and the speculations of conceptual art were a dissident avant-garde reaction to the old, formal ideas of representation in art which had lost touch with the new '60s social feeling. However, the more the artist deviated, the more abstract and incredulous the works became, the more tolerance and conformity were required from the audience. In addition a pre-knowledge of the artist's own formal language was needed, for, as it became more abstract so it became more personalised, with less and less common points between the artist and other people's realities, the resulting works becoming increasingly self-referenced. Instead of directly addressing the world around the artist, the work cut itself off, it became exclusive, it functioned within a club of pre-knowledge.

This encapsulation of art in the late '60s became in turn the symbol that artists reacted against in the early '70s, in their attempts to redefine and give art a new, socially meaningful function within society. Important to this development was the postulation of theoretical

frameworks that could extend the territory and meaning of art within society. Issues raised at this time questioned the 'market' function of the art object's exclusivity, and its role in reinforcing the determinism of the dominant culture. The existing institutional set-up was challenged and a socially based art defined that took into account issues concerning an artwork's meaning and the availability of its language for an audience. The theoretical arguments made embraced the general social outlook of the period; consequently they were built on notions of tolerance, mutualism and pluralism, the same kind of underpinning that was fundamental to conceptual art. Unfortunately, this resulted in very elaborate theories that rarely made it into works of art; the few attempts that were realised found it impossible to continue as a sustained practice. One of the main reasons for this was that approval, legitimisation, still had in the end to come from the dominant culture, to which the work was in opposition.

Approval from the community is an important mechanism for validation, reward for any endeavour, and the artist looks to his immediate art community for his validation. In the absence of being able to establish an alternative infrastructure to keep pace and support the new forms of art practice, the artist was still dependent on the existing object-based institutions for that validation. For, though the artist was attempting to break new ground in following through his theories into practice, approval was still needed from the professionals and their authoritative institutions, to give confidence that the right track was being pursued. Consequently, apart from affecting the economic basis of this new work before it could develop its own means of support, validation did so psychologically. As already stated, an art practice that set out to deny the authority and relevance of established art institutions was unlikely to get much support from them, and this was one crucial reason for the inhibition of these developments. Furthermore, art practices historically evolved to function inside art institutions, were simply inoperable when transferred to the world outside. When artists did try such a transference they were met with complete misreading, or indifference, even failing to obtain recognition from people that it was indeed a work of art which they were confronting.

Despite these shortcomings, despite the important social upheavals and the resulting differences in social outlook that have occurred, the various developments in art at the end of the sixties and the early seventies still exert an enormous influence on artists' practices today.

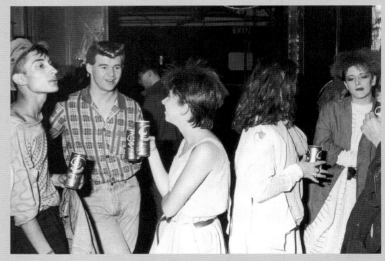

THE FAILURE OF STYLISM

The perpetuation and celebration of the avant-garde notion has alone been enough to ensure that there is a continual evolution of the visual language made by artists. For as long as there are vested interests working to further the social and property functions of the art object then innovation in language has a validity; it injects new life into the system and gives it a façade of being up to date. However, this aeration of new languages is not coupled with any real change in the parameters governing the form, context and social meaning of the artwork. Innovation in language is supposed to be made by the artist to show individual identity, to state uniqueness and separation from other artists, thus the onus is on the artist to stamp a recognisable mark on to the artwork through innovating an original style in language, and it is this pursuit that I call stylism. It is a fact that the pursuit of stylism goes on quite independently of the priorities,

preoccupations, of the world outside the 'art professional' and attendant institutions. This self-centred, academic closing off is culturally celebrated, and even signals separateness to the public through the self-referenced, abstract languages that have been especially created by the artist. In the art history of the dominant culture, stylism is equated with progression in the evolution of art; the creation of precedence that gives further creative twists to self-referenced languages which are then ratified, sanctified by the art institutions to which they are bound.

However, not all artists have ignored the change in the social climate that has taken place. The very notion existing of avant-gardism would tend to mean that something of the social changes would have been encapsulated, if only the visually public outface, into new stylistic innovations. Those artists who have attempted to reappraise their practice and respond on a deeper level have ended up being appropriated by the same institutions and professional mechanisms in society that have legitimised the current cultural repression. It is important to understand the process by which this appropriation takes place, for it is a continual pressure and hazard that has in the past and, unless checked, will in the future render any possibility of the artist intervening in the cultural process meaningless. There is an intertwining between the artwork as object and stylism, the latter being layered on to the historical rules that govern that art object, i.e. painting, sculpture etc. within the dominant institutional culture.

Though artists in the past have always externalised their conceptions about the world in a physical manifestation of one sort or another, the idea of the self-referenced abstract art object is relatively recent, a product of our object-based culture. For it is perceived by the dominant culture that the art object is better able to fulfil the expectations and function of the possession of property than any other manifestation that the artist might make as it reinforces the property base of society. The value which uniqueness has in the elevation of possessive power has given the combination of the object with stylism an overwhelming dominance, creating enormous pressures on the artist to go into the production of stylistically dextrous objects. By production I mean that from one original conception a succession of works is produced, each a variation on the first original concept.

The artist has been caught between two directly conflicting pressures, one unavoidable, emitting from the effects of changes in society on the street, the other from an aloof institutional art world, to produce unique objects resulting in no more than a further dextrous twist in stylism. Some artists have recently tried to embody some aspects of the sensibility being generated in the New Reality, which has quickly been perceived by them as giving their language, their stylism, a new currency. But the resulting art objects have all been held within the art institutional social context that is certainly not close to, or even has any conception of, the environmental conditions that generated a counter-consciousness within and against the New Reality. 'Newness' has a definite currency within a market that is directed at the private collector; also the link between the act of discovery and newness becomes an attribute seized on by the art professional to give status. Something new is in itself attention-grabbing and, while the pressure of the art world's vested interests to do something new is enormous, so is the pressure from the artist's personal drive to give fulfilment to the ego. However, should the audience try to penetrate beyond the new stylisms and search for a deeper social meaning, it becomes quickly apparent that what is being made is just a manipulation of language for its own sake. 'Newness' is not lasting, and so any marketable edge in presenting an innovation in stylism, even if it appears to have a socially significant language, wears off, and the art object is then again reliant on the purely formal academic criteria of institutions.

Artists have attempted to give their work inside art institutions a social connection in a number of ways, the most important being by the synthesising of images and objects from the street, and then presenting them as art objects. Another strategy, and one that was doomed to fail immediately, was the taking of artworks normally bound to the inside of these institutions and then repositioning them on the street. When this was tried, they simply could not be read by the audience and, more often than not, were destroyed. Unfortunately the preoccupation by artists with the images of advertising also fails to achieve a cultural meaning beyond art institutions but for completely different reasons. The thinking was that by recycling the imagery of advertising and, in the process, transforming it in an artwork, artists could build up a semiotic language that would have the availability of advertising strategies. Artists mimicked the visual composition and coding used in advertising, but only the stylistic visual format of single-frame presentations, representing images that were devised and deterministically employed by the dominant culture, as refined art objects.

These attempts to widen an artwork's meaning by reusing already idealised images, those of the dominant culture, have been doomed by that very fact. As previously stated, the dominant culture's idealised images are object-based, reducing people and social relationships to objects and property; so the imitation of these images by implication renders the artwork object-based as well; it simply becomes stylistic representations of advertising. Both approaches towards seeking greater social meaning do nevertheless typify the growing awareness by artists that they should seek to resolve this issue.

LESSONS FROM MARGINAL DIVERSITY

It is ironic that the most articulate and widespread cultural response to the rise of authoritarianism has been made not by artists whom one would expect to be well placed to make such a response, but by those who would seem least likely and able to have the motivation and the means. What the generation that grew up in the early 1970s on the New Reality housing schemes have managed to achieve is of immense importance to everyone, especially the artist, for they have established their own cultural forms of expression as an overt statement of a counter-consciousness based on self-organisation and community.

The catalyst for this explosion of creative forms in the mid-1970s was first-hand experience of the deteriorating environment and life in the New Reality, which directly affected the psychology and identity of young residents stigmatised by their surroundings. These young people were contained, not just physically, but socially, and were made to feel by that containment utterly remote from the dominant culture's idealisations that were being constantly projected on to them for emulation. In fact there was no possibility of emulating those projections for there was neither the economic means nor the psychological will to conform, for the projections had become remote by reflecting a life with possessions that could never be obtained and

this generated increasing alienation and hostility. Another focus of this generation's alienation was the further promotion by the dominant culture of a professional identity and the practice of professionalism in areas that had already been rejected by them. This rejection on one hand was directed towards the institutional bureaucracy that people were made increasingly dependent upon, i.e. the various social services, and on the other hand towards the music business, for music was one of the most important catalysts for community feeling. Both, but especially the latter, were by 1975 seen as projecting a distant world that had already become a symbol of alienation.

Music had become big business and, instead of being made in accessible clubs by local musicians, was now presented by stars to mass audiences through huge concerts, on elaborately packaged LPs and videos, on TV commercials, all of which tended to elevate the performers into the realms of God-like figures.

Instead of following the projected cultural stereotypes into a reflective passivity as the artists had done, a young generation of residents asserted to anyone, including themselves, that they did indeed exist, even if this had to mean that graffiti and destruction proliferated on the estates. People fought back against their entrapment. What was perceived as wanton vandalism by the authorities can also be seen as an expressed creativity, directed at the context that was most meaningful, the physical fabric of the building in which they lived. The punk movement, when it first came to public notice, strongly expressed the idea of self-organisation (DIY – Do It Yourself – was an important slogan to punk) and contextual expression. The punk ideology was anti-professional, it was for complete spontaneity, it was also aggressive and alienated; but it expressed a basic mutuality between participants, through seeking common languages and common meanings, for now the audience were also the creators. The fundamental message of punk that is so culturally important for the artist, is that everyone has the potential to express their own creativity, and that what is meaningful to people is relative to the context in which it is received and made. The most well-known form of this DIY spontaneity is through the punk bands that were formed and the DIY records that they made, but other manifestations were equally important: fanzines, dance and forms of dress and personal adornments. All the different manifestations of self-creativity reinforced in various ways the sense of community for a generation that had been made to feel so culturally isolated and created a common bond between those that had been so alienated. One way in which this was visually stated to other people was through forms of dress that used codes which were aggressively tangential to the norms of society, and as such they became an important means of denoting independent existence, displaying rejection of the normative world outside the group.

The means by which these new DIY codes were created was through an important cultural act taking place. Diverse codes and symbols, sometimes with obvious authoritative connotations, were borrowed from the dominant culture, brought together and given a different meaning by being transformed into a new language that reflected the self-identity and sensibility of the creators. Important to these transformations was that the codes and symbols had already been discarded, or seen as taboo by the dominant culture, and that bringing them into new original relationships made them an unacceptable challenge to society. The act of simply transporting the code from social context to social context changed the previously accepted

meaning of the codes, and thus they could leave the domain of the dominant culture. The act of transformation is the fundamental act of human creativity, and within our own culture this is shrouded in mystique and often projected as the exclusive preserve of the artist. But for once the whole of society was quickly made aware of the new codes and what they meant by their display on the streets.

While rejecting the norms and beliefs of the dominant culture, punk still had to co-exist within it, this dilemma being resolved by establishing as a natural consequence of their DIY philosophy their own parallel world of social resources. Thus punk subsequently evolved over a number of years into more established foundations of a counter-culture, a culture of the night. Agents for communication and centres of community were set up, not as in any institutional hierarchy, or with any monolithic permanence, but as a continually changing, self-organising network. Particularly important to this more recent 'night culture' in the '80s are the 'private clubs', started by individuals from those New Reality housing estates, principally for their friends, to create a feeling of community, and to screen themselves from the prying eyes of the dominant culture so that they could freely express themselves. The importance of these private clubs as a context or institution is that they were a denial of the property values held by the dominant culture's institutions, for they were started mutually amongst friends for friends.

The relevance to the artist of these private clubs is that they were there to act as a creative catalyst, to further an origination and expression that would be unacceptable to the prevailing social norms, certainly those dominant in the Art Museum. The private clubs were institutions of a kind and as such they were a statement by the night people of their self-organisation, and patterns (in actuality they were opening and closing all the time) and preferences evolved and were altered by those who created them. Here the relationship between the creators of cultural activity and the audience was totally interwoven. Simply there was no separation; the audience were participants. This inter-relationship between creators, while marginal and without the resources of the dominant culture, nevertheless succeeded in developing a parallel world, and even intervening in the dominant culture's process of generating new perceptions of itself.

Such an interventional effect was only transient, but the punks and night people accepted that transience as an essential element to socially based expression. It is from marginalised areas of creativity such as punk that the artist can find powerful heuristics relevant to his own situation, and by taking them on board can gain a tactical confidence. I repeat that it is important to note that, at a time when the artist baulked at facing up to the rise of an authoritative institutional culture, others, physically, socially, economically, psychologically marginalised and alienated from that dominant culture, created their own powerful expressions.

This text first appeared in S. Willats, *Intervention and Audience*, London (Coracle) 1986, where it was illustrated with photographs by the artist, as shown.

CHRONOLOGY

ELIZABETH MANCHESTER AND PAUL BAYLEY

1974

ART

Victor Burgin: exhibits *Lei Feng* at Lisson Gallery, London
COUM Transmissions: perform at several London venues, including Roundhouse, Art Meeting Place and Film-Makers' Co-op
Gilbert & George: *Dark Shadow* at Nigel Greenwood Gallery, London
Peter Hujar: first solo exhibition at Floating Foundation of Photography, New York
Barbara Kruger: first solo exhibition at Artists Space, New York
David Lamelas: makes *The Desert People* in Los Angeles, shown at Collegiate Cinema, London, by Jack Wendler Gallery
Andrew Logan: makes giant painted fibreglass flowers for sculpture garden on roof of the Biba store in Kensington, London; moves into studio at Butler's Wharf, along with Derek Jarman and others, where parties are held and Jarman's Super-8 films screened
Paul McCarthy: performs *Heinz Ketchup* and *Sauce* in Los Angeles; *Hot Dog*, *Meat Cake #1* and *2* and *Penis Painting* in Pasadena; and *Meat Cake #3* in Newspace Gallery, Los Angeles
Gordon Matta-Clark: *Splitting*, first cut house, in New Jersey; participates in *Anarchitecture Show* in SoHo, New York (group exhibition)
Jamie Reid: creates artwork for Christopher Gray's book on Situationism, *Leaving the 20th Century*
Hannah Wilke: solo exhibitions at Ronald Feldman Fine Arts, New York, and Margo Leavin Gallery, Los Angeles

• *Beyond Painting and Sculpture*, organized by Richard Cork for Arts Council, and including Victor Burgin, Gilbert & George and John Stezaker, tours UK
• Emergency Tenant Protection Act passed in New York State, facilitating rehabilitation of light industrial spaces by artists in Lower Manhattan
• The Kitchen and Anthology Film Archives move to SoHo, New York
• Los Angeles Institute of Contemporary Art (LAICA) founded
• *Transformer* exhibition at Kunsthalle, Lucerne, looks at the imagery of David Bowie, Brian Eno and Bryan Ferry

MUSIC

Brian Eno: *Taking Tiger Mountain (by Strategy)* (Island)
Iggy and the Stooges: play last concert in Detroit, a performance later released as *Metallic KO* (Skydog)
The Patti Smith Group: 'Hey Joe' (Mercury/Sire), first single
The Residents: *Meet the Residents* (Ralph), self-released LP
Sex Pistols: Malcolm McLaren takes on management of what will become the Sex Pistols

• CBGB, New York, hosts gigs by Television, the Ramones and Blondie
• Malcolm McLaren and Vivienne Westwood rename their shop SEX, and Jordan becomes its figurehead

Derek Jarman as Miss Crêpe Suzette at the third Alternative Miss World, Andrew Logan's studio, Butler's Wharf, London, 22 March 1975

1975

ART

COUM Transmissions: perform at Oval House Theatre, Royal College of Art and Art Meeting Place, London
Derek Jarman: wins Andrew Logan's Alternative Miss World as Miss Crêpe Suzette (above); judges include Celia Birtwell and David Hockney
David Lamelas: makes *The Violent Tapes of 1975*, commissioned by and exhibited at Institute of Contemporary Arts (ICA), London
Paul McCarthy: performs *Sailor's Meat* and *Tubbing* in his Pasadena studio and *Dancer-Rumpus Room* at University of Southern California Medical Centre, Los Angeles
Robert Mapplethorpe: takes the portrait of Patti Smith that will be used on the cover of her album *Horses*
Gordon Matta-Clark: the artist and his friends spend the summer cutting an industrial building at Pier 52 on the Hudson River (*Day's End*); they are discovered after three months' work, and a warrant is issued for Matta-Clark's arrest; he flees to Europe

MUSIC

The Electric Eels: 'Agitated' (Rough Trade) recorded in Cleveland, not officially released till three years later
The Modern Lovers: 'Roadrunner' released as part of *Beserkley Chartbusters* (Beserkley) compilation LP
Pere Ubu: '30 Seconds Over Tokyo' (Hearthan), debut release
The Ramones: play first gigs in Los Angeles
Sex Pistols: play first gig, at St Martin's College of Art, London
Television: 'Little Johnny Jewel' (Ork), debut release

• *Punk* magazine launched in New York
• Rough Trade, shop and independent record label, opens in London
• *Street Life* magazine launched in London

Adrian Piper: performs *Some Reflective Surfaces* at Artists Space, New York, and makes *The Mythic Being* series in Cambridge, Massachusetts
Martha Rosler with Allan Sekula: exhibit at The Kitchen, New York, and broadcast *The Evening News* at Los Angeles Hilton
Stephen Willats: installs *Meta Filter* at The Gallery, London

• AIR (Artists Information Registry) Gallery opens on Shaftesbury Avenue, London

1976

ART

Victor Burgin: *Possession* poster is pasted in the streets of Newcastle-upon-Tyne; solo show at ICA, London
COUM Transmissions: *Prostitution* exhibition, ICA, London, which includes framed pages from pornographic magazines featuring Cosey Fanni Tutti, causes questions to be asked in the House of Commons; they perform 'Cease to Exist No. 4' at LAICA, Los Angeles
Gilbert & George: *Mental* at Robert Self Gallery, London, and *Dead Boards* at Sonnabend Gallery, New York
Peter Hujar: publishes *Portraits in Life and Death*
Derek Jarman: first full-length feature film, *Sebastiane*
Mike Kelley: *Dancing Partner*, first performance at CalArts, Valencia, California
David Lamelas: moves to Los Angeles; exhibits *The Violent Tapes of 1975* at Claire Copley Gallery, Los Angeles
Andrew Logan: *Goldfield* installation staged at Whitechapel Art Gallery, London; demolition of his giant flower sculptures in Biba's roof garden
Paul McCarthy: performs *Political Disturbance* at Biltmore Hotel, Los Angeles, and *Class Fool* at University of California, San Diego
Gordon Matta-Clark: *Doors Through and Through* features in *Rooms*, launch exhibition at P.S.1 Contemporary Arts Center, Queens, New York
Adrian Piper: performs *Some Reflected Surfaces* at Whitney Museum of American Art, New York
Jamie Reid: begins creating artwork for the Sex Pistols
John Stezaker: shows at Nigel Greenwood Gallery, London
Hannah Wilke: *Starification Photographs and Videotapes* at University of California at Irvine
Stephen Willats: publishes *Art and Social Function: Three Projects*

• *Artscribe*, *Art Monthly* and *Camerawork* magazines all launched in UK
• *Studio International*'s 'Art & Social Purpose' issue, edited by Richard Cork, features Rosetta Brooks, Victor Burgin, Gustav Metzger, John Stezaker and Stephen Willats

MUSIC

Blondie: *Blondie* (Private Stock), debut LP
Crime: 'Hot Wire My Heart' (Crime)
Devo: *The Truth About De-Evolution*, a film by the band, wins a prize at Ann Arbor Film Festival and is championed by David Bowie
The Damned: 'New Rose' (Stiff)
Richard Hell and the Voidoids: *Blank Generation* (Ork), EP
The Modern Lovers: *The Modern Lovers* (Beserkley), debut album produced by John Cale and recorded in 1972
The Patti Smith Group: *Horses* (Arista), debut LP, with cover image by Robert Mapplethorpe
The Ramones: *The Ramones* (Sire), debut LP
The Runaways: 'Cherry Bomb' (Mercury)
The Saints: 'I'm Stranded' (Power Exchange)
Sex Pistols: play at Andrew Logan's Valentine's Ball in February and at Manchester Free Trade Hall in July; release 'Anarchy in the UK' (EMI); dropped by EMI after Bill Grundy television interview scandal
Throbbing Gristle: play first performance at Air Gallery, London, and officially launch at opening of COUM's *Prostitution* exhibition at ICA

• 100 Club, London, hosts International Punk Rock Festival, 20–21 September
• The Masque club opens in Los Angeles
• *Max's Kansas City*, compilation album of bands that regularly played at this New York club, a rival scene to CBGB, including Pere Ubu and Suicide
• Roxy Club opens in London
• *Sniffin' Glue* fanzine launched
• Stiff Records founded

Throbbing Gristle poster for *Music from the Death Factory*, 1976

1977

ART

Jean-Michel Basquiat: starts spray-painting graffiti on subway cars and slum buildings in Lower Manhattan, inventing the signature SAMO (same old shit) with school friend Al Diaz

COUM Transmissions: perform *Genetic Fear* at ACME Gallery, London

Nan Goldin: exhibits with David Armstrong at Atlantic Gallery, Boston

Jenny Holzer: *Truisms* posted all over New York

Peter Hujar: *New York Portraits* at Marcuse Pfeifer Gallery, New York

Derek Jarman: makes Super-8 films with Jordan, including *Jordan's Dance* and *Jubilee Masks*

Mike Kelley: forms the band the Poetics, along with Don Krieger and Tony Oursler

David Lamelas: exhibits at Whitney Museum of American Art, New York, in *The New American Filmmakers Series*

Linder: creates photomontage used for cover artwork of 'Orgasm Addict' (United Artists) by the Buzzcocks (below)

Andrew Logan: *Reflections 77* at Patrick Seale Gallery, London

Paul McCarthy: performs *Grand Pop #1* and *2* at USC Medical Center, Los Angeles, also *Hollywood Halloween*

Robert Mapplethorpe: dual exhibitions at Holly Solomon Gallery and The Kitchen, both New York, his breakthrough shows

Martha Rosler: performs *What's Your Name, Little Girl?* on CLOSE Artists' radio KPFK, Los Angeles; *Performance Transformations* and *What is Feminist Art?*, both at The Women's Building, Los Angeles

Hannah Wilke: posts *Marxism and Art* posters outside Leo Castelli Gallery, New York

- LACE (Los Angeles Contemporary Exhibitions), an artist-run space, opens
- New Museum for Contemporary Art opens in New York
- *Pictures* exhibition, Artists Space, New York, curated by Douglas Crimp and travelling to Los Angeles Institute of Contemporary Art, includes Jack Goldstein, Robert Longo and Sherrie Levine

MUSIC

Blondie: *Plastic Letters* (Chrysalis)

David Bowie: *Low* (RCA) and *Heroes* (RCA), both produced by Brian Eno in Berlin

Buzzcocks: *Spiral Scratch* (New Hormones), EP, first UK do-it-yourself release, from Manchester; 'Orgasm Addict' (United Artists), first release on major label; *Another Music in a Different Kitchen* (United Artists), debut LP

Chrome: *Alien Soundtracks* (Siren)

The Clash: 'White Riot' (CBS); *The Clash* (CBS)

The Dead Boys: 'Sonic Reducer' (Sire)

Brian Eno: *Before and After Science* (Polydor)

The Germs: 'Forming' (What), first single

Richard Hell and the Voidoids: *Blank Generation* (Sire)

Kraftwerk: *Trans-Europe Express* (EMI)

Bob Marley: *Exodus* (Island)

Iggy Pop: *The Idiot* (RCA) and *Lust for Life* (RCA), produced by David Bowie in Berlin

Sex Pistols: 'God Save the Queen' (Virgin), unofficial bestselling single in the Queen's Jubilee week; *Never Mind the Bollocks* (Virgin)

Suicide: *Suicide* (Red Star)

Talking Heads: *Talking Heads '77* (Sire), first LP

Throbbing Gristle: *Second Annual Report* (Industrial)

The Weirdos: 'Life of Crime' (Bomp)

Wire: *Pink Flag* (Harvest)

X-Ray Spex: 'Oh Bondage! Up Yours' (Virgin)

- Malcolm McLaren and Vivienne Westwood rename their shop Seditionaries
- Elvis Presley dies
- *Search and Destroy* magazine launched in San Francisco
- *Slash* magazine launched in Los Angeles
- Socialist Workers Party founds Rock Against Racism and Anti Nazi League

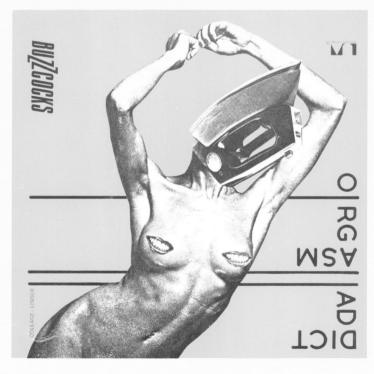

Linder and Malcolm Garrett
Single cover of the Buzzcocks' 'Orgasm Addict', 1977

1978

ART

Jean-Michel Basquiat: *The Village Voice* reveals him to be the graffiti artist SAMO

Gilbert & George: *New Photo Pieces* at Sonnabend Gallery, New York

Jenny Holzer: *Truisms* exhibited with audio at Franklin Furnace, New York, first major show

Derek Jarman: releases *Jubilee*, featuring Jordan and Adam Ant

Linder: designs *Beating Hearts* poster with Malcolm Garret for the Buzzcocks; creates post-punk group Ludus; produces the fanzine *The Secret Public* with Jon Savage, published by New Hormones; designs *Real Life* album sleeve for Magazine

Andrew Logan: sound-and-light spectacular *Egypt Revisited* in a tent on Clapham Common, London

Robert Mapplethorpe: publishes *X Portfolio*, containing images depicting gay sadomasochistic acts

Gordon Matta-Clark: dies of cancer at age thirty-five

Raymond Pettibon: designs cover for *Nervous Breakdown* (below), first album by local band Black Flag (Greg Ginn, his brother, is guitarist); self-publishes first book of cartoons, *Captive Chains*

Martha Rosler: performs *Domination and the Everyday* at LAICA, Los Angeles

John Stezaker: *Fragments* at Photographers' Gallery, London

Hannah Wilke: exhibits *So Help Me Hannah* at P.S.1, New York; performs *Hannah Wilke Can: A Living Sculpture Needs to Make a Living* at Susan Caldwell Gallery, New York

David Wojnarowicz: moves to East Village, New York; starts working in abandoned Hudson River piers

• *Art for Society: Contemporary British Art with a Political Purpose* at Whitechapel Gallery, London, includes John Stezaker, Mary Kelly, Peter Kennard, Victor Burgin, Stephen Willats and Conrad Atkinson
• *Art for Whom?*, curated by Richard Cork at Serpentine Gallery, London, features Conrad Atkinson and Stephen Willats
• Colab (Collaborative Projects, Inc.) opens New Cinema in New York
• Fashion Moda founded by Stefan Eins and Joe Lewis in South Bronx, New York
• *High Performance* magazine launched in Los Angeles

MUSIC

Black Flag: *Nervous Breakdown* (SST), EP

Blondie: *Parallel Lines* (Chrysalis)

The Clash: *Give 'Em Enough Rope* (CBS)

Crass: *Feeding of the 5000* (Crass)

Devo: 'Q: Are We Not Men? A: We Are Devo' (Virgin), debut single

The Fall: 'Bingo Masters Breakout' (Step Forward)

Gang of Four: *Damaged Goods* (Fast), EP

The Human League: 'Being Boiled' (Fast)

Magazine: *Real Life* (Virgin)

MARS: '3E' (Ze)

Normal: 'Warm Leatherette' (Mute)

Pere Ubu: *The Modern Dance* (Blank)

Sex Pistols: band splits; John Lydon assumes own name and forms Public Image Ltd (PiL); Nancy Spungen dies

Siouxsie and the Banshees: *The Scream* (Polydor)

Snatch: 'All I Want' (Lightning)

Teenage Jesus and the Jerks: 'Orphans' (Migraine), single heralding the start of what becomes known as No Wave

Throbbing Gristle: *DOA: The Third and Final Report* (Industrial), LP, and *United/Zyklon B Zombie* (Industrial), EP; perform at London Film-Makers' Co-op

• Factory Records founded in Manchester; releases *A Factory Sample*, which includes tracks by Joy Division and Situationist stickers
• Mudd Club opens in New York

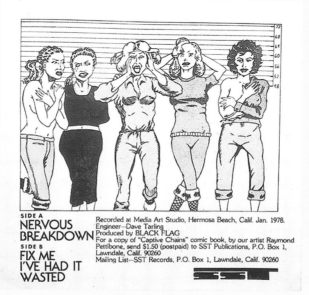

Raymond Pettibon
Back cover of Black Flag's *Nervous Breakdown*, 1978

1979

ART

Jean-Michel Basquiat: forms the band Channel 9 with Michael Holman, Shannon Dawson and Vincent Gallo

Tony Cragg: first solo exhibition at Lisson Gallery, London

Nan Goldin: *The Ballad of Sexual Dependency* debuts at Mudd Club, New York, during Frank Zappa's thirty-ninth birthday party

Jenny Holzer: *Fashion Moda Window* project with Stefan Eins at Fashion Moda in the Bronx, New York

Peter Hujar: *Recent Photographs* at Marcuse Pfeifer Gallery, New York

Derek Jarman: feature film *The Tempest* released

Mike Kelley: *The Poltergeist: A Work between David Askevold and Mike Kelley* at Foundation for Art Resource (FAR), Los Angeles; performs *The Monitor and the Merrimac* and *The Big Tent*

Linder: collaborates on film *Red Dress*, produced by Factory/New Hormones

Andrew Logan: premiere of the film *The Alternative Miss World*; fire guts Butler's Wharf studios

Robert Longo: first solo exhibition at The Kitchen, New York; forms the band Menthol Wars with Richard Prince and performs at Tier 3, New York

Paul McCarthy: performs *Contemporary Cure All* and *Deadening* at LAICA, and *San Francisco: The Shithole of America* at ARTCOM, both Los Angeles

Mark Morrisroe: starts working with 195 Polaroid camera

Martha Rosler: exhibits video works at ICA, London

Cindy Sherman: first solo exhibition at Hallwalls, Buffalo

• First New York graffiti exhibition organized by Crash, a nineteen-year-old graffiti artist, at Fashion Moda
• *Hayward Annual* exhibition features Victor Burgin, COUM Transmissions, Gilbert & George and John Stezaker
• *Picture/Photographs* exhibition at Castelli Graphics, New York, includes Nan Goldin and Richard Prince
• PS122 Gallery, a performance venue, opens in East Village, New York

MUSIC

Cabaret Voltaire: 'Nag Nag Nag' (Rough Trade)

The Clash: *London Calling* (CBS)

The Dead Kennedys: 'California über Alles' (Alternative Tentacles)

The Fall: *Live at the Witch Trials* (Step Forward)

Gang of Four: *Entertainment* (EMI)

The Germs: *The Germs* (Slash)

Joy Division: *Unknown Pleasures* (Factory)

Nurse with Wound: *Chance Meeting on a Dissecting Table of a Sewing Machine and an Umbrella* (United Dairies)

The Pop Group: 'She is Beyond Good and Evil' (Radar)

Public Image Ltd: *Metal Box* (Virgin); this album, following swiftly from their first, virtually defines post-punk

Sex Pistols: Sid Vicious dies; *The Great Rock 'n' Roll Swindle*, film and soundtrack album

The Special A.K.A.: 'Gangsters' (Two Tone), first release by Midlands-based multiracial band fusing ska and punk

Swell Maps: *A Trip to Marineville* (Rough Trade)

Talking Heads: *Fear of Music* (Sire), produced by Brian Eno

Throbbing Gristle: 'We Hate You (Little Girls)/Five Knuckle Shuffle' (Sordide Sentimentale) and *20 Jazzfunk Greats* (Industrial)

• Club 57 opens in New York
• Futurama, first of an annual festival of new music over two days in Leeds, includes Public Image Ltd and Joy Division
• *No New York* (Antilles), produced by Brian Eno, presents a new generation of New York bands

1980

ART

Cerith Wyn Evans: screens *And Then I 'Woke Up'* at London Film-Makers' Co-op

Keith Haring: begins doing chalk on black paper subway drawings in New York

Barbara Kruger: solo exhibition at P.S.1, New York

David Lamelas and Hildegarde Duane: *Scheherazade* screened at Long Beach Museum of Art, California

Raymond Pettibon: designs album covers for *Jealous Again* by Black Flag and *Paranoid Time* by the Minutemen and cover of the first issue of the review *No Magazine*

Richard Prince: first solo exhibitions at Artists Space, New York, and CEPA Gallery, Buffalo

Jamie Reid: creates artwork for the Sex Pistols' feature film *The Great Rock 'n' Roll Swindle* and for Malcolm McLaren's protégés Bow Wow Wow

Cindy Sherman: one-person exhibitions at The Kitchen and Metro Pictures, New York

• Arts Council makes budget cuts and ceases funding forty-one organizations
• *Issue: Twenty Social Strategies by Women Artists*, curated by Lucy Lippard at ICA, London, includes Jenny Holzer, Adrian Piper and Martha Rosler
• *Public Spirit, First Performance Festival*, organized by Highland Art Agents (HAA) in several Los Angeles venues, includes projects by Mike Kelley, Paul McCarthy and John Duncan
• *The Real Estate Show*, organized by Colab on the Lower East Side, New York, addresses gentrification in the area; it opens for one day before being closed
• *The Times Square Show*, organized by Colab, includes Jean-Michel Basquiat, Nan Goldin, Keith Haring and Jack Smith – graffiti, pornography, film and fashion
• *ZG* magazine launched in London, edited by Rosetta Brooks

MUSIC

Adam and the Ants: *Kings of the Wild Frontier* (CBS)

The Associates: *The Affectionate Punch* (Fiction)

Bad Brains: 'Pay to Cum' (Bad Brains), influential hardcore single by US Rastafarian punks

Dead Kennedys: *Fresh Fruit for Rotting Vegetables* (Cherry Red)

Durutti Column: *The Return of the Durutti Column* (Factory), LP in sandpaper sleeve designed to destroy other sleeves when stored

The Fall: *Grotesque (After the Gramme)* (Rough Trade)

Josef K: 'Radio Drill Time' (Postcard)

Joy Division: *Closer* (Factory), its release preceded by the suicide of the band's lead singer, Ian Curtis

Ludus: *The Visit* (New Hormones), EP, and 'My Cherry is in Sherry' with B-side 'Anatomy is Not Destiny' (New Hormones)

Orange Juice: 'Falling and Laughing' (Postcard)

Throbbing Gristle: filmed by Derek Jarman in 'A Psychic Youth Rally' at Heaven, London

• *The Face* and *i-D* magazines launched in London, chronicling the nascent New Romantic scene
• Futurama 2 Festival, Leeds, includes Siouxsie and the Banshees and Echo and the Bunnymen
• *Re/Search* magazine launched in San Francisco

Martha Rosler
Secrets from the Street: No Disclosure, 1980

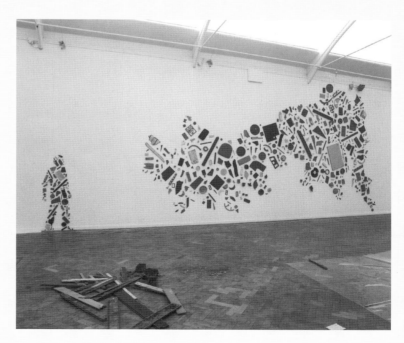

Installation view of the exhibition *Tony Cragg*,
Whitechapel Art Gallery, London, 1981

1981

Tony Cragg: solo exhibition at Whitechapel Gallery, London, for which he creates a set of works drawing on British national symbols (p. 203)
Cerith Wyn Evans: screens *A Certain Sensibility* at ICA, London
Gilbert & George: *Photo-Pieces 1971–80* at Whitechapel Gallery, London, includes *Dirty Words Pictures*
Keith Haring: exhibits at Mudd Club and Club 57, New York; curates *Beyond Words* and *Lower Manhattan Drawing Show* (the second including Jean-Michel Basquiat and David Wojnarowicz) at Mudd Club
Derek Jarman: film *In the Shadow of the Sun* premieres at Berlin Film Festival, soundtrack by Throbbing Gristle
Mike Kelley: performs *Meditation on a Can of Vernors* at LACE, Los Angeles; first Los Angeles gallery exhibition at Riko Mizuno
Barbara Kruger: organizes group exhibition *Pictures and Promises* at The Kitchen, New York, including Jenny Holzer and Hannah Wilke
Robert Longo: solo exhibitions at Metro Pictures, New York, and Gagosian Gallery, Los Angeles, featuring *Men in the Cities* series
Paul McCarthy: performs *God Bless America* at Exile Gallery, Los Angeles, and *Death Ship* at Sushi Gallery, San Diego, and Artemesia Gallery, Los Angeles
Mark Morrisroe: first solo exhibition at The 11th Hour, Boston; makes first Super-8 film
Tony Oursler: first solo exhibitions, *One Choice* at University of California at Berkeley, and *Video Viewpoints* at Museum of Modern Art (MOMA), New York
Raymond Pettibon: produces *Tripping Corpse* magazine (eleven issues to 1988)
Adrian Piper: participates in group exhibitions at New Museum, Franklin Furnace and Group Material, all in New York
Richard Prince: solo exhibitions at Metro Pictures, New York, and Richard Kuhlenschmidt Gallery, Los Angeles
Martha Rosler: solo exhibition at Franklin Furnace, New York
Cindy Sherman: solo exhibition at Metro Pictures, New York
Bill Woodrow: exhibits first sculptures using twin-tub washing machines in group exhibition *Objects and Sculptures* at Arnolfini, Bristol, and ICA, London (right)

• *Bomb* magazine launched by Colab in New York
• *British Sculpture in the 20th Century* at Whitechapel Gallery, London, includes Tony Cragg and Bill Woodrow
• Civilian Warfare, Nature Morte and FUN galleries open in East Village, New York
• *New York/New Wave*, curated by Diego Cortez at P.S.1, New York, includes Jean-Michel Basquiat, Nan Goldin, Keith Haring and Robert Mapplethorpe

Laurie Anderson: 'O Superman' (110), reaches number two in British charts
Black Flag: *Damaged* (SST)
Blondie: 'Rapture' (Chrysalis), rap meets New Wave with accompanying video featuring graffiti artists
D.A.F. Deutsch-Americanische Freundschaft: 'Der Mussolini' (Virgin)
Brian Eno and David Byrne: *My Life in the Bush of Ghosts* (EG), featuring sampled radio sounds with repetitive beats, and also influenced by rap and hip-hop culture
ESG: 'You're No Good' (Factory), a rare example of hybrid US funk with an edgy skeletal UK post-punk sound
Fire Engines: *Lubricate Your Living Room* (Pop Aural)
Grandmaster Flash and the Furious Five: 'Adventures on the Wheels of Steel' (Sugarhill)
Heaven 17: '(We Don't Need This) Fascist Groove Thang' (Virgin)
The Human League: 'Don't You Want Me' (Virgin)
Kraftwerk: *Computer World* (EMI)
Ludus: *Pickpocket* (New Hormones) cassette accompanied by booklet *SheShe*; *Mother's Hour* (New Hormones)
Soft Cell: 'Tainted Love' (Some Bizzare)
The Specials: 'Ghost Town' (2-Tone), a summation of life in post-industrial Britain, reaches number one in charts
Throbbing Gristle: disband; Genesis P-Orridge goes on to co-found Psychic TV
Young Marble Giants: *Testcard* (Rough Trade), EP

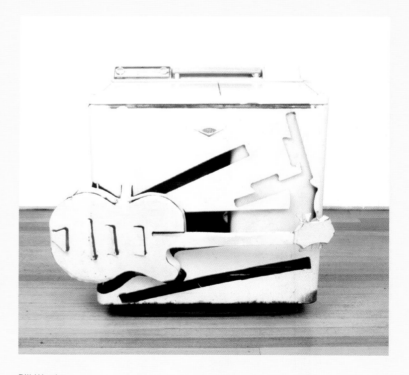

Bill Woodrow
Twin-tub with Guitar, 1981

1982

ART

Jean-Michel Basquiat: first solo exhibition at Annina Nosei Gallery, New York

Victor Burgin: publishes *Thinking Photography*, book of theoretical writings

Cerith Wyn Evans: shows film excerpts on BBC2

Gilbert & George: *Crusade* at Anthony d'Offay Gallery, London

Keith Haring: collaborates with graffiti artist LA2; first exhibition at Tony Shafrazi Gallery, New York

Jenny Holzer: *Messages to the Public*, LED billboard, Times Square, Manhattan; *Inflammatory Essays* (posters) pasted on New York streets

Mike Kelley: makes first video, *Banana Man*; *Monkey Island/Confusion*, first New York exhibition at Metro Pictures; performs *Confusion: A Play in Seven Sets, Each Set More Spectacular and Elaborate than the Last* at Mandeville Art Gallery, University of California, San Diego

Robert Longo: solo exhibition at Metro Pictures, New York

Paul McCarthy: first solo exhibition, *Human Object*, at LACE, Los Angeles; performs *Baby Boy, Baby Magic* at Al's Bar, Los Angeles

Tony Oursler: *A Scene* at P.S.1, New York, and *Complete Works* at The Kitchen, New York

Raymond Pettibon: founds *Asbestos* magazine; designs sleeves for Black Flag's albums *Six Pack* and *My War*

Richard Prince: solo exhibition at Metro Pictures, New York

Cindy Sherman: solo exhibitions at Gagosian Gallery, Los Angeles, and Metro Pictures, New York; another solo show travels Europe

Stephen Willats: publishes *Cha Cha Cha* (Coracle)

David Wojnarowicz: first solo exhibition at Milliken Gallery, New York; group exhibitions at Franklin Furnace, Barbara Gladstone Gallery, Civilian Warfare and Gracie Mansion Gallery, all New York; action installation at P.S.1, New York

Bill Woodrow: first solo exhibition at Lisson Gallery, London

• *Cave Canem*, group exhibition at Mudd Club, New York, includes Jenny Holzer, Mike Kelley and Tony Oursler

• *Documenta 7*, curated by Rudi Fuchs, features Jean-Michel Basquiat, Tony Cragg, Keith Haring, Jenny Holzer, Barbara Kruger, Robert Longo, Martha Rosler and Cindy Sherman

• *Illegal America* exhibition at Franklin Furnace, New York, includes Chris Burden, Gordon Matta-Clark and Carolee Schneemann

MUSIC

Grandmaster Flash and the Furious Five: 'The Message' (Sugarhill), hip hop goes over ground

Ludus: *The Seduction* (New Hormones) and *Danger Came Smiling* (New Hormones)

Malcolm McLaren: 'Buffalo Girl' (Charisma), UK single showcasing US rap and scratching techniques, bringing them to a mainstream audience

Psychic TV: debut appearance at *The Final Academy*, London, a multimedia event featuring William Burroughs and Brion Gysin; *Force the Hand of Chance* (Some Bizzare)

Soulsonic Force with Africa Bambaataa: 'Planet Rock' (21), distinct Kraftwerk influence from the emerging New York hip-hop scene

• In response to Bucks Fizz winning the Eurovision Song Contest, Linder performs in the Hacienda club, Manchester, in a dress made of discarded chicken meat and black net, whipping off her skirt to reveal a black dildo

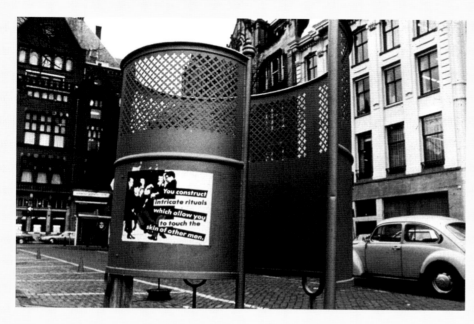

Poster by Barbara Kruger pasted in the streets of Amsterdam, 1982

1983

ART

Cerith Wyn Evans: solo exhibition at London Film-Makers' Co-op
Gilbert & George: *The Believing World*, Anthony d'Offay Gallery, London
Jenny Holzer: solo exhibition at ICA, London
Mike Kelley: *Monkey Island* installation at Rosamund Felsen Gallery, Los Angeles
Barbara Kruger: solo exhibition at ICA, London
Robert Mapplethorpe: retrospective begins at ICA, London, and travels UK
Tony Oursler: *Panic House* at LACE, Los Angeles; Oursler and Kelley perform *X Catholic* at Beyond Baroque Literary/Arts Centre, Venice, California
Richard Prince: exhibits *Spiritual America*, appropriated photograph of a naked, pre-pubescent Brooke Shields, in his gallery of the same name on the Lower East Side, New York; court cases follow; solo exhibition at ICA, London
Jamie Reid: first solo exhibition at Brixton Art Gallery, London
Martha Rosler: *Martha Rosler: Six Videotapes, 1975–1983* at The Office, New York; exhibits video work at ICA, London
Cindy Sherman: solo exhibition at Metro Pictures, New York
David Wojnarowicz: solo exhibitions at Hall Bromm Gallery and Gracie Mansion Gallery, New York; many New York group exhibitions; organizes Wardline Pier Project with Mike Bidlo

• International with Monument, CASH, Pat Hearn and PPOW galleries all open in East Village, New York
• Museum of Contemporary Art (MOCA) opens in Los Angeles
• *The New Art* at Tate Gallery, London, includes Cerith Wyn Evans, Robert Mapplethorpe, Cindy Sherman and Bill Woodrow
• *The Sculpture Show* at Hayward Gallery and Serpentine Gallery, London, includes Tony Cragg and Bill Woodrow
• Whitney Biennial, New York, includes Jean-Michel Basquiat, Keith Haring, Barbara Kruger and Cindy Sherman

MUSIC

Cocteau Twins: *Head Over Heels* (4AD)
Frankie Goes To Hollywood: 'Relax' (ZZT)
Ludus: 'Breaking the Rules' (Sordide Sentimental)
New Order: 'Blue Monday' (Factory), marking a move in the direction of the dance floor, and with sleeve design by Peter Saville; *Power, Corruption and Lies* (Factory)
The Smiths: 'Hand in Glove' (Rough Trade)
Sonic Youth: *Kill Yr Idols* (Zensor), debut record

Graffito by David Wojnarowicz on the wall of an abandoned pier, photograph by Peter Hujar, 1982–83

1984

ART

Jean-Michel Basquiat: exhibits at Mary Boone Gallery, New York; exhibition at Fruitmarket Gallery, Edinburgh, travelling to ICA, London
Cerith Wyn Evans: participates in *The Salon of 1984* at ICA, London
Keith Haring: paints murals in Manhattan and all over the world
Peter Hujar: diagnosed HIV positive
Mike Kelley: *The Sublime* at Rosamund Felsen Gallery, Los Angeles, and Metro Pictures, New York
Mark Morrisroe: solo exhibition *Inside the Boy Next Door* at Vision Gallery, Boston; moves to New York
Tony Oursler: solo exhibition at Anthology Film Archives and *L7, L5* at The Kitchen, New York
Adrian Piper: *Funk Lessons* distributed by The Kitchen, New York
Hannah Wilke: participates in *Artist's Call*, curated by Lucy Lippard, at Franklin Furnace, New York, and *Art and Ideology* exhibition at New Museum, New York, curated by Benjamin Buchloh, Donald Kuspit, Lucy Lippard *et al*.
David Wojnarowicz: solo exhibitions at Civilian Warfare and Gracie Mansion Gallery, New York; participates in *Limbo and Portrayals*, both at P.S.1, New York; also East Village group exhibitions in Europe and across the US, including LACE, Los Angeles
Bill Woodrow: participates in *Salvaged*, P.S.1, New York

• *Difference: On Representation and Sexuality* at New Museum, New York, and ICA, London, includes Victor Burgin, Hans Haacke, Barbara Kruger, Sherrie Levine and Martha Rosler
• Guerrilla Girls form in response to *International Survey of Painting and Sculpture* at Museum of Modern Art, New York, in which less than 10 per cent of the artists exhibited are women

MUSIC

Frankie Goes To Hollywood: 'Two Tribes' (ZZT)
Hüsker Dü: 'Eight Miles High' (SST)
The Jesus and Mary Chain: 'Upside Down' (Creation)
Pet Shop Boys: 'West End Girls' (Epic)
The Shockheaded Peters: 'I: Bloodbrother Be (£4,000 Love Letter)' (El benelux)

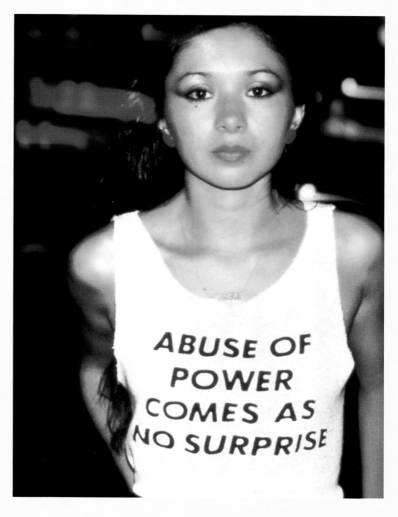

Jenny Holzer
From *Truisms*, 1977–79
T-shirt worn by Lady Pink, New York, 1983

Artists' Bibliographies

CLEMENTINE HAMPSHIRE

Jean-Michel Basquiat

Born 1960 in Brooklyn, New York. Basquiat was a self-taught artist. He first attracted attention with his graffiti under the signature SAMO in New York City. Died 1988 in New York.

Selected bibliography
Basquiat, exhib. cat., ed. M. Mayer, New York, Brooklyn Museum, 2005
Jean-Michel Basquiat, exhib. cat., London, Serpentine Gallery, 1996
Jean-Michel Basquiat, exhib. cat., ed. R. Marshall, New York, Whitney Museum of American Art, 1992
Jean-Michel Basquiat: Paintings 1981–1984, exhib. cat., Edinburgh, Fruitmarket Gallery, 1984
R. Ricard, 'The Radiant Child', *Artforum*, December 1981, p. 42

Victor Burgin

Born 1941 in Sheffield, England. Studied at the Royal College of Art, London, and Yale University, New Haven, Connecticut. Lives and works in Paris and Somerset, England.

Selected bibliography
Relocating: Victor Burgin, exhib. cat., Bristol, Arnolfini, 2002
Victor Burgin, exhib. cat. by P. Wollen, F. Pacteau and N. Bryson, Barcelona, Fundació Antoni Tápies, 2001
Between, exhib. cat. by V. Burgin, London, Institute of Contemporary Arts, 1986
V. Burgin (ed.), *Thinking Photography*, London (Macmillan) 1982
Victor Burgin: Modernism in the Work of Art, exhib. cat., Eindhoven, Van Abbemuseum, 1977

COUM Transmissions

An artists' group formed in 1969 by Genesis P-Orridge (b. 1950, Manchester); at the time of the *Prostitution* exhibition in 1976, it featured P-Orridge, Cosey Fanni Tutti (b. 1951, Hull) and Peter Christopherson (b. 1955, Leeds).

Selected bibliography
G. P-Orridge, *Painful but Fabulous*: *The Lives and Art of Genesis P-Orridge*, New York (Soft Skull) 2003
S. Ford, *Wreckers of Civilisation: The Story of COUM Transmissions and Throbbing Gristle*, London (Black Dog) 1999
WACK! Art and the Feminist Revolution, exhib. cat., ed. C. Butler and L.G. Mark, Los Angeles, Museum of Contemporary Art, 2007

Tony Cragg

Born 1949 in Liverpool. Studied at Gloucester College of Art and Design, Wimbledon School of Art, London, and the Royal College of Art, London. Lives and works in Wuppertal, Germany.

Selected bibliography
Tony Cragg: Signs of Life, exhib. cat., Bonn, Kunst-und-Ausstellungshalle der Bundesrepublik Deutschland, 2003
G. Celant, *Tony Cragg*, London (Thames & Hudson) 1996
Tony Cragg: Sculpture, 1975–1990, exhib. cat., Newport, Calif., Newport Harbor Art Museum, 1990
Tony Cragg: XLIII Biennale di Venezia, exhib. cat., London, British Council, 1988
Tony Cragg, exhib. cat. by M. Francis, London, Whitechapel Art Gallery, 1981

Cerith Wyn Evans

Born 1958 in Llanelli, Wales. Studied at St Martin's School of Art, London, and the Royal College of Art, London. Lives and works in London.

Selected bibliography
Bubble Peddler, exhib. cat. by M. Cousins *et al.*, Graz, Kunsthaus Graz, 2007
Cerith Wyn Evans: In Which Something Happens All Over Again for the Very First Time, exhib. cat., Paris, Musée d'Art Moderne de la Ville de Paris; Munich, Städtische Galerie im Lenbachhaus und Kunstbau, 2006
The Curves of the Needle: Cerith Wyn Evans, exhib. cat., Vienna, BAWAG Foundation, 2005
Cerith Wyn Evans, exhib. cat., Frankfurt am Main, Frankfurter Kunstverein, 2004
Look at That Picture …: How Does It Appear to You Now? Does It Seem to be Persisting?, exhib. cat., London, White Cube, 2003

Gilbert & George

Gilbert was born 1943 in the Dolomites, Italy; George was born 1942 in Devon. Both studied at St Martin's School of Art, London, where they met in 1967. They live and work in London.

Selected bibliography
Gilbert & George, exhib. cat., London, Tate Modern, 2006
Gilbert & George: The Dirty Words Pictures, exhib. cat. by M. Bracewell and L.G. Corrin, London, Serpentine Gallery, 2002
Gilbert & George: The Complete Pictures, 1971–1985, exhib. cat. by C. Ratcliff, London, Hayward Gallery, 1986
Gilbert and George: Crusade – An Exhibition of Post Card Pieces, exhib. cat., London, Anthony d'Offay Gallery, 1982
Gilbert & George, the Sculptors, exhib. cat. by C. Ratcliff and B.M. Reise, Berne, Kunsthalle Bern, 1981
Gilbert & George, *Dark Shadow*, London (Art for All) 1974

Nan Goldin

Born 1953 in Washington, D.C. Studied at Tufts University, Massachusetts. Lives and works in New York, Paris and London.

Selected bibliography
J. Jenkinson (ed.), *The Devil's Playground*, London (Phaidon) 2003
Nan Goldin: I'll Be Your Mirror, exhib. cat., ed. N. Goldin, D. Armstrong and H.W. Holzwarth, New York, Whitney Museum of American Art, 1996
D. Armstrong, W. Keller and H. Werner Holzwarth (eds), *Double Life*, New York (Scalo) 1994
D. Armstrong and W. Keller (eds), *The Other Side*, Manchester (Cornerhouse) 1993
M. Heiferman, M. Holborn and S. Fletcher (eds), *The Ballad of Sexual Dependency*, New York (Aperture Foundation) 1986

Keith Haring

Born 1958 in Reading, Pennsylvania. Studied at the School of Visual Arts, New York. Died 1990 in New York.

Selected bibliography
Keith Haring: Memoria Urbana, exhib. cat., Madrid, Fundacion ICO, 2005
The Keith Haring Show, exhib. cat., ed. G. Mercurio and D. Paparoni, Milan, Triennale di Milano, 2005
Keith Haring: Heaven and Hell, exhib. cat., ed. G. Adriani, Karlsruhe, Museum für Neue Kunst, 2001
Keith Haring, exhib. cat., ed. G. Celant and I. Giannalli, Turin, Castello di Rivoli, 1994
Keith Haring: Future Primeval, exhib. cat. by B. Blinderman, Normal, Ill., University Galleries, Illinois State University, 1990
H. Geldzahler and K. Haring, *Art in Transit: Subway Drawings*, photos by Tseng Kwong Chi, New York (Harmony) 1984

JENNY HOLZER

Born 1950 in Gallipolis, Ohio. Studied at Ohio University and Rhode Island School of Design, and completed the Independent Study Program at the Whitney Museum of American Art. Lives and works in Hoosick, New York.

Selected bibliography
Jenny Holzer, exhib. cat., Bordeaux, CAPC Musée d'Art Contemporain, 2001
D. Joselit, R. Saleci and J. Simon, *Jenny Holzer*, London (Phaidon) 1998
N. Smolik (ed.), *Jenny Holzer: Writing = Schriften,* Stuttgart (Cantz) 1996
M. Auping, *Jenny Holzer*, New York (Universe) 1992
Jenny Holzer, exhib. cat. by D. Waldman, New York, Guggenheim Museum, 1989
Abuse of Power Comes as No Surprise: Truisms and Essays, exhib. cat., New York, Barbara Gladstone Gallery, 1983
Jenny Holzer, with A-one, Mike Glier and Lady Pink: Survival Series [14 works], exhib. cat., London, Lisson Gallery, 1983

PETER HUJAR

Born 1934 in Trenton, New Jersey. Died 1987 in New York.

Selected bibliography
Peter Hujar: Night, exhib. cat. by B. Nickas, New York, Matthew Marks Gallery; San Francisco, Fraenkel Gallery, 2005
P. Hujar and K. Kertess, *Peter Hujar: Animals and Nudes*, Santa Fe, N. Mex. (Twin Palms) 2002
Peter Hujar: A Retrospective, exhib. cat., ed. U. Stahel and H. Visser, Amsterdam, Stedelijk Museum; Winterthur, Fotomuseum, 1994
Peter Hujar, exhib. cat. by S. Koch and T. Sokolowski, New York, Grey Art Gallery and Study Center, New York University, 1990
P. Hujar and S. Sontag, *Portraits in Life and Death*, New York (Da Capo Press) 1976

DEREK JARMAN

Born 1942 in Northwood, Middlesex, England. Studied at King's College London and the Slade School of Fine Art, London. Died 1994 in London.

Selected bibliography
R. Wymer, *Derek Jarman* (British Film Makers), Manchester (Manchester University Press) 2005
T. Peake, *Derek Jarman*, London (Little, Brown) 1999
Derek Jarman: A Portrait, exhib. cat. by R. Wollen, London, Barbican Art Gallery, 1996
D. Jarman, *Chroma: A Book of Colour – June '93*, London (Vintage) 1995
D. Jarman, *Modern Nature: The Journals of Derek Jarman*, London (Vintage) 1992

MIKE KELLEY

Born 1954 in Detroit, Michigan. Studied at University of Michigan, Ann Arbor, and the California Institute of the Arts, Valencia. Lives and works in Los Angeles.

Selected bibliography
The Uncanny: Mike Kelley, exhib. cat., Liverpool, Tate Liverpool, 2004
M. Kelley, *Foul Perfection: Essays and Criticism*, ed. J.C. Welchman, Cambridge, Mass. (MIT Press) 2003
I. Graw, J.C. Welchman and A. Vidler, *Mike Kelley*, London (Phaidon) 1999
Mike Kelley: Catholic Tastes, exhib. cat. by E. Sussman, New York, Whitney Museum of American Art, 1993
Mike Kelley, exhib. cat. by T. Kellein, Basel, Kunsthalle Basel, 1992
Cave Canem: Stories and Pictures by E. Beckman, J. Casebere, K. Gordon, J. Holzer, M. Kelley, J.D. King, B. Komoski, J. Miller, T. Oursler, J.D.L. Platt, D. Walworth and M. Winn, New York (Cave Canem Books) 1982

BARBARA KRUGER

Born 1945 in Newark, New Jersey. Studied at Syracuse University, New York, and Parsons School of Design, New York City. Lives and works in New York City and Los Angeles.

Selected bibliography
Barbara Kruger: Twelve, exhib. cat., Glasgow, Tramway, 2005
Barbara Kruger, exhib. cat. by A. Vettese., P. Fabbri and M. Pierini, Siena, Palazzo delle Papesse Centro Arte Contemporanea, 2002
Barbara Kruger, exhib. cat., ed. A. Goldstein, Los Angeles, Museum of Contemporary Art, 1999
Remote Control: Power, Cultures, and the World of Appearances, Cambridge, Mass. (MIT Press) 1993
K. Linker, *Love for Sale: The Words and Pictures of Barbara Kruger*, New York (Harry N. Abrams) 1990
Barbara Kruger, exhib. cat. by L. Barrie and J. Harper, Wellington, National Art Gallery, 1988
Barbara Kruger: We Won't Play Nature to Your Culture, exhib. cat., London, Institute of Contemporary Arts, 1983

DAVID LAMELAS

Born 1946 in Buenos Aires. Studied at the Academia Nacional de Bellas Artes, Buenos Aires, and St Martin's School of Art, London. Lives and works in Berlin and Los Angeles.

Selected bibliography
N. Fitch, *Exploding Information: Communication and Institutional Critique in the Early Work of David Lamelas*, diss., University of London, Courtauld Institute of Art, 2005
David Lamelas: A New Refutation of Time, exhib. cat., Munich, Kunstverein München; Rotterdam, Witte de With, Center for Contemporary Art, 1997
David Lamelas: Fifteen Years, exhib. cat. by J. Glusberg, Buenos Aires, Centro de Arte y Comunicación, 1978
David Lamelas, exhib. cat. by K. Arnatt *et al.*, London, Nigel Greenwood Gallery, 1970

LINDER

Born 1954 in Liverpool. Studied at Manchester Polytechnic. Lives and works in Lancashire, England.

Selected bibliography
C. Wood, 'The Working Class Goes to Paradise', *Untitled*, no. 40, Spring 2007, pp. 4–9
L. Bovier (ed.), *Linder: Works, 1976–2006*, Zurich (JRP/Ringier) 2006

ANDREW LOGAN

Born 1945 in Witney, Oxfordshire, England. Studied at the Oxford School of Architecture. Lives and works in London.

Selected bibliography
Andrew Logan, exhib. cat., Ruthin, Wales, Ruthin Craft Centre Gallery, 1998
Andrew Logan, 1991: An Artistic Adventure, exhib. cat., Oxford, Museum of Modern Art, 1991
Andrew Logan: Goldfield 1976 – Giant Wheat, Butterflies and Mice, exhib. cat., London, Whitechapel Art Gallery, 1976

ROBERT LONGO

Born 1953 in Brooklyn, New York. Studied at Buffalo State College. Lives and works in New York.

Selected bibliography
Robert Longo, exhib. cat. by H.N. Fox, Los Angeles, Los Angeles County Museum of Art, 1989
R. Longo, *Men in the Cities, 1979–1982*, New York (Harry N. Abrams) 1986
Robert Longo: Sequences/Men in the Cities, exhib. cat., ed. L. Barnes, Long Beach, University Art Museum, California State University, 1986
C. Ratcliff, *Robert Longo,* New York (Rizzoli) 1985
Robert Longo: Dis-illusions, exhib. cat. by R. Hobbs, Iowa City, University of Iowa Museum of Art, 1985

PAUL MCCARTHY

Born 1945 in Salt Lake City. Studied at the University of Utah, San Francisco Art Institute, and the University of Southern California, Los Angeles. Lives and works in Altadena, California.

Selected bibliography
Paul McCarthy: Head Shop, Shop Head: Works 1966–2006, exhib. cat., ed. M. af Petersens and P. McCarthy, Stockholm, Moderna Museet, 2006
Paul McCarthy: LaLa Land – Parody Paradise, exhib. cat., ed. S. Rosenthal, London, Whitechapel Art Gallery, 2005
Paul McCarthy at Tate Modern, exhib. cat., London, Tate Modern, 2003
R. Rugoff, K. Stiles and G. Di Pietrantonio, *Paul McCarthy*, London (Phaidon) 1996

ROBERT MAPPLETHORPE

Born 1946 in Floral Park, New York. Studied at the Pratt Institute, Brooklyn, New York. Died 1989 in Boston.

Selected bibliography
Robert Mapplethorpe, exhib. cat. by R.F. Hartley, Edinburgh, Scottish National Gallery of Modern Art, 2006
G. Celant, *Robert Mapplethorpe*, exhib. cat., London, Hayward Gallery, 1996
A.C. Danto, *Playing with the Edge: The Photographic Achievement of Robert Mapplethorpe*, Berkeley (University of California Press) 1996
G. Celant (ed.), *Mapplethorpe*, exhib. cat., Copenhagen, Louisiana Museum for Moderne Kunst, 1992
Robert Mapplethorpe: The Perfect Moment, exhib. cat. by J. Kardon, Philadelphia, Institute of Contemporary Art, University of Pennsylvania, 1989

GORDON MATTA-CLARK

Born 1943 in New York. Studied French literature at the Sorbonne, Paris, and architecture at Cornell University, Ithaca, New York. Died 1978 in New York.

Selected bibliography
G. Moure, *Gordon Matta-Clark: Works and Collected Writings,* trans. S. Margaretten, Barcelona (Ediciones Polígrafa) 2006
C. Diserens (ed.), *Gordon Matta-Clark*, London (Phaidon) 2003
P.M. Lee, *Object to be Destroyed: The Work of Gordon Matta-Clark*, Cambridge, Mass. (MIT Press) 2000
Gordon Matta-Clark: A Retrospective, exhib. cat., Chicago, Museum of Contemporary Art, 1985
G. Matta-Clark, *Splitting*, New York (Loft Press) 1974

MARK MORRISROE

Born 1959 in New Malden, Massachusetts. Studied at the School of the Museum of Fine Arts, Boston. Died 1989 in New York.

Selected bibliography
K. Ottmann, *Mark Morrisroe and His Works,* Santa Fe, N. Mex. (Twin Palms) 1999
Emotions and Relations: *Nan Goldin, David Armstrong, Mark Morrisroe, Jack Pierson, Philip-Lorca diCorcia*, exhib. cat. by F.C. Gundlach, C. Heinrich and D. Zbikowski, Hamburg, Hamburger Kunsthalle, 1998
Mark Morrisroe 1959–1989: *Eine Retrospektive*, exhib. cat., Berlin, Neue Gesellschaft für Bildende Kunst, 1997
Mark Morrisroe: Polaroids, Photogravures, Dirt Magazine, Films, Videos, Music, Performance, Prints, exhib. cat., New York, Pat Hearn Gallery, 1996
Boston School: Mark Morrisroe (1959–1989) – A Survey from the Estate, Organized by the Pat Hearn Gallery, exhib. cat., Boston, Institute of Contemporary Art, 1995

TONY OURSLER

Born 1957 in New York. Studied at California Institute of the Arts, Valencia. Lives and works in New York.

Selected bibliography
Tony Oursler, exhib. cat., ed. E. Janus, Rome, Museo d'Arte Contemporanea di Roma, 2002
Tony Oursler, exhib. cat., ed. E. Janus and G. Moure, Valencia, Institut Valencià d'Art Modern; San Sebastián, Koldo Mitxelena Kulturunea; and Lisbon, Centro Cultural de Belém, 2001
Tony Oursler: Introjection, Mid-Career Survey 1976–1999, exhib. cat. by D. Rothschild, Williamstown, Mass., Williams College Museum of Art, 1999
Tony Oursler: My Drawings, 1976–1996, exhib. cat., Kassel, Kasseler Kunstverein, 1997

RAYMOND PETTIBON

Born 1957 in Tucson, Arizona. Studied at the University of California, Los Angeles. Lives and works in Hermosa Beach, California.

Selected bibliography
Raymond Pettibon: Whatever It Is You Are Looking For You Won't Find It Here, exhib. cat., Vienna, Kunsthalle Wien, 2006
Raymond Pettibon: Plots Laid Thick, exhib. cat., Barcelona, Museu d'Art Contemporani de Barcelona, 2002
R. Storr, D. Cooper and U. Loock, *Raymond Pettibon*, London (Phaidon) 2001
R. Ohrt (ed.), *Raymond Pettibon: The Books 1978–98*, Cologne (Verlag der Buchhandlung Walter König); New York (D.A.P.) 2000
Raymond Pettibon, exhib. cat., ed. U. Loock, Berne, Kunsthalle Bern, 1995

ADRIAN PIPER

Born 1948 in New York. Studied at the School of Visual Arts, New York, and City College of New York. Studied philosophy at Harvard University, Cambridge, Massachusetts. Lives and works in Berlin.

Selected bibliography
Adrian Piper: Since 1965, exhib. cat., Barcelona, Museu d'Art Contemporani de Barcelona, 2003
Adrian Piper: A Retrospective, exhib. cat., by M. Berger, Baltimore, Fine Arts Gallery, University of Maryland, 1999
Adrian Piper, exhib. cat., Birmingham, Ikon Gallery; Manchester, Cornerhouse, 1991

RICHARD PRINCE

Born 1949 in the Panama Canal Zone. Lives and works in upstate New York.

Selected bibliography
R. Brooks, J. Rian and L. Sante*, Richard Prince*, London (Phaidon) 2003
Richard Prince: Paintings, Photographs, exhib. cat., Basel, Museum für Gegenwartskunst; Zurich, Kunsthalle Zürich; Wolfsburg, Kunstmuseum Wolfsburg, 2002
Richard Prince: Early Photographs, 1977–1979, exhib. cat., New York, Skarstedt Fine Art, 2001
Richard Prince: Photographs, 1977–1993, exhib. cat., ed. C. Haenlein, Hanover, Kestner-Gesellschaft, 1994
Richard Prince, exhib. cat. by L. Phillips, New York, Whitney Museum of American Art, 1992
Spiritual America, exhib. cat., Valencia, Institut Valencià d'Art Modern, 1989

JAMIE REID

Born 1947 in Croydon, Surrey, England. Studied at Wimbledon College of Art, London, and Croydon Art School. Lives and works in Liverpool.

Selected bibliography
J. Reid and J. Savage, *Up They Rise: The Incomplete Works of Jamie Reid*, London (Faber & Faber) 1987
A Talent to Shock, exhib. cat., London, Hamiltons Art Gallery, 1986

MARTHA ROSLER

Born 1943 in Brooklyn, New York. Studied at Brooklyn College, City University of New York, and the University of California, San Diego. Lives and works in Brooklyn.

Selected bibliography
Martha Rosler: Passionate Signals, exhib. cat., ed. I. Schube, Hanover, Sprengel Museum, 2005
M. Rosler, *Decoys and Disruptions: Selected Writings, 1975–2001*, Cambridge, Mass. (MIT Press in association with International Center of Photography) 2004
Martha Rosler: Positions in the Life World, exhib. cat., ed. C. de Zegher, Birmingham, Ikon Gallery; Vienna, Generali Foundation, 1998
M. Rosler, *3 Works [I. The restoration of high culture in Chile. II. The Bowery in two inadequate descriptive systems. III. In, around, and afterthoughts (on documentary photography)]*, Halifax (Press of the Nova Scotia College of Art and Design) *c*. 1981

CINDY SHERMAN

Born 1954 in Glen Ridge, New Jersey. Studied at Buffalo State College. Lives and works in New York.

Selected bibliography
C. Sherman, *The Complete Untitled Film Stills*, exhib. cat., New York, The Museum of Modern Art, 2003
E. Williams, C. Sherman, The Glove Compartment AKA Gian Carlo Feleppa, *Early Work of Cindy Sherman*, East Hampton, NY (Glenn Horowitz Bookseller) 2000
Cindy Sherman: Retrospective, exhib. cat. by A. Cruz, E. Smith and A. Jones, Los Angeles, Museum of Contemporary Art; Chicago, Museum of Contemporary Art, 1997
Cindy Sherman, exhib. cat., ed. K. Schampers and T. Schoon, Rotterdam, Museum Boijmans Van Beuningen, 1996
R. Krauss, *Cindy Sherman, 1975–1993*, New York (Rizzoli) 1993
Cindy Sherman, exhib. cat. by P. Schjeldahl and L. Phillips, New York, Whitney Museum of American Art, 1987

JOHN STEZAKER

Born 1949 in Worcester, England. Studied at the Slade School of Fine Art, London. Lives and works in London.

Selected bibliography
'Demand the Impossible', interview with M. Bracewell, *Frieze*, issue 89, March 2005, pp. 88–93
John Stezaker: Film Still Collages, exhib. cat., Frankfurt am Main, Friedman-Guinness Gallery, 1990
John Stezaker: Works 1973–78, exhib. cat., Lucerne, Kunstmuseum Luzern, 1979
Fragments: John Stezaker, exhib. cat., London, The Photographers' Gallery, 1978

HANNAH WILKE

Born 1940 in New York. Studied at the Tyler School of Art, Philadelphia. Died 1993 in Houston, Texas.

Selected bibliography
Hannah Wilke: Exchange Values, exhib. cat., Vitoria-Gasteiz, Spain, Artium, 2006
Hannah Wilke, 1940–1993, exhib. cat., Berlin, Neue Gesellschaft für Bildende Kunst, 2000
Hannah Wilke: A Retrospective, exhib. cat., Copenhagen, Nikolaj, Copenhagen Contemporary Art Center; Helsinki, Helsinki City Art Museum, 1998
Intra-Venus, exhib. cat., New York, Ronald Feldman Fine Arts, 1995
T. Kochheiser (ed.), *Hannah Wilke: A Retrospective*, Columbia (University of Missouri Press) 1989

STEPHEN WILLATS

Born 1943 in London. Studied at Ealing School of Art, London. Lives and works in London.

Selected bibliography
S. Willats, *Beyond the Plan: The Transformation of Personal Space in Housing*, Chichester (Wiley-Academy) 2001
City of Concrete, exhib. cat. by S. Willats, Birmingham, Ikon Gallery, 1986
S. Willats, *Intervention and Audience*, London (Coracle) 1986
Means of Escape, exhib. cat. by S. Willats, Rochdale, Rochdale Art Gallery, 1984
S. Willats, *Cha Cha Cha*, London (Coracle/Lisson Gallery) 1982
The New Reality, exhib. cat. by S. Willats, Londonderry, Orchard Gallery, 1982
The Lurky Place, exhib. cat. by S. Willats, London, Lisson Gallery, 1978
S. Willats, *Art and Social Function: Three Projects*, London (Latimer New Dimensions) 1976

DAVID WOJNAROWICZ

Born 1954 in Red Bank, New Jersey. Died 1992 in New York.

Selected bibliography
G. Ambrosino (ed.), *David Wojnarowicz: A Definitive History of Five or Six Years on the Lower East Side,* New York (Semiotext(e)) 2006
D. Wojnarowicz, *Rimbaud in New York 1978–79*, New York (PPP Editions) 2004
Fever: The Art of David Wojnarowicz, exhib. cat., ed. A. Scholder, New York, New Museum of Contemporary Art, 1999
D. Wojnarowicz, *Close to the Knives: A Memoir of Disintegration,* London (Serpent's Tail) 1992
David Wojnarowicz: Tongues of Flame, exhib. cat., ed. B. Blinderman, Normal, Ill., University Galleries, Illinois State University, 1990
David Wojnarowicz: Paintings and Sculpture, exhib. cat. by D. Wojnarowicz and C. McCormick, Philadelphia, Institute of Contemporary Art, University of Pennsylvania, 1985

BILL WOODROW

Born 1948 in Henley, Oxfordshire. Studied at Winchester School of Art, Hampshire, St Martin's School of Art, London, and Chelsea School of Art, London. Lives and works in London.

Selected bibliography
Bill Woodrow: Sculpture 1980–86, exhib. cat. by L. Cooke, Edinburgh, Fruitmarket Gallery, 1986
Bill Woodrow: Beaver, Bomb and Fossil, exhib. cat., Oxford, Museum of Modern Art, 1983
Bill Woodrow: Sculpture, Drawings, exhib. cat., London, Lisson Gallery, 1982
Objects and Sculptures: Edward Allington, Richard Deacon, Antony Gormley, Anish Kapoor, Margaret Organ, Peter Randall-Page, Jean-Luc Vilmouth, Bill Woodrow, exhib. cat., Bristol, Arnolfini; London, Institute of Contemporary Arts, 1981

LIST OF PLATES

An asterisk (*) indicates that the artist is represented by an alternative work in the exhibition.

JEAN-MICHEL BASQUIAT

Page 18
Untitled (Man with Halo), 1982
Chalk on paper
80 × 60 cm (31½ × 23½ in.)
Museum Boijmans Van Beuningen, Rotterdam
© ADAGP, Paris and DACS, London, 2007

Page 19
Untitled (Sword and Sickle), 1982
Chalk on paper
80 × 60 cm (31½ × 23½ in.)
Museum Boijmans Van Beuningen, Rotterdam
© ADAGP, Paris and DACS, London, 2007

Page 21
Kings of Egypt II, 1982
Oil on canvas
170 × 170 cm (67 × 67 in.)
Museum Boijmans Van Beuningen, Rotterdam,
Collection Sonnenberg
© ADAGP, Paris and DACS, London, 2007

Pages 22–23
* *Untitled*, 1982
Acrylic, oil paintstick, spray paint and colour photocopy
paper on canvas
152.5 × 183 cm (60 × 72 in.)
Daros Collection, Switzerland
© ADAGP, Paris and DACS, London, 2007

VICTOR BURGIN

Pages 24–26
From *UK76*, 1976
11 silver gelatin prints mounted on aluminium
Each 100 × 150 cm (39½ × 59 in.)
Courtesy the artist

Pages 27–29
From *US77*, 1977
12 silver gelatin prints mounted on aluminium
Each 100 × 150 cm (39½ × 59 in.)
Courtesy the artist

COUM TRANSMISSIONS

Page 31
Press release/poster for the exhibition *Prostitution*, 1976
29.5 × 21 cm (11½ × 8¼ in.)
Courtesy Cabinet, London
Archive of Cosey Fanni Tutti

COSEY FANNI TUTTI

Page 32
'Meet Geraldine', *Playbirds*, vol. 1, no. 5, 1975
Magazine action
6 magazine pages
66 × 58.5 cm (26 × 23 in.)
Courtesy Cabinet, London
Archive of Cosey Fanni Tutti
Photograph: Andy Keate

GENESIS P-ORRIDGE

Page 34
Venus Mound
From *TAMPAX ROMANA*, 1976
Wooden box, broken statue and tampons
30.5 × 30.5 × 15 cm (12 × 12 × 6 in.)
Courtesy the artist and James Birch, London
Photograph: Andy Keate

Page 35, left
It's That Time Of The Month
From *TAMPAX ROMANA*, 1976
Wooden box, clock and tampons
30.5 × 30.5 × 15 cm (12 × 12 × 6 in.)
Courtesy the artist and James Birch, London
Photograph: Andy Keate

Page 35, right
Pupae
From *TAMPAX ROMANA*, 1976
Wooden boxes, hairpiece and tampon
30.5 × 30.5 × 15 cm (12 × 12 × 6 in.)
Courtesy the artist and James Birch, London
Photograph: Andy Keate

TONY CRAGG

Page 37
Crown Jewels, 1981
Found plastic
300 × 200 cm (118 × 78¾ in.)
Paliotto Collection, Naples
Courtesy Galleria Lia Rumma, Naples/Milan

Pages 38–39
Policeman, 1981
Found plastic
400 × 120 cm (157½ × 47¼ in.)
Courtesy the artist and Lisson Gallery, London

CERITH WYN EVANS

Page 41
Epiphany, 1984
16 mm film transferred to DVD
30 min., colour, sound
Courtesy the artist and Jay Jopling/White Cube, London
© the artist

GILBERT & GEORGE

Pages 42–43
The World of Gilbert & George, 1981
16 mm film transferred to DVD
69 min., colour, sound
Arts Council England, London
© Arts Council England

NAN GOLDIN

Page 50
Greer and Robert on the bed, NYC, 1982
Cibachrome print
76 × 101.5 cm (30 × 40 in.)
Courtesy the artist and Matthew Marks Gallery, New York

Page 51
French Chris at the Drive-in, NJ, 1979
Cibachrome print
76 × 101.5 cm (30 × 40 in.)
Courtesy the artist and Matthew Marks Gallery, New York

Page 52
Nan and Brian in bed, NYC, 1983
Cibachrome print
76 × 101.5 cm (30 × 40 in.)
Courtesy the artist and Matthew Marks Gallery, New York

Page 53, top
Robin and Kenny at Boston/Boston, Boston, 1983
C-type print
51 × 61 cm (20 × 24 in.)
Courtesy the artist and Matthew Marks Gallery, New York

Page 53, bottom
Brian on the phone, NYC, 1981
Cibachrome print
76 × 101.5 cm (30 × 40 in.)
Courtesy the artist and Matthew Marks Gallery, New York

Page 54
Skeletons coupling, New York City, 1983
Cibachrome print
101.5 × 76 cm (40 × 30 in.)
Courtesy the artist and Matthew Marks Gallery, New York

Page 55
Nan one month after being battered, 1984
Cibachrome print
76 × 101.5 cm (30 × 40 in.)
Courtesy the artist and Matthew Marks Gallery, New York

KEITH HARING

Page 56
* *Untitled*, 1981
Ink on paper
96 × 126.5 cm (37¾ × 49¾ in.)
Courtesy Estate of Keith Haring, New York

Page 57
* *Untitled*, 1981
Sumi ink on paper
56 × 76 cm (22 × 30 in.)
Courtesy Estate of Keith Haring, New York

Page 59
Untitled, 1983
Vinyl paint on vinyl tarpaulin
305 × 305 cm (120 × 120 in.)
Courtesy Max Lang, New York
© Estate of Keith Haring, New York

JENNY HOLZER

Page 60
Inflammatory Essays, 1979–82, and *Truisms*, 1977–79
Street installation, Seattle, Washington, 1984
Offset posters
Courtesy the artist
© Jenny Holzer, ARS, New York and DACS, London, 2007
Photograph: Deborah Oglesby

Pages 60–61
Inflammatory Essays, 1979–82
Offset posters
Each 43 × 43 cm (17 × 17 in.)
Tate, London
© Tate, London, 2007, and Jenny Holzer, ARS, New York
and DACS, London, 2007

Page 62
From *Inflammatory Essays*, 1979–82
Offset poster
43 × 43 cm (17 × 17 in.)
Courtesy the artist
© Jenny Holzer, ARS, New York and DACS, London, 2007

Page 63
From *Inflammatory Essays*, 1979–82
Offset posters
Each 43 × 43 cm (17 × 17 in.)
Tate, London
© Tate, London, 2007, and Jenny Holzer, ARS, New York
and DACS, London, 2007

PETER HUJAR

Page 64, top
West Side Parking Lots, NYC, 1976
Silver gelatin print
51 × 40.5 cm (20 × 16 in.)
Courtesy Matthew Marks Gallery, New York
© The Peter Hujar Archive

Page 64, bottom
Two Queens in a Car, Halloween, 1977
Silver gelatin print
51 × 40.5 cm (20 × 16 in.)
Courtesy Matthew Marks Gallery, New York
© The Peter Hujar Archive

Page 65
Candy Darling on Her Deathbed, 1974
Silver gelatin print
51 × 40.5 cm (20 × 16 in.)
Courtesy Matthew Marks Gallery, New York
© The Peter Hujar Archive

Page 66
Woolworth Building, 1976
Silver gelatin print
51 × 40.5 cm (20 × 16 in.)
Courtesy Matthew Marks Gallery, New York
© The Peter Hujar Archive

Page 67
Halloween DOA, 1980
Silver gelatin print
51 × 40.5 cm (20 × 16 in.)
Courtesy Matthew Marks Gallery, New York
© The Peter Hujar Archive

Page 68
The World Trade Center at Night, 1976
Silver gelatin print
51 × 40.5 cm cm (20 × 16 in.)
Courtesy Matthew Marks Gallery, New York
© The Peter Hujar Archive

Page 69, top
Cindy Lubar as Queen Victoria, 1974
Silver gelatin print
51 × 40.5 cm cm (20 × 16 in.)
Courtesy Matthew Marks Gallery, New York
© The Peter Hujar Archive

Page 69, bottom
Girl in My Hallway, 1976
Silver gelatin print
51 × 40.5 cm cm (20 × 16 in.)
Courtesy Matthew Marks Gallery, New York
© The Peter Hujar Archive

DEREK JARMAN

Pages 74–75
Jordan's Dance, 1977
Super-8 film transferred to DVD
12 min., colour, silent
Courtesy James Mackay, London

MIKE KELLEY

Page 77
* *The Poltergeist*, 1979
7 silver gelatin prints
213.5 × 513 cm (84 × 202 in.)
Courtesy the artist

Page 78
* *The Poltergeist* (detail), 1979
Silver gelatin print
106.5 × 80 cm (42 × 31½ in.)
Courtesy the artist

Page 79
* *The Poltergeist* (detail), 1979
Silver gelatin print
106.5 × 163 cm (42 × 64¼ in.)
Courtesy the artist

BARBARA KRUGER

Page 81
Untitled (I am your almost nothing), 1982
Black-and-white photograph
183 × 124.5 cm (72 × 49 in.)
Private collection
Courtesy Mary Boone Gallery, New York,
and Corvi-Mora, London
© DACS 2007

Page 83
Untitled (Your comfort is my silence), 1982
Black-and-white photograph
142 × 101.5 cm (56 × 40 in.)
Daros Collection, Switzerland
Courtesy Mary Boone Gallery, New York
© DACS 2007

DAVID LAMELAS

Pages 84–87
The Violent Tapes of 1975, 1975
10 black-and-white photographs
Each 23.5 × 36 cm (9¼ × 14¼ in.)
Courtesy Galerie Kienzle & Gmeiner GmbH, Berlin

LINDER

Page 89
Jordan, 1977
Linocut on paper
22 × 19 cm (8¾ × 7½ in.)
Courtesy Stuart Shave/Modern Art, London

Page 90
Red Dress XIII, 1979
Photomontage
23.5 × 19.5 cm (9¼ × 7¾ in.)
Courtesy Stuart Shave/Modern Art, London

Page 91
Untitled, 1977
Photomontage on paper
15.5 × 17 cm (6 × 6¾ in.)
Courtesy Stuart Shave/Modern Art, London

Pages 92–93
Untitled, 1977
Photomontage on card
18 × 18.5 cm (7 × 7¼ in.)
Courtesy Stuart Shave/Modern Art, London

ANDREW LOGAN

Page 101
Homage to the New Wave, 1977
Metal, resin, glass and stone
124 × 23 × 16 cm (48¾ × 9 × 6¼ in.)
Arts Council Collection, Southbank Centre, London
Courtesy the artist

ROBERT LONGO

Page 102
Untitled (Eric), 1981
From *Men in the Cities*, 1978–82
Charcoal and pencil on paper
244 × 152 cm (96 × 60 in.)
The Museum of Contemporary Art, Los Angeles,
The Scott D.F. Spiegel Collection
Photograph: Paula Goldman

Page 103
Untitled (Joe), 1981
From *Men in the Cities*, 1978–82
Charcoal and pencil on paper
203 × 127 cm (80 × 50 in.)
Tate, London
© Tate, London, 2007

PAUL McCARTHY

Pages 104–107
Rocky, 1976
14 drawings, pencil on paper
Each 60.5 × 48 cm (23¾ × 19 in.)
Beta SP videotape, 21.5 min., colour, sound
Tate, London
Courtesy the artist and Hauser & Wirth Zürich London
© Tate, London, 2007

ROBERT MAPPLETHORPE

Page 108
American Flag, 1977
Silver gelatin print
51 × 40.5 cm (20 × 16 in.)
Courtesy Alison Jacques Gallery, London
© Robert Mapplethorpe Foundation. Used by permission.

Page 109
Patti Smith, 1975
Silver gelatin print
51 × 40.5 cm (20 × 16 in.)
Courtesy Alison Jacques Gallery, London
© Robert Mapplethorpe Foundation. Used by permission.

Page 110
Jim and Tom, Sausalito, 1977
Silver gelatin print
51 × 40.5 cm (20 × 16 in.)
Courtesy Alison Jacques Gallery, London
© Robert Mapplethorpe Foundation. Used by permission.

Page 111
Charles Tennant, 1978
Silver gelatin print
51 × 40.5 cm (20 × 16 in.)
Courtesy Alison Jacques Gallery, London
© Robert Mapplethorpe Foundation. Used by permission.

Page 112
Lily, 1977
Silver gelatin print
51 × 40.5 cm (20 × 16 in.)
Courtesy Alison Jacques Gallery, London
© Robert Mapplethorpe Foundation. Used by permission.

Page 113
Joe, NYC, 1978
Silver gelatin print
51 × 40.5 cm (20 × 16 in.)
Courtesy Alison Jacques Gallery, London
© Robert Mapplethorpe Foundation. Used by permission.

GORDON MATTA-CLARK

Page 114, top
Exterior view of *Day's End*, 1975
Courtesy Estate of Gordon Matta-Clark and
David Zwirner, New York
© ARS, New York and DACS, London, 2007

Page 114, bottom
Interior view of *Day's End*, 1975
Courtesy Estate of Gordon Matta-Clark and
David Zwirner, New York
© ARS, New York and DACS, London, 2007

Page 115
Day's End, 1975
Cibachrome print
40.5 × 51 cm (16 × 20 in.)
Courtesy Estate of Gordon Matta-Clark and
David Zwirner, New York
© ARS, New York and DACS, London, 2007

MARK MORRISROE

Page 122
La Mome Piaf, 1983
C-type print
51 × 40.5 cm (20 × 16 in.)
Courtesy The Estate of Mark Morrisroe
(Collection Ringier), Fotomuseum Winterthur
© The Estate of Mark Morrisroe

Page 123
Self-Portrait with Broken Arm, 1984
C-type print
51 × 40.5 cm (20 × 16 in.)
Courtesy The Estate of Mark Morrisroe
(Collection Ringier), Fotomuseum Winterthur
© The Estate of Mark Morrisroe

Page 124
Untitled (The Starn Twins), 1983
C-type print
51 × 40.5 cm (20 × 16 in.)
Courtesy The Estate of Mark Morrisroe
(Collection Ringier), Fotomuseum Winterthur
© The Estate of Mark Morrisroe

Page 125
Untitled (Self-Portrait in Drag), 1981
Black-and-white photograph
51 × 40.5 cm (20 × 16 in.)
Courtesy The Estate of Mark Morrisroe
(Collection Ringier), Fotomuseum Winterthur
© The Estate of Mark Morrisroe

Page 126
* *Hello from Bertha*, 1983
C-type print
40.5 × 51 cm (16 × 20 in.)
Courtesy The Estate of Mark Morrisroe
(Collection Ringier), Fotomuseum Winterthur
© The Estate of Mark Morrisroe

Page 127
Fascination, 1982
C-type print
51 × 40.5 cm (20 × 16 in.)
Courtesy The Estate of Mark Morrisroe
(Collection Ringier), Fotomuseum Winterthur
© The Estate of Mark Morrisroe

TONY OURSLER

Page 129
The Loner, 1980
Videotape transferred to DVD
30 min., colour, sound
Courtesy the artist and Lisson Gallery, London

Pages 130–31
The Loner, 1980
Production still
Videotape transferred to DVD
30 min., colour, sound
Courtesy the artist and Lisson Gallery, London

RAYMOND PETTIBON

Page 132
* *No Title (Make me come)*, 1981
Pen and ink on paper
28 × 21.5 cm (11 × 8½ in.)
Courtesy the artist and Regen Projects, Los Angeles

Page 133
* *No Title (The gun was)*, 1984
Pen and ink on paper
35.5 × 26 cm (14 × 10¼ in.)
Courtesy the artist and Regen Projects, Los Angeles

Page 134, top
No Title (If a Vietnamese), 1982
Pen and ink on paper
28 × 21.5 cm (11 × 8½ in.)
Courtesy the artist and Regen Projects, Los Angeles

Page 134, bottom
No Title (We burned down), 1983
Pen and ink on paper
28 × 21.5 cm (11 × 8½ in.)
Courtesy the artist and Regen Projects, Los Angeles

Page 135
No Title (The LSD really), 1982
Pen and ink on paper
35.5 × 25.5 cm (14 × 10 in.)
Courtesy the artist and Regen Projects, Los Angeles

Page 137
No Title (I wouldn't make), 1982
Pen and ink on paper
24 × 23 cm (9½ × 9 in.)
Courtesy the artist and Regen Projects, Los Angeles

ADRIAN PIPER

Pages 138–39
* *The Mythic Being: I/You (Her)*, 1974
10 black-and-white Polaroids and felt-tip pen
20.5 × 12.5 cm (8 × 5 in.)
Walker Art Center, Minneapolis, T.B. Walker
Acquisition Fund, 1999

RICHARD PRINCE

Page 140, top
* *Victoria*, 1983
From *The Entertainers*, 1982–83
Ektacolor photograph
76 × 114.5 cm (30 × 45 in.)
Courtesy Sadie Coles HQ, London
© Richard Prince

Page 140, bottom
* *Didre*, 1983
From *The Entertainers*, 1982–83
Ektacolor photograph
127 × 190.5 cm (50 × 75 in.)
Courtesy Sadie Coles HQ, London
© Richard Prince

Page 141
* *Kassandra*, 1983
From *The Entertainers*, 1982–83
Ektacolor photograph
127 × 190.5 cm (50 × 75 in.)
Courtesy Sadie Coles HQ, London
© Richard Prince

Pages 142–43
Laoura, 1982
From *The Entertainers*, 1982–83
Ektacolor photograph
76 × 101.5 cm (30 × 40 in.)
Richard and Ellen Sandor Family Collection, Chicago
© Richard Prince

JAMIE REID

Page 152
God Save the Queen (Single Cover), 1977
Newsprint, photocopy and paper collage
42 × 29.5 cm (16½ × 11¾ in.)
Private collection, Houston, Texas
© Jamie Reid

Page 153
God Save the Queen (Swastika Eyes), 1977
Newsprint, photocopy, ink and paper collage
42 × 29.5 cm (16½ × 11¾ in.)
Private collection, Houston, Texas
© Jamie Reid

MARTHA ROSLER

Pages 154–55
* *The Bowery in two inadequate descriptive systems*,
1974–75
24 silver gelatin prints on board
Each 25.5 × 56 cm (10 × 22 in.)
San Francisco Museum of Modern Art
© Martha Rosler
Photograph: Ben Blackwell

CINDY SHERMAN

Page 156
Untitled Film Still #5, 1977
Silver gelatin print
17 × 24 cm (6¾ × 9½ in.)
The Museum of Modern Art, New York,
Robert B. Menschel Fund, 1995
Courtesy the artist and Metro Pictures, New York

Page 157
Untitled Film Still #34, 1979
Silver gelatin print
24 × 19 cm (9½ × 7½ in.)
The Museum of Modern Art, New York,
Robert B. Menschel Fund, 1995
Courtesy the artist and Metro Pictures, New York

Page 158
Untitled Film Still #24, 1978
Silver gelatin print
16.5 × 24 cm (6½ × 9½ in.)
The Museum of Modern Art, New York
Courtesy the artist and Metro Pictures, New York

Page 159
Untitled Film Still #28, 1979
Silver gelatin print
19 × 24 cm (7½ × 9½ in.)
The Museum of Modern Art, New York
Courtesy the artist and Metro Pictures, New York

Page 160
Untitled Film Still #83, 1980
Silver gelatin print
18 × 24 cm (7 × 9½ in.)
The Museum of Modern Art, New York
Courtesy the artist and Metro Pictures, New York

Page 161
Untitled Film Still #60, 1980
Silver gelatin print
24 × 19 cm (9½ × 7½ in.)
The Museum of Modern Art, New York
Courtesy the artist and Metro Pictures, New York

JOHN STEZAKER

Page 162
Eros VII, 1977–78
Postcard collage
15 × 19.5 cm (6 × 7¾ in.)
Courtesy The Approach, London
Photograph: Peter White

Page 163, top
* *Eros XV*, 1977–78
Postcard collage
10 × 15 cm (4 × 6 in.)
Courtesy The Approach, London
Photograph: Peter White

Page 163, bottom
Eros IX, 1977–78
Postcard collage
11.5 × 15 cm (4½ × 6 in.)
Courtesy The Approach, London
Photograph: Peter White

Page 164
Untitled, 1978
Film-still collage
20.5 × 26 cm (8 × 10¼ in.)
Courtesy The Approach, London
Photograph: Peter White

Page 165
Untitled, 1979
Film-still collage
20.5 × 25.8 cm (8 × 10¼ in.)
Courtesy The Approach, London
Photograph: Peter White

Page 166
Recto-Verso, 1980
Collage
45 × 35 cm (17¾ × 13¾ in.)
Courtesy The Approach, London
Photograph: Peter White

HANNAH WILKE

Page 168
* *Marxism and Art: Beware of Fascist Feminism*, 1977
Offset poster
29 × 23 cm (11½ × 9 in.)
Courtesy Alison Jacques Gallery, London,
and Ronald Feldman Fine Arts, New York
© DACS, London and VAGA, New York, 2007

Page 169
* *S.O.S. Starification Object Series*, 1974
From *S.O.S. Starification Object Series*, 1974–82
Performalist self-portrait with Les Wollam
Black-and-white photograph
101.5 × 67.5 (40 × 26½ in.)
Private collection
Courtesy Alison Jacques Gallery, London,
and Ronald Feldman Fine Arts, New York
© DACS, London and VAGA, New York, 2007

Page 170
So Help Me Hannah, 1979–85
From *So Help Me Hannah*, 1978–85
Multiple video performance
25 min., colour, sound
Courtesy Alison Jacques Gallery, London,
and Ronald Feldman Fine Arts, New York
© 2007 Donald Goddard
Photo: Zindman/Fremont

Page 171, left
* *Beyond the Permissibly Given (Kuspit)*, 1978–84
From *So Help Me Hannah*, 1978–85
Performalist self-portrait with Donald Goddard
Black-and-white photograph
152.5 × 101.5 cm (60 × 40 in.)
Courtesy Alison Jacques Gallery, London,
and Ronald Feldman Fine Arts, New York
© 2007 Donald Goddard

Page 171, right
* *Exchange Values (Marx)*, 1978–84
From *So Help Me Hannah*, 1978–85
Performalist self-portrait with Donald Goddard
Black-and-white photograph
152.5 × 101.5 cm (60 × 40 in.)
Courtesy Alison Jacques Gallery, London,
and Ronald Feldman Fine Arts, New York
© 2007 Donald Goddard

STEPHEN WILLATS

Pages 178–79
I Don't Want to Be Like Anyone Else, 1976
Black-and-white prints, Letraset, ink and gouache on card
6 panels, each 109 × 76 cm (43 × 30 in.)
Courtesy the artist and Victoria Miro Gallery, London
© The artist

Pages 180–83
Are You Good Enough for the Cha Cha Cha?, 1982
Black-and-white prints, photographic dye, acrylic paint,
pencil and objects mounted on paper and card
3 panels, each 144.5 × 90 cm (57 × 35½ in.)
Tate, London
Courtesy the artist and Victoria Miro Gallery, London
© The artist

DAVID WOJNAROWICZ

Pages 184–89
From *Arthur Rimbaud in New York*, 1978–79
Silver gelatin prints
28 × 35.5 cm (11 × 14 in.) landscape;
35.5 × 28 cm (14 × 11 in.) portrait
Courtesy The Estate of David Wojnarowicz, New York;
Cabinet, London; and PPOW, New York
© The Estate of David Wojnarowicz

BILL WOODROW

Pages 190–91
Armchair and Washing Machine with Bobo Mask, 1982
Armchair, washing machine and acrylic paint
213 × 280 × 120 cm (84 × 110¼ × 47¼ in.)
Courtesy the artist and Waddington Galleries, London
Photograph: Bill Woodrow

Contributors

ROSETTA BROOKS is an art critic and writer based in Southern California. She was the founder and editor of the London-based *ZG* magazine and has written on such artists as Robert Rauschenberg, Jack Goldstein and Richard Prince.

DAVID BUSSEL is an independent curator and writer based in London. He has contributed to various publications, including *Artforum*, *Flash Art* and *Frieze*.

CARLO McCORMICK is a popular-culture critic and curator based in New York. He is Senior Editor of *Paper* magazine and has contributed extensively to numerous publications, including *Aperture*, *Art in America*, *Art News*, *Artforum*, *Spin* and *Vice*.

MARK SLADEN is a curator and writer based in London. Formerly Senior Curator at Barbican Art Gallery, he is Director of Exhibitions at the Institute of Contemporary Arts (ICA), London.

TRACEY WARR is a writer and curator specializing in body art and site-specific art. She is editor of *The Artist's Body* (2000) and is currently a researcher in art and social contexts at Glasgow School of Art.

ANDREW WILSON is an art historian, critic and curator based in London. He was Deputy Editor of *Art Monthly* for nine years and is currently Curator of Modern and Contemporary British Art at Tate, London.

ARIELLA YEDGAR is a curator and writer based in London. She is co-curator of the exhibition *Panic Attack! Art in the Punk Years* at Barbican Art Gallery.

CREDITS

The illustrations in this book have been reproduced courtesy of the following:

p. 6: Courtesy Matthew Marks Gallery, New York, © The Peter Hujar Archive, New York; p. 8: Courtesy Porridge With Everything Archives, Inc, © Throbbing Gristle; p. 10: Courtesy Archive of Cosey Fanni Tutti, © Monte Cazazza; p. 11: © André Morin; p. 12: Courtesy Adrian Piper Research Archive, Berlin; p. 15: Photograph by Tseng Kwong Chi, © 1984 Muna Tseng Dance Projects, Inc., New York. Drawing by Keith Haring, © 1984 Estate of Keith Haring, New York; p. 17: Courtesy BFI Stills, London, © Jean-Marc Prouveur; p. 44: Courtesy Rex Ray; p. 45: Courtesy The Approach, London. Photograph: Peter White; p. 47: Courtesy Estate of Gordon Matta-Clark and David Zwirner, New York, © ARS, New York and DACS, London, 2007; p. 49: © Hulton-Deutsch Collections/Corbis; p. 71: Courtesy the artist and Arts Council Collection, Southbank Centre, London; p. 73: © The artist. Courtesy the artist and Victoria Miro Gallery, London; p. 95: © Bettmann/CORBIS; p. 97: Courtesy the artist; p. 98: Courtesy Martha Cooper, New York; p. 117: Photograph: Robyn Beeche; p. 119: Courtesy Ronald Feldman Fine Arts, New York, © 2007 Donald Goddard; p. 120: Photograph: Alex Gerry, www.alexgerry.com; p. 144: Courtesy the artist; p. 147 (left): Photograph: Bob Gruen, © Bob Gruen; p. 147 (right) © Sex Pistols Residuals; p. 148: Photograph: Bob Gruen, © Bob Gruen; p. 150: Courtesy The Hospital, London, © Sex Pistols Residuals; p. 173: Courtesy The Approach, London. Photograph: Peter White; p. 174: Courtesy private collection, © DACS, London, 2007; p. 175: Courtesy Stuart Shave/Modern Art, London; p. 176: © Leeds Museums and Galleries (City Art Gallery); pp. 192, 194, 196: Courtesy the artist; p. 198: Courtesy the artist. Photograph: Barry Lattegan; p. 199: Courtesy Porridge With Everything Archives, Inc, © Throbbing Gristle; p. 200: Courtesy the artists and Stuart Shave/Modern Art, London; p. 201: Courtesy the artist and Regen Projects, Los Angeles. Photograph: Joshua White; p. 203 (top): Courtesy the artist; p. 203 (bottom): Courtesy Whitechapel Art Gallery, London. Photograph: Boyd Webb; p. 204: Courtesy the artist and Tate, London. Photograph: Edward Woodman; p. 205: Courtesy Mary Boone Gallery, New York; p. 206: Courtesy The Estate of David Wojnarowicz and PPOW, New York, © The Estate of David Wojnarowicz; p. 207: Photograph: Lisa Kahane. © Jenny Holzer, ARS, New York and DACS, London, 2007

The publishers have made every effort to trace and contact copyright holders of the illustrations reproduced in this book; they will be happy to correct in subsequent editions any errors or omissions that are brought to their attention.

Extract on p. 94: 'The Way We Were', words by Alan Bergman and Marilyn Bergman, and music by Marvin Hamlisch. © 1973, Colgems-EMI Music Inc, USA. Reproduced by permission of Screen Gems-EMI Music Publishing Ltd, London WC2H 0QY

Acknowledgements

The editors would like to thank the following people for sharing their knowledge and expertise during the research for this project: Paul Bayley, David Bussel, Stuart Comer, Lisa Le Feuvre, Elizabeth Manchester, Carlo McCormick, Brian Sholis and Lydia Yee, with an especially big thank you to Andrew Wilson.

The editors would also like to thank the following for their generous support and assistance during the research on the following artists: **Jean-Michel Basquiat**: Dr Hans-Michael Herzog and Walter Soppelsa, Daros Collection, Switzerland; The Estate of Jean-Michel Basquiat, New York; Sjarel Ex and Sandra Tatsakis, Museum Boijmans Van Beuningen, Rotterdam; Nicola Vassell, Deitch Projects, New York. **Victor Burgin**: Galerie Thomas Zander, Cologne. **COUM Transmissions**: James Birch; Andrew Wheatley, Cabinet, London. **Tony Cragg**: Francesca Boenzi, Galleria Lia Rumma, Naples/Milan; Nicholas Logsdail, Lisson Gallery, London; Paliotto Collection, Naples; Candy Stobbs, Whitechapel Art Gallery, London. **Cerith Wyn Evans**: White Cube, London; Natalie Lazarus. **Gilbert & George**: Richard Gooderick, Arts Council England, London; Ben Borthwick, Tate, London; Tim Marlow and Susan May, White Cube, London. **Nan Goldin**: Cristopher Canizares, Matthew Marks Gallery, New York; Nan Goldin Studio, New York; Katrina del Mar. **Keith Haring**: Julia Gruen, Estate of Keith Haring, New York; Suzanne Geiss, Deitch Projects, New York; Arielle Caruso and Max Lang, Max Lang, New York; Muna Tseng Dance Projects, Inc., New York; Gianni Mercurio. **Jenny Holzer**: Tate, London; Alanna Gedgaudas and Mindy McDaniel, Jenny Holzer Studio, New York; Sprüth Magers, London. **Peter Hujar**: Cristopher Canizares, Matthew Marks Gallery, New York. **Derek Jarman**: James Mackay, London; Dave McCall, BFI Stills, London. **Mike Kelley**: Jenna Filia and Andrew Massad, Christie's, Los Angeles; Serena Cattaneo Adorno and Mark Francis, Gagosian Gallery, London; Noëllie Roussel, Patrick Painter Gallery, Santa Monica; Rosamund Felsen, Rosamund Felsen Gallery, Santa Monica; Carol Vena-Mondt. **Barbara Kruger**: Dr Hans-Michael Herzog and Walter Soppelsa, Daros Collection, Switzerland; Tommaso Corvi-Mora, Corvi-Mora, London; Ron Warren, Mary Boone Gallery, New York. **David Lamelas**: Jochen Kienzle and Jeneba Sesay, Galerie Kienzle & Gmeiner GmbH, Berlin. **Linder**: Kirk McInroy and Stuart Shave, Stuart Shave/Modern Art, London. **Andrew Logan**: Arts Council Collection, Southbank Centre, London; Olga Lamas, Andrew Logan Studio, London. **Robert Longo**: George Davis and Robert Hollister, The Museum of Contemporary Art, Los Angeles; Tate, London; Paulo Arao, Robert Longo Studio, New York. **Paul McCarthy**: Tate, London; Gregor Muir, Hauser & Wirth Zürich London. **Robert Mapplethorpe**: Alison Jacques and Laura Lord, Alison Jacques Gallery, London; Joree Adilman, Robert Mapplethorpe Foundation, New York. **Gordon Matta-Clark**: Estate of Gordon Matta-Clark, New York; Jessica Eckert and Cameron Shaw, David Zwirner, New York; Rebecca Cleman and Josh Kline, Electronic Arts Intermix, New York. **Mark Morrisroe**: Dr Sabine Schnakenberg, Haus der Photographie, Deichtorhallen, Hamburg; Alexandra Blättler, The Estate of Mark Morrisroe, Winterthur; Thomas Seelig and Urs Stahel, Fotomuseum Winterthur; Aurel Scheibler, Berlin; Sammlung F.C. Gundlach, Hamburg; Ramsey McPhillips. **Tony Oursler**: Karolin Kober, Lisson Gallery, London. **Raymond Pettibon**: Tanya Brodsky, Yasmine Rahimradeh and Shaun Caley Regen, Regen Projects, Los Angeles; Sadie Coles and Pauline Daley, Sadie Coles HQ, London. **Adrian Piper**: Angie Morrow and Stephanie Smith, Smart Museum of Art, Chicago; Dr Elisabeth Klotz, Adrian Piper Research Archive, Berlin; Thomas Erben, Thomas Erben Gallery, New York. **Richard Prince**: Sadie Coles and Pauline Daley, Sadie Coles HQ, London; Richard and Ellen Sandor. **Jamie Reid**: David Marrinan-Hayes, The Hospital, London; John Marchant, X Marks Art Management, London. **Martha Rosler**: Jay Gorney, Mitchell, Innes & Nash, New York. **Cindy Sherman**: Eva Respini, The Museum of Modern Art, New York; Cornelia Grassi, greengrassi, London; Tom Heman and James Woodward, Metro Pictures, New York. **John Stezaker**: The Approach, London; William Horner. **Hannah Wilke**: Alison Jacques and Laura Lord, Alison Jacques Gallery, London; Marco Nocella and Sarah Paulson, Ronald Feldman Fine Arts, New York; Helen Kornblum. **Stephen Willats**: Tate, London; Victoria Miro Gallery, London. **David Wojnarowicz**: Tom Rauffenbart, The Estate of David Wojnarowicz, New York; Marvin Taylor, The Fales Library & Special Collections, New York; Andrew Wheatley, Cabinet, London; Justin Murison, PPOW, New York; Ian White. **Bill Woodrow**: Felix Mottram, Waddington Galleries, London.

Index